TECHNIQUES
OF THE
IMPRESSIONISTS

TECHNIQUES
OF THE
IMPRESSIONISTS

Anthea Callen

CHARTWELL
BOOKS, INC.

A QUANTUM BOOK

Published by Chartwell Books
A Division of Book Sales Inc
114 Northfield Avenue
Edison, New Jersey 08837
USA

Copyright © 1982 Quarto Publishing plc

This edition printed 2001

ISBN 0-89009-545-0

QUMIMP

This book was produced by
Quantum Books Ltd
6 Blundell Street
London N7 9BH

Art director Alastair Campbell
Production director Edward Kinsey
Editorial director Jeremy Harwood
Senior editor Kathy Rooney
Editor Nicola Thompson
Art editor Caroline Courtney
Picture research Anne-Marie Ehrlich
Paste-up Janel Minors
Illustrator Sally Launder

Filmset in Great Britain by
Oliver Burridge and Company Limited, Crawley, Sussex,
and Text Filmsetters Limited, Orpington, Kent
Color origination in Hong Kong
by Hong Kong Graphic Arts Service

Printed in Singapore by Star Standard Pte. Ltd.

QED would like to thank the photographers taking details of the paintings – Mike Fear (in the English galleries) and Hubert Josse (in France). Special thanks also go to all the art galleries, public collections and private collectors who have contributed to the book. We are particularly grateful to Dr Dennis Farr and Robyn Featherstone at the Courtauld Institute Galleries, London; Gordon Robertson of A.C. Cooper Photographers, London; Mr Galloway at The National Gallery, London; Graham Langton at The Tate Gallery, London; James Holloway at The National Museum of Wales, Cardiff; Philip S. Vainker at The Burrell Collection, Glasgow; and S.P.A.D.E.M. in particular for their kind help and enduring patience

CONTENTS

FOREWORD

Ironically, people who write on art frequently overlook the practical side of the craft, often concentrating solely on stylistic, literary or formal qualities in their discussion of painting. As a result, unnecessary errors and misunderstandings have grown up in art history, only to be reiterated by succeeding generations of writers. Any work of art is determined first and foremost by the materials available to the artist, and by the artist's ability to manipulate those materials. Thus only when the limitations imposed by artists' material and social conditions are taken fully into account can aesthetic preoccupations, and the place of art in history, be adequately understood. It was with an intuitive conviction of the importance of this approach that I began my research into artists' materials and techniques over ten years ago. My conviction has been strengthened by my findings, which I am presenting here in an abbreviated and, I hope, accessible form. Looking at art is the key to art history, and I trust that this book will encourage people to look at paintings with renewed enthusiasm and a greater understanding of how and why they were made. I owe debts of gratitude to friends and colleagues too numerous to mention here individually, but I thank them all. Especial thanks must go to my thesis supervisor at the Courtauld Institute of Art, University of London, Dr R. W. Ratcliffe; and to M. Marc Havel, Paris, of Lefranc Bourgeois. The Leverhulme Trust Fund provided financial support which enabled me to pursue my research in France, for which I am very grateful. I would also like to thank my parents, who have given me their support throughout. This book is dedicated to my friend James Barrett, who, like me, believes that understanding stems from remaining in contact with how things are made.

Anthea Callen.

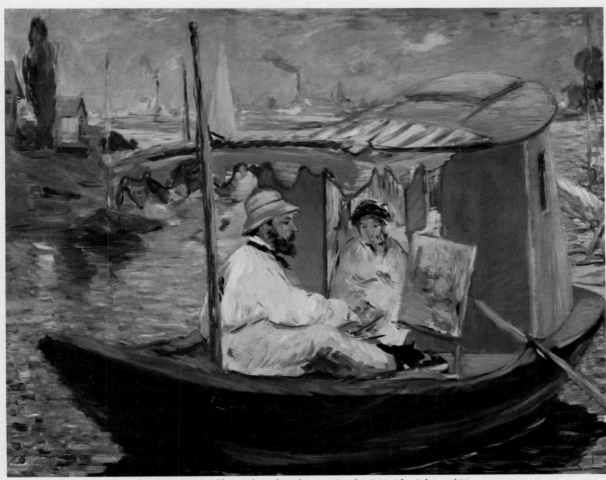

Claude Monet and his wife on his Floating Studio *(1874) by Edouard Manet*

'In a new age, new techniques. It's a simple matter of good sense', commented the young French writer and critic J. K. Huysmans (1848–1907) extremely perceptively on the innovatory Impressionist group in 1879. However, it had taken almost a century of social, political and artistic upheaval, and of struggle against the extreme stranglehold of the French Academy, for all but a few to recognize this fact. Traditional conventions in French art were deeply ingrained, and the whole established structure of the art world dug in its conservative heels against change, novelty and the needs of the new age. From the French Revolution of 1789 onwards, three generations of young, independent artists were forced to seek their own alternatives in style, training, patronage and painting methods, against the power monopoly invested in the Academy. The rise of Impressionism, with its radical new aims and painting techniques, can only be understood against the background which dictated artistic taste, and against which these young artists reacted.

The rise of the Academies

During the Italian Renaissance, artists like Leonardo (1452–1519) and Michelangelo (1475–1564) had struggled to raise the status of the artist from the medieval position of humble artisan. Because painting was felt to soil the hands and involve manual labor, it had not been accorded the status given to such scholarly pursuits as music, mathematics and literature. In order to rectify this, when the first art academies were founded in the sixteenth century, they taught only the most intellectual aspects of art — the scientific study of anatomy, the geometry of perspective for constructing an illusion of space and, most importantly, drawing. Although color is a real presence in nature, line as such does not exist. The outlines, contours and shading used in drawing are technical devices intended as a way of enabling artists to translate the appearance of three-dimensional objects onto a flat surface. Therefore by stressing the superiority of drawing artists were emphasizing the most intellectual and abstract aspect of their work, that element in which the humanizing, rationalizing influence of the human mind could best be seen. Painting, or coloring, was relegated to a secondary role because of its association with the senses and with the vulgar imitation of raw nature, as well as with the dirty, practical side of art. At all costs painting had to be seen to appeal to the higher, moral side of the human mind, not merely to satisfy sensual appetites.

This split between the intellectual and the senses, between line and color, artist and artisan, was perpetuated in seventeenth century France, when the Royal Academy was founded there in the 1640s. The most famous artists of this period, like Nicolas Poussin (c 1594–1665) and Claude (1600–1682), spent

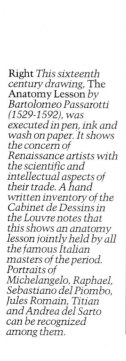

Right *This sixteenth century drawing,* The Anatomy Lesson *by Bartolomeo Passarotti (1529-1592), was executed in pen, ink and wash on paper. It shows the concern of Renaissance artists with the scientific and intellectual aspects of their trade. A hand written inventory of the Cabinet de Dessins in the Louvre notes that this shows an anatomy lesson jointly held by all the famous Italian masters of the period. Portraits of Michelangelo, Raphael, Sebastiano del Piombo, Jules Romain, Titian and Andrea del Sarto can be recognized among them.*

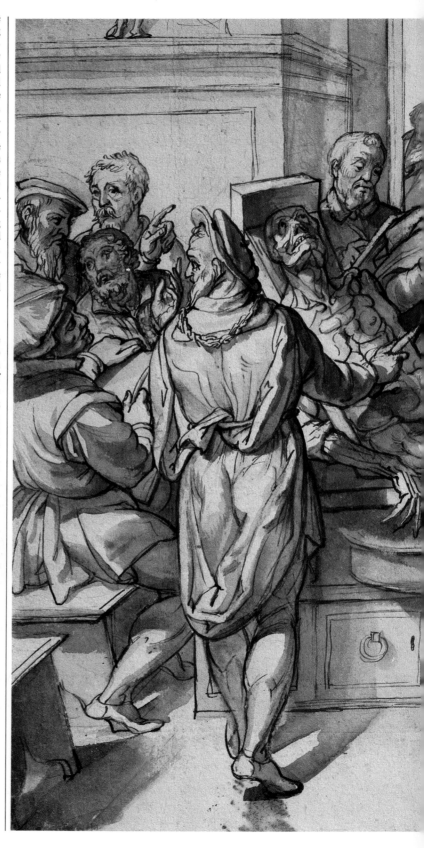

most of their lives in Italy, enjoying the privileged status by then accepted as due to the greatest talents. The renowned theorists of the period took up the debate between the mind and the senses, transforming it into the contemporary division between those in favor of the classicizing Poussin, and those behind the flamboyant colorist from Flanders, Peter Paul Rubens (1577–1640). The Academy had been founded to improve the status of French artists, to bring art within the control of the absolute monarch Louis XIV, and to free artists from what they considered the retrogressive stranglehold of the traditional guilds. While the guilds, established during the Middle Ages, stressed thorough practical training and craftsmanship, the Academy concentrated upon drawing, in particular from the human figure which was considered the principal vehicle for embodying and expressing the highest human ideals.

The human form was not simply to be 'imitated' in drawing, but to be idealized – in conformity with ancient Greek, Roman and Renaissance art – to represent the purest forms of an ideal of truth and beauty upon which the mind could reflect and thus be elevated.

These attitudes influenced the choice of subject matter which, as a result, fell into a distinct hierarchy according to the degree of spiritual elevation it was felt to display. Lowest on the scale were still life, animal painting, rural landscape and genre or domestic scenes. Historical landscape painting, by which was meant a heroic landscape with a moral or classical theme, together with portrait and religious subjects, were more highly regarded. However, the most highly respected type of painting was history painting, which represented heroic deeds from the history of the Greeks and Romans. Through this type of work, the artist could best show skill in depicting both the nude and draperies. To this end, the Academy encouraged students to familiarize themselves with details of classical history and mythology and to study and copy the works of suitable Old Masters.

Paralleling this high ideal, academic artists – unlike their guild counterparts – were from the first forbidden to advertise or hawk their products. Such lowly, mercantile activity was considered beneath the dignity of fine artists. Instead, a regular venue, the Salon, so named after the *Salon Carré* in the Louvre where the first exhibitions were held, was established as the sole acceptable market place for the work of Academy-trained artists. The power of the Salon grew, and it retained its monopoly as the main outlet for artists' work until the latter part of the nineteenth century.

Teaching under the Academy

By the nineteenth century, the academic training of the artist had become ritualized into a rigid formula, which was self-perpetuating and changed only with great reluctance to meet the new needs of the age. The Academy was renamed the Ecole des Beaux-Arts in the reign of Napoleon I, and it only accepted students who already showed proven ability in drawing. Drawing instruction at the Ecole was given by members of the Academy, by then an honorary elite body of artists who were elected to life membership by other academicians and who advised the government on all artistic matters. Academicians controlled not only the curriculum at the Ecole, but also the competitions students had to enter and win to achieve success and consolidate their careers. Academicians were also jurors dictating entry to and medals awarded at the annual Salon exhibitions. The Academy thus effectively dominated art production and was able to perpetuate its conservative style and taste.

Academic control of teaching was not limited to drawing instruction at the Ecole; academicians prepared students for entry into the Ecole with drawing lessons in their private teaching studios or *ateliers*, where they also instructed advanced students in painting practice. The great encyclopedia, compiled by the French writer Denis Diderot (1713-1784) and published in the latter half of the eighteenth century, shows the typical progress of students through the various stages in the hierarchical drawing curriculum, which would give them access to the Ecole. The first stage involved copying either drawings or engravings, first in terms only of outline, then with hatched shading. This was known as work 'from the flat' because students had merely to imitate the

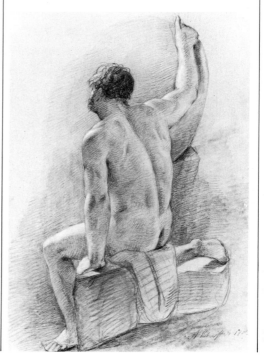

Left *Born in Holland, the artist Ary Scheffer (1795-1858) was – with Delacroix and Géricault – one of the three prize pupils at the studio of Guérin (1774-1833), where he enrolled in 1812. This life study of 1807, drawn in black crayon and white chalk on paper, is obviously a very youthful work, presumably done in Holland. If the date is correct this shows the artist began his training at a very tender age. The academic technique of parallel hatched strokes contained by contours is seen here, built up to create subtle tonal gradations which are finally heightened with white chalk. Because life drawings became so closely associated with academic training, they became known as* Academies. *The full title of this work is* Academy drawn after Life.

simple lines to which the form had already been reduced.

Once this was successfully mastered, the student moved on to drawing low-relief sculpture. Here the fall of light and shade on the simple raised forms had to be translated into shading. This shading followed strict conventions and formed an important part of the approach to painting approved by the Academy.

It was called *chiaroscuro*, which means light-dark in Italian. To achieve the subtleties of *chiaroscuro* shading, series of distinct, hatched parallel marks indicated shaded areas, while the white of the paper was left blank to represent highlights. For this, pencil or graphite, a crisp precise medium, was preferred during the first half of the century. Chalk or charcoal, which were softer and more suited to the rubbed

Right Greek Slave *(c1869) by Jean-Léon Gérôme (1824-1904) is an example of* ébauche *in oil on canvas. The title added to this academic nude study immediately suggests that it was intended to be seen in the classical tradition, although the contemporary appearance of the woman's face makes no concession to classicism. The ennobling title and slight idealization of the form simply vindicate the subject. The figure has been most tightly and completely worked, and the* ébauche *stage is shown complete there. The carefully laid, gradated tints for the flesh are fully blended until individual brushmarks are imperceptible. This creates a stark contrast with the background, which remains only roughly laid in. A thin wash of translucent color was rubbed on loosely in the early stages of execution. This shows the marks of the broad bristle brush and the pale ground glowing through. It also reveals the lines, drawn with a ruler, which indicate the interior in which it was intended to situate the completed figure.*

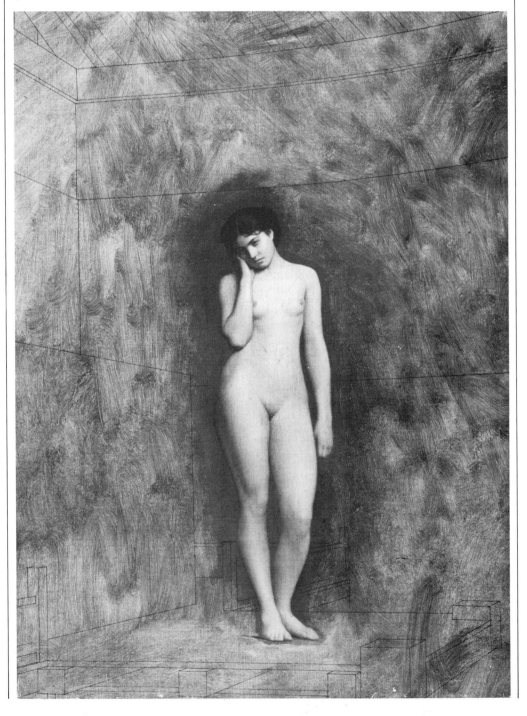

blending which was used to create tonal gradations, became the popular media as the system liberalized.

The next step was for students to draw from sculpture in the round. First only parts of, and then complete statues, usually cast after antique examples, had to be translated into delicate patterns of line, built up to recreate on flat paper the illusion of form in space. Because the reliefs and sculptures were cast in white plaster, no color was present to distract the eye; the form presented itself simply in monochrome gradations of tone from light to dark. As the models from which the students worked were already idealized works of art, they helped to inculcate in the students a mannered vision of nature, which encouraged them to draw the live model in a conventional, idealized and unindividual way. Thus, by the time students graduated to work from the live figure, their drawing style had already been formed.

Although the real color and anatomical idiosyncracies of the human figure were a shock to the students' unaccustomed eyes, the tendency to see the form only in abstract line and tonal gradations was already well ingrained. Models were commonly posed in noble stances derived from antique statues, which both aided the transition from cast to live model, and maintained the emphasis on the classical tradition. Such exercises were designed to give students the competence to tackle complex figure compositions based on classical themes, which would prepare them for the grand Rome Prize, the final competition toward which all their studies were directed.

Only when students were thoroughly proficient in drawing from the live model were they permitted to use color. The master generally gave a brief introduction to the materials and tools of painting and their care, and then the students began copying a painted head. This was either an example specially executed by the master, or, occasionally, students were sent to the Louvre to copy an Old Master head. Venetian or Flemish artists were usually chosen because their lively handling and color were simpler to imitate. Students were then put to work from a live head, before going on to attempt to paint the nude model. The first stage in the painting process was the thinly painted laying in of the lines, broad masses and half-

tones of the subject, which provided the base for the finished painting. This stage was called the *ébauche*. This first layer had to be 'leaner', in other words contain less oil, than the final reworking, to adhere to the rule 'fat over lean', essential to competent oil painting. This rule is important because, if an oily layer is laid over an even oilier base, the latter will continue drying after the final coat is dry, thus causing the top layer to shrink and crack, exposing the underpainting.

Students were taught to prepare their palette in advance, using mainly earth colors plus Prussian blue, black and lead white. As the nineteenth century progressed, the use of the earth colors, which were relatively stable chemically, gave way to a preference for the impermanent beauties of tarry colors, like bitumen, which destroyed many paintings. Carefully prepared tints, which were thoroughly mixed with a pliant knife on a palette, were arranged in separate rows aligned with the outer edge of a clean palette – lights, darks and intermediary halftones. Once the palette was ready, light charcoal lines were drawn onto the primed canvas to indicate the contours of the form. The canvas was then gently tapped or blown on to remove excess dusty particles of the charcoal, to prevent their muddying the wet oil colors.

Next a dilute red-brown mixture was prepared by adding turpentine to an earth-color mixture, and with this transparent tint the charcoal contours were reworked and strengthened using a fine sable-hair brush. Again with the dilute mixture, called the 'sauce', the main areas of shadow were broadly laid in, normally with a larger, stiffer hog's hair brush, following the guidelines provided by the contours. Backgrounds were generally roughed in as early as possible, to block out the pale priming color which, because of its glaring brilliance, made it difficult for the student to judge the correct tonal values in the picture. Detail was avoided in this early stage, only the general effects of light and shade were sought.

Then, with thicker paint and usually a stiff brush, the lights – or parts of the painting directly illuminated by the fall of light – were added, but not at full strength. Next came the careful work of building up the delicately gradated halftones between the lights and the

Below *These scale pictures show typical nineteenth century artists' brushes, taken from French color merchants' catalogs of the period. The fan-shaped sable hair blending brush (1) was designed to be used dry to blend the mosaic-like touches of wet color on the* ébauche *of the figure. Most writers on technique scorned the use of the blending brush, finding its effects too soft and facile. Instead artists were supposed to use deft strokes of each appropriate tint to link the gradated tones of the flesh. The fine hog's hair bristle brushes (2-9), have round or flat ferrules. They are long-haired, to permit deft, flexible handling. They come with round, pointed or squared ends. These shapes all exploit the natural taper and curve of the hair, so that*

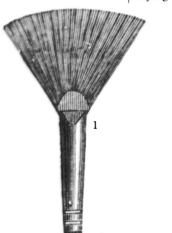
1

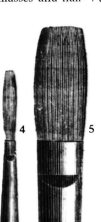
2 3

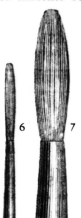
4

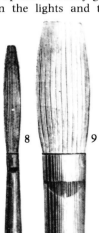
5 6 7 8 9

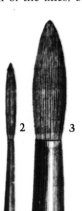

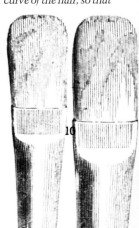
10 1

darks, to give relief to the form. These were placed side by side in separate, mosaic-like touches of color, which were finally blended until the changes in tone were imperceptible and the brushstrokes no longer visible. After blending the halftones, a few lively, expressive brushstrokes of color were applied to both lights and darks, to help the work retain a feeling of spontaneity.

Once this stage was complete, the work was left to dry thoroughly. The most thinly painted, dilute areas of color — the shadows and general background — would dry fairly rapidly due to evaporation of the turpentine spirit. The more thickly applied halftones and highlights could take a week, more usually two, to dry. The *ébauche* stage was then finished by first scraping down the dry surface, to remove any irregularities which might interfere with the smooth movement of the brush during reworking. Then the mosaic application of halftones was repeated, the highlights brought to full strength, and the color of the shadows deepened and enriched.

When painting from the live nude, students had to work rapidly to complete the *ébauche*. They had also to work in relatively thin paint, or it would not dry in time to be finished in the week allotted to each pose. Many unfinished life paintings survive, indicating how difficult it was to complete a figure study in so short a time. Backgrounds were generally left loose and vague, the greatest care being devoted to working up the precise tonal and color values on the figure itself.

The technical formula most widely recommended for executing the *ébauche* in the *ateliers* was to paint the lights thickly, in opaque impasto and, in contrast, to wash in the shadows thinly and transparently. This technique, normally retained for the finishing as well as the *ébauche* stage, aided the rendering of form in two important ways. First, the subtle transition from balanced light to shadowed areas created a convincing illusion of form in space — a sculpture-like solidity. Secondly, the physical character of the finished surface, with projecting impasted lights and flat shadows, gave a relief-like authenticity to the actual paint surface. The raised, light parts of a picture were intended to pick up and reflect back to the spectator the actual light in the room where the

work was hung, thus reinforcing the illusion of light in the picture itself. For this reason, artists preferred to hang their work under a light source comparable to that under which it had been executed, preferably with the actual light source falling at the same angle as the painted fall of light so they would not contradict each other.

The art student's life

Students usually started to study at the Ecole between the ages of 15 and 18. Training would last for at least five years. The art student's day began early. In summer the long daylight hours permitted drawing classes in the *ateliers* to begin as early as 7am. The *rapin* — the newest student — arrived even earlier to tidy and organize the studio, and in winter to light the stove. Classes in the *ateliers* lasted only for the morning, finishing usually around noon or 1pm. The *atelier* masters normally visited their students only once or at most twice each week, to advise and to criticize their work and to set 'homework', such as compositional exercises or copying, to prepare students for Ecole competitions.

The afternoons were spent in the painting and drawing collections of the Louvre, making copies from the Old Masters. This was a crucial element in the Ecole program. Copying was intended to familiarize students with the techniques of the past, and to inspire them to emulate the compositional ideas and devices of the great masters. Students also collected and copied engravings and lithographs after Old Master paintings.

Drawing classes at the Ecole, for those advanced enough to register there, began in the late afternoon, usually at 4pm. Students normally worked from casts or the live model at the Ecole. During the summer months, most students were encouraged to draw and paint from nature, doing outdoor landscape work. A knowledge of landscape was considered essential even for students primarily interested in figure painting, as they needed to be able to paint authentic landscape backdrops to their figure compositions. It was also thought important in training the students' powers of observation.

Constrained by the tightly organized teaching program, students learned to work at

the brush retains its shape when full of color and springs back into shape even after vigorous use. A cheap, poor brush rapidly becomes splayed, losing its shape and its ability to hold the paint. With such a brush, it is difficult to control the marks made. Each of the brush forms creates a distinctive mark. The six shorter haired bristle brushes (10-15), are stubby and square ended. They were ideal for use with the stiff paint consistency preferred by most of the Impressionists. They are graduated in size, for varying size of mark and suited to different scales of canvas size. The broad, flat brush (16) is for varnishing. The full, soft badger-hair brush (17) is another blending brush with a round ferrule. It serves the same function as the fan shaped blender.

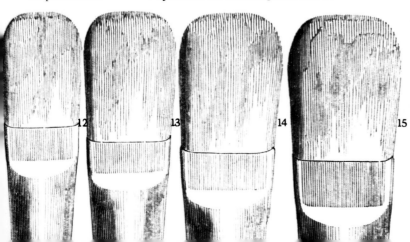

speed in order to succeed in the numerous timed drawing and painting competitions around which their studies were structured. Each competition marked a progressively more demanding step on the ladder toward the most coveted award, the Prix de Rome, which assured the winner fame after four or five years' study at the French Academy in the Italian capital. Until the early nineteenth century, only one Rome Prize – in history painting – was awarded every year and thus, because of the large numbers of students involved, few students had any real chance of success in this outdated system. Neither consistent application, nor even talent guaranteed advancement. Each master backed a protégé, and this often encouraged servile imitation in preference to independent originality on the part of the young artists.

The Academy's authority questioned

Although the overall program of teaching at the Ecole remained little changed from the seventeenth century until the reforms of 1863, new emphases were apparent in the nineteenth century system. The powerful impact of Jacques Louis David (1748–1825), who headed the classical revival and whose influence dominated art training and practice from the 1790s, led to a greater stress on life drawing and on the use of halftones to create 'sculptural' forms. His famous pupil Ingres (1780–1867) followed him, albeit with somewhat different concerns, as the major influence on French art through his teaching. Since many of the older independent artists, such as Delacroix (1798–1863) and Corot (1796–1875), did not run teaching *ateliers*, they produced no 'schools' of followers as such.

Another new factor was the marked increase in competitiveness resulting from the rapid growth in numbers of would-be artists from the late eighteenth century onwards. The collaborative studio-workshop training and practice still common in the seventeenth century had disappeared. The new individualism, inspired by the French Revolution of 1789 and the rise of the bourgeoisie, found its parallels in the career structure of artists. Professionalism, reinforced by a rigorous, quantifiable training, gradually gave artists a new middle class respectability and social acceptability.

By the early nineteenth century, certain more liberal changes were essential to the survival of the academic system, confronted as it was with growing dissention and dissatisfaction among independently minded artists. Some recognition of new trends had to be given by the Academy, for social and economic upheaval had created new official state and bourgeois patrons, whose needs and taste were often at variance with academic ideals. In 1816 the Academy introduced an official four yearly Rome Prize in historic landscape painting, to placate the taste of public and artists for this increasingly popular genre, and at the same time to bring it within the Academy's control. How-

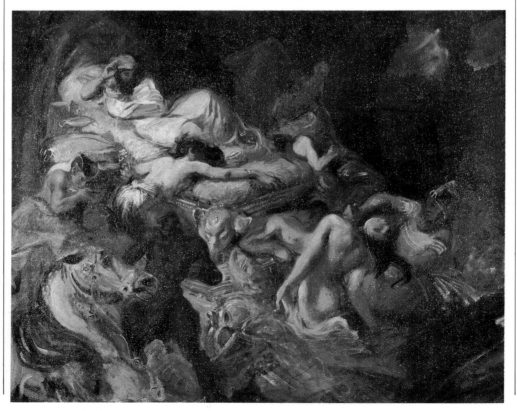

Right *This version of* The Death of Sardanapalus *by Delacroix is the oil sketch painted on canvas (c1827). Delacroix's painting is an example of the compositional* esquisse, *the smallish broadly handled preparatory oil in which color and composition for a large painting were worked out. This was usually preceded by drawn compositional sketches, also worked from the imagination, and ideas for individual figures or groups, such as the small ink drawing, or thumb-nail sketch opposite. Precise details for figures were then worked out in drawn and painted studies from posed life figures, and changes were often made.*

Right *The final painting of Delacroix's* The Death of Sardanapalus *(1828) was executed in oil on canvas. The subject of this huge work was inspired by the English poet Byron, whose tragedy* Sardanapalus – *based on a classic theme – was published in London in 1821, and in a French translation in 1825. However, Byron does not describe any scene like that depicted by Delacroix. This picture was painted for the Salon exhibition of 1828, and is an excellent example of the artist's romantic style. Subtle details of naturalistic color worked out in preparatory pastel drawings, were finally subsumed to the dominant warm harmonies which give the painting its emotive power.*

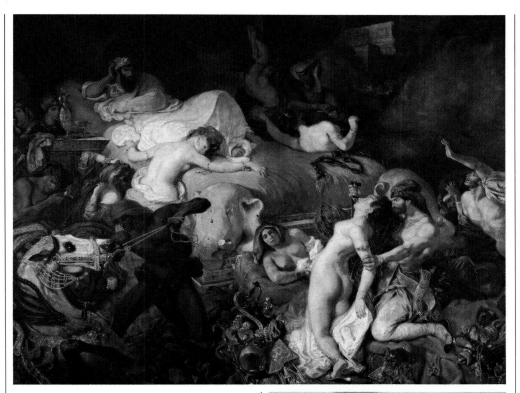

Left *This small thumbnail sketch or* croquis *for Delacroix's* Death of Sardanapalus *shows the artist toying with ideas for the poses of his figures, later to be planned in greater detail. The expressive energy of Delacroix's handling is just as apparent in this drawing medium as in his oil sketch and the final canvas.*

ever, this fostered only the classical landscape tradition, and was thus later to force the budding schools of Romantic and Realist landscape painting into open opposition to the Academy. However, in 1863, when most of the Impressionists were students, the Rome Prize for landscape was abolished.

Ironically, some aspects of the academic curriculum itself laid the foundations for the independent stylistic innovations which led to Impressionism and which eventually eroded the Academy's supremacy. The concentrated nature of the academic training ensured that students spent the majority of their time on the freely worked stages of painting – the *ébauche* of the life model, and the *esquisse*. This was the compositional sketch in oils intended to prepare students for the Rome Prize competitions. This sketch was adopted as a preliminary competition for the Rome Prize in 1816, indicating a new officially approved emphasis on the looser, preparatory stages of the painting process, as against previous concentration on the tightly methodical finishing procedures.

The compositional *esquisse* was broadly and expressively handled. Masses of light, shade and color were laid down to create the design which embodied the artist's first inspired idea for the final painting. Careful finish was not expected for this sketch, in which – on the contrary – spontaneity and originality were the prime qualities sought. The painted sketch was normally preceded by drawn sketches and, if and when the final work was to be executed,

the artist followed up the painted *esquisse* with a series of carefully drawn and painted *études*. These were studies from life of individual elements in the composition, which refined and tightened the original idea. The compositional scheme was then transferred by drawing onto the final canvas, and the slow, meticulous process of executing the finished picture began. Critics of the academic system argued that this laborious process resulted in a sterile and mannered final product. They felt that this meant the artist's original inspiration was inevitably lost because touches of individuality were eliminated on the smooth surface where individual brushstrokes should not be discernible.

The concept of originality was a major issue much debated in nineteenth century artistic circles. Conservative traditionalists, on the one hand, associated originality with the elitist idea of genius, the inventive spark which set one individual apart from the common herd. On the other hand, a new definition of originality, with

its roots in Revolutionary and post-Revolutionary democratic thinking, saw it as an innate characteristic of every human being — the uniqueness of each separate personality. These opposing definitions reflect the continuation of the deep division between the intellectual and the manual which had its roots in Renaissance ideals and aspirations.

In terms of artistic practice, the academic notion of genius was embodied in the later stages of finishing a painting, when the artist's mind refined and perfected the first, inspired idea. The newer and more 'democratic' idea of originality held that the artist's uniqueness was most apparent during the preparatory stages, when personal expression and inspiration, rather than intellect, guided the artist's hand. Thus, by unwittingly creating a program which stressed (at least in terms of time) the preparatory stages of painting — the *ébauche* and the *esquisse* in particular — the Academy fortuitously promoted the modern definition of the idea of originality.

The Independents and new ways of training

It was among the independent artists and movements that the new concept of originality was consciously adopted and striven after, which placed them in opposition to the ideals laid down by the Academy. There were some *atelier* masters who fostered new methods and original talent, remaining unconvinced that the Academy's program of directing students exclusively towards the Rome Prize was the best way to produce good artists. Among those who offered alternatives were Charles Gleyre (1806–1874) and Thomas Couture (1815–1879), neither of whom belonged to the Academy. They are therefore referred to as 'independent' artists. Gleyre, whose pupils in the early 1860s included Monet, Renoir, Sisley and Bazille, encouraged his students to make outdoor studies, communicating an admiration for landscape painting, and an appreciation of craftsmanship, which proved especially relevant to Renoir. Couture's most famous pupil was Edouard Manet (1832–1883), who remained with his master from 1850 to 1856, absorbing his unconventional attitudes to light and shade, handling, and immediacy.

Couture encouraged his students to work rapidly and simply to 'keep the first vivid impression'. He often suppressed detail and halftones in the interests of direct spontaneity. His brushwork was lively, his colors often dragged in thick confident strokes, and his forms, reduced to broad masses, outlined in strong contours. Couture passed on his love of the Old Masters to Manet, and their friendly association ended only in 1859, when Couture saw that Manet had abandoned the master's commitment to historic guises for his subject matter. Under the influence of writers like the poet Charles Baudelaire (1821–1867), Manet turned

to fusing Old Master themes with modern life subjects. That year he exhibited in his studio his rejected Salon entry, *The Absinthe Drinker*, a modern dress subject which Couture considered lacking in the refining moral overtones of the classical tradition.

Other alternatives for art students sprang up as the century progressed. Around the time of the restoration of the monarchy in 1815, Suisse, an ex-model in David's studio, established an open life studio on the corner of the Quai des Orfèvres. There, unfettered by teaching or competitions, artists as diverse as Ingres, Courbet, Manet and Cézanne were to find access to life models, both male and female, to further their own training and interests. The *atelier* of Rodolphe Julian, which came to be known as the Academy Julian, founded in 1868, became internationally renowned among independent artists. While it did prepare students who wished for the Ecole, Julian's liberal program became for many an alternative to that formal training. Horace Lecoq de Boisbaudran's classes from 1841 to 1869 provided another option for drawing instruction. He invented a method of training by drawing from memory, which encouraged originality in a way unknown in servile copying from the model. His most famous students were the sculptor Auguste Rodin (1840–1917) and painter and lithographer Henri Fantin-Latour (1836–1904).

Another extremely influential figure in the challenge to the Academy was Eugène Delacroix who was regarded as an independent artist. Delacroix considered himself as a painter who was simply bringing new energy and vitality to a tired classical tradition. However, conservatives criticized him as an innovator, while his works were revered by younger artists for their expressive color and bold brushwork. The visible sign of the brush, which was suppressed by academic 'finish' came to represent for the Impressionist generation the outward mark of the artist's individuality — a personal calligraphy which identified originality and uniqueness. Delacroix founded no school of followers as did Ingres and the academic masters, but his example was important to many younger independent artists, particularly the Impressionists.

Corot was another extremely important independent artist who, although he kept no formal teaching studio, frequently taught and encouraged young artists, including the leading Impressionists Camille Pissarro (1830–1903) and Berthe Morisot (1841–1895). Corot had trained in the classical landscape tradition, but he abandoned the traditional *chiaroscuro* way of rendering light and shade in landscape. He was also innovatory and influential in advocating immediacy and the importance of the first impression as evidence of the artist's most genuine personal response to the subject. His maxim was 'Always the masses, the whole, . . .

Right *Horace and Lydia was painted in 1843 by the French artist Thomas Couture. Not a member of the Academy, he was extremely influential as a teacher. His most famous pupil was Manet and Couture's influence can be seen in some of Manet's work. This work is broadly handled with strong contrasts between light and dark and few halftones. As in Manet's* Luncheon on the Grass *and* Olympia, *the shadows form contours round the figures. However, unlike Manet, Couture used brown in his shadows, following the traditional practice, whereas Manet used black which was considered revolutionary.*

that which strikes you. Never lose the first impression which has moved you.' Significantly, such advice had become common currency by the 1870s, when the Impressionist style was at its height.

New approaches to landscape painting

In nineteenth century France, landscape painting, especially rural landscape, was the type of painting least fettered by the rules of academic tradition. This was the key reason why it became the leading area for the stylistic and technical innovations which reached their peak with Impressionism.

Many older independent artists — like both Delacroix and Corot — did not break completely with the academic tradition because they con-

tinued to maintain the importance of the highly finished work of art. However, they made technical innovations by emphasizing the sketch element in their work. Thus Corot adapted the opaque shadows taught by his neoclassical masters to represent more truthfully the delicate nuances of tonal value he perceived in nature. In his experimental outdoor studies, Corot concentrated on the overall effect of natural light and shade, choosing distant subjects in order that excessive detail should not detract from this general effect. He added white to all his colors to heighten the overall luminosity in his paintings, thus bringing them closer to a faithful rendering of outdoor light effects. By contrast, the conventional academic *chiaroscuro* technique dictated that, in landscape

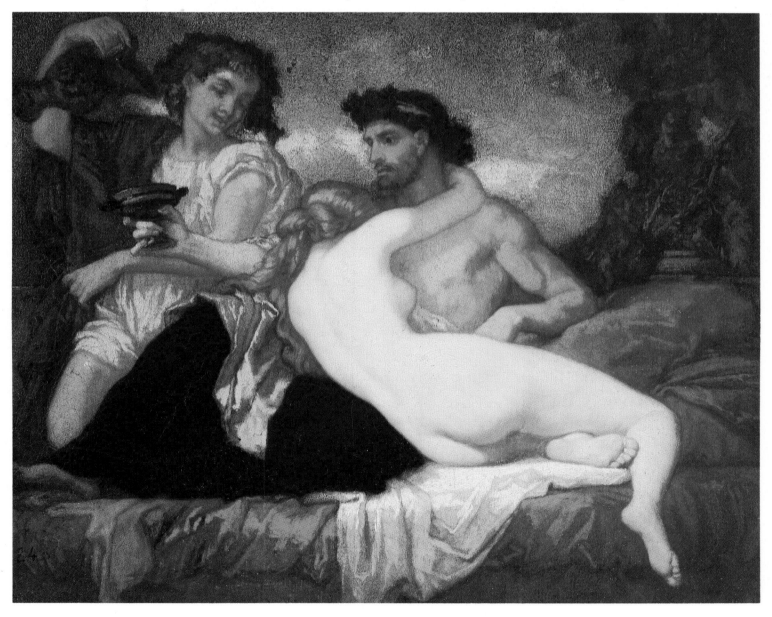

Below Two Poplars at the Villa Farnese (c1783) by Pierre-Henri de Valenciennes (1750-1819) was executed in oil on paper. Valenciennes rounded off his academic art training in Paris with a period in Italy from 1777 to 1786, during which he studied the Italian Masters, and also made open-air studies in oil. The oil study recorded the artist's impression before the natural scene outdoors. It was intended to sharpen the powers of observation and the facility of swift execution, and to serve as a memory aid for studio landscapes. During the nineteenth century, outdoor studies gradually replaced studio-finished landscapes as the final work.

painting, artists should artificially darken the pale range of tones found in nature and, correspondingly, lighten the pitch of the naturally somber tonal values found indoors, when painting interior scenes.

Academic landscape painting made little direct reference to real light effects in nature. Instead, a classical formula was advocated, which arbitrarily placed darks in the foreground, with somber theatrical 'wings' of trees or buildings to right and left, the scene growing systematically paler toward a luminous horizon. The lights and darks were a schematized studio invention intended mainly to direct the viewer's eye into the pictorial space. The whole was planned to represent an idea, a human ideal, not real raw nature – indeed the unidealized imitation of nature was condemned as being base and purely mechanical. Whereas in academic figure painting the *esquisse* was the most freely and spontaneously executed stage, and *études* of individual compositional elements were relatively slowly and carefully worked under static studio lighting conditions, in landscape painting the *étude* formed the loose stage, in which the artist's response to the natural

effect was captured. Speed in the outdoor *étude* was essential, because of the fast changing, ephemeral lighting effects which had to be translated into paint.

In the academic landscape program, these small *études* from nature provided the raw material and visual vocabulary which aided the artist's memory when the final work was undertaken in the studio. This large-scale piece subjected the initial ideas embodied in the *études* to the classicizing process, in which the classical compositional formula dictated the pictorial structure. This, in turn, dictated the balance and tonal range of light and shade, and most of the original effects were lost in the search for an internal pictorial coherence. An elevating heroic theme, either historical or biblical, was another requirement of academic landscape painting. As accurate observation of particular rural sites in natural outdoor light gained in importance, so artists gradually abandoned studio reworking, preferring more truthful studies executed entirely before nature.

The loss of traditional technical knowledge
Delacroix was one among many nineteenth

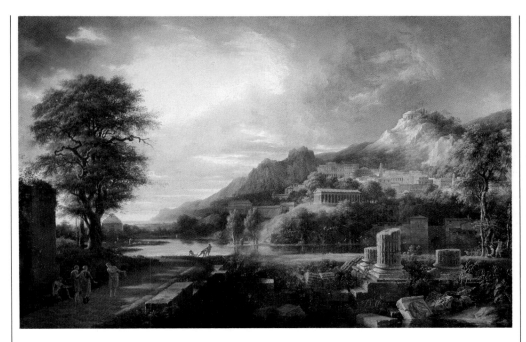

Left *Valenciennes was responsible for the revival in the 1780s of the ideal 'historical landscape' in the seventeenth century manner.* The Ancient City of Agrigentum: Ideal Landscape *(1787) was painted in oil on canvas. In 1800 he published an important treatise on landscape painting, and his ideas dominated French landscape painting for decades afterwards. His work led to the founding of the Rome Prize in landscape painting in 1816. The studio executed, historical landscape was lit by a contrived chiaroscuro, and usually contained small figures and classical ruins.*

century artists who held David responsible not simply for the classical revival but, more importantly, for the complete rupture with the tradition of technical expertise. It is true that David discouraged his students from studying and learning from their eighteenth century Rococo predecessors, but the breakdown in traditional painting methods was by then in any case virtually total.

David's affected disdain for technical tradition simply echoed the age-old split between the intellectual and manual aspects of art. The dissolution of traditional practical know-how had gone hand in hand with the rise of academic training in the seventeenth century. The craft-based guilds had fostered practical expertise, which was handed down by the apprenticeship system from master to pupil. Apprentices had originally to learn all the skills of the trade before they began studying drawing and painting, and thus they were well versed in the chemistry of their materials.

In the early days of the Academies, painting techniques were similarly picked up from the master in whose *atelier* students worked. However, as the preparation of materials was taken out of the hands of trainees and taken over by professional merchants and specialists, there was no longer a need for this side of the trade to be learned, leaving artists with no practical knowledge of their materials. Nothing was introduced into the students' training to replace this lost knowledge, and awareness of the basic constituents and properties of their tools-in-trade was soon lost to artists.

This development is not surprising in view of the attitude of artists to the sordid practicalities which had long linked their profession to that of the common artisan. But not only was the knowledge of materials lost, techniques for handling them survived only to become sterile rules, meaningless and misunderstood by those who used them. Artists' problems were further complicated in the nineteenth century by the introduction of mass-production into the artists' materials trade, which transformed their equipment almost beyond recognition.

Contemporary writers disagreed as to the cause of this technical malaise. Some traditionalists felt inadequate training of the artist was to blame. Color merchants, like the famous English paint chemist George Field, were quick to take this side to defend their profession. He wrote in 1835 that the 'odium of employing bad articles attaches to the artist if he resorts to vicious sources or employ his means improperly'. However, as the French specialist on artist's techniques J. F. L. Mérimée had pointed out in 1830, artists 'no longer learning the nature of their colors were incompetent to detect fraud or to distinguish the good from the inferior sort.' Many therefore used whatever came to hand and some even preferred the cheapest materials available.

Couture also believed that artists themselves rather than poor materials were to blame for the loss of sound painting. He wrote that it was a great prejudice to think that modern colors were less good than those used by the Old Masters. He naively considered that the best paints were the simplest, like those used by housepainters, and, for this reason, he felt that the excessive care and complicated preparation employed by artists' colormen were detrimental to the resulting colors. For Couture, the solidity of Old Master paintings came not

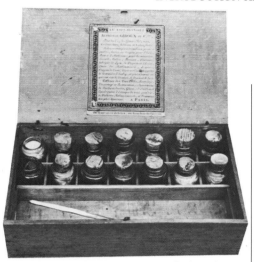

Right *This box of powder pigments in bottles was packaged and sold by the French color merchant Alphonse Giroux around 1800. The label on the lid lists materials supplied by this dealer.*

from superior materials, but simply from better painting methods. Renoir (1841–1919) had similar views, which he expressed forcibly on several occasions.

The rise of the color merchant

From about the mid eighteenth century onwards, artists thought that Old Master methods had been lost as a result of jealously guarded professional secrecy among practitioners. This notion derived from the existence of published volumes of *Secreti*. These were books of assorted chemical and medicinal recipes originating from medieval and later writers. Despite their title, however, these were expressly intended to make knowledge widely available. Thus the traditional recipes and handling techniques had been lost not as a result of any mean tight-fistedness among earlier practitioners, but through the changes in structure of artists' training which left them ignorant of such things, and deprived the printed knowledge of its practical meaning. By the time the guilds had been superseded by professional colormen, the concern was for profit rather than for durability. Preparation of materials became exclusively the business of traders, who, in the words of Mérimée 'had a stronger feeling toward their own immediate profit, than any regard to the preservation of pictures'. This resulted in the deterioration and rapid changes that took place in many eighteenth century pictures.

From about the early to mid seventeenth century up until the mid eighteenth century, the trade in artists' materials was associated with the more general trades of pharmacy and grocery. Although the influential late seventeenth century art theorist Roger de Piles mentioned 'color vendors', it was apparently only after the mid eighteenth century that artists' colormen began appearing as an independent class of trader. Most early color merchants concentrated on the manufacture of a particular commodity — watercolors, varnishes, particular oil colors or pastels, for example, and often bought their raw materials from different manufacturers. However, they all retailed a complete range of items essential to the artist, including supports, frames, brushes, drawing materials, paper, palettes and easels which were ready made by other specialist manufacturers. Thus a particular colorman could be engaged in the specialized production and improvement of one product — like the 'artificial crayons' perfected in the late eighteenth century by Conté — which would then appear amongst the merchandise retailed by other color merchants. Many merchants who began by selling artists' materials soon diversified, moving into picture dealing and restoration by way of renting out engravings and pictures for amateurs to copy. A famous example was the Durand-Ruel family, who began as paper retailers and became the first, most loyal and most important dealers in Impressionist paintings. Other firms began as small manufacturers or retailers and expanded into large-scale mass-producers and entrepreneurs, supplying their goods to the retail side of the trade.

New techniques

A further disincentive to French artists to pursue more scientifically the bases of their materials and methods, was the ever present association of craft skills with demeaning manual work. This was an especially pertinent stigma at a time when most academic and independent artists were struggling to be accepted into the bourgeois social class. Added to this, craftsmanship in the nineteenth century seems to have become inextricably, though mistakenly, linked in the minds of independent artists, with the laborious finishing procedures of Academic painting. Thus craftsmanship, in the latter third of the nineteenth century, came to be seen by many artists as a restraint upon personal expression and creativity. These were precisely the features held to be so important among independent painters. In his discussion of the need for careful craftsmanship in the build-up of the paint layer, the artist and paint scientist Vibert all but apologized for his concern, keenly emphasizing that it would not inhibit inspiration. Rather it would aid originality by providing a sound technical basis for the enduring expression of the artist's personality.

Vibert recommended *alla prima* or 'at-a-single-sitting' painting as the most durable and safe method, but, as he considered it an extremely difficult technique that few could master, he insisted upon careful underpainting. The methods promoted by academic training were in fact contradictory. On the one hand, hasty execution was encouraged because students were pressured by time. However, on the other hand, speed was incompatible with the reworked, multilayered finishing techniques fostered by the Academy, because slow and thorough drying of each successive layer in an oil painting is essential to the work's durability. These successive reworkings resulted in a complex paint layer which was extremely vul-

nerable because of the increased number of unpredictable chemical reactions involved. The independent rural landscapists, and later the Impressionists, discouraged repeated reworkings by advocating *alla prima* painting and landscape *études* executed rapidly before nature. This meant that they were simultaneously insisting upon the importance of permanency in their works.

Thus, from the 1850s on, the growing popularity of the rapid, sketch-like *alla prima* painting technique — which facilitated the recording of natural effects — had clear practical advan-

tages. In addition to its aesthetic attraction in reflecting the artist's originality, it was also more suited to the new, mass-produced materials available. Many independents, like Manet in the 1860s, were to attempt a compromise between old and new methods, trying to fuse traditional elements with the search for immediacy, for the effect of spontaneity in their work. It was as a result of the lively experimentation which dominated artistic activity during this decade, that the obsolete *chiaroscuro* techniques were finally superseded by the novel techniques of Impressionism.

Left *Ingres painted this work,* Bather *(1826), in oil on canvas. Ingres' work shows the attempt to combine landscape backgrounds with figures painted indoors, in the studio. The main figure in particular demonstrates the problems of integrating an indoor lit figure in an invented landscape, for the crisply focused light and sharp, warm shadows could only result from an interior setting. However, the gently diffused light and shade on the back and legs softens the contrast between the nude and her surroundings, and the other bathers appear only in half shadow. This treatment, and the opaque color in the shadows, show how Ingres reacted against the severe tonal contrasts of academic chiaroscuro. The main bather had appeared in an earlier work,* The Valpinçon Bather *(1808) and shows Ingres' love of reusing certain poses. This is comparable to Degas' later reworkings of both poses and themes.*

INTRODUCTION

1860 1870

The 1860s was a decade of dynamic change in painting, a period in which tradition and innovation were fused in the work of major independent, non-academic artists like Edouard Manet (1832–1883) and Edgar Degas (1834–1917), to produce a new style of painting which aptly reflected the modern age. In the next decade, the 1870s, this style was to develop and become established as Impressionism.

The new face of Paris

Under Louis Napoleon's Second Empire (1852–1870), the very face of Paris itself was transformed. Narrow cobbled medieval streets of houses throughout the city center were razed to make way for the new tree-lined boulevards, designed by Napoleon III's architect Baron Haussmann (1809–1891). Along these broad avenues – like the rue de Rivoli, boulevards St. Germain and St. Michel and avenue de l'Opéra – terrace cafés opened up, and in this environment of light-filled sunny promenades, the life of the Romantic dandy artist, the cool *flâneur* or boulevard stroller, took on new meaning.

The avant-garde Parisian artist was no longer the painter of agricultural life or peasants, but of modern city life – the sophisticated dandy's world of cafés, racetracks, parks, concerts, balls, the opera and the ballet. Backstage, behind Haussmann's elegant, pale stone facades, lay the *demi-monde*, the twilight world which serviced the sophisticated leisured pleasures which characterized the Second Empire's decadent opulence. These city workers – the street musicians, ragpickers, waiters, laundresses, milliners, barmaids, singers, shopgirls, dancers, courtesans, prostitutes in the *maisons closes* – began to dominate the subject matter of Manet and Degas from the early 1860s. But new subjects, a more direct representation of contemporary themes, demanded new techniques. During the 1860s Manet and Degas, among other artists, found alternatives to academic practice which were more suited to their aesthetic needs. The techniques they evolved look forward to Impressionist methods, which began to emerge in the latter part of the decade in the work of Monet, Renoir, Sisley, Pissarro and Cézanne.

Old versus new techniques

Impressionist painting came into its own in the 1870s. The Impressionist artists rejected the dark transparent shadows, subtle tonal modeling, somber hues and earth colors of academic *chiaroscuro*. Instead, they advocated bright colors, thinly pale-primed canvases and mat, opaque paint surfaces which were uniformly loaded. Developments in the 1860s paved the way for these changes, each of which can be related to the new characteristics of modern painting materials – which differed markedly from those that had made possible the techniques of the Old Masters.

During the nineteenth century, two distinct methods had been widely established for the rendering of light, subtle halftones and shade in studio painting. The first technique, inspired by Flemish oil painters, dominated academic theory and practice in the first two-thirds of the century. It contrasted thin transparent shadows with opaque impasted lights in painting. As these effects became harder to achieve with modern, machine-ground colors, this method was gradually displaced by a more uniformly solid handling, based on Venetian techniques. In this method, both light and shade were rendered in opaque colors, applied with a loaded brush, while the shadows were deepened and enriched only in the final stages by the addition of transparent glazes. This latter method – minus the final glazing – gained wider popularity through Manet's novel approach in the 1860s and was to form the basis for the densely painted surfaces of Impressionist works in the 1870s.

There were clear-cut practical reasons for this change, determined both by developments in the artists' materials trade, and by artists' loss of traditional practical knowledge. Since at least the mid eighteenth century, artists had grown ever more aware that their technical expertise was inadequate to recreate a handling comparable to that of the Old Masters. Further, changes in modern paints due to mass-production made such emulation virtually impossible. In fact, the development of the Impressionists' loaded shadow technique was far from purely aesthetic in inspiration – the mechanical production of colors played a central role in this change from the use of transparent colors. Three factors were of particular importance – mechanical grinding, oil binders, and the additives used to keep paint homogeneous in the new tube containers.

Mechanical grinding of artists' colors

Traditionally, paint had been ground by hand by skilled workers, using a stone muller on a flat slab made of impermeable stone, such as porphyry. Mechanical grinding first became feasible around 1800, when an Englishman, Rawlinson, published details of a hand-operated, single-roll grinding mill, which was recommended by the influential Royal Society of Arts. Bouvier, the Swiss-French painter and writer on artists' methods, recorded that in 1801 he had first considered the possibility of mechanical grinding, in order to aid the arts and improve the lot of the hand color grinder, who was often obliged to work with poisonous chemicals. In 1833 the Parisian *Annual Commercial Directory* carried an advertisement for the firm of Bonnot & Cerceuil, manufacturers of oil colors for printing wallpapers and for the building trade, which stated that their steam-powered grinding machinery was at the dis-

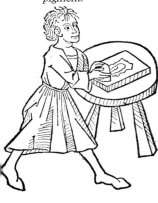

Below *This wood engraving shows an apprentice or workman grinding artists' color in the 1400s. A smooth slab of impermeable stone such as porphyry was normally used. The stone muller was moved over it, grinding the color with the binder in rhythmical circular movements. Vermilion, the pigment being ground here, requires extensive grinding to produce sufficiently fine particles to give good color. The grinding time and volume of oil binder required varies from pigment to pigment.*

posal of customers for the grinding of all their colors and pigments.

Mechanical grinding was at first considered to produce paints too coarse for artists' colors, which were known as *couleurs fines* to distinguish them from coach or house painting colors. The first color merchant to offer mechanically ground artists' colors was Blot, in the rue St. Honoré, Paris, in 1836.

Although in the early days of mechanical grinding too coarse a substance had been produced for use by artists, growing sophistication soon solved this technical problem, but, instead, overgrinding became a common practice. This meant that the subtle variations required in grinding different pigments to bring out their individual characteristics, were lost. These changes affected what artists could achieve with their colors, making dark transparencies problematic, but encouraging thick opaque painting. When properly ground, oil colors varied greatly in texture. Some tended to be runny, like viridian, ultramarine and vermilion. Others — especially the full-bodied earth colors — were naturally stiffer in consistency and had a coarser grain texture. Dyestuffs, like the red alizarin lakes, may have no discernible particles. When ground correctly, these differences should remain apparent. The distinction in feel of a pigment's qualities, evident to an experienced hand-grinder, were hard to recapture in machine grinding. This, combined with the introduction of additives to create an artificial, uniformly buttery consistency regardless of the properties of individual pigments, resulted in a blandness of paint texture unknown in the old days of hand-grinding to order.

Oil binders and additives

Linseed oil was the traditional binder with which powder pigments were ground to make oil colors. However, of all the drying oils used in painting, linseed is the most prone to yellowing. It forms a skin when thickly applied, and thus is best suited to use in thin layers, as in the Old Master techniques, which involved repeated reworkings in thin glazed films. Poppy oil, which came into use only in the seventeenth century, when it was popular with the Dutch, was the most important binder in nineteenth century France. The paint expert Vibert noted that 'today, only poppy oil is used, except for a few dark colors with which the use of linseed oil is accepted.' Unlike linseed oil, which gives the paint surface a smooth, even quality, poppy oil is naturally more buttery in texture. Colors ground in poppy oil retain the mark of the brush, giving a raised textured effect which was exploited by Manet in the 1860s, and which encouraged the development of the textural, descriptive brushwork characteristic of Impressionist techniques. Because it is slow drying, poppy oil was particularly useful where extensive wet-in-wet handling was required,

without the repeated reworkings to which it was unsuited.

Artists' colors had traditionally been prepared only as and when they were needed, thus long-term storage presented little problem. However, the rapid expansion of commercial color grinding in the nineteenth century gave rise to a pressing need for an extended shelf-life for the product. There was little point in mass-producing colors which then spoiled during storage in the unpredictable time-lag between manufacture and purchase. As ready ground colors tend to separate from their oil binder when left to stand, and as old oil jellies in the tube, ways had to be found to make sure that paints retained an even consistency, and that the pigment stayed fully dispersed in the oil. Although collapsible tin tubes were only invented in 1840, suitable containers for storing paint had been sought long before then. Bladders for watercolors were in existence in the fifteenth century, and in 1684 the art theorist Roger de Piles mentioned that in Paris some colors, ready ground with their oil binder, were already being sold in pigs' bladders by 'color vendors'. The problems associated with storing oil colors were widely acknowledged by the mid eighteenth century.

Around 1790, an Englishman called Blackman began marketing a new type of ready

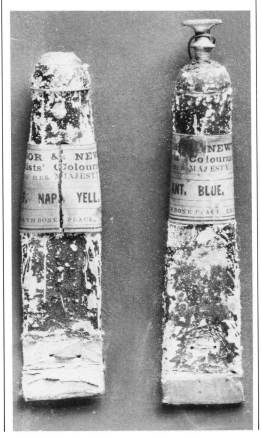

Left *This photograph shows two early collapsible tin tubes manufactured by Winsor and Newton around 1841-1842. Collapsible tin tubes were invented, patented and perfected in London by the American artist John Goffe Rand between 1841 and 1843. They improved the handling and portability of oil paints, and solved the problem of airtight storage. Winsor and Newton developed a competitive variant of Goffe Rand's version, which, however, rapidly became the norm. Stoppers are used here instead of screw caps, which Rand promoted. Although tube colors made outdoor oil painting easier, the invention cannot be considered the cause of this practice, since outdoor oil sketching had been popular since the 1780s.*

ground oil color in bladders, which were stiffer in consistency than normal oil colors. He said they were intended to make it easier for landscapists to undertake 'excursions into the country where it might be inconvenient to carry pigments of that kind in the state in which they were usually sold.' To achieve this stiffer paint texture, Blackman added sperm whale oil, or spermaceti – a brittle white fatty substance commonly used in ointments and candles. This addition also involved the inclusion of excesses of oil, for which his colors were soon criticized.

Beef and mutton tallow were other harmful stiffening additives often included in nineteenth century paint manufacture, and these were especially destructive as they never dried. They were thus advantageous only for the color manufacturers, who, as Vibert commented, 'are solely preoccupied with the commercial side of their trade. Their aim is to make colors which retain their freshness in tubes for the longest time possible, and in all climates.'

Wax, especially paraffin wax, was another common additive used in oil colors. While a small proportion of wax – no more than 2 per cent – dissolved in oil of turpentine, improves the consistency of oil colors, and indeed reduces yellowing, excesses are damaging. During this period, up to 30 per cent of wax dissolved in fatty oils was often added, resulting in sticky, dark colors, prone to cracking. Excesses of wax and extra oil went hand in hand. To counteract the fluidity produced by increasing the oil content, which made grinding easier, manufacturers put in more wax to restore the paint's stiffer consistency. This, in turn, permitted them to cut down the amount of pigment required to give a good paint texture. As the pigment was invariably the most costly item in paint manufacture, any reduction increased the color merchants' profits.

By the 1860s color merchants also justified the inclusion of excessive amounts of wax on the grounds that it made the colors more suitable for painting with a palette knife, which had been made popular by Courbet (1819–

1877) in paintings like *Deer Haven* (1866). Manet also used knife application of color in the 1860s, particularly for broad background areas. The technique was exploited in this decade and the early 1870s, by some of the younger independent artists, especially Paul Cézanne (1839–1906) and Camille Pissarro (1830–1903). However, knife painting draws the oil binder to the paint surface, and thus aggravates the problem of the yellowing of oil by encouraging it to gather in a surface film. This drawback, together with the Impressionists' growing preference for uneven brush-textured handling, resulted in their abandoning the technique in the later 1870s. It was never adopted by the other members of the Impressionist group, including the major Impressionists, Claude Monet (1840–1926), Pierre Auguste Renoir (1841–1919) or Alfred Sisley (1839–1899).

Unnecessarily large quantities of oil are dangerous, whether in the support priming or in the paints themselves. All oils darken and yellow with age, discoloring and distorting the original color balance and harmonies in a work. Thus, for artists in the 1860s, and particularly the Impressionists later, excessive oils in paints were a serious problem, as their painting required durable bright, light colors. Pale colors were obviously more vulnerable to yellowing and discoloration than dark ones, so, where a luminous effect and subtle color relations were the aim of a painter, special care had to be taken to protect these colors from destruction. Soaking out excess oil by placing colors on blotting paper prior to use, was one precaution adopted by many Impressionist painters.

Every individual pigment has its own optimum level of oil absorption, which it is inadvisable to exceed. This level is the amount of oil required in grinding to achieve both a thorough 'wetting' of each pigment particle, and also the complete dispersal of pigment particles in the oil, to produce an ideal paint consistency. Like the oil absorption level, this ideal

Below These traditional early nineteenth century oil color containers were pig's bladders, thonged tight and stoppered with ivory tacks, which did not affect the paint chemically. Paints in bladders tended to deteriorate rapidly once they were pierced. In France, collapsible tin tubes only replaced bladders relatively slowly. In 1850, the same volume of color cost 10 centimes more in tubes than in bladders, while in 1855 they still cost 5 centimes extra. The average price of a bladder of paint was then 25 cents, so the difference in cost was considerable.

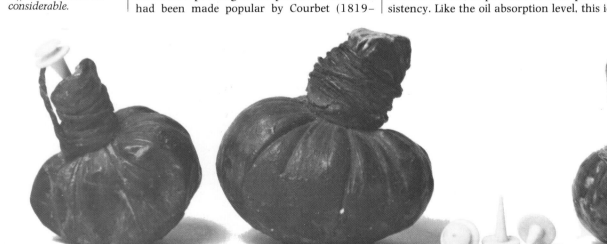

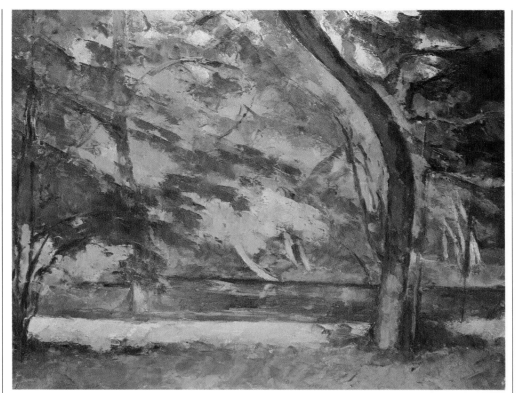

Left *This work,* L'Etang des Soeurs, at Osny, near Pontoise *(1877) by Paul Cézanne shows skilled use of the difficult painting knife technique. The method was popularized by Courbet – and bastardized by less skillful painters, who brought it into ill repute. This technique can be seen in the paint handling, especially in the diagonals which establish rhythms in the foliage. The disadvantage of the technique is its tendency to draw the oil binder to the surface, thus increasing the problems caused by the yellowing of oil.*

consistency varies from pigment to pigment. Some colors, such as raw sienna, naturally absorb high proportions of oil binder, while others, like lead white, require very little oil in grinding. In the long run, pigments which require less oil will result in greater permanency, as these will tend to dry quicker and yellow less.

The homogeneous consistency of modern commercial paints made it difficult for artists to vary their uniformly buttery paint quality – its relative opacity or transparency, stiffness or fluidity – without mixing the colors with harmful thinning vehicles or thickening unctions. Inevitably, any addition to the paint increased its chemical complexity, making its safe usage harder to predict or control. Experts maintained that if only colors were from the outset manufactured with varied viscosity, according to their inherent characteristics and their requisite function on the artist's palette, this further adulteration by the artist could be avoided.

Thus mechanical grinding, poppy oil binder, and waxy additives all combined as factors influencing the texture of mid nineteenth century paints. They no longer possessed the distinctions in texture, that had lent themselves so appropriately to the variations of thin transparency and raised opaques characteristic of Flemish methods, which so many artists continued to seek in their *chiaroscuro* handling. By the 1860s the gradual breakdown of this method, made even more difficult by artists' ignorance of traditional handling techniques, was well under way.

However, rendering the conventional deep, transparent shadows was still a major preoccupation of many artists. For instance, as late as 1867, Manet's teacher, the artist Thomas Couture (1815–1879), described light as mat and shadow as transparent in nature, and noted that the artist's palette was well stocked with sound opaque colors suitable for rendering the lights, but that few good transparent colors were available. Many sound bright transparent colors were on the market then, but traditionalists considered these crass and vulgar, and therefore unsuitable for academic painting. However, it was precisely these colors, usually with the addition of opaque, stable lead white, which were included in the palettes of Manet, Degas and the Impressionists.

New techniques established

One of the new techniques which was to be exploited in Impressionist painting was the uniform 'loading' of the paint surface, even in the shadows. Whereas in academic convention, the shadows had been painted thinly and transparently, by the mid nineteenth century many independent artists preferred to paint more solidly, by loading opaque paint in shadow and light areas alike. However, there had been precedents in France for this development. In

Right The Raft of the Medusa *(1819) by Théodore Géricault was exhibited at the Salon of 1819. The dramatic forms in Géricault's huge contemporary history painting are 'sculpted' by strong contrasts of light and dark. Light falls like a spotlight from the upper left, creating splashes of luminosity which direct the spectator's gaze from lower left up, following the lines and gestures of the figures along the rising diagonal, which ends subtly in the man at the pinnacle of the pyramidical composition. In this way, Géricault combines old and new devices, in depicting this story of modern heroism.*

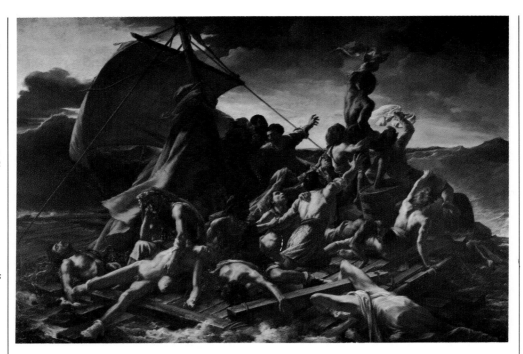

particular the great eighteenth century painter of domestic scenes Chardin (1699–1779) had used this technique, and his works were much admired by, among others, the artists Paul Cézanne and Camille Pissarro.

In the nineteenth century, Géricault (1791–1824) was the first independent artist to load his shadows, for example in his *Raft of the Medusa* (1819). However, he attempted to retain their transparency by using bitumen – the worst and most dangerous of the glazes, then disparagingly referred to as 'brown sauces', against which painters of the 1860s reacted. When first applied, bitumen gives a seductive, warm transparent brown, apparently ideal for deep shadows. But bitumen is a tarry substance, akin to the asphalt used for surfacing roads today, and, consequently, it never dries completely. Its subsequent cracking and blistering in fluctuating environmental temperatures destroys the paint surface, while the color blackens, losing transparency as it ages.

Géricault's example was followed by the young Delacroix (1798–1863) in the *Barque of Dante* (1822). Such practices, and those of the Romantics, who adopted glutinous brown transparencies, were brought to artists' attention by writers like the famous aesthetician Charles Blanc in the 1860s, who warned of their dangers. Both Courbet and Millet (1814–1875) – whose influence on the younger generation was crucial – also loaded their shadows, although Courbet was more guilty than Millet of the misuse of bitumen. It is significant that all these precedents for richly loaded paint surfaces were among independent artists, painters who were all seeking alterna-

tives to the academic tradition, and whose example was of particular relevance to the younger artists of the 1860s.

Only two artists of the older generation, who trained and worked in an essentially classical tradition, were to prove vital to the younger painters. These were Ingres (1780–1867) and the landscapist Corot (1796–1875). Ingres studiously avoided the use of bitumen in his work, adopting the thinly scumbled opaque shadows taught him by David (1748–1825), which resulted in a shallow pictorial space and a lightness of color which was not found in the work of his academic followers. Corot too, used lead white in his shadows, showing greater concern for depicting the real effects of outdoor light. As a result the overall effect in his landscapes is one of pale silvery luminosity, rather than the somber, toned-down conventional lights and darks of academic studio landscapes, or the heavy darks of Romantic landscapes.

One of the key reasons why Romantics and many Realist painters loaded their shadows, was because they mainly used supports primed with pale grounds, and these needed to be well covered if dark shadows were to be effective. A convincing recession, or turning away of form into shadow, was hard to create on pale grounds. Pale colors tend to advance visually, and dark ones to recede, so dark grounds have an inherent sense of depth which pale grounds lack. In fact, pale grounds have an insistent flatness which resists the most determined efforts to create an illusion of depth on them. Courbet, attempting to persuade the youthful Monet to adopt dark grounds in the early 1860s, was well aware of their advantages

when he commented that, on a brown ground 'you can dispose your lights, your colored masses; you immediately see your effect.'

As early as 1750 artists had been aware that the technique of using transparent shadows and thinly applied halftones was vulnerable to the ravages of time. Because the paint layer — the picture itself — becomes increasingly transparent with age, these subtle effects soon disappeared when painted over dark grounds. Even on pale grounds, the overall balance was soon lost, for, as the paint layer grew more transparent, the glazed shadows lost their depth of contrast with the impasted lights. In the long term, pale grounds were safest, as they maintained the overall luminosity of the painting, whereas dark grounds — which darkened further with age — 'rose up' and subdued the hues in the paint layer. It was precisely for these reasons that artists in the 1860s preferred pale grounds.

Isolated examples exist of early works by Cézanne, Monet and Renoir from this decade, executed on dark grounds inspired by Courbet. But, following the example of Manet, they soon adopted pale grounds almost universally because of their brilliance and superior durability. This practice became so common that, in 1865, Pasteur, a professor of geography, physics and chemistry, noted in a lecture at the Ecole des Beaux-Arts that 'nowadays scarcely any but canvases primed white or barely tinted are used.'

In view of the weight of contemporary evidence demonstrating the technical undesirability of chiaroscuresque methods — whether using transparent or loaded shadows — it may seem surprising that so many artists persisted in their use of them. However, not only did these methods have a long and distinguished history, but by the nineteenth century chiaroscuro had become more than just a technique.

In the seventeenth century chiaroscuro had simply meant either the overall light effect in a composition, or the particular fall of light and shade on each object to give it the necessary relief. By the 1860s, the definition of chiaroscuro incorporated a crucial aesthetic ideal too. Its aim, in the words of the important art theorist Charles Blanc, was 'not simply to give relief to the forms, but to correspond to the sentiment that the painter wishes to express, conforming to the conventions of a moral beauty as much as to the laws of natural truth.' Thus the original, practical role of chiaroscuro had become overlaid with a new ideological meaning. Chiaroscuresque handling in painting had become synonymous with the academic ideal of elevated moral truth and beauty. Therefore, any rejection of chiaroscuro was associated in the minds of the powerful conservative faction, with a rejection of the highest ideals of painting's moral social role, and thus with a rejection of the established conventions of academic art as a whole.

As a result, paintings which failed to exhibit the thin transparent shadows and impasted lights of the approved chiaroscuro tradition, were consistently criticized by conservatives for their lack of elevated moral tone. Such paintings were considered deficient in the spiritual, intellectual, refining side of art, which had, since Renaissance times, been thought crucial to the production of great art. A painting which lacked the rational pictorial conventions of chiaroscuro was dismissed as raw imitation of nature, banal and unimaginative.

This attitude echoed the traditional split between artist and artisan, between the intellectual and the purely manual in art. For this reason, Impressionist painting was characterized by its critics as exhibiting nothing but manual dexterity. It was even considered seditious. Especially following the Paris Commune of 1871, these artists were often dismissed as communists and anarchists for their flouting of traditional values in art.

The influence of photography

Reflecting upon the art of Manet and his followers in the 1860s, the painter and art historian Eugène Fromentin blamed photography for the decline in moral spirituality which he saw in their painting. He felt their work lacked the 'fantasies of the imagination' and the subtle 'mysteries of the palette' which he admired in Dutch and Flemish seventeenth century art. In this period photography had changed artists' vision, particularly their understanding of the effects of light. As a result, with Manet's work in mind, Fromentin observed, 'painting has never been so clear, so explicit, so

Left *Watson's Nude Study of 1856 shows the typical effects of mid nineteenth century photography. Although at first photography was dominated by the aesthetics of painting, technical limitations imposed by the new medium meant that the subtle effects of* chiaroscuro *were impossible to reproduce in a photograph. The lack of sensitivity of early plates or film meant that the delicate gradations of tone from light to dark, so admired by academic painters, were reduced in photographs to simplified blocks of light and dark. Artists like Manet were thus inspired by photography because it suggested an alternative to academic* chiaroscuro *lighting.*

Below Manet's Olympia *(1863) was exhibited at the Salon of 1865. The work is close in size to the largest standard canvas format portrait 120, which measures 130 x 194 cm (51¼ x 76½ in). Manet's stark full face lighting obliterates tonal gradation. Light and shadow appear as broad, simplified masses or shapes. The directness of the lighting complements the uncompromising presentation of the nude which, as a result, fails to conform to academic conventions.* Olympia *confronts the viewer, who becomes, by implication, her male customer. The artist thus combines new technical as well as aesthetic devices to subvert the traditional depiction of the nude.*

formal, so crude.' The rise of photography from the 1840s, had, for artists, complicated the issue of the illusionistic representation of reality. On the one hand, photography showed them for the first time ever, an 'objective' picture of reality, provoking some artists to attempt an even more fastidiously representational style of painting. On the other hand, for others the very existence of the photographic image was a release from the demands of painstaking representation of the visual world, leaving them free to pursue a more personal recording of nature, like that of the Impressionists. Their method was based on the translation into paint of the individual artist's optical perceptions, a phenomenon beyond the camera's reach. It also freed artists to explore the problems of painting itself.

The lack of sensitivity of early photographic plates or films produced a number of distortions, which were noticed by contemporary critics. In particular, the subtleties of lighting considered so crucial to *chiaroscuro* effects — delicate reflected lights in shadows, and gradated halftones — were destroyed by photogra-

phy. The resulting exaggeration of darks and lights gave dramatic, simplified areas of strong tonal contrast, which flattened three-dimensional forms into broad, uniform tonal shapes. Thus, artists like Manet, Degas and Fantin Latour (1836–1904), who studied photography in the 1860s, found in its stark contrasts a new way of depicting a simplified, more direct impression of the natural world. Artificial lighting was used in photography from the mid 1850s, created either by electrical batteries or the powerful white flare produced by burning magnesium wire. This resulted in even more extreme oppositions of light and dark. A comparable effect is apparent in Manet's 1863 works *Olympia* and *Luncheon on the Grass*.

Studios and lighting

The evolution of new painting technique went hand in hand with changes in studio design and lighting, which were adapted to suit the new aims of the independent artists. The changing layout of the artist's studio reflected the transformation in the organization of pictorial light. The emphasis on a chiaroscuresque handling

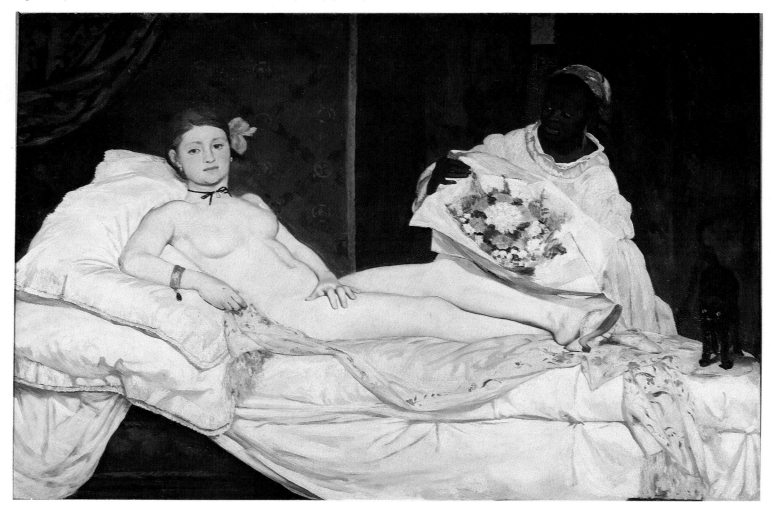

during the century, with its accompanying palette dominated by earth colors and browns, coincided with a studio lighting designed to encourage a tonal pictorial structure. A single high window, giving a controlled light source, was then in common use. This practice gave sharp lights, delicate halftones and deep transparent shadows. All studios normally faced north. This gave a cool, stable light because it was unaffected by the sun's daily passage across the sky, which produced distracting fluctuations in the color of the light and constantly shifting shadows. The academically approved, carefully premeditated, tonal palette layout, with colors gradated from light to dark, and with all the halftones ready mixed by the painter, could only work when painting was done under stringently controlled, steady lighting conditions like these.

A cool northern studio light creates contrasting warm shadows. These were made darker by the restricted volume of light and by the subdued colors with which the walls were generally painted. Thus a tonal palette of somber warm earth colors was perfect for rendering these effects.

The studio environment was therefore constructed to give constant chiaroscuresque lights and shades. Although artists were working from 'nature', it was a nature determined by preconceived ideas of painting, intended only to result in an end-product in which form was depicted through *chiaroscuro*. Multiple light sources and south-facing studios were occasionally recommended by writers criticizing the cool drabness of accepted northern lighting, but they were rarely adopted before the development of Impressionism in the 1870s.

Landscape painters move outdoors

As the technical difficulties in *chiaroscuro* painting increased, and dark brown transparent shadows became harder to depict with assured permanency, this form of traditional studio setup gave way to newer environments. The rise of landscape painting was a key factor in this change, for as artists became more committed to an accurate depiction of outdoor sites and lighting, the studio gradually moved outdoors too. At first, in spite of the brilliant sunlight and reflected ambient atmospheric light found outdoors, artists, as it were, took their studio light out with them — they still saw their outdoor environment in terms of *chiaroscuro* and the browns of studio shadows. To some extent this vision was determined by the types of site and lighting preferred in the first half of the century. Dramatic storms, dawns, sunsets, forest or craggy scenes all tend to create strong contrasts of light and shadow, which could be

Left *Léon Cochereau's painting of* David's Teaching Atelier *(1814) shows how high windows were used to create a restricted volume of cool northerly daylight, which resulted in a static, controlled fall of light and shade on the model. The lights are bright, as if spot lit, and halftones to make deep warm shadows across the form. The side lighting falling from left to right across the figure enhances the form, emphasizing anatomical detail. A tonal palette is aptly suited to recording these effects. Students are all lined up on the left for, with right-handed painters, light falling from the left onto the work means the artists are not impeded by the shadow cast by their working right arm.*

Right Women in the Garden, *(1866) by Claude Monet was refused by the jury at the Salon show of 1867. Painted in oil on white-primed canvas, this was Monet's first fully successful large-scale figure painting. It shows his commitment to modern life subjects and to creating unified effects of outdoor light in his work. The white dresses provide a neutral base on which to demonstrate the effects of the colored light he observed out of doors. The white is warmed by the yellow sunlight where it falls on the fabric, and, in the shadowed areas, the white is contrastingly modified by cool colors. The violet-blues in the shadows on the foreground dress are composed of the complementary contrast of the yellow light with violet, plus the blue reflected from the sky. The green-striped white dress on the left is tinged by green reflections from the surrounding foliage. Monet has completely rejected the cool light and warm brown of studio modeling, replacing them with contrasts of color.*

translated in a broadly *chiaroscuro* technique. In any case, many such works, although based on outdoor studies, or even begun outdoors, were normally completed under darker studio conditions.

However, the example of outdoor studies by Corot, with their gold or pale lighting and luminous shadows, provided an important alternative to younger independent painters in the 1860s. Increasingly, artists began to complete their paintings out of doors in order to retain the unity of natural light effects and the impact of the first impression. This renewed determination to capture the quality of light observed *in situ* brought a freeing of artistic vision, which stimulated painters to study brighter, lighter scenery in full daylight.

One of the major problems with studio-executed landscape paintings, especially those including figures, had always been the creation of a convincingly unified lighting. In such paintings, the background lighting was usually quite distinct from that on the figures, which were executed from models under the strictly controlled abrupt lights and darks of the studio. On figures under natural outdoor light, the gradations from light to shade are softer and the shadows more diffused and attenuated, filled with reflected light from the sky. Even in works like Manet's *Luncheon on the Grass*, in

which a high academic studio lighting was abandoned, the stark tonal contrasts of interior light are still in evidence. Manet adopted a dramatic frontal light, falling directly onto his figures, which obliterates halftones and reduces shadow to little more than striking black contours. This flattening, full-face light familiar to the artists from contemporary photography, produces broad blocks of light and dark when used indoors. During the 1870s the same full-face light was to be exploited by the Impressionists outdoors, where, by contrast, it suppresses tonal contrasts because shadows fall behind the objects depicted.

The impact of Japanese prints

Japanese woodblock color prints, which became widely popular in France from the early 1860s, were an important source of inspiration which offered an alternative to the conventions of European painting. As the critic Théodore Duret remarked in 1878, Japanese prints showed French artists 'the specific appearances of nature by means of bold, new methods of coloring.' These prints used flat areas of bright color, rather than modeling form through a depiction of the fall of light and shade. Form was both implied and denied in their work by evocative contour and by overlapping planes of color. A Western single-point perspective had never been developed independently by Japanese artists. Instead, space was suggested by placing one object behind another. Unusual, often high viewpoints, looking down on a scene were often adopted in Japanese prints, and this emphasized a decor-

Right *Japanese prints were widely available in France from the early 1860s, and examples of Japanese art were exhibited for the first time on a large scale at the Paris World's Fair of 1867, where the Japanese had a pavilion. This color woodblock print shows* Wisteria Blooms over Water at Kameido *(c1857) by the Japanese artist Hiroshige. The Japanese love of nature, and their pleasure in representing it in their art, attracted French artists' admiration almost as much as their modern life subjects, their unusual compositions and their use of brilliant color. Prints such as this one combine the decorative and naturalistic, and this proved an important example to French artists.*

ative flatness of form and space by tipping the scene up closer to the surface of the picture. This device was taken over by avant-garde artists from the 1860s on, giving their pictures a spatial and compositional flatness which complemented the new uniform loading of their paint surfaces.

In Japanese prints, sensual line and blocks of vivid color weave patterns across the picture surface, causing the eye to wander undirected over it instead of forcing the eye to focus on a central point of interest. A comparable phenomenon resulted from the peculiarities of photography, and both proved a timely alternative to academic conventions. The photograph, although no more 'objective' in the strictest sense than the human eye, showed a different picture than that possible with human binocular vision. Within a given depth or field of focus, the camera's monocular lens records every object with equal force and clarity. Human vision is more selective, in that, outside a central focal area, all objects are more or less blurred. A new interest among artists in creating an overall focus of attention in their work was a natural outgrowth of the study of photographs. 'Snapshot' photography, which came in in the early 1860s, succeeded in freezing moving figures. This new vision of accidentally distributed passers-by became a feature of paintings at this time, in which apparently casually placed or cut-off figures gave an air of direct immediacy. The modern city life in Paris could thus be rendered with the sensation of a glimpse of the uninterrupted panorama of teeming activity, a slice of fleeting life, seen most typically in the work of Degas.

Thus, many artists began to avoid a central or single point of focus in their compositions, experimenting instead with designs that had no hierarchy of pictorial interest. This type of leveling process, which failed to direct the spectator's eye into a traditional self-contained, coherent pictorial space and toward a fixed point of interest, left public and critics bewildered. Few understood the aims of this style, and most critics exhorted the independent artists to return to the conventions of traditional academic *chiaroscuro*, which had imposed their own familiar aesthetic order on the painter's subject. The combination of an even, uniform focus, an overall loading of the paint surface, and a flattened pictorial space in the new painting gave no easy clues to the reading and understanding of the pictorial intention. Manet's *Concert in the Tuileries* (1862) and Degas' *Chrysanthemums* (1858–1865), are excellent examples of this.

Toward Impressionism

While photography afforded a new and — broadly speaking — more naturalistic vision of light than the conventionalized lighting in *chiaroscuro* painting, it still presented form in

Right Woman with Chrysanthemums (1858-1865) by Edgar Degas was painted in oil on canvas. It is likely that this work began as a relatively conventional flower study – a testament to Degas' admiration for Delacroix who painted similar subjects. The figure was only added later. The resulting asymmetrical composition probably dates from 1865, when Degas was experimenting with less conventional designs. The off-center placing of the figure shows Degas' active opposition to academic conventions, which dictated a strict hierarchy of composition based on the relative importance of objects depicted.

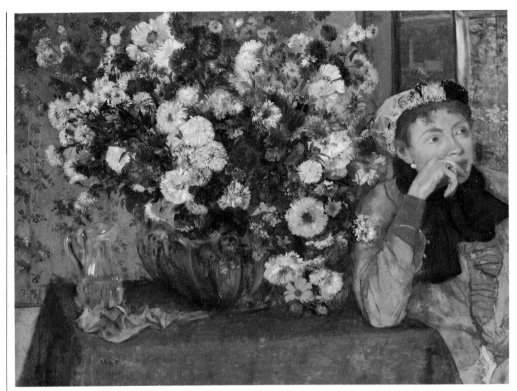

terms of strong tonal lights and darks. Although in their studio-painted studies of interiors the younger independent artists relied greatly on the example of Manet, Degas and Courbet during the 1860s, their landscape work shows them moving away from tonal handling. Thus Monet's reworking of Manet's radical subject of 1863, *Luncheon on the Grass* in 1865 to 1866, of which only fragments survive, attempted a more authentic depiction of outdoor light effects. A more successful painting, Monet's *Women in the Garden* (1866), begun outdoors and finished in the studio, created a new unity between the effects of sunlight on landscape and figures.

In their pre-Impressionist work of the 1860s, artists like Monet and Renoir already gave hints of later developments. The shadows in Monet's *Women in the Garden*, like those in Renoir's *Lise with a Parasol* (1867) and *The Pont des Arts* (1867) were filled with reflected light and cool blue-violet hues picked up from the sky, contrasting with the pervasive warmth of the sunlight. Monet's early experiences in outdoor work with his mentor Eugène Boudin (1824–1898) along the Normandy coast, in the late 1850s and early 1860s, gave him an advantage over Renoir who only began painting outside in 1863. He did this at the instigation of his tutor Charles Gleyre (1806–1874), in whose sympathetic anti-academic teaching studio he had first met Monet, Sisley and Frédéric Bazille (1841–1870) in the autumn of 1862. Since they all worked together regularly, both indoors

Below La Grenouillère by Renoir dates from 1869. Renoir had gained more experience in figure painting than in work directly from landscape subjects during the 1860s, and his touch shows less confidence and experience than that of Monet. Like Monet, Renoir gave his work a strong underlying structure, with series of vertical and horizontal lines, and recession aided by the foreground boats.

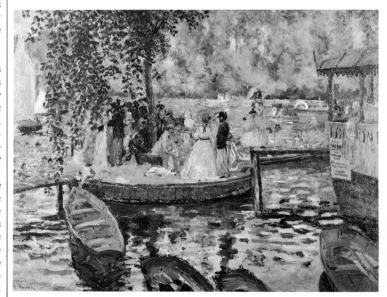

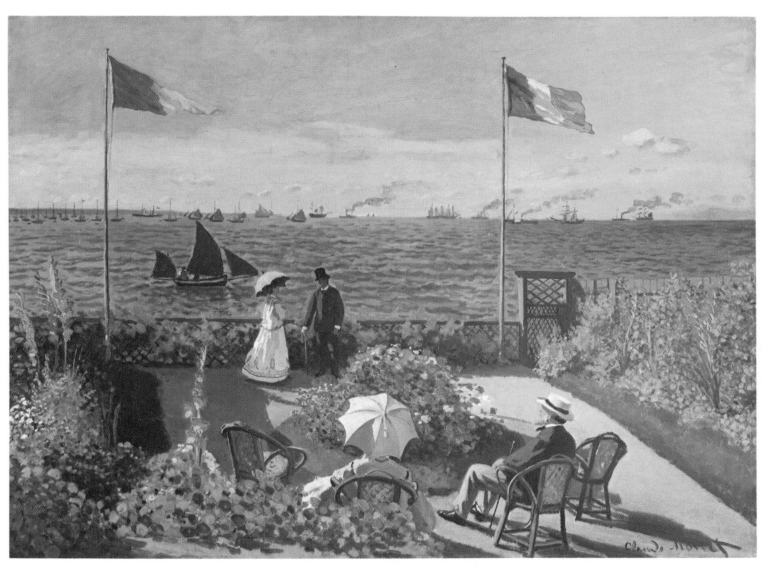

and out in the 1860s and early 1870s, they were able to benefit from each other's growing expertise and competence.

When in Paris, they all joined Manet's gatherings of artistic and literary figures at the Café Guerbois, on one of the new boulevards — now avenue de Clichy — in the Batignolles quarter on the fringe of Montmartre. These discussions often included writers and critics like Emile Zola, Edmond Duranty and Théodore Duret. Artists who joined them included Degas, Cézanne, Renoir, Fantin Latour and Pissarro. Monet later recalled that 'from them we emerged with a firmer will, with our thoughts clearer and more distinct.' As they only painted during daylight hours, in the evenings they were free to meet, argue and exchange the latest ideas. It was during this time that many of these artists began to formulate the project for independent group shows, which would

provide an alternative venue to the official Salon exhibition. This idea finally came to fruition in 1874, the year of the first group exhibition, at which a critic coined the name 'Impressionism'.

The year 1869 is now commonly seen as the turning point in the development of the Impressionist style. That summer, Monet and Renoir worked side by side along the banks of the river Seine at La Grenouillère, one of the new leisure spots just outside Paris. With their portable easels and traveling paintboxes, they painted rapid studies in free sketchy brushwork, attempting to capture the fleeting effects of sunlight on mobile water, to note down their impressions before the transitory scene. Although their methods and palette were to change considerably in the following decade, the basis for the new Impressionist techniques was already established.

Above *In* Terrace at Sainte-Adresse *(1867) the afternoon sunlight falls from the left, almost diagonally towards the spectator. Yet stark contrasts of light and shade are kept to a minimum, and used for decorative effect rather than for structuring form or space. Bright colors are concentrated into flat shapes, such as the sky, sea and sunlit terrace. This is reminiscent of Japanese prints. A stark geometric grid of lines also flattens the pictorial space. Sharp contrasts of red and green dominate the lower half of the canvas.*

GUSTAVE COURBET

Deer Haven on the Stream of Plaisir-Fontaine, Doubs/
La Remise de chevreuils au ruisseau de Plaisir-Fontaine
Oil on reused canvas (1866)
174cm × 209cm/68½in × 82¼in

Gustave Courbet emerged as a force in modern painting around the time of the revolution of 1848.

He came from a landowning peasant background in the Jura, the French province close to the Swiss alps, in south-east France. Courbet's father owned land and vineyards scattered on the plateau of Flagey, and property in the towns of Ornans and Flagey. The Flagey farmhouse was simple and unpretentious, while their townhouse was a grander, bourgeois establishment. Courbet's first major canvas, the *Burial at Ornans* (1849–1850), showed his father in his bourgeois clothes and role, while in *Peasants of Flagey Returning from the Fair* (1850–1855) he appears in a peasant's smock and stovepipe hat. Thus, personal experience placed Courbet in a strong position to portray the contradictions and divisions of social class in rural France, because his own family was moving upward socially.

The power of Courbet's direct and uncompromising subjects — unidealized representations on a monumental scale of ordinary rather than heroic figures — was apparent from their problematic reception in the Salon exhibitions. Having gained a second class gold medal at the Salon of 1849 with his *After Dinner at Ornans*, Courbet was automatically exempt from the necessity of submitting his works to the Salon jury. Without this exemption, it is doubtful that his major canvases following *After Dinner*, a relatively traditional subject, would have gained acceptance.

Courbet's Realism took its inspiration from the works of the great seventeenth century masters, such as Rembrandt (1606–1669) and the Dutch, whose work he saw on a visit there in August 1846. The Spaniards Velazquez (1599–1660) and Zurbaran (1598–1664), and Italians Guercino (1591–1666) and Cara-

vaggio (1573–1610) were vital to his development in the 1840s. He also looked at the French seventeenth century realists, the Le Nain brothers, whose work had been rescued from obscurity by the critic Champfleury, a friend who also championed Courbet's painting. Works by the Le Nain brothers were brought to light from the Louvre cellars in 1848, at a time when their depictions of working people had pertinent appeal for radical French artists. Courbet combined these sources with an appreciation of simple, popular images, like those of the crude woodblock color prints, which were widely distributed throughout France. He sought to unite the methods of the Old Master realists with the simple flat compositions of popular prints, to bring a new directness to his art.

Although, like most of the Old Masters to whom he turned, Courbet loaded his shadows, painting them thickly and darkly, his technique was essentially based on the tradition of *chiaroscuro*. He worked from dark to light, seeing himself, as he remarked, as the equivalent of the sun lighting up a dark landscape. With only a few exceptions in his later landscapes, his shadows were usually filled with the browns of the studio setting in which even his outdoor studies were normally completed. He used the problematic, non-drying color, bitumen. In his early years, this was often as a result of financial necessity because bitumen was a cheap color. Courbet's work exhibits a powerful combination of Rembrandtesque *chiaroscuro* with texturally evocative paint handling. Instead of adopting the conventional, smooth academic method for creating an illusion of reality, his application of colors actually imitates natural textures.

Courbet did not always work on a dark ground, building up to the lights. He often

Alley of Chestnut Trees at Celle-St. Cloud (1867) by Alfred Sisley was influenced by Courbet's forest landscapes. Sisley chose a comparable dark setting and deer motif, but with fewer contrasts of light and shade. Sisley's work has a deeper sense of space, but the recession created by the path is ambiguous. Unlike Courbet, Sisley uses brushwork with less textural differentiation, resulting in a thinner paint layer. The blue of the sky, with much white added, was worked over the greens of the tree foliage.

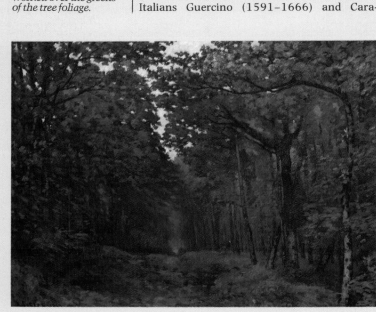

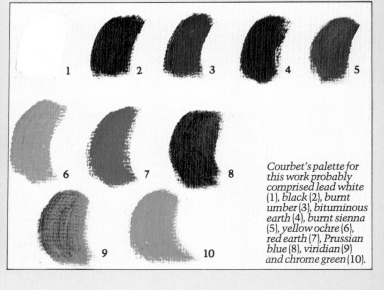

Courbet's palette for this work probably comprised lead white (1), black (2), burnt umber (3), bituminous earth (4), burnt sienna (5), yellow ochre (6), red earth (7), Prussian blue (8), viridian (9) and chrome green (10).

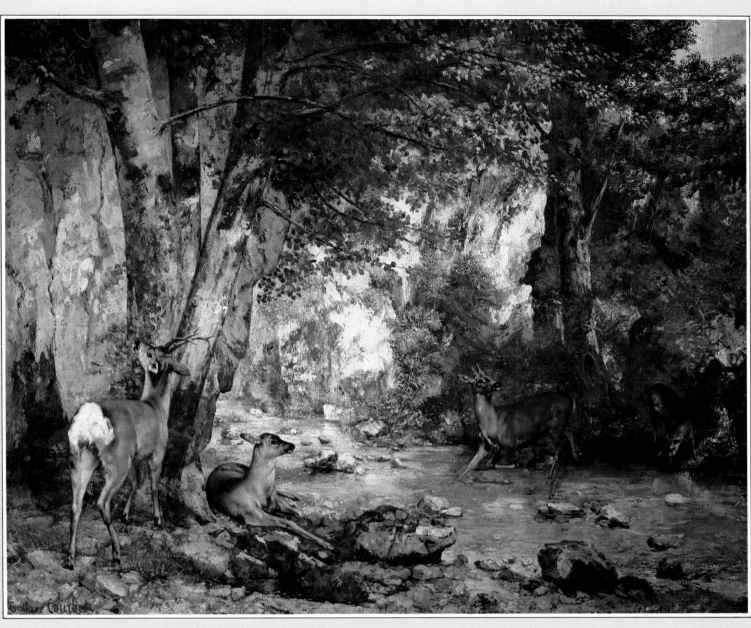

Knife-applied color built up thinly wet over dry to give bark texture

Brush application of greens for textural foliage

Hog's hair brushmarks denote fur texture

Red earth signature reinforces picture plane and thus contradicts the illusion of space in the painting

Color dabbed on with a rag or sponge to give distinctive foliage texture

Opaque, knife-applied highlights

Whole body of stag moved up and right, and diminished in size, the change now visible

Delicate knife painting

Works like this finally gained Courbet general acclaim among public and critics in France. Contemporary critics of Impressionism commonly saw Courbet as a direct precursor of the new style, because of his commitment to naturalism. However, a perceptive critic, Henry Houssaye, noted in 1882 that, since Courbet used a good amount of chiaroscuro in his painting, he could not really be heralded as a precursor of Impressionism. In opposition to Courbet's approach, the Impressionists avoided extreme contrasts of light and shade. Thus Houssaye was the first critic to define Impressionism in terms of technique rather than purely on stylistic grounds. Courbet built up his painting from dark to light, combining studio work with painting out of doors, in front of his subject.

Actual size detail
A rich paint, probably bound with poppy oil, has retained the marks of the hog's hair brush, permitting the artist to use this effect to describe the animal's hair. The supple movement of the brush also gives an excellent sense of the muscular body of the stag. Adjustments were made here. For instance, the position of the ear has been changed, making it smaller. The break in the paint depicting the antler confirms the fact that the deer were added at a late stage in the composition. The canvas texture is still faintly in evidence in places, and the contrast between brush and knife application of color shows clearly.

bought ready made, white or tinted primed canvases in standard sizes, and adjusted them to suit his needs. Thus in *Seascape at Palavas* (1854) a white commercial ground was covered by the artist with an opaque red earth ground, before he began to paint his subject. In other works, like the *Flagey Oak* (1864), a white ground has been overlaid with a transparent coat of warm brown paint, to give depth to shadows and a color harmony to the picture.

In *Deer Haven*, which was executed over a previous painting, the ground is no longer visible. However, X-rays of the picture indicate that Courbet applied a thick new ground which obliterated the earlier composition. This second ground probably contained lead white as it is impervious to the X-rays. The present paint layer of *Deer Haven* is covering and, in general, opaque. Courbet's surfaces are in fact deceptive. At a distance they give an appearance of rugged masonry as a result of the broken overworking of colors. Closer inspection, however, shows the superb delicacy of the artist's handling, where thin layers of brushed or knife-applied color give an effect of textural solidity, without excessive bulk.

Courbet used a variety of unconventional methods to create the textural variations in his paintings. He is said to have, on occasions, even added sand to his colors to give an earthy texture. His techniques in *Deer Haven* are no less ingenious. The landscape itself, a well-known spot near Ornans, was mainly painted outdoors, while the deer were added in Courbet's Paris studio during the winter of 1865–1866, when he hired some deer to 'sit' for him. He is also known to have worked from dead deer. Not surprisingly, the landscape and deer are handled quite differently. He used deft touches with palette or painting knife to give substance to rocks, tree trunks and some river-side foliage. The bulk of the foliage is handled with a stiff brush, indicating the individual leaves with precision. Less distinct foliage in the background and top right are applied with color on a rag or sponge, dabbed on to give a feathery effect which contrasts with the more solid handling of brushed foliage and knife-work. Finally, the brushwork used on the fur of the deer contrasts with the more vigorous rendering elsewhere. The treatment of the deer is very delicate, and the raised brushmarks left by the hog's hair brush literally recreate the texture of fur. The resulting contrast makes the deer stand out, almost like cardboard cutouts. This was doubtless exaggerated by their being added later.

Courbet painted repeated versions of this theme, which won him enormous acclaim at the Salon of 1866. It brought him, for the first time, widespread acknowledgement for his talent, which had previously been treated with general hostility because of his controversial subject matter. Despite Courbet's importance as an example to the younger artists, his essentially traditional *chiaroscuro* browns meant that they reacted against his handling of light and shade in the later 1860s.

Knife handling of color gives a broken irregular quality to the paint layer, although the actual paint is remarkably thin and delicate. Creamy-whites have been laid over dark brown, which shows through and strengthens contrasts between light and dark. Quite different are the thinly brushed tendrils of color depicting fine twigs. Thickly applied but basically transparent sienna is visible under rag-dabbed pale greens. The end of a round hog's hair brush was used to apply blobs of dark green, and the bristles give variety to the texture of the different leaves. The brilliant touches of orangey, yellow ochre were probably deftly flecked on with the tip of a supple painting knife.

In this detail changes made by Courbet are apparent. The young stag was originally larger, and placed further down and to the left. The initial ear and neck line can be seen as a ghost-like presence to the left of the current position, and the forelegs were originally below those finally added.

The lack of shadows cast by the deer and the contrast created by differentiated brush and knife handling, make the deer stand out against the surroundings, so that they almost appear to float. The light and shade on the animal also does not match with the fall of light in the landscape behind.

EDGAR DEGAS

The Bellelli Family/La Famille Bellelli (1859–1860)
Oil on pale primed canvas
200cm × 253cm/79in × 99½in

Edgar Degas left France for Italy in June 1856 to make the traditional trip to study the Italian masters *in situ*. However, he had a more personal reason for his trip, since his paternal grandfather had been exiled to Naples, and his father had been born there. At that time, his relatives in Naples, his aunt Laure, his father's sister, and her Baron husband, were themselves in exile in Florence, because the Baron had been involved in the political upheavals of the struggle for the unification of Italy. After visits to cities including Venice, Assisi and Rome, Degas finally arrived in Florence to see his relations in August 1858, only to find his aunt away in Naples, caring for her sick father, Degas' grandfather, who died on 31 August. What was probably intended as a brief stay in the end lasted nine months. During that time, Degas began to plan a large portrait of his relatives, the Bellelli family, making drawn and painted studies which he took back with him to Paris, where the painting was executed in his Paris studio on the rue Madame.

This portrait is Degas' earliest large-scale work, and, while showing his debts to past art, it looks ahead to his innovative mature style. Scholars have likened the work to the portrait of the royal family, *The Maids of Honour* (1656) by the seventeenth century Spanish painter Velazquez (1599–1660). This also uses the subtle device of a background mirror to add depth to the composition. Degas' introduction of an apparently invented red chalk portrait drawing of his recently deceased grandfather, which can be seen on the rear wall behind his aunt's head, places the painting in a long European tradition of portraits which, since the Renaissance, have included a dead member of a family to link past and present. The French Renaissance style, medium and mounting of this drawing seem to confirm the traditional link which Degas intended to suggest. The precision with which he planned the painting included, among numerous preparatory drawings, one projecting how the finished work would look, with even its frame carefully set out in detail.

Old Master sources can be balanced against possible nineteenth century influences on this picture. Degas was a great admirer of Ingres (1780–1867), and had studied with a pupil of his at the Ecole des Beaux-Arts in the mid 1850s. Ingres' delicate group portrait drawings, done mainly in Rome in the 1810s, show a frieze-like distribution of figures across the picture surface in a shallow pictorial space, similar to that in Degas' portrait.

The soft, almost full-face lighting adopted by Degas for this painting is certainly reminiscent of the lighting commonly adopted by Ingres for his painted portraits. However, in a manner typical of Degas, the lighting serves more than just a flattering function in his painting of the Bellelli family. The tensions between the morose and ill-tempered Baron and his wife were common knowledge in the Degas family, and the difficulties could hardly have passed unnoticed by Degas during his prolonged stay with them. The lighting accentuates the division already implied by the composition, separating the father from his wife and two daughters. The fall of light on the three females is clear but gentle, confirming Degas' allegiance to his aunt's side of the family. Documentary evidence suggests Degas had a close and affectionate relationship with her. By contrast, the father, whose back is turned unconventionally towards the spectator, is obscured by shadow, and his features are left ill defined. Mother and daughters are linked not only compositionally and by light, there is also physical contact between them – a protective arm around one daughter, and a merging of black skirts with the other.

The black clothes of the women bear witness to their mourning for the aunt's father, a mark of respect strikingly absent in the casual clothes worn by the Baron. The clear black shapes of mother and daughter form a strong pyramid to the left of the composition, the mother's head being linked directly with the hanging portrait of her father. The crispness, echoed in the rather severe look of sorrow on the mother's face, is in marked contrast to the soft lack of definition surrounding the Baron, who is placed against a complex background. Behind him the geometry of the fireplace gives way to the fuss of ornaments and reflected details in the mirror. Although less taut and unconventional in structure than Degas' later portrait compositions, the germ of his later methods is already clearly present. This can be seen particularly in his use of space and composition not simply to present his sitters, but to suggest the complex emotional and psychological characteristics.

Of particular interest among the preparatory studies for his work is an oil study executed on lightweight *étude* canvas, made expressly for studies, for the hands of Laure Bellelli which, in the final picture, rests on the table. The paint layer in the final work is remarkably fine and thin, accentuating the classical draftsmanship which underlies the picture. Despite its thinness, the paint is generally opaque and as a result the color of the pale priming cannot be identified with accuracy, as it only glows through the thinly scumbled colors of the paint layer. In the tradition of Ingres, various degrees of finish are used, with a fairly high finish on the important areas and more loosely handled brushwork in wallpaper and carpet.

The painting was in the possession of the Bellelli family until around 1900 when, because it had suffered some damage, Degas brought it back to Paris. Until Degas' death, it remained in his studio, a relatively unknown work despite its importance as a major early canvas.

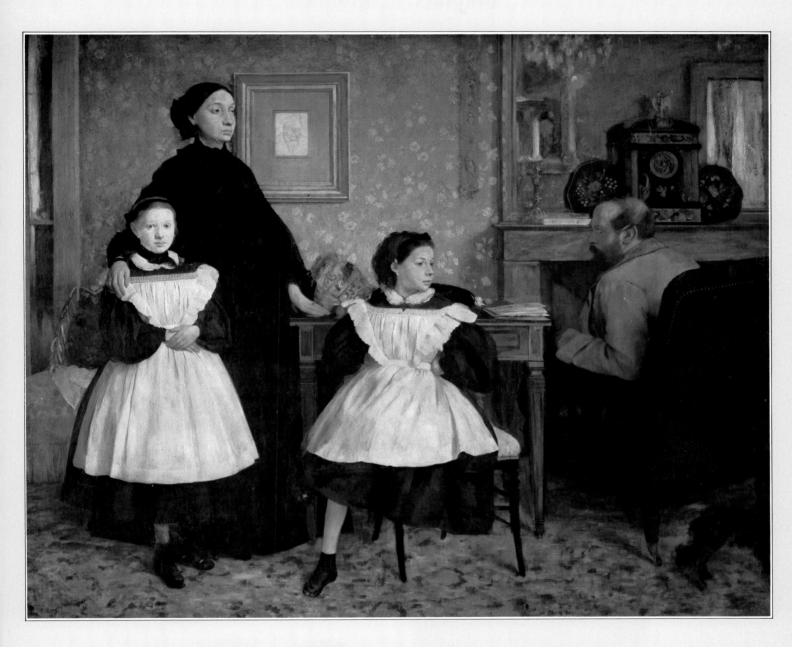

Oil colors used to 'imitate' red chalk drawing

Dense blacks give flat, unmodulated shapes

Cracks reveal previous orange layer

Light reflecting off varnished surface of painting

Scraped underpainting and knife-applied color

Textural brushwork following form

Damage to flesh painting around girl's eye restored

Fine brushwork in varied off-whites for delicate fabric texture

Dragged, dryish colors

This extremely large family group portrait is on a scale traditionally reserved for portraits of major political or historical dignitaries. The canvas size is non-standard. Although it can be linked back to compositional precedents, for example the early group portrait drawings of Ingres, Degas' painting contains a novel emphasis upon the deeper psychological aspects of his sitters' characters. Family tensions are echoed and reinforced by artistic devices which create pictorial tension. Thus, even in this early work, Degas' talent for fusing technical and aesthetic elements in his art can already be seen.

Here Degas intentionally silhouetted the profile of his aunt against the dark edge of the picture frame behind her, to stress the fine features of his chief sitter. The paint layer, although thin and delicate, is opaque, with smoothly blended flesh painting reminiscent of Ingres. A crack to the left of the mouth results from damage to the canvas. Light is reflected off the varnish especially in the darker parts of the painting, where slight blistering has made the paint surface irregular. The pale parts of the picture, which contain lead white, are more stable and durable.

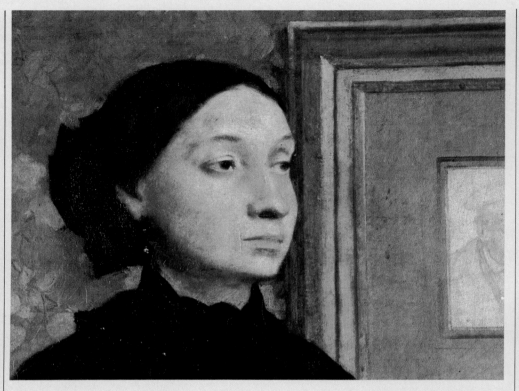

The variety of brushwork used to evoke texture is evident here. Feathery directional strokes follow the movement of the Baron's hair, not disguising the way it is swept over to hide his balding scalp. Details of decoration on the mantel ornament are picked out either in vermilion or in an earth red which is given comparable brilliance by the surrounding dark hues. Damage to the face has been restored, as has a vertical fissure running across the mantel ornament.

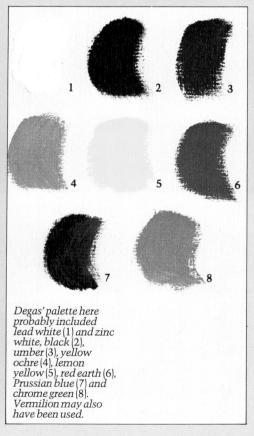

Degas' palette here probably included lead white (1) and zinc white, black (2), umber (3), yellow ochre (4), lemon yellow (5), red earth (6), Prussian blue (7) and chrome green (8). Vermilion may also have been used.

Actual size detail
Detail in the modeling of the hand is kept to a minimum in the final painting, which nevertheless works perfectly at the correct viewing distance for this large canvas. The paint layer is very thin in the lower area of the decorative fabric, giving a speckled effect where it has caught on the nodes or in the dips of the fine-textured canvas support. The speckled effect on the flesh paint seems to be unintentional. Here, varnish and dirt have darkened the paint in the canvas grooves. There is some surface cracking. This either results from overpainting before the first layer is dry or from working with lean color over a fatty layer, which takes longer to dry. Cracks in the final dark layer now reveal the underlayer of rich pinkish orange color.

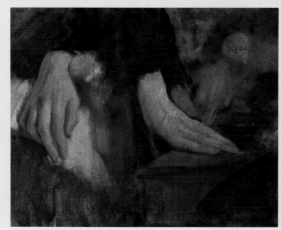

One of the few extant preparatory works for his portrait, this oil study or étude is typical of this stage in the traditional painting procedure. Having established the compositional design, Degas then made these careful studies of his aunt's hands to assist the accurate representation of them in the final work. He made minor changes to their position on the finished canvas. Degas used the special étude weight canvas for this work.

EDOUARD MANET

Concert in the Tuileries/La Musique aux Tuileries (1862)
Oil on white primed canvas
76cm × 118cm/30in × 46½in

During the 1860s Manet was influenced not only by photography and Japanese prints, but also by the work of several Old Masters, including the seventeenth century Spanish artist Velazquez (1599–1660). In *Concert in the Tuileries*, Manet was reworking the theme of a painting in the Louvre which had at that time been mistakenly attributed to the Spanish master, and which was thought to show Velazquez and his circle of friends. Transferring the idea to modern Parisian bourgeois society and dress, Manet depicted himself — to the extreme left — surrounded by friends including the writers Charles Baudelaire and Théophile Gautier, Manet's brother Eugène, the composer Offenbach, the Realist critic Champfleury, and the artist Fantin Latour. Although scenes from Parisian life were still relatively innovatory as subjects for fine art oil painting, illustrations and popular prints of such subjects had been common since at least the 1790s. More modern prototypes could have been an illustration of a military concert in the Tuileries, published in the magazine *l'Illustration*, or prints from popular mid nineteenth century illustrated books of Parisian life. Thus, in a way typical of his 1860s work, Manet combined influences from the Old Masters with inspiration from contemporary sources and popular imagery.

Reviewing Manet's posthumous exhibition and studio sale in an article published in February 1884, the critic Joseph Péladan forcefully repeated the myth that Manet was incapable of composing a picture. He wrote that Manet was 'merely a painter, and a painter of fragments — devoid of ideas, imagination, emotion, poetry, or powers of draftsmanship.' These were all factors associated with the academic tradition of *chiaroscuro* which Manet rejected. Thus, this critic reinforced the connection, commonly made by conservatives, between modern non-academic methods, and the anti-intellectual tendency in art. Manet's style was considered visually fragmented because it lacked the unifying pictorial coherence which *chiaroscuro* lighting gave to a picture. In some respects, however, Manet was indeed a painter of fragments — fragments of modern life in which he intentionally sought to convey the experiences of such a life more directly than established artistic conventions permitted.

Concert in the Tuileries, depicting a segment of the panorama of leisured city life, broke established compositional conventions because the frieze-like distribution of figures across the picture surface gave no central point of focus. The picture was therefore seen by critics as being without *any* composition whatever. In fact, the composition is tightly organized, but in a manner quite novel for its time. There is little spatial recession, and no pictorial hierarchy to subordinate the whole to a main center of action. The spectator is on eye-level with the standing crowd, which reduces recession into depth by stressing the solid horizontal band which the figures form across the canvas. Another device is also used to keep the viewer separate from the scene, for the artist has created a stage-like effect — there are cropped figures only to left and right of the picture and none protrude below the bottom framing edge to 'intrude' into the viewer's space. The picture is a long strip of action, apparently arbitrarily cropped at either side, but very neatly contained by the framing edges top and bottom. The careful positioning of figures or objects right up to the lower edge leaves little open foreground, and this also discourages spectator participation in the scene. Gone are the exaggerated gestures and conventionalized expressions which made academic art eloquent. Instead, the figures whose eyes gaze out, stare blankly and indifferently, with cool, worldly nonchalance.

The line of top hats, the upper extreme of the line of figures, cuts the picture in two just over halfway up the composition. The relatively unmodulated band of green foliage which fills the upper half again emphasizes the picture's flatness. Pillar-like tree trunks punctuate the horizontal rhythm, which moves from left to right — the normal direction for the eye to follow when viewing paintings in Western culture. The trees unite upper and lower halves of the composition. The central foreground tree also links foreground and background, by appearing to sweep up and back. Its ambiguous position in space tends to pull the backdrop of greenery out toward the surface of the picture.

According to his early biographer Antonin Proust, Manet worked outdoors during 1861, making oil studies for this painting every afternoon between two and four o'clock. However, despite this contention, only one or two drawings survive, and the work itself is a studio painting.

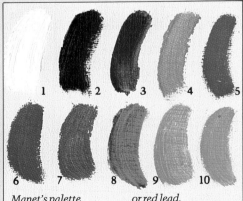

Manet's palette probably comprised lead (1) and zinc whites, black (2), raw umber (3), yellow ochre (4), red earth (5) or red lead, ultramarine blue (6), cobalt blue (7), viridian green (8), possibly cobalt green (9) and chrome (10) green.

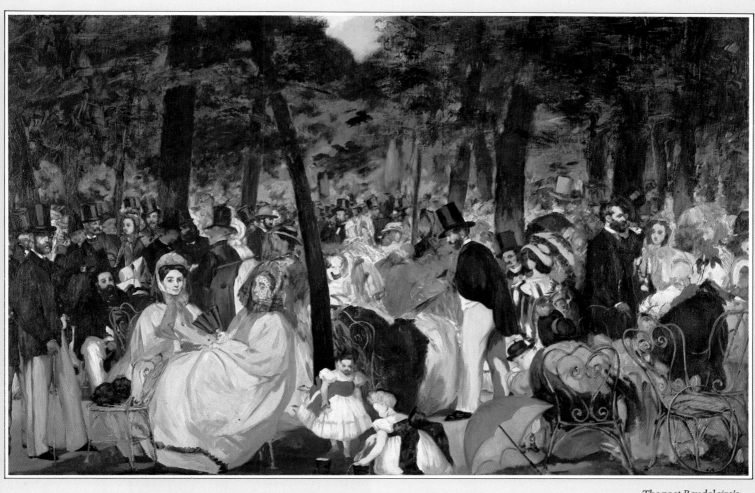

The poet Baudelaire's plea for artists to treat modern life subjects was first made in his Salon review of 1845, and later extended to form an essay, written in 1859-1860 and published in 1863. Artists like Manet took up the challenge, at the same time seeking a new style and pictorial construction to reflect modern themes. The unbroken parade of figures across the picture surface enhances the sense of immediacy, as does the staccato effect created by alternating blocks of light and dark color. The traditional, careful tonal modeling of form has been abandoned and replaced by strong tonal contrasts punctuated by bright color, which enliven the surface and negate depth. The picture was painted on a non-standard canvas.

Thin dark transparent underlay, probably raw umber and viridian, applied with a painting knife

Light reflecting off varnish over irregular, loaded paint surface

Opaque, viridian-based green mixture with white, brushed on over dry transparent green paint

Blue-tinged black paint

Probably a mixture of ultramarine and cobalt blues added to white, and slurred on wet into wet

Loaded opaque creamy-whites

Red earth or red lead

Position of parasol altered

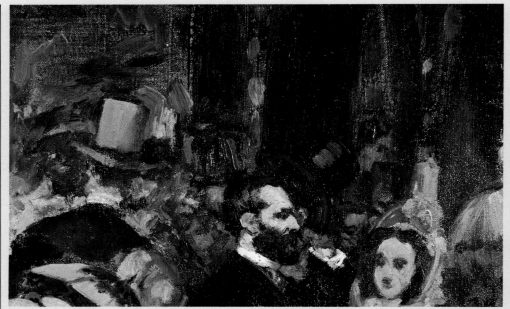

The figures were worked, with little preparatory underpainting or ébauche, directly onto the white ground. The swift wet-in-wet application of colors with a loaded brush contrasts with the thin transparent laying in of the background greens. This device helps the eye to distinguish between foreground and background. The heads are constructed with succinct, lively brushstrokes in simple blocks of light and dark, which gives a vigorous immediacy to the form and captures the quality of the crowded scene. Mixed oranges create a vivid complementary contrast when juxtaposed with the blues of the dress.

Actual size detail
The white ground remains uncovered in places. This shows the initial ébauche stage was very rudimentary. The disposition of figures is indicated mainly by bold contours. Thinnish opaque yellow ochre underpaint filled in the area of the dress which was then built up wet in wet with paler ochre hues. The black for the veil was dragged lightly through the wet flesh color, and the net motif added in blobs of black applied with the brush tip.

Although Manet at first adopted the thin brown initial lay-in of colors — the academic *ébauche* recommended by his teacher Couture — he rejected Couture's 'tomb-like' lighting which gave deep dominant shadows. Instead, Manet used strong natural light, falling directly onto his figures, which, as the artist stated, 'presents itself with such unity that a single tone suffices to render it.' His use of white or pale tinted grounds — in this work off-white — strengthened the flat, pale areas in his painting. These contrast with his liberal use of black, to portray the dress of the elegant dandies. Straight black was shunned by academic artists, as its emphatic presence disrupted muted harmonies. Thus, the fragmented feel in Manet's work also stems from his use of color. A jolting effect greets the eye as it moves abruptly over the canvas from white to black shapes, with bold primary hues.

The enclosing canopy of translucent mixed greens was applied mainly with a palette knife. The most opaque, reworked areas of tree are the brighter brushed greens — chiefly viridian and white — which form a pale, emphatic line above the top-hatted heads on the left. The paint layer, although quite thin, is predominantly opaque in the lower half of the picture. Despite the fact, as Monet noted, that Manet 'always wanted his painting to have an air of being painted in a single sitting', he was a slow and cautious artist, often scraping down his canvas at night, to begin again over the first thinly applied layer of color. *Concert in the Tuileries* was acquired from Manet in 1882 by the avid collector Jean-Baptiste Faure, an opera baritone who began buying work by Manet and the Impressionists as early as 1873.

A fluid transparent viridian green mixture, probably including either raw umber or black, was used for the tree trunks (left). These parts are still relatively transparent, although a thicker loading of paint was used than for the foliage. The paler greens were added over the dry background greens, to stand for the foliage. The white ground glows through creating the effect of light filtering through the trees.

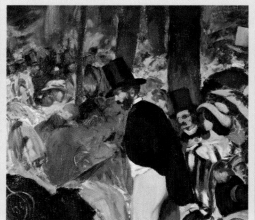

Unpainted patches of the white ground can be seen among the loosely painted blacks of the skirt of the veiled woman. The grayish blues of the veil were produced by streaking black into the wet paint. The fan is painted with white and viridian green.

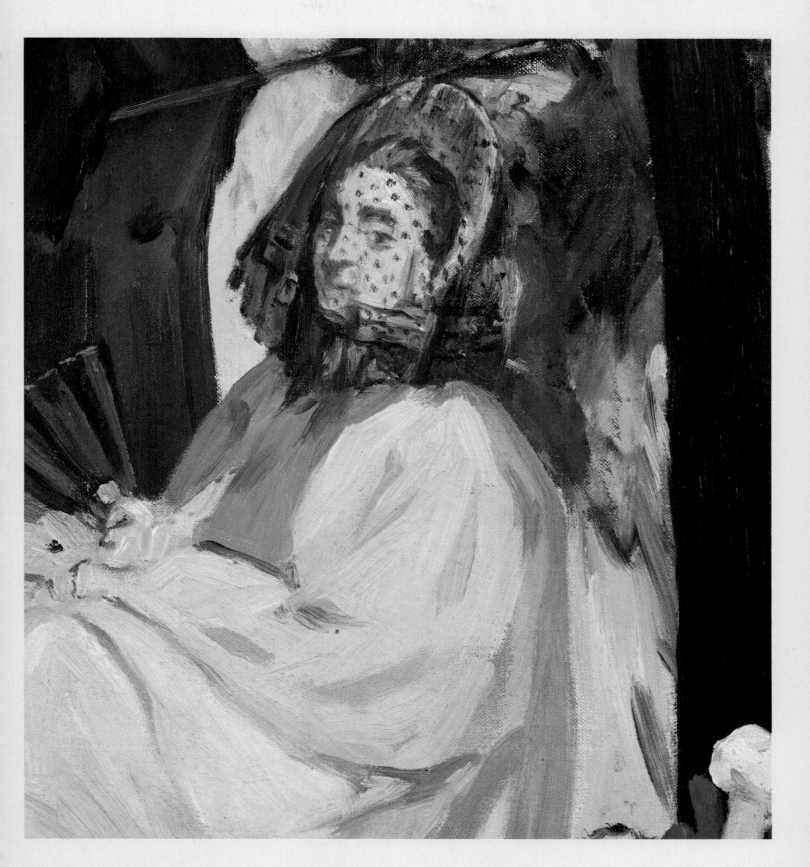

CAMILLE PISSARRO

L'Hermitage at Pontoise/L'Hermitage à Pontoise (1867)
Oil on reused, horizontal chevron twill canvas
91cm × 150.5cm/$35\frac{1}{8}$in × $59\frac{1}{4}$in

Camille Pissarro lived at L'Hermitage in the north-east part of Pontoise, between 1866 and 1868. He was to return to the area after the upheavals of the Franco-Prussian War and Paris Commune of 1870 and 1871, spending much of his time living and painting there during the 1870s and early 1880s. The work is close in its large scale and elongated format to several other paintings by Pissarro from the mid 1860s, and it is likely that they were intended for showing at the official Paris Salon exhibitions. Although infused with a relatively naturalistic outdoor light and careful observation of natural detail, this was undoubtedly a work executed in the studio. Like his radical compatriots, Pissarro was at this stage of his career still following the traditional procedure of executing studies in the open air, then working up large-scale variants indoors in order to present carefully considered, finished pictures at the Salon. Despite this practice, the painting combines striking elements of prophetically innovatory work with the influence of older artists in the Realist tradition.

The richly painted and varied somber greens are reminiscent of Courbet's forest landscapes, while the panoramic format, broad foreground, punctuated with small-scale toiling figures, and solidly constructed buildings are a reminder of Pissarro's debt to his teacher Corot (1796–1875). While there is a stark contrast between the darks of the landscape and the pale tones of sky and buildings, the light and dark are not used to structure form in a traditional manner. In fact the even, ambient light from the overcast sky eliminates shadows which might strengthen form. Instead, the powerful sense of structure visible in the buildings is created through varied, descriptive brushwork which follows the form and the directions of the planes, and imitates natural surface textures. There are remarkable compositional similarities between Pissarro's picture and that of the same subject from the previous year by Charles Daubigny (1817–1878). Daubigny's vigorously painted landscapes were highly influential in the development of Impressionism. Both artists chose a low viewpoint, close to ground level, and both show a broad open foreground with small, integrated figures, and buildings in the middle distance. In both paintings, the hillside is placed parallel to the picture plane, running horizontally just over halfway up the canvas.

However, Pissarro differs from Daubigny in the extraordinary solidity of his handling of form, and in his lively use of diagonals. The strong foreground horizontals are broken at the bottom right of Pissarro's painting by a diagonal moving in toward the center of the composition. This is taken up, reiterated and reinforced by the diagonal roofs of the buildings and the insistent, flattened stripes of the hillside fields. The hill rises immediately behind the buildings, blocking off distance, and these elements flatten the picture, producing a compact and relatively shallow pictorial space. This lack of deep recession is accentuated by the immediacy of the colors in the background.

Landscape artists frequently used graduated brushwork to indicate increasing distance. In other words, loose broad brushstrokes were used to depict the objects closest to the viewer, while those at a distance were shown with smaller and smaller touches towards the skyline. In Pissarro's painting, however, the size of brushmark remains relatively uniform throughout the landscape, so that his touch tends to contradict the illusion of space, making the spectator very aware of the painted surface.

In *L'Hermitage* Pissarro used an unusual canvas weave, a chevron or herringbone twill, which runs horizontally. However, because this picture was executed over a previous painting, the build-up of paint layers has resulted in the canvas texture being almost completely hidden, except in certain areas, such as the lower edge of the picture, where the paint is less built up. Had there been only a single painting on this support, the canvas texture would doubtless have had a stronger impact.

The paint, which is rich and buttery in consistency, has been applied in separate touches or strokes of a loaded broad bristle brush, building up wet layers over dry with some mixing of color wet into wet on the surface of the painting. The palette is composed predominantly of subdued earth colors and dark greens, with accents of brightish hues restricted to picking out the figures. All the colors are mixed with varying amounts of white to produce a solid, opaque paint layer. This would have been essential in order to obliterate the previous composition.

Spatial ambiguity and the tension between flatness and an illusion of depth are often accentuated rather than eased by the presence of figures in Pissarro's landscapes from this time on. Figures were traditionally incorporated into landscape paintings almost to legitimize the genre as they humanized a scene and gave it a readily identifiable sense of scale. Varied costume and human activity could also locate the picture historically, geographically and socially. Although in this painting there is no direct sunlight to cast shadows and thereby define the precise spatial location of the figures, their relative scale nevertheless helps to establish the spatial relationships in the composition. The bending male worker is carefully placed so that the loss of his feet among the vegetables disguises the uncertainty of his position in space, the vegetable patch almost fulfilling the function of a cast shadow. In later works, for example Pissarro's *Hillside at L'Hermitage* (1873), such guises are abandoned, permitting the artist to exploit such daring spatial complexities to the full.

On his teacher Corot's advice, Pissarro began painting from nature in the summer of 1857, and the unpretentious simplicity of this scene, painted 10 years later, is typical of the type of subject, chosen by Corot. The elongated horizontal format canvas used here by Pissarro is comparable to those generally preferred by Corot, although it is somewhat larger. This canvas is close to the standard format vertical marine 80 (146 x 89 cm/57½ x 35in). Slight variations in commercially manufactured products were common, as were marginal size differences from one color merchant to another. The large scale of this landscape suggests both that it was one of the paintings Pissarro intended for the Salon exhibition, and that it was a composition executed in the studio although based on studies outdoors. The unity of the even, gris clair lighting shows how successfully the artist retained his first impression in the final work.

Final sky painting worked up to edge of skyline

Wet-in-wet brushstrokes

Slab-like brushstrokes building up structure of forms

Brilliant pink accents, probably vermilion and white mixed

Long descriptive strokes

Light reflected off heavily varnished paint surface

Raised dry paint from brushstrokes of previous painting apparent

Dabbed strokes for leaves

This detail shows white flecks of light bounced off the irregular brush-marks by the thick varnish applied over the paint layer. The paint layer is thick and opaque, the color rich and juicy, loaded on to follow and thus construct the forms of the architecture. In this way, descriptive textural brushmarks replace the form-giving fall of light and shade traditionally used to create structure in painting. The gray-blue of the large roof was laid in with a painting knife, such as those used by Courbet and Daubigny, but most of the paint was applied with hog's hair brushes. Criss-cross, dabbed brushstrokes were used for the foliage, while the contours of the roofs were added later to define the planes.

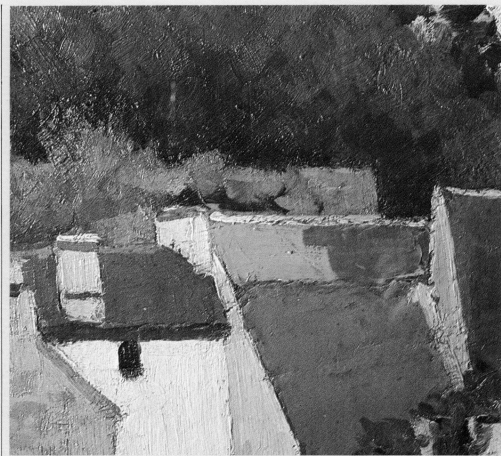

Irregular, dried brushmarks beneath the paint of the wall and the central tree, are remnants of the previous composition over which the present work was executed. The strong horizontal strokes of greens and browns are broken by opposing dry marks from the painting below. Artists often reused canvases as they could not always afford fresh supports. The stooping female figure is summed up with a few deft strokes of rich opaque color applied with a loaded brush.

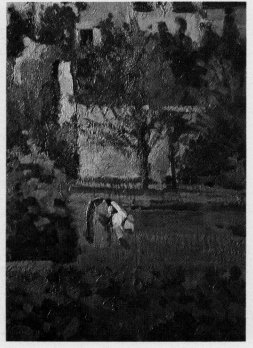

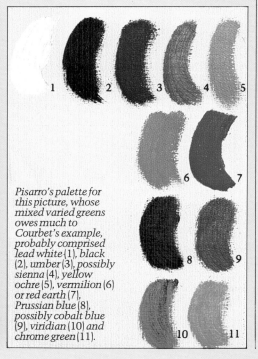

Pisarro's palette for this picture, whose mixed varied greens owes much to Courbet's example, probably comprised lead white (1), black (2), umber (3), possibly sienna (4), yellow ochre (5), vermilion (6) or red earth (7), Prussian blue (8), possibly cobalt blue (9), viridian (10) and chrome green (11).

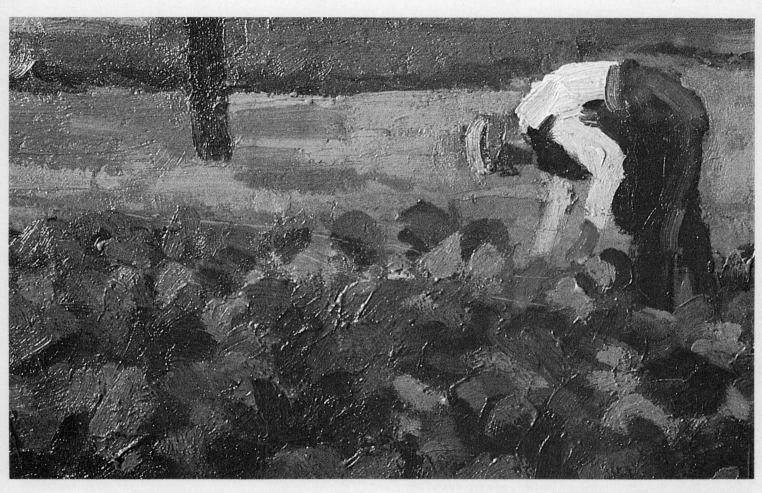

Actual size detail
The light catching and reflecting off the varnished surface again reveals the brushwork of the previous composition because these brushmarks do not relate to the structure of the present painting. The pale green, possibly a chrome green mixture, at the base of the wall was added after the tree was painted, as the pale green strokes finish short of the colors in the tree trunk. Black, white and umber were juxtaposed for the small figure, with yellow ochre slurred into the black and umber mix to depict the trousers. The position of the figure's head has been moved

slightly to the right and up. The colors are mainly broken, mixed both on the palette and also worked wet into wet on the paint surface.

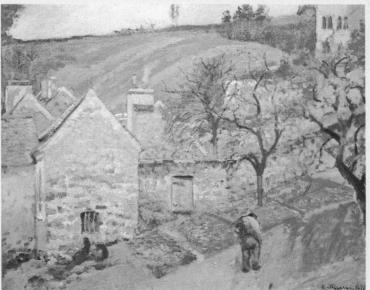

Pissarro's later work, Hillside at l'Hermitage (1873), is on a much squarer, standard figure 20 format canvas (61 x 73cm/24 x 28¾in), and shows a more daring use of light and space. Unlike the earlier work, this painting has a high skyline. Both use diagonal bands of color. This creates a flatness which is enhanced by the even tonality and lighting. The squarish format complements the artist's high viewpoint, emphasizing the chunky interlocking shapes of buildings and land. No direct fall of light and shade structures form, rather, a flat pattern of shapes is created over the picture surface. Pissarro's experiments with flat compositional designs were counterbalanced by the naturalistic descriptive brushwork he used at this time.

PIERRE AUGUSTE RENOIR

*Portrait of Frédéric Bazille/Frédéric Bazille à
son chevalet* (1867)
Oil on pale primed canvas
105cm × 73.5cm/41¾in × 29⅛in

Unlike most of his colleagues, who belonged to the middle or upper classes, Renoir came from the humbler background of the artisan class. His father was a tailor and his mother a seamstress. Thus, it was not surprising that his artistic talent was at first channeled into a career in the crafts. Between 1854 and 1858 he was apprenticed to a firm of porcelain painters, and as a biographer André later remarked 'He retained from his first *métier* of painting on porcelain the taste for light and transparent colors.' When Renoir decided on a career in the fine arts, his respect for tradition led him to enroll for drawing classes at the official Ecole des Beaux-Arts, where he studied from the model each evening for two years from April 1862. Seeking a liberal and yet respected painting master, he signed up with Charles Gleyre, whose name as his teacher appears as early as October 1861, on an application for permission to copy from Renaissance drawings at the Parisian print collection, the Cabinet des Estampes. While most of his friends had independent means or financial support from their families, Renoir had to earn enough money to pay for his tuition before he began training.

Frédéric Bazille (1841–1870), like Cézanne, came from the south of France. His family lived in Montpellier, and was wealthy enough to support Bazille in his wish to become a painter. He too, enrolled at Gleyre's *atelier*, in the autumn of 1862, where he met Renoir, together with Sisley and Monet. Gleyre's studio was closed because of financial difficulties and the master's ill-health in March 1864, thus curtailing the group's artistic training. Renoir and Bazille had a close friendship during the 1860s, up until the latter's untimely death in action during the Franco-Prussian War of 1870. Bazille's position enabled him to help the poorer Renoir, who lived with Bazille in Paris in 1866, and again from autumn 1867, when Renoir and Monet both shared Bazille's Paris studio in the rue Visconti.

It was during this time that the *Portrait of Bazille* was painted. It shows Bazille working on a *Still Life with Heron* which survives today. The still life upon which he was working looks very different in Renoir's version from Bazille's original. While Bazille's work is tight and carefully handled, Renoir's version shows a freer, broader interpretation which does not match the fine sable brushes he has painted in Bazille's hands. Renoir's portrait presents Bazille close up to the picture surface, filling almost the entire picture space. Although he is engrossed in his own work, the sitter's presence is very strong and immediate. Bazille was a very tall, lanky figure, as can be seen by his hunched-over knees and by his appearance in other contemporary portraits.

As in comparable portraits from this period by Degas and especially Manet, the sitter is shown surrounded by the attributes of his profession, which tell the viewer about his character and social life. The large studio easel, known as a *chevalet méchanique* or English easel, indicates that Bazille was well off, as it was an expensive piece of equipment. Designed mainly for very large-scale pictures, it was built on castors and could be moved with ease around the studio. The bar on which the picture rests could be cranked up and down mechanically, and the body of the easel could be shifted forward to change the angle of the painting. It was a complex item of joinery, usually made in solid hardwood.

Other pieces of studio equipment were also included in the portrait. Bazille uses a small, rectangular palette, of the kind usually included in portable paint boxes. It fitted into the box lid where colors left on it were protected from squashing against other objects. Behind Bazille's back, a couple of canvases are turned to face the wall, a trick to prevent the dust gathering on newly painted surfaces. The exposed rear of the stretcher adds to the information which can be gleaned from the picture, by indicating that modern dry-jointed key stretchers were being used by these artists. Key stretchers, invented in France around 1750, were designed to solve the problem of sagging canvases. When canvas sagged on the cheaper, fixed-jointed stretchers, it had to remain loose unless it was restretched and tightened. With dry-jointed key stretchers, the corner keys, visible at one corner in Renoir's painting, could be tapped further in, forcing the stretcher bars out and thus making the canvas tauter. However, care had to be taken not to overdo this, as, while canvas is relatively elastic, the paint layer is rigid, and excessive tightening could cause it to crack.

This picture shows a typical nineteenth century studio easel, like that used by Bazille in Renoir's picture. This diagram came from a color merchant's catalog, advertising an 'English easel' made in waxed oak, almost 2 meters (6 feet) high.

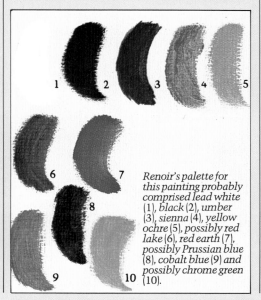

Renoir's palette for this painting probably comprised lead white (1), black (2), umber (3), sienna (4), yellow ochre (5), possibly red lake (6), red earth (7), possibly Prussian blue (8), cobalt blue (9) and possibly chrome green (10).

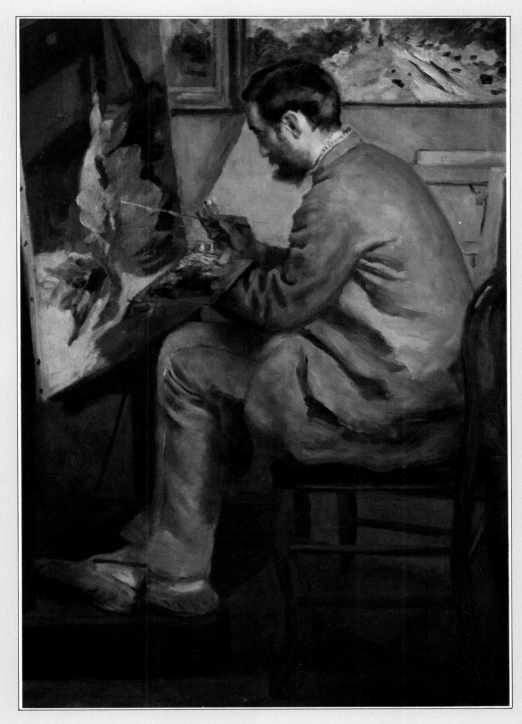

Nineteenth century portraits and self-portraits of artists provide vital evidence of the social role of artists and image they had of themselves at that time. In this period the social status of the painter was no longer clear, and many artists led a bohemian or dandy life on the fringes of society. In this picture, Renoir has shown Bazille in the role of the craftsman, actively engaged in his work. By contrast, many other pictures of artists show them as thinkers, intellectuals or dreamers, separated from the practical aspects of their trade. This approach echoes the traditional split between craftsman and thinker, artist and artisan, which was so deeply entrenched in European thought. Renoir himself was a very dedicated craftsman, aware of the importance of the careful handling of materials and of the value of sound craft traditions. Renoir's use of black in the shadows is reminiscent of Manet's work, as is his broad, simple modeling of form. The artist's pose is characteristic, with the palette gripped in the left hand, the thumb through the hole in palette. Spare brushes are held bunched in the fingers of the left hand.

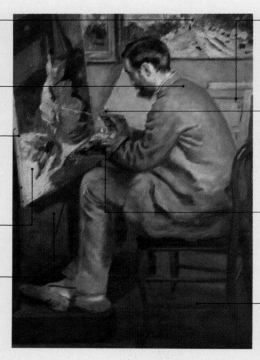

Early snow scene by
Monet

Thinly applied opaque
color

Unframed canvas edge,
showing pale
commercial priming
and tacks on canvas
edge

Freely brushed, more
impasted wet-in-wet
handling of color

Mechanical English
studio easel

Key stretcher, added late
over gray wall color

Fine sable and hog's hair
brushes

Rectangular palette
with two dippers for oil
and turpentine

Localized cracking of
dark glaze, possibly
applied over a fatter
(oilier) underlayer

Actual size detail
*The original hues of the
painting have been
distorted by discolored
varnish and dirt in the
crevices of the paint,
especially in the thickly
daubed colors for the
palette. Dirt is also
visible in the grooves of
the canvas grain, giving
a speckled effect not
intended by the artist.
The paint for the hand is
deftly worked in rapid
confident strokes.*

*Opaque gray
underpainting was
applied over the ground
beneath much of the
background of the
picture, filling in around
the edges of the figure.
The colors for the
stretcher on the right
were applied loosely
over the dry, gray paint.
Gray, usually tinted
warm or cool in hue,
was commonly used for
the walls of studios at
this time. A
combination of subtle,
mixed earth colors,
blacks, grays and whites
dominates this section
of the painting, the
colors are thinly but
opaquely applied with a
delicate, feathery touch
which was already
characteristic of Renoir.*

Renoir's portrait shows that Bazille is work-
ing on a ready primed, commercial canvas,
because the exposed edge on the left reveals
not the color of raw canvas, but the color of
a pale priming which goes around the edge to
the back of the stretcher, passing under the
securing tacks. A home-primed canvas was
normally primed after stretching, so that the
ground only appears on the front surface.

In this portrait, Renoir himself probably used
ready primed canvas because the ground,
although obscured with paint, looks putty-
colored on an unpainted strip down the left
edge. However, the canvas is not of a standard
size. Renoir's portrait shows the influence of
Manet in composition, type and in treatment.
The figure is broadly handled in relatively flat
areas of color, without subtle tonal modeling.
Strong contours help to define the form. How-
ever, Renoir's application of color already has
his individual touch, a feathery, delicate quality
Renoir's brushwork was to prove aptly suited
to rendering the vibrant, flickering effects of
natural light in his Impressionist work. The
muted palette colors relate well to the indoor
setting here, where the studio walls are painted
a conventional dull greenish-gray. The dull
ground color corresponds well to the hues of
the paint layer. This painting was admired by
Manet and became part of his collection. It is
not known whether it was a gift from Renoir,
or whether Manet bought the work as a gesture
of support for the young artist's talent. The sub-
ject and purchaser of this work indicate the im-
portance of friendships with other artists to the
independent, later Impressionist, painters.

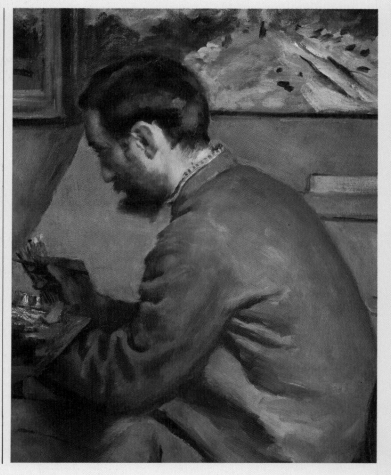

CLAUDE MONET

Bathing at La Grenouillère/Les Bains de La Grenouillère
(1869)
Oil on white primed canvas
73cm × 92cm/28$\frac{3}{4}$in × 36$\frac{1}{4}$in

During the 1860s, Monet divided his time between his childhood home on the Normandy coast, Paris, and the countryside around the capital. In the earlier part of the decade he had mainly worked near Fontainebleau, southeast of Paris, which was the home of the influential Barbizon school of landscape painters. During that period he came under the influence of older landscapists, like Courbet, who had preferred dark forest settings for their paintings. As his Impressionist style and interests evolved, Monet's love of more open, sunlit scenery, including parks and gardens, gradually emerged, as did the palette which was to complement such scenery. This change in the second half of the decade, was echoed by his growing preference for landscapes to the north and west of Paris, such as Ville d'Avray where *Women in the Garden* was begun in 1866, and Bougival, near where *Bathing at La Grenouillère* was executed three years later.

La Grenouillère was a riverside bathing and boating resort, popular among weekend trippers during the Second Empire (1852–1870) and after. It had a floating restaurant which is seen in another of the paintings executed by Monet during his two-month stay there in the late summer of 1869, and it appears in similar works by Renoir often painted sitting alongside Monet. The resort was situated on the Ile de Croissy, facing the left bank of the Seine.

In Monet's picture, which looks northeasterly, the afternoon light falls from behind the artist – a lighting effect he would have seen in Manet's studio work. However, although this full-face light is used, it is not exploited for the overall brilliance it gives to more open scenery. Monet only turned to this device in the 1870s. Instead, because of the close proximity of dense, overhanging trees, Monet has produced a study with alternating blocks of dark pierced by patches of dazzling sunlight, resulting in contrasts of light and shade reminiscent of Manet's work from the early 1860s. The juicy quality of Monet's paint is also similar to that found in Manet's work of this decade.

Unlike Manet's work, this painting was executed outdoors, and the brushwork is a witness to the speed required to capture the transitory effects which such scenery offered. The paint layer is generally opaque and hides the white ground, except in the most sketchily executed area, the upper right-hand corner. However, the white ground has helped retain the brilliance of the paint layer, which has recently been cleaned. A letter from Monet to his friend, the artist Frédéric Bazille (1841–1870) on 25 September 1869, when he was working at La Grenouillère, makes it clear that Monet was still working in the traditional manner, seeing studies like this as preparatory work for larger, possibly studio executed works.

In this painting, Monet's brushwork is vigorous and the individually distinguishable brushmarks indicate that hog's hair brushes between about 1–2cm ($\frac{2}{5}$–$\frac{4}{5}$in) wide were used. There is little variation between the size of stroke in foreground and background to suggest depth, although more uniformly straight horizontal strokes and pastel shades on the distant water aid the impression of depth and recession. His brushwork is strongly descriptive, catching the character of different forms. Long unbroken strokes outline the boats, short horizontal daubs indicate the foreground water, abrupt jabs are used for flowers and foliage. Monet rejected traditional, smooth brushwork which created an illusion of surface texture; instead, his varied handling helps to evoke the actual natural textures. Monet's talent for summarizing the essential character of his landscapes was already apparent in his early caricatures, which demanded an ability to capture basic features concisely.

Monet's palette for this picture was already fairly limited, moving toward the restricted range of the Impressionists. Black – the absence of light – appears to have been abandoned, confirming his move away from Manet's influence. Most of the colors typically found in Monet's Impressionist palette are already in evidence. Vermilion, one of the few traditional colors used by Monet, has been identified virtually pure in the red flowers on the left, and mixed with other colors elsewhere. The greens were viridian, emerald and chrome, the latter a commercially produced mixture of Prussian blue and chrome yellow widely marketed in the period. All three greens were modern colors. Chrome yellow and lemon yellow mixed, were used in the brightest greens of the background trees. Because of their tendency to blacken in the presence of sulphides, the chrome yellows were abandoned by most of the Impressionists toward the end of the 1870s. Monet replaced them with the more stable cadmium yellows. Cobalt violet, available from 1859, was the first opaque pure violet pigment to appear on the market and was therefore rapidly adopted by artists. It was used here by Monet in mixtures, for example in the foreground water. The early eighteenth century invention, Prussian blue, was used by Monet in the darkest mixtures, such as the swimming costumes, while cobalt blue is the bright blue of the water. Lead white was consistently used by Monet throughout his career, but, as strong contrasts form the basis of this composition, its role in this picture was relatively limited. In his paintings from the 1870s on, lead white was liberally used in most of his color mixtures, bringing with it a new overall brilliance and pale pastel-like quality, as he sought to depict the light tones and minimal light-dark contrasts of full sunlit landscapes. Interestingly, a family of colors commonly used by Monet from the early 1870s, the red

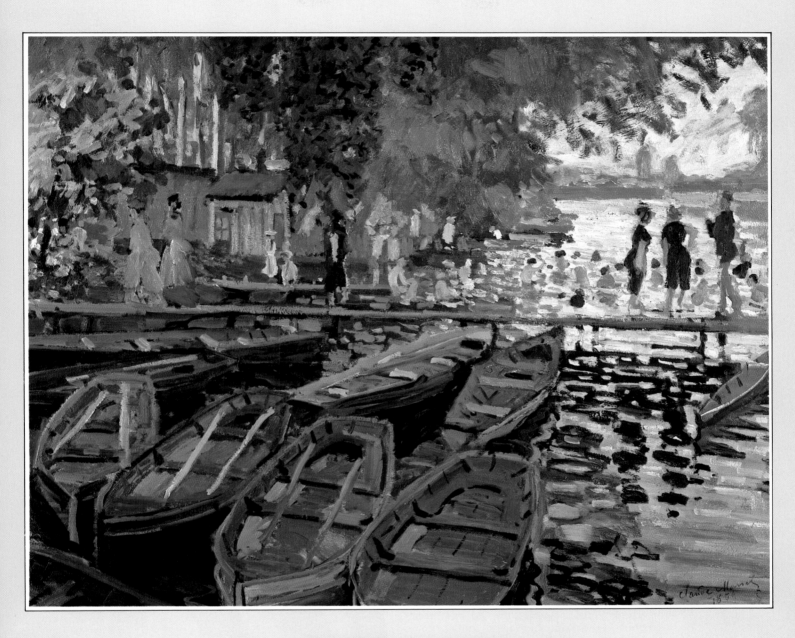

This leisure scene is animated by Monet's lively brushwork. As well as descriptive of surface textures, the brushmarks, which are almost equal in scale throughout the picture, unify the design. The overall opacity and thickness of the paint consistency add to this effect. The colors are premixed, and also slurred together on the surface. The canvas is a standard, squarish figure 30 format.

Dragged dryish color laid wet over dry

Vermilion used almost pure

Colorful neutral or grayish hue, red and green mixed

White ground showing through

Green of foliage extended in late addition

Prussian blue for bathing costumes

Small boat late addition to adjust composition

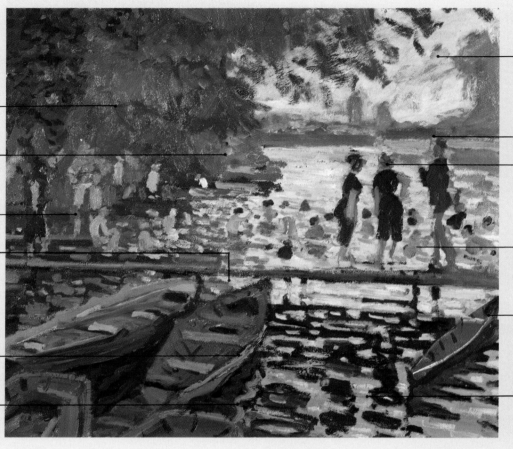

Light reflecting off varnished surface over irregular impasted brushmarks

Chrome yellow slurred wet-in-green mixtures

The paint of the bathing shorts appears to have red lake slurred into it

Late brushstrokes in blue with much white for the water surface, dragged horizontally over the piers of the duckboard and partially obliterating them to give effect of dazzling sunlight off the water

Strong, linear brushmarks define and outline the forms of the boats

Zigzag brushmarks indicate reflections on the water

Wet-over-dry reworking, dark foliage extended and pale distant trees obliterated, during late adjustments to the top right corner of the composition

Blues added around heads

Vermilion slurred wet into paint of women's bathing hats

Figures cursorily indicated in quick strokes

Small boat added as a late compositional touch, its presence acting like a full stop, preventing the eye from slipping off the right canvas edge

Short horizontal dashes for broken reflections off agitated water surface

alizarin lakes, has not been identified on this picture. The artificial alizarin, more permanent than the natural organic root derivative madder lake, was only discovered in 1868, which may account for its absence here. Both Prussian blue and probably chrome green were abandoned by Monet during the 1870s. Monet combined slurred wet-in-wet mixing on the canvas with premixed hues. For example, the somber colors on the boats are obtained by mixing complementaries, like red and green, which give darkish neutral hues that are more colorful than those made by sullying a color with black.

The apparently accidental nature of the composition is deceptive. The striking horizontal of the duckboard, which cuts right across the picture surface, is placed almost exactly halfway up the picture. This was an unconventional device at this date. The broad shapes of light and dark above and below that line echo each other, giving a flat decorative unity to the composition which is reinforced by the harmonizing colors and patterned brushwork. Thus, even at this early stage in his career, Monet was already preoccupied with contrasts of naturalistic illusion and flat pattern, which were to become a feature of Impressionism, and to remain with Monet throughout his life.

Monet's palette for this painting, which has been analyzed by the National Gallery, comprised lead white (1), chrome yellow (2), lemon yellow (3), vermilion (4), cobalt violet (10), Prussian blue (5), cobalt blue (6), emerald green (7), viridian green (8) and chrome green (9).

Actual size detail
The dragged overlaying of the stiffish blue and white paint mixture allows the earlier dry layer of olive green to show through. Such effects add to the vibrant impression of flickering light and color. The colors of the dresses were slurred wet into wet — blue, white and vermilion, or blue, gray and white. Dried, older brushstrokes can be seen cutting across under the present colors, perhaps indicating a previous compositional design. The strong horizontal of the duckboard has been strengthened by dragging dryish, pale pinky-blue over dark, dry paint.

INTRODUCTION

1870
1880

The 1870s saw the peak of Impressionism, both as a coherent group movement and as a painting style. During that decade, artists divided their time between landscape painting and studies of Parisian life. The gentle rural landscape along the Seine valley between Paris and Normandy formed the main source of inspiration for Monet, Sisley and Pissarro. Renoir, who regularly worked beside Monet during the first half of the decade, also painted many scenes of interiors, figures and city subjects. Monet and Renoir were joined in Argenteuil by Manet in 1874. In Manet's paintings of this period, figures, as usual, dominated even his outdoor scenes, although he lightened and brightened his palette at this time. During the decade, Degas and Manet continued their emphasis of the 1860s, painting mainly themes of modern Parisian life, such as the boulevards, café scenes, the Opera and the ballet. Gustave Caillebotte (1848–1894) split his allegiance between city life and landscape. The earliest works in the Impressionist style by Mary Cassatt (1845–1926) date from the latter part of the decade, and her subjects included the Opera, indoor and outdoor figure scenes. She often chose themes comparable to those of Berthe Morisot (1841–1895), but their style and handling were quite individual. Pissarro and Cézanne often worked on landscapes together during this period, although Cézanne divided his time between the north and his native Provence.

By the mid 1870s, the artists' period of apprenticeship was over and their ideas, aims and differences firmly established as a result of regular discussions at Paris cafés from the latter half of the 1860s onwards. Indeed, by this time the Impressionists — or independents as they were still called in the early part of the decade — found themselves, with the exception of Manet, sufficiently united in their disagreement with the academic system and its outlet, the Salon exhibitions, to present a united opposition to those institutions. Although their first discussions on the subject in the mid 1860s had come to nothing, by 1874 the members of the Impressionist group finally established their own alternative exhibitions, independent of the official Salon. Their first show took place in April and May 1874, when a critic coined the term 'Impressionist'.

Basic methods of Impressionism

The brilliant young French Symbolist poet, Jules Laforgue (1860–1887), gave a perceptive and informed description of the Impressionist approach, in an article written in 1883. He said the Impressionist artist was one, who 'forgetting the pictures amassed through centuries in museums, forgetting his optical art school training — line, perspective, color — by dint of living and seeing frankly and primitively in the bright open air, . . . outside his poorly lit studio — has succeeded in remaking for himself a natural eye, and in seeing naturally and painting as simply as he sees.' In seeking to free themselves from the conventional studio vision of line, space and *chiaroscuro*, the Impressionist painters had to re-educate their eyes by careful observation of natural outdoor light effects. They had to learn *not* to see landscape through the artificial eye of European painting.

Photography gave them one alternative vision of the natural world which was not based on painting, and Japanese prints provided another artistic option. The Impressionists' friend and patron Théodore Duret, politician and art critic, noted in an important essay in 1878 'Before Japan it was impossible; the painter always lied. Nature with its frank colors was in plain sight, yet no one ever saw anything on canvas but attenuated colors, drowning in a general halftone.' With their 'piercing colors placed side by side', Japanese artists showed 'new methods for reproducing certain effects of nature which had been neglected or considered impossible to render'. Duret summarized 'After the Impressionists had taken from their immediate predecessors in the French school their forthright manner of painting out of doors from the first impression with vigorous brushwork, and had grasped the bold, new methods of Japanese coloring, they set off from these acquisitions to develop their own originality and to abandon themselves to their personal sensations.'

While their older colleagues, Manet and Degas, remained essentially committed to studio working methods, albeit novel ones, the younger artists, Monet, Renoir, Pissarro, Morisot, Sisley and Cézanne, used outdoor landscape studies as the vehicle for their research into new ways of painting the real world. They abandoned the strongly contrasting lights and darks of Romantic and Realist painting. In particular they rejected the use of the somber earth colors, browns and blacks, which dominated the palettes even of artists like Manet and Degas in the 1860s. Instead they explored the pale colors and close tonal values of studies by Corot (1796–1875), the luminous skies of outdoor seascapes by Boudin (1824–1898), and even the pale opaque shadows which helped flatten pictorial space in works by Ingres (1780–1867). They began to exploit more fully the light-enhancing properties of pale commercial primings, and gradually replaced the traditional brown *ébauche* with a brightly colored initial laying in of paint which related directly to the final colors of the painting. They continued and extended the making of outdoor *études*, adopting this freely executed study stage as their finished work.

Supports

Although the smooth, dark surface of mahog-

any panels was often used to advantage by earlier nineteenth century landscapists, the Impressionists preferred the lively give and texture of woven fabric supports. Prepared paper and card were often also used as supports for oil sketching in this period for reasons of economy and their light weight which made them easy to carry. Canvas is a coarse cloth woven usually from flax or cotton, but sometimes from hemp. Its widespread use as a painting support dates from the Italian Renaissance. The rise in importance of fabric supports coincides with the increasing cultivation of flax in Europe from the Middle Ages on. It remained the most important vegetable textile fiber in Europe until the end of the eighteenth century, when cotton began to be imported on a large scale from the United States. Canvas was first used in easel painting merely to provide an underkey for the gesso grounds of medieval panel paintings, and only emerged slowly as an independent painting support. The adoption of canvas went hand in hand with the development of oil painting. Its textured surface stimulated experiments, especially among the Venetian artists, in expressive brush and oil paint handling, which produced emotive effects impossible to obtain with fast drying egg tempera colors on smoothly primed rigid panel supports.

By the early nineteenth century, ready made canvases were being sold in France in a standardized range of sizes for easel painting. The range then available, in a squarish rectangular format designed for portrait and figure work, spanned from a small (No 3) canvas, measuring approximately 6in (15.5cm) by 8in (20.5cm), to the largest, (No 120), measuring approximately 6 feet (1.9 meters) by 4 feet (1.2 meters). At that time the metric scale had not yet been fully established. In the early 1830s a longer 'landscape' format was introduced, together with an even more elongated 'marine' shape. By the 1850s five series were on the market. These were the original portrait, vertical landscape, horizontal landscape, vertical marine, and horizontal marine series. Within these five series, each format number had the same sized shorter side, only the longer side varied in length. The code-numbering of portrait formats probably had its origin in the seventeenth century when the major art theorist Roger de Piles recorded that canvas pieces were sold according to cost — a 'canvas of 20 sous' was of given, commonly accepted dimensions. Thus, for example, a canvas costing 20 sous became canvas size No 20.

Despite the fact that most artists and writers thought that the dimensions of standard formats had been rationally conceived to conform with some aesthetic, harmonious ratio, such as the influential 5:8 proportions of the Golden Section, they were in fact determined purely by economic factors. In order to be able to prepare stretched canvases and picture frames in advance, color merchants found it expedient to use fixed measurements, rather than having to follow the whims of artists by making numerous sizes to order.

Before mechanization in the weaving industry, hand-loom widths for canvas depended upon the distance a shuttle could be thrown through the warp by the weaver. In France this was commonly around 1 meter (3 feet) up to a maximum of 1 meter 40cm (4ft 6in). When standardized sizes are analyzed in relation to the canvas widths available, it is clear that the formats chosen were those which could be cut most economically from the fabric, avoiding undue wastage. For large-scale paintings, like those of historic subjects often shown at the important, annual Salon exhibitions, artists had to order specially made canvases, which were sewn from strips of fabric.

The mechanical spinning and weaving of linen was about 50 years behind developments in the mechanization of the cotton industry, so entirely machine-made linen canvas was not common before the mid nineteenth century. Although large, unbroken widths of canvas made massive pictures simpler as the century progressed, the tendency was, on the contrary, to smaller, easel-scale paintings. This development was prompted by two chief factors — the demands of outdoor painting, which made very large canvases unmanageable, and the neces-

Below *This table shows the main standardized canvas formats. Commercially produced ready primed, ready stretched canvases in a wide range of standard sizes were available off the peg to artists in the nineteenth century. The range shown here of five series from portrait to horizontal marine, were on the market by the mid 1850s, and still sold in the 1890s. This table came from the 1896 catalog of the French color merchant Lefranc. The measurements are in centimeters.*

TABLE OF STANDARDIZED CANVAS FORMATS

NO	PORTRAIT OR FIGURE	LANDSCAPE		MARINE	
		HORIZONTAL	VERTICAL	HORIZONTAL	VERTICAL
1	21.5 × 16	21.5 × 14	—	21.5 × 11.5	—
2	24.5 × 19	24.5 × 16	—	24.5 × 14	—
3	27 × 21.5	27 × 19	—	27 × 16	—
4	32.5 × 24.5	32.5 × 21.5	—	32.5 × 19	—
5	35 × 28.5	35 × 27	35 × 24	35 × 21.5	35 × 18.9
6	40.5 × 32.5	40.5 × 29.7	40.5 × 27	40.5 × 24	40.5 × 21.5
8	46 × 38	46 × 35.1	46 × 32.5	46 × 29.7	46 × 27
10	55 × 46	55 × 43.2	55 × 38	55 × 35.1	55 × 32.5
12	61 × 50	61 × 45.9	61 × 43.2	61 × 40.5	61 × 38
15	65 × 54	65 × 48.5	65 × 45.9	65 × 43.2	65 × 40.5
20	73 × 59.5	73 × 56.7	73 × 54	73 × 51.3	73 × 48.5
25	81 × 65	81 × 62.1	81 × 59	81 × 56.7	81 × 54
30	92 × 73	92 × 70.2	92 × 67.5	92 × 64.8	92 × 62.1
40	100 × 81	100 × 73	—	100 × 65	—
50	116 × 89	116 × 81	—	116 × 73	—
60	130 × 97	130 × 89	—	130 × 81	—
80	146 × 113.4	146 × 97	—	146 × 89	—
100	162 × 130	162 × 113.4	—	162 × 97	—
120	194 × 130	194 × 113.4	—	194 × 97	—

sity for artists to produce many, smaller paintings to satisfy the new middle-class market, which called for reasonably priced works which would fit in small city apartments.

Most nineteenth century artists used standardized canvases for their easel-scale works, but the Impressionists and those who followed them found new more appropriate ways of exploiting them. Thus the commercial availability of a product had a direct impact on the most basic level of artistic creation – the initial selection of canvas shape on which to start work. This inevitably influenced compositional design, as this must relate to the canvas edges and overall shape. So an artist planning to tackle a particular subject must choose the most suitable canvas proportions to enhance the projected design. The positioning of the subject on the chosen canvas size and shape is called *mise en page*, and is a crucial, though underestimated, determining factor in Impressionist painting. It shows how self-conscious these artists were, contrary to the currently popular myth of their naive spontaneity.

Non-standard supports
Although the majority of their works are on standardized canvases, the Impressionists did not adopt them wholesale. They also experimented with unusual canvas shapes, either to suit particular subjects or to complement innovatory compositions. These would have been made up to order, usually with ready primed canvas. Monet and Degas were among the artists most overtly and consistently experimenting with novel formats and compositions. For example, certain of Monet's studies from the early 1870s of Dutch land- and seascapes, were executed on canvases selected in advance to complement the low-lying panoramic scenery of Holland. These made-to-order canvases more elongated in shape than even the longest commercial 'marine' format. Artists were also beginning to explore the potential of completely square canvases.

Monet and Degas both began using square canvases in the latter 1870s, and Pissarro then Gauguin followed soon after. Because of the symmetry of their sides, square canvases accentuate an appearance of flatness, making it difficult to create the illusion of reality which a rectangular format can more readily suggest. Therefore square formats were avoided by conservative artists, while they presented the independent painters with an exciting challenge. On square canvases they could more readily wrestle with the problems of compositions in which a balance is created between the illusion of depth and a simultaneous stress on flat surface design.

Priming
Standardized canvases were sold not merely ready stretched on their wooden stretchers by

nineteenth century color merchants, they were also ready primed for the artist to begin painting directly. Commercial priming was done on large expanses of canvas, which were later cut down to the standard sizes and tacked onto their respective stretchers. It is thus possible to identify commercial preparations by examining the canvas edge, as the priming goes right round to the back of the stretcher. Where canvases are primed by hand *after* stretching, only the face side is covered, and raw canvas remains visible on the overturned edges and around the back.

For priming, the canvas was tacked to huge wooden frames in the workshop and balanced on trestles, the canvas was then primed horizontal. Using tools, like the priming blade which dates back well before the seventeenth century, the first layer of glue size was applied to the fabric. Two skilled men, one either side the flat of canvas, picked up the preparation in ladles and spread it thinly with the blades, working back and forth from the middle out. The size layer sealed the pores of the canvas and made it less absorbent, and therefore less vulnerable to the corrosive effects of the oxides present in the oil of the ground – the next layer. The size dried preventing undue movement in the fabric threads. The surface was then rubbed lightly with a pumice stone to remove fuzz and protruding irregularities in the weave. Then the ground coats, one or two layers of opaque color bound with oil, were applied with the priming blade, ideally allowing thorough drying time between coats. One of the hazards of off-the-peg ready primed supports was that artists had no means of telling when the canvas had been primed, and if it had been left long enough to dry thoroughly. Cracking all over the paint layer could result from a ground which continued to dry long after it had been painted on. Despite this danger, it was rare for artists to take the trouble to prepare their own canvases. As oil grounds could take a year or more to dry, artists were often advised to store them before use to make sure they had a sound base on which to work.

The relatively smooth, two-coated preparation was in general more popular before 1870, but after then Impressionist experiments with canvas texture made the grainy single coat the more sought after. A French color merchant's handbook in 1883 outlined the key differences: 'The texture of the cloth under the prepared ground leaves a good grain, which assists in spreading and laying on the colors, and is useful in giving different textures to the various objects represented. Canvases are prepared with coarse or fine grains, which may be suitable for large or small paintings, or for different styles of working. . . . Canvases may be more or less covered with the prepared ground. The thickly covered is more suitable for small figures and high finish, and the thinly covered is

Right Dancers (c1880) by Degas was unfinished. This means that the unifying warm hue of the raw canvas shows clearly among the colours. This picture, and the Portrait of Duranty *(1879), show Degas experimenting with the novel compositional potential of specially made square canvases. Abstract, decorative designs which stress the flatness of the picture plane are easier to create on square formats. Here, geometric shapes are contrasted with the nebulous forms of the tutus which are set against them. The dancers are set in a diagonal which recedes from lower right to upper left, in opposition to the diagonal of the foreground bench. The rectangles in the background, parallel to the picture plane, reinforce it. The unfinished handling provides a softening contrast with the taut composition. The stiff scumbling, seen clearly in the painting of the floor, shows the dragging which is inevitable when working in paint on a relatively absorbent support – this canvas was unprimed but probably sized with glue.*

better adapted to broad and rapid painting.'

A variety of different weights and weaves of canvas fabric were sold commercially for artists' use. Linen was the most common, but cotton and hemp fabrics were also available. Diagonal twill and plain were the two most common weave patterns used for artists' canvas, but odd examples of other more unusual weaves, like the herringbone twill, can also be found. The plain, one-under-one-over simple weave, known as tabby, was sold in a wide choice of weights, ranging from the thin, loose-woven sketching canvas held together by its priming, through to the thickly textured, tightly-woven strong weights. The choice of canvas weight varied according to the size of painting, large ones requiring strong fabric, and to the financial means of the artist. Students often used sketching canvas or the cheapish 'ordinary' weight canvas which was widely sold.

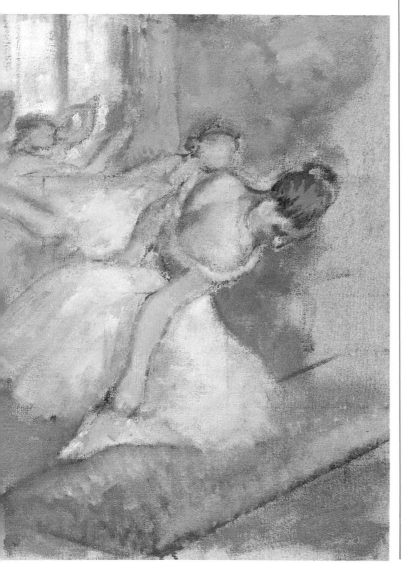

Supports and paint texture

Among the Impressionists, Monet and Pissarro both preferred a single-coat primed, grainy texture, which they exploited in combination with a dry, stiffish paint quality. The dragged and often crumbly or crusty colors of the paint layer clung well to the textured key of such canvases, which at the same time served to break the movement of the loaded brush across it. This created a stippled and vibrant web of color through which the ground or previous layers of color could show. When working on smoothly primed canvas or panel, it is possible to build up veiled layers through which earlier colors show. However, the dragged and broken effects in the work of Monet, Pissarro, Sisley, Morisot and Cassatt could only be achieved by combining the properties of stiffish paint applied with a bristle brush on a textured support. This is why panel was almost never used as a support by Impressionist painters.

While white was the most common color for ready primed canvas in the nineteenth century, a wide range of pale tinted preparations were also available on off-the-peg canvas. These included beige, cream, pinkish gray, bluish gray, putty, milk-chocolate brown, and oatmeal. None were darker than a middle tone, and most were considerably paler. One of the main innovations of the Impressionists was that the overall tonal key in their paintings was made lighter and brighter as a result of the concern to represent natural outdoor light. It thus became logical to exploit white and pale tinted primings in the same manner as dark grounds had been used traditionally. A middle to dark colored ground had traditionally been used to speed up execution as it played an active role as a unifying middle tone, which was left to show through the paint layer.

Although, during the 1860s, the all-covering opacity of the paint layer had tended to obliterate the pale grounds used by the independent artists, from about 1870 the ground was increasingly exploited as a color or value in its own right. Patches of white or tinted ground were left bare, to read through the loosely handled web of the colors in the paint layer. By choosing a ground tint appropriate to the particular light effect to be painted, the artist saved precious time in front of the subject, where speed was essential if transient lighting conditions were to be captured.

Incorporating the ground-tint into the final effect side-stepped the necessity for an all-covering paint layer, a necessity which had traditionally been seen as the great disadvantage of pale grounds. A white ground, on which all colors look good, was the perfect base for the technique of the Impressionists who sought to capture subtle color values, minute variations in hue and in warm and cool colors in outdoor light.

Above *and below These are samples of nineteenth century canvas. Reverse side of* primed *étude weight canvas.*

Face side of étude weight canvas, primed with one coat of ton clair, *a pale yellowish tinted ground.*

Demi-fine *or half fine weight canvas primed with one coat gray ground to give a grainy or à grain face.*

Half-fine canvas with two coats gray priming to give smooth or lisse face.

Unprimed face of twill weave canvas, showing diagonal texture. All these samples date from c1900.

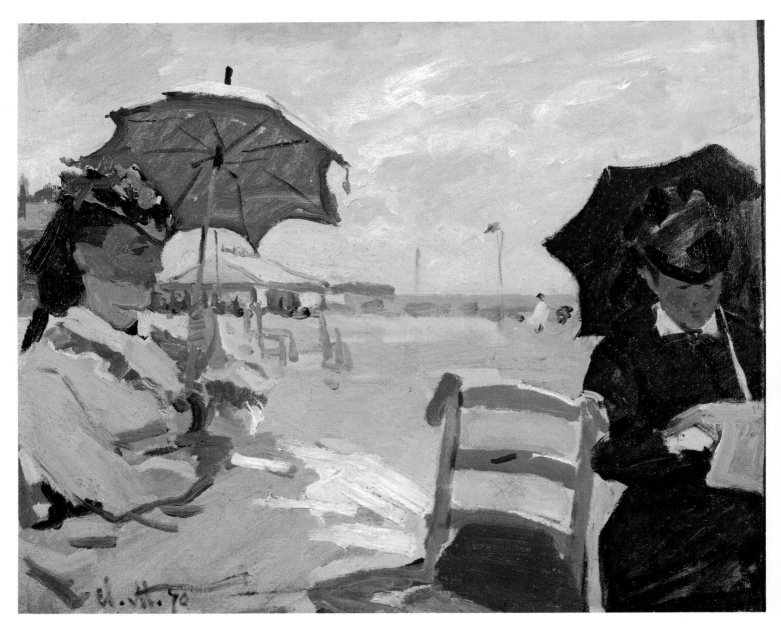

Above The Beach at
Trouville (1870) by
Monet has grains of sand
on the surface. This was
confirmed when the
work was cleaned in
1965. This definitely
means it was painted in
situ. The cool gray
ground is left to stand
among the paint layer
colors, on the beach,
center, and around the
chair. It also unifies
these hues and saves
painting the entire
canvas. The canvas
itself is small, measuring
37.5 x 45.7cm
(14¾ x 18in).

Painting color and light

The white or pale grounds acted as a luminous
unifying field, a visual metaphor for the brilliant
light effects portrayed. In purely physical terms,
the actual light-reflective properties of white
bounces light back into the spectator's eye,
enhancing the luminous appearance of the
paint surface. The irregular texture of the
grainy, single-primed surface exaggerates this
effect, because it scatters the reflected light,
producing a pale, pastel quality. When Monet,
Pissarro, Sisley, Morisot, Cassatt and, to some
extent, Cézanne, Manet and Degas used
dragged dryish colors mixed with large
amounts of light-reflective lead white, these
increased the pale, chalky paint surface.

Oil paints derive their richness of color, or
glowing transparency, from the oil binder they
contain. The glassy quality of oil allows light to
penetrate deep amongst the pigment particles,
so that when it is finally reflected back to the
eye it is rich with color. Inversely, paint with a
minimal amount of oil binder appears mat and
pale in color, because light is bounced rapidly
back to the eye before it has had time to become
saturated with color. This is why in nature,
wet surfaces appear darker in color than dry
surfaces. The Impressionists recognized that
the chalky, pastel-like quality produced by
paint with only a small amount of oil imitated
the effects of pale, reflected light in nature. To
exploit this, Monet and Degas — and probably

numerous other contemporaries — are recorded as having soaked most of the oil from their colors before use. One way to do this was to leave their colors on blotting paper for several minutes, before using them. Degas then diluted this paste with turpentine and laid it in thin mat washes, while Monet, and the other Impressionists except Cézanne and Renoir, applied it neat, as a dryish chalky paste ideal for abrupt dragged impasto. It is no coincidence that the pale mat surfaces of Millet's large pastel drawings, exhibited in Paris in 1875, were admired at this time.

In Impressionist painting, pale grounds were often used to stand for the lightest tones. Thus unpainted patches of ground left visible among the colors of the paint layer were used instead of applied color as the pale tones in the upper register of the tonal scale. In Cézanne's work in particular, pale cream or white grounds were left to show through as glowing highlights. As their use of this technique and their knowledge of color became more sophisticated, the Impressionists began exploiting the potential of tinted grounds for their color value.

They were aware of the influential color theories of Michel-Eugène Chevreul (1786–1889), and they experimented with the effects of color contrasts. These are strongest when colors opposite each other on the color circle are placed side by side. The artists used such complementary contrasts as a means of enhancing their representation of the atmospheric effects of light and color. Thus a cream ground, showing through a loosely painted blue sky, with roughly scumbled white clouds, resulted in an optical effect of warm, glowing sunlight. The warm cream would be enhanced — made to look warmer and pinker — by the adjacent blue, which would appear correspondingly cooler. Cream showing through the cloud areas would add an airy effect of warmth. This calculated exploitation of color effects produced an ethereal lightness which was impossible to obtain by a more conventional — and deadening — build-up of colors. So, floating veils of translucent, contrasting color or dragging openly worked webs of opaque color over a tinted ground enabled these artists to create a superb impression of natural phenomena. It was realized that color temperature played an important role in the depiction of natural light effects and that the distinction between warm and cool colors made it possible for the eye to distinguish between very subtle nuances of color with imperceptible contrasts of tone.

Color contrasts and juxtapositions of warm and cool colors were also used to evoke form without recourse to conventional tonal modeling. This was possible because warm colors appear to come forward, and cool colors appear to recede. In nature, warm yellow sunlight finds its contrast in the luminous blue-violet reflected light of the shadows. Thus where colors were equivalent in tone but exhibited such warm-cool contrasts, these

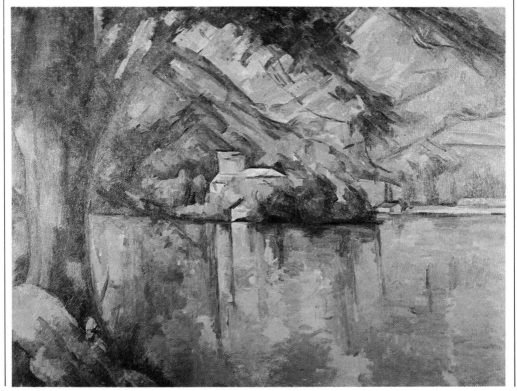

Left *Cézanne painted The Lake of Annecy while on a visit to Talloires in July 1896. It shows how contrasts of color temperature — warm and cool colors — can be used instead of purely light-dark tonal contrasts to create a sense of form in space. On the central turret, warm, pinkish-yellow colors indicate the side on which the light falls, from left to right. By contrast, the shadowed side, filled with reflected light from the sky, is tinted blue. The pervasive atmospheric light outdoors means that contrasts of light and shade are minimalized, thus highlights and shadows are close in tonal value, and so distinctions between light and shade are made through warm-cool contrasts.*

Right *Chevreul's Chromatic Circle of Hues was first published in 1839. His experiments showed how colors opposite each other on the color circle – complementary colors – are mutually enhancing.*

Below *In* The Bridge at Villeneuve-la Garonne *(1872) by Alfred Sisley the midday sun falls full on the scene. All the shadows are suppressed except those in the reflection of the dramatic bridge structure.*

could be used to describe form or movement in space. The inherent tonal differences of colors could also be exploited. Because, in the spectrum, blue is relatively dark in tone compared to, say, a pale yellow, these colors together could provide pure, luminously colored equivalents for traditional dark-light contrasts, giving structure to form.

The Impressionists' protracted study of open-air light effects led them to question the accepted conventions of 'local' color. Local color is the 'actual' colour of objects — the greenness of grass or yellowness of lemons. They noticed that every object's 'local' color appears to the eye modified by reflected colors from surrounding objects and by the colored atmospheric light or sunlight. Rather than painting the colors they had learned objects to be, the Impressionists tried to put down only the colors they actually *saw*.

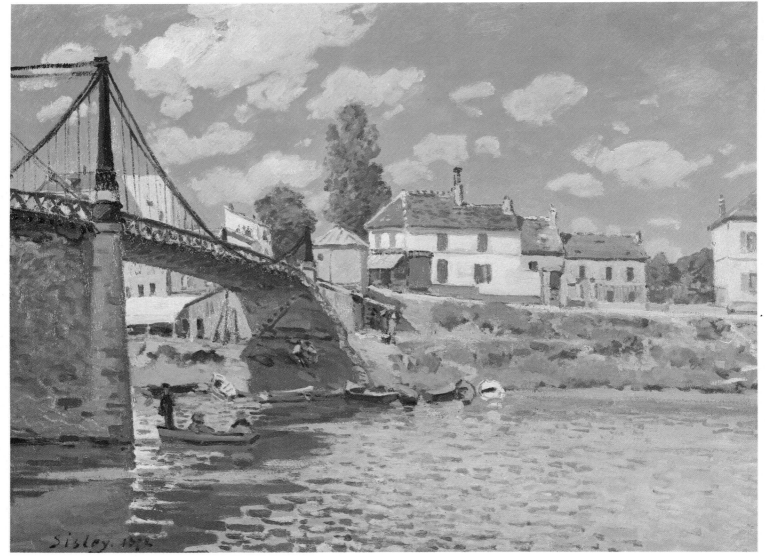

Left *Chevreul's Chromatic Scale of Tones shows the gradation of a red from white to black through all variations of tint. Tonal gradations were used by academic painters to create relief on form, but pure color could also be used. As can be seen from the color circle, yellow is pale in tone compared to blue. Such inherent tonal differences between colors were used by Impressionist and Neo-Impressionist painters to structure form through color.*

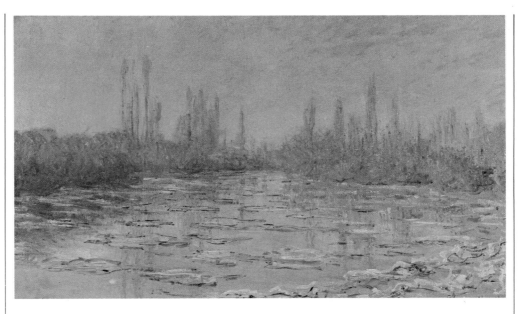

Left *Monet painted* Break up of Ice on the Seine: Ice Floes *in 1880. This dramatic natural event depicted lasted only a few days in early January 1880, yet Monet produced about 17 canvases of it. These included a larger variant of this picture, painted later for the Salon of 1880, where it was refused. Thus he was supplementing outdoor work with studio-painted variations. Snow and ice along with water provided ideal vehicles for the effects of colored light. The unconventional central axis balances the trees and their reflections, while the water surface is defined by the colored ice floes. This canvas is more elongated than the narrowest marine 40 standard format, measuring 60 x 100cm (23¾ x 39½ in).*

New vistas

The types of natural lighting the Impressionists chose to depict were selected expressly for the luminous brilliance of their effects, and for their lack of strong tonal contrasts. The Romantics, and Realists like Courbet were, in the words of Edmond Duranty, the critic friend of Degas, 'persuaded that light only existed on condition that it was thoroughly surrounded by shadows. The basement with a ray of light coming through a narrow air hole . . .'. The Impressionists avoided deep dark forest settings, choosing instead open airy scenes, from broad new city boulevards to river- and seascapes. They chose their subjects and viewpoints so that the fall of light produced only minimal shadows. One of the most popular choices was full-face light, which fell directly onto the subject from behind the artist, thus casting any shadows out of sight *behind* the objects in the scene. *Gris clair*, a clear, pale, gray light, is what results from a luminous but overcast sky, leaving a shadowless, even diffusion of light, was also widely exploited. The harsh bleaching effects of midday sun, where shadows are at their shortest, was another type used. Where shadows were included, they were always full of reflected light, and barely darker in tone than the sunlit parts.

Water and snow were, for all but Renoir, studied for their light and color reflective properties. Snow provided a white field, comparable to the white canvas preparation, which showed off all the most delicate varied nuances of warm colored light and shadow. Water was also an excellent vehicle for insubstantial, fluctuating film color, picking up and reflecting light and colors from sky, atmosphere and all surrounding objects. Reflections were also used to structure compositions, for, as mirror-images of real objects, they could strengthen the abstract design qualities in a picture.

The sketchy execution of the picture was essential to the final appearance of immediacy, and to the process of capturing fugitive light effects. Painting had to be a rapid jotting down of visual sensations.

In seeking an appropriate means to render their sensations, the Impressionists looked to the techniques used in earlier landscape studies, and in the freely handled compositional *equisses* common to all art students' training. The Impressionists' use of broken color may in part have its origin in the academic method, where mosaic-like touches of color were used to build up the halftones. However, since the seventeenth century, the use of separate touches of color had been recommended as a means of avoiding sullying the purity of color by overmixing. So, for artists like the Impressionists, who wanted to achieve maximum purity of color, this method made obvious sense, although their touches of color were by no means uniform. Instead of using linear drawing to define form or space, color and brushwork served this purpose in their work. Thus, the varied size, direction or shape of a brushstroke was intentionally eloquent. The foregrounds were often handled in large strokes, distances in small, almost imperceptible touches to give the appearance of depth. Small jerky strokes differentiated foliage from the longer strokes of boughs and tree trunks; objects reflected on water were often described by vertical marks. Reflected light off the water surface was shown in contrasting long, horizontal dashes. Buildings were 'constructed' by solid touches or planes of color which followed and stressed their form.

Below *Renoir painted*
Gust of Wind around
1873. The detail (right)
shows that Renoir
exploited a beige ground
to provide a warm
color base which
shows among the cooler
greens of the paint layer.
The delicate feathery
strokes of yellow-greens,
viridian, white and
yellow ochre, with
touches of vermilion, are
floated wet in wet over
the beige priming.
Where the ground shows
through it appears even
warmer by contrast to
the acid greens. This
suggests the dry grasses
on the hillside. Thinly
applied color for the
distances contrasts with
impasted touches to
evoke foreground
textures. Loaded
blue-grays and white for
the sky and clouds are
warmed by the beige
ground to suggest
sunlight flickering
through from behind.

Traditional academic methods of finishing had assumed that one section of the painting would be brought to completion each day. By contrast, Impressionist methods involved making constant adjustments over the entire canvas. This was obviously easier on an easel-size canvas, which the eye could take in complete in a single glance.

A premeditated preparation of colors and tones laid out on the palette, as required by academic practice, was obsolete for the Impressionists, because open-air painting inevitably necessitated a moment to moment evolution of color mixtures on the palette. These had to be adjusted or abandoned as the light effects changed, and the artist took up a new canvas or began a new subject.

The idea of the visual world presenting itself to the eye in colored patches of light, or *sensations*, which was central to the Impressionists' method, derived from contemporary theories about perception. Rejecting the conventional use of abstract lines and edges to give an illusion of form, the Impressionists began to paint light. Their aim was to perceive and record direct optical sense data, or 'visual sensations' as they were called, instead of

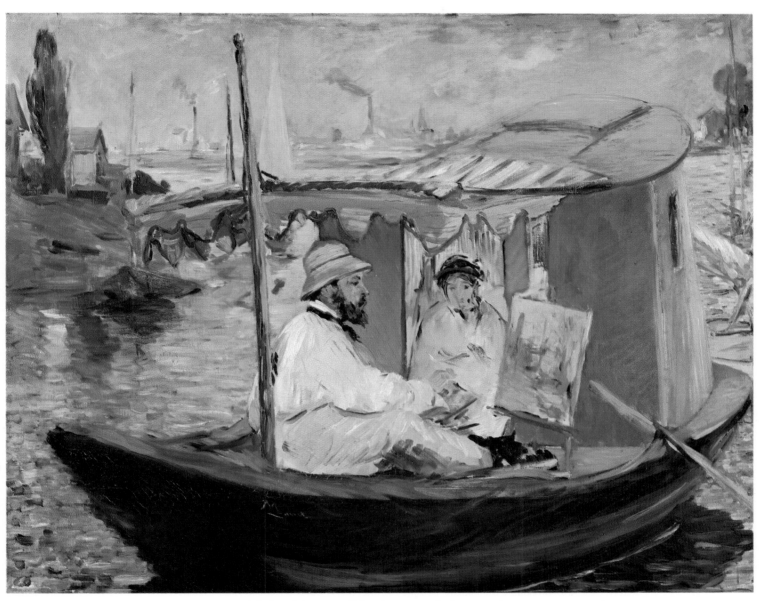

depicting a scene modified and 'corrected' by the intervention of the intellect, which gave only a rationally conceived notion of the real world. This explains references among the Impressionists to the desire for the infant's untutored eye. The Impressionists tried to unlearn their received knowledge of the visual world, and confront its myriad array of colored patches directly. These they translated into touches of paint, which only coalesced into a coherent image as the picture progressed. The importance of depicting visual sensations helps explain why Cézanne described Monet as 'just an eye, but what an eye!'

This search for pictorial equivalents to the artist's perceptions or sensations of light and color outdoors was quite different from the later, more codified and pseudoscientific concerns of the Neo-Impressionists, such as Georges Seurat (1859–1891), in the mid 1880s. Their attempts to create 'optical' color, through the partial fusion on the spectator's retina of colored light emananting from tiny painted dots, has been consistently confused by many critics and art historians, with the 'colored patch' Impressionist technique. No optical fusion was intended or sought in Impressionist painting. The artists simply intended that the colors and brushstrokes should — at an appropriate viewing distance — present the spectator with a coherent equivalent of the painter's visual perceptions.

These methods were developed during the 1870s by Monet, Renoir, Pissarro, Morisot, Cézanne and Sisley. They were carried forward in modified forms during the following years.

Above *Manet painted Claude Monet and his Wife on his Floating Studio in 1874. Influenced by Impressionist methods, Manet began painting out of doors in the early 1870s, working with Monet and Renoir in 1874 at Argenteuil, where this work was painted. Manet has lightened his palette and abandoned the harsh contrasts of light and shade and the rich darks of his studio-painted landscapes of the 1860s.*

JEAN FRANCOIS MILLET

Autumn, The Haystacks/L'Automne, les meules
(1868–1874)
Oil on deep lilac rose primed canvas
85cm × 110cm/33½in × 44¼in

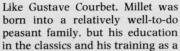

Like Gustave Courbet, Millet was born into a relatively well-to-do peasant family, but his education in the classics and his training as a painter, inevitably placed him in the new bourgeois class. But his loyalty to his origins and his dislike of city life meant that Millet settled in rural surroundings, in the village of Barbizon on the edge of the Fontainebleau forest southeast of Paris. Since the 1820s and 1830s Barbizon had become a popular haunt for the new landscape painters. Its countryside combined wild forest with calmer agricultural scenery, and it was close enough to Paris to enable painters to visit their color merchants, dealers, and the exhibitions held in the city.

When Millet moved to Barbizon in 1849, escaping the cholera epidemic which followed the 1848 revolution in Paris, there was already a colony of artists there, including his friend, the landscapist Théodore Rousseau (1812–1867). Millet's paintings of agricultural life, although imbued with a monumentality derived from Michelangelo (1475–1564), showed a new forthright directness in the representation of peasant life, which had hitherto been treated with idyllic – and unthreatening – sentimentality. His powerful, often large-scale treatment of subjects like *The Sower*, of which two painted versions date from 1850, was quite naturally seen as radical in an era when political rights were being demanded by agricultural workers.

Landscape, usually the agricultural landscape, played an important role in Millet's art throughout his career, but, in his later years, it came to dominate his output. However, even in his pure landscapes, there is always an implied human presence. In *Autumn, The Haystacks*, one of a series of four seasons commissioned late in his life, the human presence is indicated not only by the diminutive figure of the shepherd, but also by the distant farm buildings and by those huge products of human toil, the haystacks themselves. The theme of the cycles of nature, whether seasonal or the hours of the day, has been a consistent feature of Millet's work, reflecting the endless, timeless round of labor which he saw as the lot of the agricultural worker.

This particular cycle of four pictures derived from a series of large-scale pastel drawings, a medium used increasingly by Millet from the late 1850s on, and which proved an admirable substitute for the more expensive oil paintings among less wealthy collectors. His part in establishing the value of large-scale pastel drawings among collectors set an important precedent in the 1860s, which was later exploited by Manet, Degas and Cassatt. Before this, pastel had either been downgraded by its association with women artists, or passed over because of its links with 'decadent' Rococo art in the eighteenth century, when pastel had been popular. However, with the revival of French Rococo and renewed admiration for Chardin (1699–1779) among mid and later nineteenth century artists, that stigma was removed.

The large pastel seasons, of which only *Spring*, *Summer* and *Autumn* survive, were drawn between 1867 and 1873. The two earliest, *Summer* and *Autumn*, were probably completed by March 1868, and seen by the collector Frédéric Hartmann, when he visited Millet in Barbizon. Hartmann had been dazzled by Millet's large pastels, when he had been shown one in Paris by Millet's friend and biographer Alfred Sensier. Originally a patron of Théodore Rousseau, Hartmann became a patron of Millet after Rousseau's death in 1867. After Hartmann's visit to Barbizon in March 1868, Millet began work on the commissioned cycle of four seasons in oil, of which only the last, *Winter*, remains unfinished. The *Autumn* oil painting is based directly on the composition already worked out by Millet in pastel.

In April 1868, Millet wrote to Sensier, requesting him to have his color merchant Blanchet prepare four canvases especially for the work. Although the canvases are larger than the paper supports used for the pastel, their proportions are almost identical, and so transposing the design onto canvas presented no problems.

The ground colors required by Millet for the oil paintings were carefully specified. Three were to be deep lilac rose and one was to be yellow ochre. However, the final canvases do not match with this order, as only two, *Spring* and *Autumn*, were actually executed on the lilac rose preparation, while *Winter* and, more obviously, *Summer* are unmistakably primed with yellow ochre. In *Summer*, the bright yellow ground was left to show through in many areas, unifying the colors of the composition and standing for the golden heat of the July buckwheat harvest.

Autumn was painted between 1868 and 1874. It makes a fascinating comparison with the earlier pastel version, particularly in technical terms, affording a contrast not only between the two different media, but also between the effects of color over quite differently colored grounds. The pastel was executed on a dull, yellow-buff colored paper, which unifies the pastel colors and is left to show through among them. As a result, the lowering, stormy warmth of the afternoon sky, produced by the lilac rose ground in the oil, is absent in the pastel. The pale, dusty colors of the pastel give an appearance of tranquility to the drawing, which, in the richer, more saturated oil colors, turns more to a sense of foreboding, with the impending storm heralding the arrival of winter. The lilac rose of the ground in the oil is made more violet, optically, by overlaying contrasting yellowish-greens in the sky, and the acid greens among the grass.

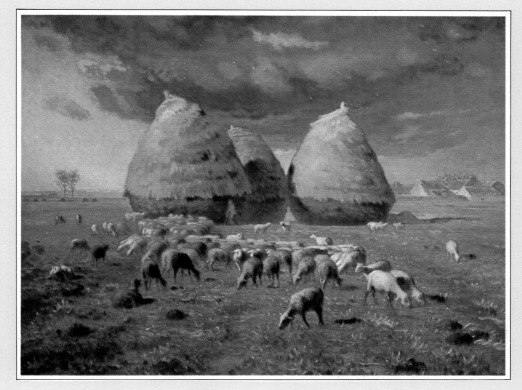

Millet's Autumn, The Haystacks, *was executed on a non-standard canvas format, clearly intended to be comparable in its proportions to the format used for the pastel version, from which its composition derives. The oil version is marginally larger than the pastel. The composition of the drawing remained unchanged when transferred to the canvas. The differences between the two are in the medium and its contrasting effects, and in the differing hues of the grounds used. Although Millet's application of paint is often relatively chalky and dry, oil paint is richer and juicier than pastel because of the oil binder it contains. Thus the colors are more richly saturated, and deep tints easier to achieve than in pastel. Millet rarely exploits the potential for transparency in oil colors, preferring mat opaque effects similar to those of pastel.*

This is the earlier pastel drawing on which the oil painting was based. Where the lilac pink of the ground under the oil gives a warm unity of light, the dull ochre yellow color of the paper support under the pastel has an entirely different effect. Instead, a somber overcast light is produced, suggesting a gray afternoon with no warm, sunset effect like that in the oil. Pastel and oil both lend themselves well to the rendering of natural textures. Perhaps the greatest contrast is in the handling of the sky, where fluid scumbles in the oil replace the linear build-up of color in the pastel. Both techniques allow the color of the support to play a vital role in the final effect. The paper support is not a standard format, but was cut to suit the compositional design Millet had in mind.

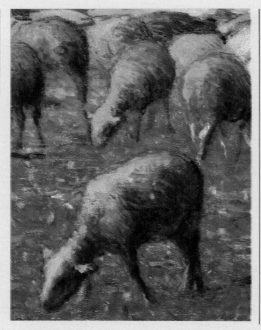

The black chalk or charcoal underdrawing is strongly in evidence here, showing Millet's talent for swift caricatural lines which capture the characteristic features of the sheep. The lilac pink ground shows through clearly, especially at the contours where the paint is thin or non-existent. The ground color is warmed further by the sharp cool greens of sheep and grass applied over it. Although quite thinly painted in most parts, the colors are mainly opaque.

The ground shows through among the sheep, where the artist's preparatory drawing-in of the broad contours of the composition in charcoal or black chalk is strongly in evidence. Millet's touch in pastel and oil is comparable. Although the oil binder inevitably makes the brushstrokes juicier, the use of added white and a dryish paint consistency have enabled Millet to create effects not dissimilar to those in the pastel, especially in the chalky, dragged strokes depicting the spiky, stubbly grass. The greater luminosity of the pastel stems from the absence of oil binder.

The adventurous techniques of these late works show how Millet kept pushing forward with new ideas and methods, which were to have continuing relevance to following generations of painters, from Pissarro and Degas to the later artists Seurat and van Gogh. An important exhibition of Millet's large-scale pastel pictures in 1875 came at an opportune moment for these younger artists, and the publication in 1881 of Sensier's magnificently illustrated biography of the artist, further reinforced Millet's influence on the Impressionists.

Actual size detail
Recession into the distance is created both through the use of narrow horizontal bands of color, and by the gradual tonal lightening toward the pale skyline. This technique echoes the natural phenomenon called aerial perspective, where distant views grow hazy and pale blue the further they recede from the eye. Millet used little underpainting or ébauche. A thin, transparent greeny-brown wash, unevenly applied, was laid under the opaque greens of the field and worked up to the charcoal contors of the sheep. They were mainly left without underpainting, to allow the warm ground to show through. The sheep in the immediate foreground was firstly indicated with thickish but transparent raw sienna, which was then worked over roughly with opaque palish greens and greeny-blacks for the shadows.

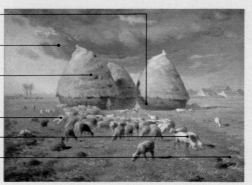

Thin opaque shadows

Pale greens among sky blues

Dragged brush and knifed on dryish, chalky color

Lilac pink ground

Thick opaque lights

Transparent sienna under opaque touches

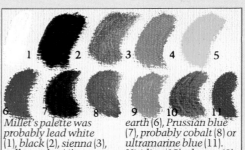

Millet's palette was probably lead white (1), black (2), sienna (3), yellow ochre (4), probably chrome yellow (5) and a red lake, red earth (6), Prussian blue (7), probably cobalt (8) or ultramarine blue (11). Viridian (10), chrome (9) and emerald greens may also have been used.

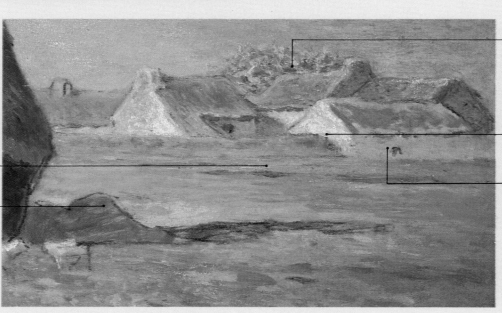

Probably emerald green

Thinly scumbled opaque color

Varied brushwork, foliage depicted in freely daubed strokes of opaque impasted color, contrasting with plane-following brush-strokes for buildings and roofs

Pale tints, much lead white added

Lilac pink ground shows through the thin opaque colors depicting the buildings

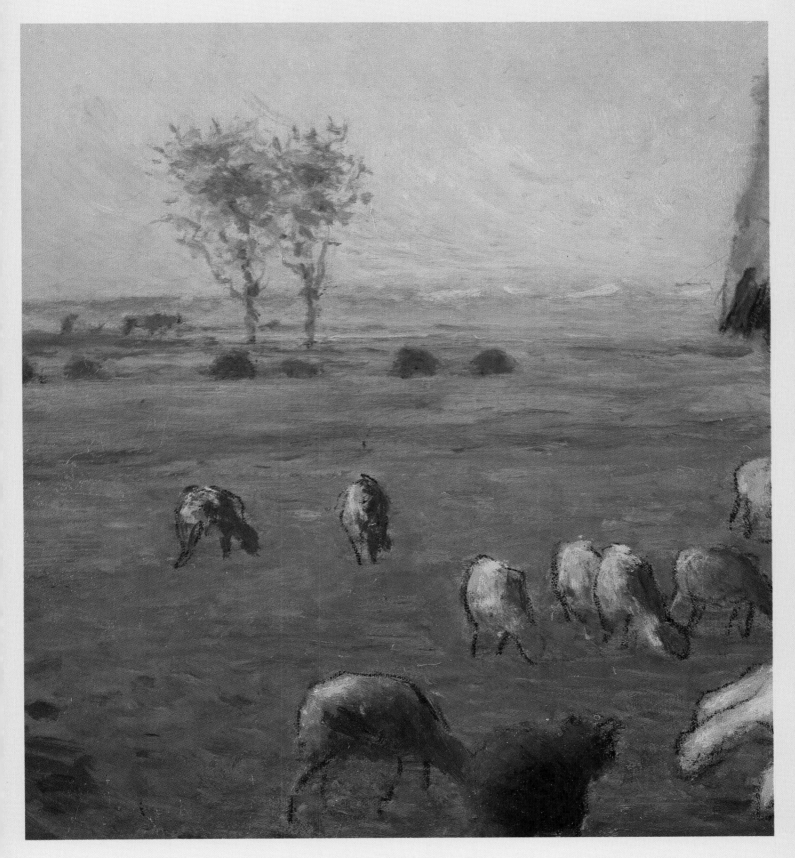

PAUL CEZANNE

House of the Hanged Man/La Maison du pendu (1873)
Oil on pale primed canvas
55cm × 66cm/21½in × 26in

Discouraged by his father, Cézanne's artistic debut was hesitant, but by 1861 he was spending considerable periods in Paris, encouraged by his childhood friend the writer Emile Zola (1840–1902). Failing several attempts to get himself admitted to the Ecole des Beaux-Arts, Cézanne often studied in the life class at the independent Académie Suisse, and copied from Old Masters like the seventeenth century French classical painter Nicolas Poussin (c1594–1665) in the Louvre. In 1861 Cézanne met Camille Pissarro at the Academy Suisse, and formed a close friendship which was to be of crucial importance to both artists. Pissarro was older and a more experienced painter than Cézanne. As early as 1857, he had begun painting from nature on the advice of Corot. Cézanne's style of the 1860s was greatly influenced by Old Masters like Rubens, and by Delacroix, whose work remained a source of inspiration. At that time, Cézanne's subjects were Romantic too — passionate scenes of murder and sexual violence were interspersed with more disciplined studies of still lifes, landscapes and portraits. He used thick, juicy paint and expressive brushwork, with a palette dominated by somber colors, especially earths and black. He regularly experimented with palette knife painting.

Although an impassioned abandon often characterized his work of the 1860s, it already contained the germ of his mature style. Strength and vitality, an obsessive dedication, a love of color and the painterly handling of his medium were already apparent. In his drawings, an idiosyncratic, directional hatched structure – which appeared occasionally in his paintings of that decade – was clearly in evidence. Cézanne began working out of doors at Pissarro's instigation, and the tight discipline of such work provided the key to organizing his emotional sensibility. From the early 1870s, he and Pissarro worked regularly together in the countryside around Paris, at Auvers and Pontoise. As a result, Cézanne lightened his palette, and thus began a lifelong research into recording his visual sensations before nature.

House of the Hanged Man, a motif from Auvers-sur-Oise, was probably painted in the spring of 1873. It is among the most heavily worked of Cézanne's canvases from this decade, and the rare appearance of a signature, and the fact that – with Cézanne's consent – it was exhibited several times during his lifetime, suggest that it was one of the rare paintings with which he was satisfied. It was executed on a standard portrait 15 format canvas, whose squarish shape complements the composition and the solid block-like shapes within it. The ground, although undoubtedly pale because of the striking luminosity of the picture, is hard to identify with confidence without removing the work from its frame. The ground is effectively obliter- ated by the dense, thick opaque paint layer, although slight paint losses at the outer edges reveal both raw canvas and what is possibly a pale gray or putty-colored ground.

Repeated reworkings, over almost the entire surface, characterize this painting. Canvas texture is practically irrelevant, but the effects of stiff, crusty paint dragged across previously dried brushstrokes, are fundamental to the grainy appearance of the picture. The tactile quality of natural surfaces, the crumbly limestone walls, roof thatch, and dusty road, are recreated by the built-up paint texture. Stiff hog's hair brushwork is combined with buttery slabs of color applied with a palette knife. In the foreground path this catches on previous brushstrokes, breaking the color to allow earlier colors to show through. This imitates the texture of natural surfaces and creates a vibrant, fragmented paint layer which scatters light, optically enhancing the picture's paleness and luminosity. Dabbed brushmarks of subtly varied colors construct the thatched roof and the grass bank beneath it, on which the movement of the brushstrokes suggests the movement into space. This directs the eye toward the central pivotal point, which is the sunlit patch of ground between the two main houses.

Despite this visual clue, and despite the artist's use of a foreground path which ought, by tradition, to invite the viewer to enter the pictorial space, other devices work against such an interpretation. The flat lighting and solid paint on the foreground path make it ambiguous — it appears as a barrier, blocking off the pictorial space. Similarly, the curve of the path, down toward the central sunlit patch, is obscured from view as it twists out of sight, thus again inhibiting easy visual access. Furthermore, the brightness of the sunlit patch is equivalent to that of the foreground path, and, by association, they appear to be on the same plane, not receding in depth. This is reinforced by a slab of palish ochre color which projects left, from the central sunlit patch of ground. By appearing to eat into, or overlap the left grass bank, this 'bite' of color disrupts the relatively coherent overlapping of identifiable natural phenomena — path, grassy bank, path again — thus stressing instead the activity of painting itself.

The solid forms and monumental shapes in this composition therefore appear stacked up, like a wall, and all are tightly interlocking. Cézanne's high viewpoint encourages this because although a distant vista appears between the houses, it is not made easily accessible, and its strong colors bring it toward the spectator. Thus there is an inherent tension in the painting, between flatness and naturalistic illusion. This was to remain a characteristic feature of Cézanne's art throughout his long and relatively solitary career as an artist.

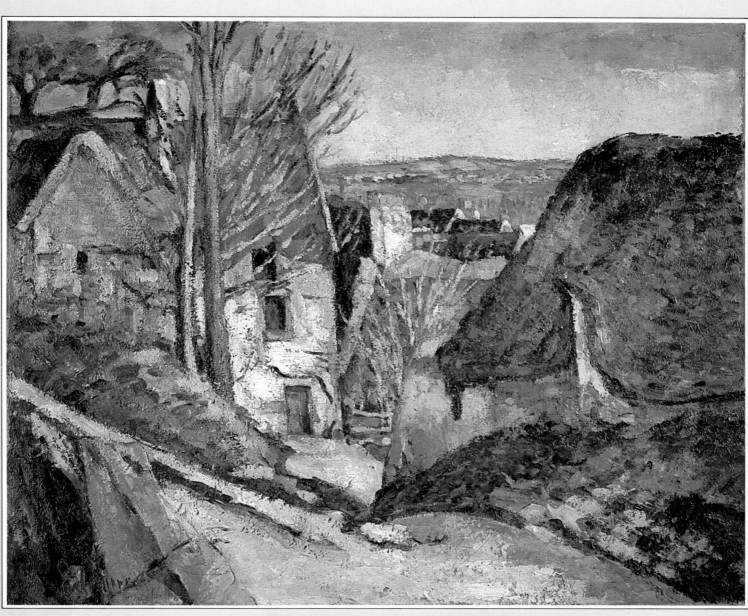

Broad, form-following
brushstrokes

Canvas grain still faintly
apparent

Thick chalky dragged
color with some dirt and
discolored varnish in
crevices

Cracking resulting from
very thickly applied
color

Thick, opaque,
knife-applied colors
evoke texture of dusty
pathway

Brilliant accents of
vermilion with white
pick up red of signature

Mixed blues with white

Brilliant accents of red,
vermilion with white,
picks up red of signature

Individual, dabbed
strokes of the brush
represent thatch in
varied greens

Strong, directional
brushstrokes suggesting
movement of path

This painting, which
was among the nine
works exhibited by
Cézanne at the first
Impressionist show of
1874, was executed on a
squarish, portrait 15
standard canvas. This
format admirably suits
the high viewpoint and
block-like buildings
selected by the artist,
which can be compared
with Pissarro's Hillside
at l'Hermitage of the
same year. The
composition fans out in
segments from a low
central point.

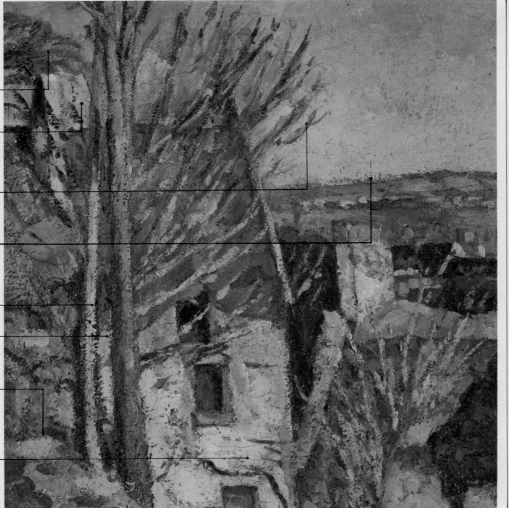

Canvas texture still showing through where paint layer thinnest

Late addition of knife applied blue and white mixture, so thick as to cast a shadow along right edge

More finely brushed color to stand for leafless branches in early spring early spring

Discoloration from dirty varnish in crevices of irregular paint layer

Chalky dragged color for trunks of trees

Added stroke of pale creamy color across to other creams of stone facade

Mixed greens and ochres applied with bristle brush

Knife-applied color describing stone of building

Actual size detail
This is one of the most heavily worked canvases by Cézanne from the 1870s. It exploits varied, descriptive handling in thick, rather chalky, dryish opaque colors. Like most of his fellow painters at this time, Cézanne avoided the use of transparent glazes, which so frequently proved unstable. Instead, lead white was added to most of his color mixtures, to increase their luminosity as well as durability. The paint layer was mainly built up wet over dry. However, in the blues of the sky lines the colors are slurred wet-in-wet. The thickness of the paint layer means that the painting must have required much time to execute. Localized fissures have occurred in places as a result of excessive paint thickness. Most of the colors are mixed, thus, despite the results of scientific pigment analysis, the picture appears dominated by earths and green hues.

Varied hues of green are visible, brushed wet into pale ochre tones. Marks of brush and knife are used to enhance the tactile surface quality of the picture, and evoke natural textures. The canvas grain of this cheap-weight support fabric is still visible through the paint layer on the right where the varnish catches the light and reflects it off the surface back to the viewer.

Cézanne's palette for this painting, which has been analyzed by the Louvre, included lead white (1), zinc white, yellow ochre (2), chrome yellow (3), *vermilion (4), cobalt blue (5), ultramarine blue (6), cerulean blue (7), emerald green (8), and possibly viridian green (9). Verdigris was also used.*

PIERRE AUGUSTE RENOIR

The Parisian/La Parisienne (1874)
Oil on cream primed canvas
160cm × 106cm/63in × 41¾in

Essentially a Parisian himself by upbringing and allegiance, if not by birth, Renoir spent most of the 1870s working in a large studio on the rue St. Georges — where this painting was doubtless executed. His artisan background and early training as a painter on porcelain gave Renoir a love of eighteenth century French Rococo themes of leisure, and an appreciation of those artists' sumptuous, colorful handling. He infused the pleasurable side of the contemporary modern leisure activities, which he painted, with an idyllic eighteenth century sensuality. During the 1870s, perhaps under the influence of Monet, Renoir painted mainly outdoor scenes, both landscapes and figures, but he also executed many indoor studies of groups or portraits or, as here, of typical Parisian characters. In the 1860s he had attempted one or two winter scenes, but, preferring the warmth and light of summer, he abandoned subjects depicting wintery lights and weather. Even his indoor studies from the 1870s onwards, infused with the knowledge from his observations of outdoor sunlight, gave an effect of pervasive warm light and cool blue-violet shadows.

Renoir's paint surfaces, as in *The Parisian*, were generally much thinner than the stiff textural impastos of the other Impressionists. He usually added a mixture of linseed oil and turpentine to his colors to make them thinner but still juicy. To avoid excessive and thus dangerous overmixing of colors on his palette, he tended to apply them wet into wet directly onto the canvas, slurring them together where necessary. The other Impressionists, especially Monet and Pissarro, achieved light-reflective luminosity in their paint surfaces by using chalky, stiff paint mixtures dominated by lead white, dragged to give opaque, vibrant effects. Renoir, by contrast, used his thin juicy translucent or scumbled colors to allow the brilliance of the ground to show through, reflecting color-enriched light back to the viewer. No dull earth colors tone down the brightness of Renoir's palette here.

The Parisian was executed on a non-standard sized canvas format, which had to be made to order. The canvas weave is fine, and the commercial ground is a carefully selected cream color, sufficiently thickly applied to leave the surface fairly smooth. Where the cream ground shows through the thin paint layer, its color is actively exploited among the applied colors of the paint layer. This technique reduces the need for an excessive build-up or reworking of the picture itself. The cream of the ground is very effectively used amongst the blues of the dress. Traditionally, the shadows were the most thinly painted, transparent parts, and highlights were built up in opaque impasto to create an almost physical relief on the paint surface. In Renoir's picture, the highlights are the thin-nest parts. By diluting his cobalt blue until translucent and applying it with deft, descriptive brushwork, almost like a wash, he has left the cream ground to glow through the blue and stand for the highlights.

Where shadows were required, helping to structure the form and folds in the dress, Renoir has simply used thicker, undiluted blue, which is thus deeper and more saturated in color. Wet-in-wet smudging of yellow into the blue in the darkest parts, deepens the shadows further without sullying them with black or brown. In places, the sparest touch of lead white was worked into the wet blue to heighten the lights. Slurring the colors gives a more colorful, lively effect than mechanical premixing on the palette. Renoir's overlaying of the cream ground with transparent blue has an optical coloristic effect, too. Warm and cool colors, or colors situated more or less opposite each other on the color circle, enhance each other optically. Thus on the dress in *The Parisian*, the thinly washed blue over cream produces an optical effect of pink so, by contrast, the blue appears cooler, the cream warmer, pinker. Cézanne's *Large Bathers* (c1898–1905) exploits similar effects.

In *The Parisian* Renoir's composition is simple and direct, with many precedents, especially in Manet's single-figure studies from the mid 1860s. Like Manet, Renoir used a full-face light, falling almost directly onto his model, but Renoir's lighting is softer, more diffuse than that adopted by Manet which produced strong tonal contrasts. Also, as in Manet's work, the figure is indistinctly located in space — no wall

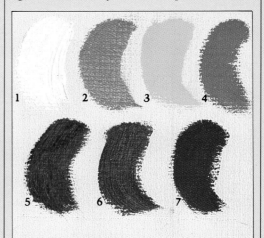

Renoir's palette for this painting probably comprised lead white (1), possibly zinc white, yellow ochre (2), chrome yellow (3), vermilion (4), possibly alizarin red (5), cobalt (6) or a mixture of ultramarine and cobalt blues (7).

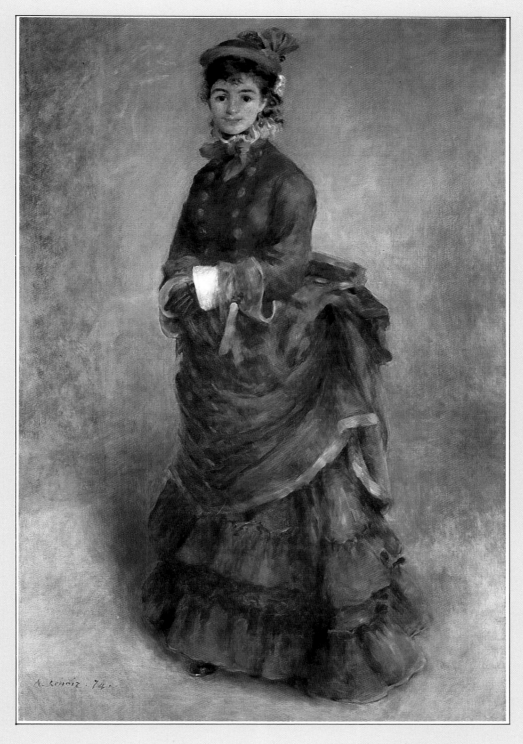

Unlike Degas' depictions of Parisian women, Renoir's pictures like The Parisian show working women at leisure rather than engaged in their trades. The slightly outmoded dress shows this to be a lower class woman sporting her Sunday finery. Renoir's use of a warm, flooding daylight, softly diffused over the figure, unifies the composition and reduces tonal contrasts to a minimum. Instead of lights and darks, warm and cool hues are used to model form, with the cream ground glowing through the thin transparent blues to stand as highlights. The paint layer is thin and varies between fine transparent layers and delicately rubbed or scumbled, opaque veils of color. The stability of Renoir's painting method was confirmed by Signac's observations on the picture when he saw it in 1898. He said 'The dress is blue, an intense and pure blue which, by contrast, makes the flesh yellow, and, by its reflection, green. The tricks of color are admirably recorded. And it is simple, it is beautiful, and it is fresh. One would think that this picture painted 20 years ago had only left the studio today.'

The thinnest blues are washed transparently over the cream ground, which glows through and appears pink in contrast to the blue. For the palest highlights, white was brushed wet into the blues, but still so thinly that the cream ground generally remains visible. White is used more thickly and is opaque and almost pure for the cuff. Here, brushwork helps to sculpt the form. In the darkest parts, blue is applied undiluted and in its most saturated form, giving a rich deep hue. Slight slurred touches of yellow are laid wet into the blue to tone down and vary the shadows.

or floor angles define the room, and the figure's cast shadow is minimal. Renoir further simplified his composition during the painting process, obliterating blue drapes which originally hung to either side of the figure, and are now just visible because the thin paint layer has become more transparent with age.

This picture was exhibited by Renoir with six other works at the first Impressionist exhibition, held in the old second floor studio of the famous Parisian photographer Nadar, at 35 boulevard des Capucines. During the month-long show, which opened on 15 April 1874 just prior to the annual Salon exhibition, the criticism received by Renoir was by no means unsympathetic. In fact, it was only when the

Impressionist style persisted and spread in popularity in the later 1870s that criticism became more hostile.

Throughout this decade Renoir continued to submit his work to the Salon as well as showing with his Impressionist friends. This earned him the scorn of hardline opponents of the Salon like Degas. Thus, like Manet, he remained committed to seeking official recognition for his work although, unlike Manet, he was also dedicated to independent shows. By the late 1870s, his work was beginning to achieve acceptance and success, at least among discerning private collectors, and the important dealer Paul Durand-Ruel bought his work regularly when finances permitted.

Actual size detail
The flounces of the woman's bustle are created by lively, descriptive brushstrokes, and the rounded tip of the broad bristle brush can be clearly seen. The blues were applied in varying degrees of dilution, thinnest for the lights allowing the cream ground to show warmly through. Cooler lights are created by slurring deft touches of white into the wet blue paint, making the layer opaque or translucent in those parts, thus covering the cream ground more thoroughly. A hint of yellow, worked wet into the deepest blue, darkens the shadow below the bustle flounce.

Cream ground actively used for flesh tints among thinly applied colors

Undiluted, saturated blue for darkest parts

White used almost pure for cuff

Cream ground appears pink through transparent blues of dress

Original blue drapes painted out making space ill defined

Vigorous bristle brushmarks convey fabric folds and texture

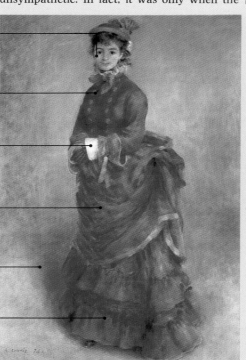

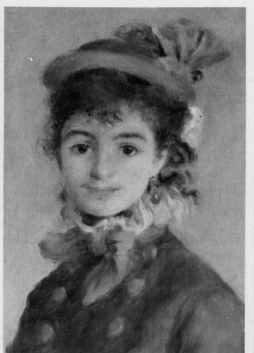

A thin, dilute sweep of the brush suggests the bonnet brim, while contrasting light feathery touches evoke the hair. The cream ground is left to stand for the cooler flesh tints, and warmer pinks were added for the facial highlights. Thus against warm hues, Renoir made the cream ground appear cooler and greener, while, among the cool blues of the dress, they seem warm.

ALFRED SISLEY

Boats on the Seine/Bateaux sur la Seine (c1877)
Oil on pale creamy primed canvas
37cm × 43.5cm/$14\frac{1}{2}$in × $17\frac{1}{4}$in

Sisley was born in Paris of British parents, and although he spent four years of his early maturity in England, he returned to France in 1861 to become an artist and remained based there throughout the rest of his life. In 1862 he entered the studio of Charles Gleyre, where he met Renoir, Monet and Frédéric Bazille (1841–1870), with whom he worked from nature in the Fontainebleau forest in the spring of 1863. Like Monet, Sisley was to concentrate on landscape painting, and he worked regularly on outdoor subjects in the Fontainebleau area during the 1860s, in the company of one or other of the group from Gleyre's studio. Like his colleagues during this decade, Sisley frequently sent paintings to the Salon, exhibiting there in 1866, 1868 and 1870. His father, who worked in commerce, died in 1871, ruined by the Franco-Prussian War, leaving Sisley with no money. For the first time the artist was forced to earn a living from his painting.

Sisley preferred gentle rural scenery in general, landscapes, villages, river views in which the human presence was manifest. During the 1870s he concentrated on subjects found in the countryside to the west of Paris, just north of Versailles, around the villages of Marly-le-Roi, Port-Marly, Celle-St. Cloud and Louveciennes. From there, he was sufficiently close to Paris to maintain easy contact with his artist colleagues and with dealers — like Paul Durand-Ruel and *père* Martin — who bought his work when they could afford to. Perhaps because of closer ties of friendship with the publisher Georges Charpentier, Sisley moved even closer to Paris, to Sèvres, in the later 1870s. Charpentier, whose writers included Zola and Huysmans, published a paper called *La Vie Moderne*. He held small one-man shows by several of the Impressionists, including Monet and Sisley, at his offices in 1880 and 1881. Georges Charpentier's wife, who sat with two of her children for an important portrait by Renoir in 1878, held a regular evening *soirée*, which was an important meeting place for many avant-garde artists and intellectuals.

During the 1880s, Sisley gravitated back to the Fontainebleau area. He concentrated on painting river scenes in particular, around the confluence of the Seine and the Loing rivers, at Marlotte, Moret and St. Mammès. As he was more distant from his colleagues, he saw the other Impressionists less frequently from this time on.

Boats on the Seine is painted on a support slightly squarer than the standard portrait 8, measuring 46cm by 38cm (18in by 15in). Sisley, always fairly poor, used an inexpensive, ordinary weight canvas, with a single layer of pale creamy priming which has left a grainy surface texture. In general, Sisley seems to have preferred a rather more bland canvas weave than that popular with Monet and Pissarro,

although here, the grain is fairly marked and is used to great effect in combination with dragged, dryish colors in the paint layer. The thin canvas priming is mat, and evidently quite absorbent, for the paint layer has a dull, mat quality and is apparently one of the rare instances where a work has remained unvarnished. Despite the Impressionists' preference for leaving their works unvarnished, to enhance the pale, light-reflective surfaces of their pictures, the habit of dealers and galleries to varnish paintings automatically in order to protect them has meant that few retain their original appearance.

This is one of the rare, truly *alla prima* or 'single sitting' Impressionist paintings. The paint layer is thin and spare, exploiting the cream priming underneath amongst the applied colors, and even the tiny figures in the foreground were added wet in wet before the first colors had dried. The handling of the sky is a superb example of the optical effects which can be achieved by contrasting warm and cool colors. The pinky whites of the clouds brushed loosely over the creamy ground are warmed by it, while the ground shows through amongst the sky blues too. This results in an ethereal, insubstantial quality which aptly evokes the atmospheric effects of the sky. The warm and cool hues enhance each other optically, to give an airy, vibrant effect to the colors, unattainable by conventional overlaying and build-up of paint layers. Sisley's agitated, lively touch in the brushwork aids the impression of fleeting, transient effects.

Sisley's choice of composition and viewpoint varied between the relatively conventional and the daringly adventurous. Often, especially during the 1870s, he used high viewpoints, or visual barriers like a screen of trees, to create a flattened, surface oriented pictorial design, as

Sisley's palette for this painting probably comprised lead white (1), possibly black (2), chrome yellow (3), vermilion (4), red alizarin lake (5), cobalt blue (6), possibly Prussian blue (7), viridian green (8), chrome green (9), and cobalt violet (10). Yellow ochre was probably used too.

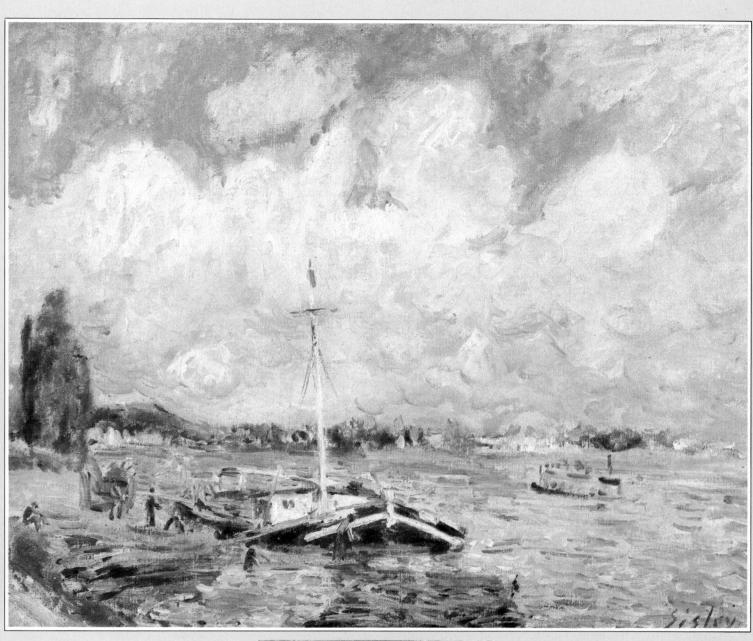

Creamy ground
showing warm against
the roughly dragged sky
blues

Touch of vermilion
slurred into whites for
additional warmth

Fine strokes for mast
and rigging

White slurred wet into
pale blues

Cobalt violet in darks
for barge

Figure added sketchily

Canvas texture apparent

Bright vermilion

Dragged and wet slurred
colors

Broad horizontal strokes
for water surface

*Few Impressionist
works were actually
painted alla prima or at
a single sitting.
However, this loosely
sketched picture is one
example of the method.
The pale, creamy ground
shows through in many
places among the colors
of the paint layer,
showing that there was
no preparatory ébauche
underneath. Sisley's
rapid handling was
essential to capture the
fleeting effects, and also
helps evoke them.*

in *Le Bois des Roches* (1880). At other times his compositions were more traditional, as here, where a low viewpoint and consequently a low horizon give a more conventional, almost panoramic appearance. However, the placing of water in the immediate foreground does serve the role of a visual barrier, discouraging the spectator from viewing the scene as a direct extension of real space, thus reinforcing a sense of the separate, pictorial space.

Sisley's distinctly visible, frenetic brushwork – although essentially form-following and descriptive – also affirms the flatness of the picture surface. His use of color shows both premixing and wet-in-wet slurring on the canvas itself. His palette is fairly limited, with the naturalistic greens and blues dominating in this river scape. Viridian predominates among the green mixtures, and the blue is probably cobalt. Black makes an appearance, broken

and therefore made more colorful by the addition of blue, to describe the hull of the river barge. Bright accents of vermilion slurred with yellow attract the eye to the distant bank, bringing it forward visually, and also linking it with the similar red which appears in the left foreground, and amongst the darks of the center foreground jetty. From the size of the figures, Sisley appears to have selected a scene quite distanced from where he set up his easel.

Sisley's retiring nature and relatively isolated existence after 1880 probably contributed to his work remaining less acclaimed during his lifetime than that, for example, of the more aggressively business-like Monet. Sisley's work, Impressionist to the last, continued to be appreciated by a small circle of discerning collectors, although it was only after his death that rises in the price of his paintings began to reflect his abilities.

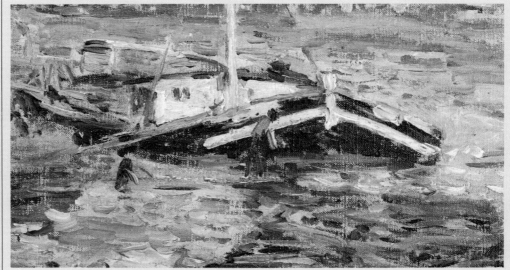

White was used almost pure on the barge, and the darks may include black, but are more likely a colorful neutral mixture of hues including cobalt violet. The dark brownish hues of jetty and bank are also mixed and include greens and vermilion. The colors were mixed on the palette and added wet in wet on the surface.

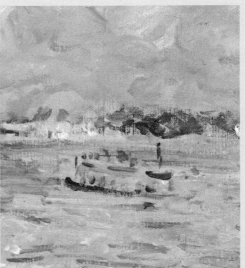

Yellows, mainly yellow ochre, mixed with white dominate the sandy hues of the bank, with chrome and viridian greens for the foliage. Blue, white, viridian green and cobalt violet were probably mixed for the hill colors. The brushwork is varied, describing the different forms and textures of the objects depicted, adding life and a sense of captured movement.

The distant boat is summarized in a few rapid brushstrokes. Its hull is a single dragged sweep of the brush, which has caught on the grainy canvas texture, exposing the creamy ground below and creating a vibrant interplay between paint and ground. Chrome yellow and vermilion were used almost pure on the far riverbank.

Actual size detail
The rather dull, mat surface of this painting indicates that it has apparently never been varnished, in line with the preference of the Impressionists. Varnish darkens and eventually discolors the original hues in a painting, and gives an artificial gloss *to the surface which many artists disliked. A mat paint surface is closer to the mat, opaque surfaces most often found in nature. A broad bristle brush was used to apply the blues and whites of the sky, over the grainy ordinary weight canvas with its creamy tinted* *commercial ground. The cream adds warmth which shows through among the blues, and a touch of vermilion was added to the whites to warm them further. The decisive strokes of the mast were added with a finer brush over the wet sky colors.*

CLAUDE MONET

Saint-Lazare Station/La Gare Saint-Lazare (1877)
Oil on pale primed canvas
75cm × 104cm/$29\frac{1}{2}$in × $41\frac{1}{2}$in

In the mid 1870s, Monet worked regularly at Argenteuil, which was close to the Seine and not far from Paris, to the north-west of the city. Alongside Renoir or Manet, or alone, Monet pursued his aims of recording his sensations of light and color in nature, slowly developing his expertise in his chosen method. Although in 1869 he had still been thinking in terms of studies outdoors for larger, possibly even studio-painted pictures, by the mid 1870s his main emphasis was upon works based solely on his visual experience outdoors, in which the unity of natural lighting could be retained.

At the second Impressionist group show of 1876, Monet showed 18 paintings, continuing his commitment with the others to find a viable alternative to the official Salon. The reasons why the Impressionists looked for alternative exhibition space were not just because they opposed the stranglehold of the Academy, but also because the Salon did not offer the kind of environment in which Impressionist paintings could be seen to advantage. The Salon had dark walls and somber lighting, and pictures were hung in rows right up to the ceiling. Most of the traditional Salon paintings were large-scale works and, with their somber light and shade, as well as their heavy, ornate gold frames, looked well in such surroundings. The Impressionists in general disliked the ornate gold frames in which Salon paintings were normally exhibited, and so they began using plain, white or pale tinted frames to set off their pictures more effectively.

Unlike the traditional Salon pieces, Impressionist paintings were generally intimate, and seen at their best in good natural daylight, preferably hung against neutral, pale wall coverings. Since most of their paintings were small in scale, intended to be hung on the walls of modern apartments, they were lost in the huge halls of the Salon.

In the Impressionist group exhibitions and one-man shows at dealers', the rooms were more appropriate in scale and the artists themselves could decide how their works were hung. In the Impressionist shows, no more than two rows of pictures were hung above each other, and the artists began to decorate the walls with colors which enhanced the color harmonies in their pictures.

The theme of the railway was, of course, a modern one in painting, but it had interested artists before the Impressionists. For instance, railway subjects had been suggested to Courbet as early as 1861 by his friend, the critic Champfleury. In 1874, Manet exhibited at the Salon a work called *The Railway*, but the picture showed only the iron railings which screened the street from Saint-Lazare Station below. The emphasis of Manet's composition was the two figures of a woman and child, apparently waiting for a train arrival. The background is obscured by steam rising from engines below. In 1876, Caillebotte chose the bridge over the Saint-Lazare railway tracks as the central theme of his *Pont de l'Europe*. However, the work focused not on the railway itself, but on the bridge with its passers-by, elegant strollers and one or two working people.

When Monet began his series of pictures of Saint-Lazare Station, he dealt not with the travelers or passers-by, but with the modern station itself, an industrial landscape filled with steam and broken sunlight. The cast iron and glass canopy of the station, within which Monet obtained permission to set up his easel, is light and delicate, its new architectural technology permitting a huge span with only thin spindly supports. All its members are fine and elegant, and its symmetrical construction made it perfect as a compositional foil for the light effects Monet portrayed.

Monet began work on this new subject early in 1877, when he was living close by in the rue d'Edimbourg, two minutes west of the station, on the opposite side of the tracks to where Manet lived. He was thus well placed to spend maximum time working in the station below. This work shows the station under full sunlight, the girders of the Pont de l'Europe spanning the middle distance of the composition. The artist faces almost due north, and the midday sunlight from the south bathes the modern apartment buildings which surround the Pont de l'Europe.

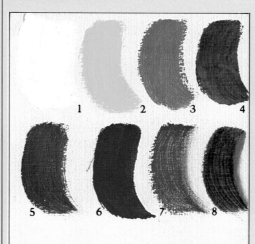

Monet's palette for this painting probably comprised lead white (1), chrome yellows (2), vermilion (3), red alizarin lake (4), cobalt blue (5), probably ultramarine blue (6), cobalt violet (7), and probably viridian green (8). Black may also have been used.

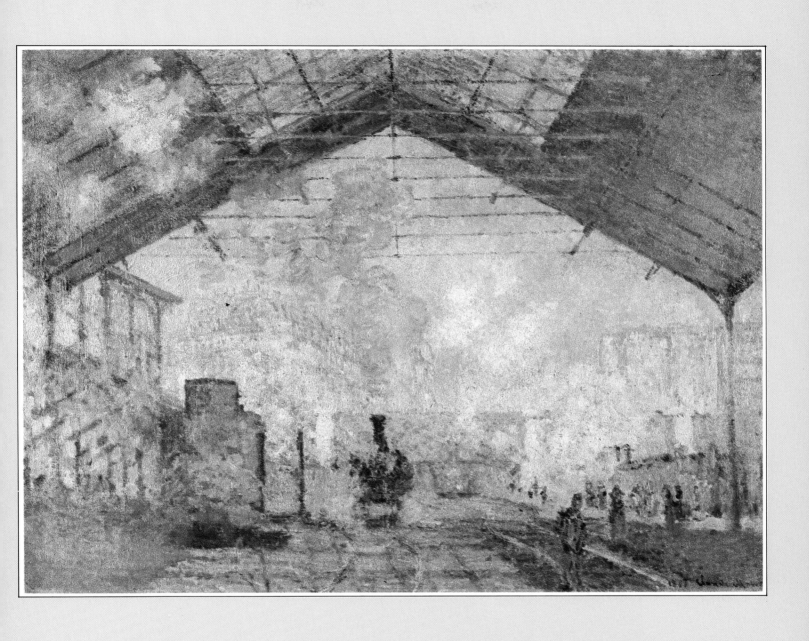

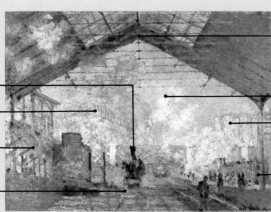

Possible use of black for engine color

Modern apartments built by Baron Haussmann

Bright chrome yellow mixed with white

Flamboyant curve to tracks added late

Central placing of vertical of canopy strut strengthens symmetry of compositional grid

Cobalt and white mix for cool, shadowy steam

Warm afternoon sun full on pale stone, painted mainly in chrome yellow and white

Touches of viridian in mixture

Like Caillebotte and Manet during this same period, Monet painted several different views of modern Parisian subjects, the best known of which are his scenes of St Lazare station. He gained permission to work in the station itself and made the effects of light and color beneath the steam-filled canopy, the main subject of his paintings. The format of Monet's standard vertical landscape 40 canvas relates well to the grid structure which underlies his composition.

Monet has set up his easel so that this section of the station canopy balances symmetrically across his composition, creating a strong formal structure. The point of the roof and the middle strut of the retaining grid of iron bars below, are made to coincide, and placed in the dead center of the composition to give a vertical axis to the pictorial structure. The main engine, shown coming towards the spectator, is placed just left of center to avoid overemphasis on the symmetry. The cool light inside the canopy has turned the train's steam a brilliant pale blue by contrast to the warmth of the sunlight outside. But warmth from the sun pouring through the window in the roof, casts golden sunlight on the tracks in the foreground, and that warmth is picked up and mingled with the blues in the shadows to left and right, and under the roof itself.

This half indoor, half outdoor scene thus provides an excellent subject for analyzing the varied effects of sunlight and shadow. The striking contrast between the more subdued hues of the foreground emphasizes the brilliant luminosity of the full-face sunlight seen through the frame of the canopy. Richer, deeper contrasts of warm and cool colors play against the paler, more dazzling tints of the background, producing a harmony of varied tones within the broad color axis blue to orange-yellow.

The paint layer itself is typical of Monet's work. It is exploiting opaque colors, made lighter and more light-scattering by the addition of lead white, and it is liberally applied, forming an almost unbroken skin obscuring the pale ground beneath. As a result the ground color, although evidently pale, is hard to identify with certainty. The ground colors most commonly used by Monet in the 1870s were pale gray, putty, oatmeal and white. The paint consistency is stiff and chalky, with colors mainly applied wet over dry. However, there is some slurring together of colors, such as the blues and white of the central cloud of steam. The effects of colored light on moisture in the atmosphere — whether steam, mist, fog or heat haze — fascinated Monet throughout his life, and provided him with an excellent vehicle for the study of light refraction through the droplets of moisture. Under such conditions the light is often shattered into its component rainbow elements, the drops of moisture serving as myriad prisms filling the atmosphere, and resulting in more colorful, scintillating effects of light.

Monet worked rapidly and enthusiastically on this group of pictures, of which seven were already finished in time for the third Impressionist show in April 1877, where this canvas was exhibited. It was bought by Gustave Caillebotte, who left his collection to the Louvre.

Actual size detail
Black may have been added to the dark blues to give the engine color, and the paint is mainly built up slowly in layers applied wet over dry. This dragging allows earlier colors to show through, aiding the effects of vibrant, dazzling light and blurring of forms. Vermilion and chrome yellow were mixed for the orange touches. In the dragged creamy whites depicting the stone pillar of the Pont de l'Europe, dirt and discolored varnish have collected in the grooves of the impasto. This indicates the degree of color distortion caused overall by old varnish.

Caked and loaded dryish colors build up to form a crusty, irregular paint surface. This physically breaks up and scatters the light bouncing off the surface, enhancing the illusion of light represented in the picture. Much of the dragged handling is applied wet over dry. A lively contrast is created between warm and cool hues, and between the stark symmetry of the station canopy and the flamboyant curls depicting the rising steam and smoke. Brushwork mainly echoes form, following planes and describing varied textures in rich paint. Colors are mostly mixed. For example, the blues and yellows were simply mixed with white to give luminous pastel-like tints evoking light.

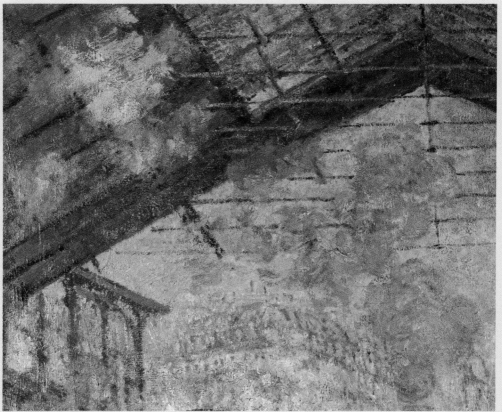

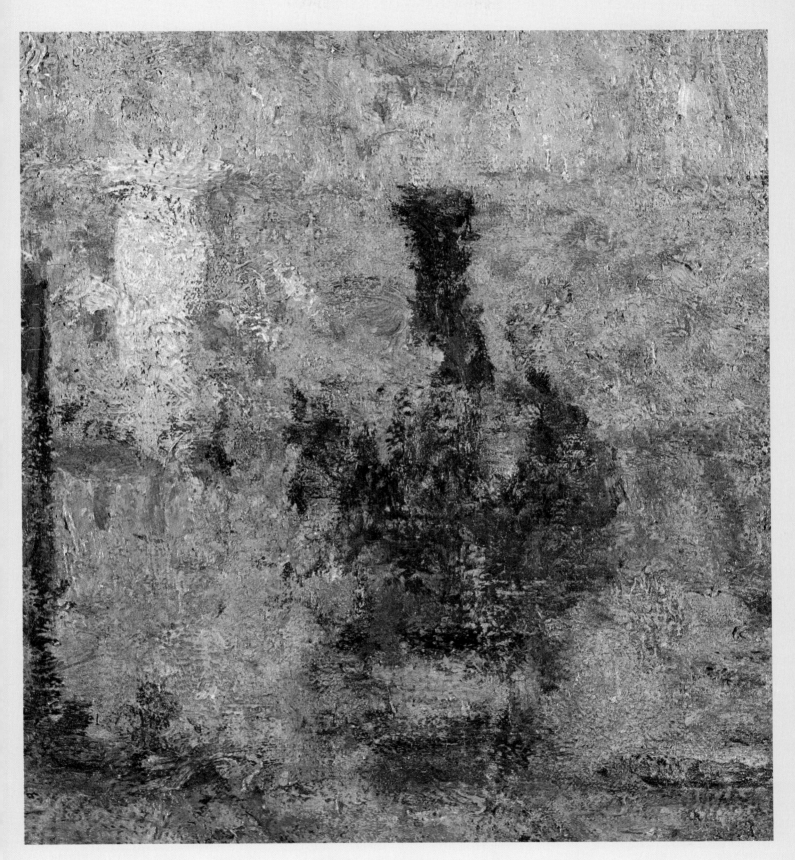

CAMILLE PISSARRO

Portrait of Madame Pissarro Sewing near a Window/
Portrait de Madame Pissarro cousant (*c*1877–1879)
Oil on twill weave, yellowish-gray primed canvas
54cm × 45cm/21¼in × 17¾in

During the Franco-Prussian war of 1870, Pissarro, who was a Danish national, as he had been born in the Danish West Indies, was unable to fight for France. So he fled with his family, first to Brittany, then to London, where they stayed in the suburb of Norwood in Surrey until the end of June 1871. During his stay in London, Pissarro, like Monet, was introduced by the landscapist Charles Daubigny (1817–1879), to the dealer Paul Durand-Ruel. He, like them, was a refugee from the war in France. Thus began the relationship between artist and dealer which was to provide Pissarro, like his colleagues, with vital support during the meager years before Impressionism was widely accepted.

On his return to France, Pissarro discovered that his house in Louveciennes, north of Versailles and to the west of Paris, had been requisitioned by the invading Prussians, and that most of the family's belongings, and the majority of his previous 20 years' artistic production had been destroyed. Only 40 out of approximately 1,500 paintings were saved. For the next 10 years, Pissarro was based north-west of Paris at Pontoise, and, in October 1878, he took the *pied-à-terre* studio at rue des Trois-Frères in Paris where this portrait of Madame Pissarro may have been painted. In November that year, their fourth son, Ludovic-Rodolphe was born in Paris. Although this portrait has traditionally been dated to around 1877, it must date from 1878–1879 if it was executed in the Paris studio, and the style of short, delicate strokes of myriad colors which are close in tone is more characteristic of the later date.

The composition of the portrait is strong and striking. Madame Pissarro's figure is cropped, and placed close to the picture surface, the wall and decorative ironwork of the balcony pushing her close to the viewer. This creates a shallow pictorial space which is not alleviated by the vista through the window, as the curls of the ironwork attract the eye and prevent it penetrating into depth. The outdoor scene is intentionally blurred, and handled with brushstrokes the same size as the interior, which again contradicts depth and recession.

The linear structure of the background is reminiscent of Degas' portrait compositions, in which the figure of the sitter was often anchored tautly within the pictorial space by interlocking horizontals and verticals. Pissarro and Degas worked together making etchings during 1879, and Pissarro used the printing facilities in Degas' studio. In the portrait, Madame Pissarro's head is placed centrally, against the vertical of the window frame which divides the composition into two almost equal halves. The horizontal bar of the balcony rail is echoed by the finer rails of the ironwork below, all of which combine with the strong vertical to create a grid against which the curves of figure are set. The intersections of horizontal and vertical lines are hidden behind the figure, locking it into place in the composition. The rounded forms of her face and hand are echoed in the curving spirals of the ironwork, further strengthening the decorative surface pattern.

The painting was executed on a standard format canvas, a portrait 10, with a single layer of commercial yellowish-gray priming which leaves the canvas texture apparent. The decisive pattern of the twill weave, a diagonal texture which goes from bottom left to top right, is actively exploited among the marks of the brush in the stiffish, chalky paint. The canvas weave is particularly evident at the juncture of blocks of color, and at the contours of forms where the paint is most thinly applied. It builds up more thickly toward the central areas, for example the swelling forms of the face which are the most thickly painted areas, while the paint is thinnest as the form recedes towards the contour lines. This helps suggest round form. The texture of the canvas also enhances the sense of flesh texture, where it is allowed to show through the paint layer.

The pale gray priming, warm in hue, plays an active role harmonizing the broken, muted colors of the paint layer. At the bottom center of the picture, the priming color shows clearly among the loosely added touches of dragged paint. Here the ground stands for the fabric which Madame Pissarro is sewing, and its texture is represented by the texture of the twill weave beneath.

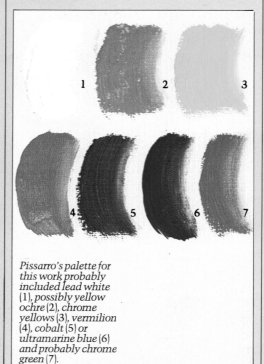

Pissarro's palette for this work probably included lead white (1), possibly yellow ochre (2), chrome yellows (3), vermilion (4), cobalt (5) or ultramarine blue (6) and probably chrome green (7).

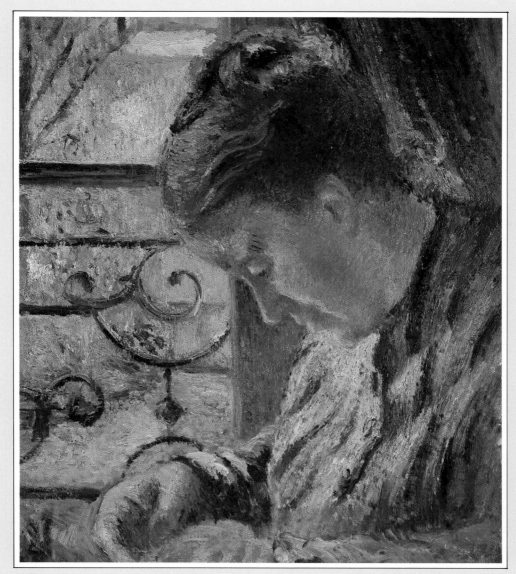

The quiet intimacy of this portrait of the artist's wife is emphasized both by her total absorption in her domestic work, and by the cropped character of the composition. This gives a close-up view of the sitter, pushing her towards the picture surface. It is a tightly organized compositional design, which relates well to the squarish, portrait 12 canvas format chosen. Like so many of Pissarro's paintings from the early 1870s on, it plays on the tension between pictorial space and flatness. The sensuous curves of the figure are echoed by the curls in the ironwork of the balcony, and both are contained within the broader grid of intersecting vertical and horizontal lines. Pissarro's brushwork has become relatively delicate and regular, often forming into hatched parallel patterns which follow the forms. But the richness of handling and color on the surface tend also to contradict strictly naturalistic qualities. A balance of warm and cool, light and dark colors is achieved here. Light touches pervade the shadow areas, and vice versa. Similarly, warm hues are added to enliven parts dominated by cool hues. This also gives a sense of the pervasive vivacity of the natural light which floods from the nearby window.

Pissarro regularly used unusual canvas weaves in the 1860s and 1870s, experimenting with the textural and compositional effects they could be used to create. In *Hoar Frost* of 1873, which was exhibited at the first Impressionist exhibition of 1874, Pissarro showed how a twill weave could enhance the impression of rough clods of earth in a landscape painting. In this painting the weave also travels diagonally from bottom left to top right, although the composition is a horizontal rather than a vertical one as in *Madame Pissarro*. The direction of the twill weave, like that of his *Hillside at l'Hermitage*, also of 1873, is used in *Hoar Frost* to stress the lines of the composition, which also move mainly from lower left to upper right. It is evident that Pissarro was

pushing further his experiments with flattening compositional designs and surfaces, counterbalanced by naturalistic brushwork, as the decade progressed. In the portrait of Madame Pissarro, the brushwork still follows form and is descriptive, but it has become more uniform in size and texture. This development looks forward to later works like *Apple Picking* of 1886.

Pissarro posed his wife against a window to create a *contrejour* or back lighting. However, the figure is not reduced to a stark silhouette, as in Degas' comparable studies. Contrasts of light and dark are kept to a minimum, and, although the fall of light adds structure to the form, it is nevertheless pervasive and the shadows colorful with reflected light.

The decorative texture of the diagonal twill weave shows at the contours, enhancing the textures. The paint on the face is loaded and stiff, built up in tiny, often regular touches with a fine bristle brush. Brushstrokes define form and varied texture. They include long strokes for the railings, and small colored accents on the face, like the dark blueish touches above the eye.

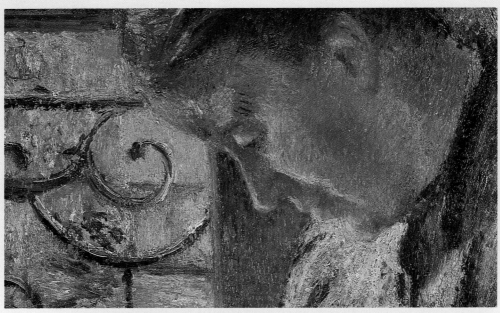

Twill canvas texture exaggerated by dragged color

Fine detailed accents in vermilion, applied wet over dry

Delicate hatched brush strokes

Colors slurred together wet in wet

Twill canvas texture exposed at contours where paint thinnest

Warm gray ground left to stand for linen fabric on which Mme. Pissarro works

This detail from Degas' study of a Woman against a Window (1871-1872) makes an interesting comparison with Pissarro's portrait. Degas' work is on a specially made support of reddish paper laid down on canvas. This provides a darker, more absorbent and smoother surface than that used by Pissarro. Degas' work is on a standard format vertical landscape 12 support, which relates well to the dominant verticals in his composition. Degas used dilute oils, and strong contrasts of light and shade in an almost monochrome tonal palette.

Actual size detail
The warm, yellowish gray ground is visible here. It is a commercial ground applied in a single thin layer which leaves the texture of the diagonal twill weave exposed. Although the canvas weave has been obliterated over much of this richly loaded surface, it has influenced the paint texture everywhere, as successive layers of stiff dragged color have been built up over it. In this detail, it was left almost uncovered, the pale gray of the priming standing for the dull colored fabric which Mme. Pissarro is sewing. The canvas texture, too, is used to indicate the feel of the fabric represented. Where it is exposed, the ground shows the results of abrasion which has worn the color off the raised canvas nodes, leaving speckles of darker linen support color peppered over the surface. Pissarro has contrasted the fairly richly dragged and slurred colors on the hand with the thin dry rubbed color enlivening the depicted fabric.

Pissarro's Hoar Frost *(1873), exhibited at the first Impressionist show of 1874, shows how the artist used twill canvas in a landscape painting. Executed on an elongated format standard vertical marine 30, the twill texture travels from bottom left to top right, following the diagonal of the pathway. Balancing this diagonal sweep are the lines of cast shadow moving from lower right to upper left. A contemporary critic disapproved of Pissarro's inclusion in his composition of shadows from trees located outside the picture. This novel device shows that the early morning sun was falling full-face onto his subject from behind the artist, and the blueish, light filled shadows were probably cast by leafless poplar trees. The flat light, pattern of crossing diagonals and the high view looking down on the scene create a decorative surface pattern which denies spatial effects.* Hoar Frost *has a dirty layer of yellowed varnish which gives a yellow cast to all the colors.*

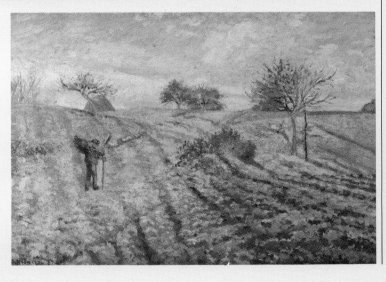

GUSTAVE CAILLEBOTTE

*Paris, A Rainy Day – Intersection of the rue de Turin
and the rue de Moscou/Temps de pluies à Paris* (1877)
Oil on white primed canvas (study)
54cm × 65cm/21¼in × 25⅔in

Gustave Caillebotte has unjustly been remembered more as a collector of the works of his Impressionist colleagues than as a painter in his own right. In his late teens, Caillebotte, son of a wealthy textile manufacturer, lived in a modern house which his father had built sometime in the mid 1860s in rue Miromesnil. This was in the new residential quarter of Paris, a few streets west of Saint-Lazare Station, with its huge bridge spanning the railway tracks. The Pont de l'Europe was one of the engineering triumphs of the Second Empire of 1852 to 1870, and six of the streets in the area converged onto it. It was one of the subjects chosen by Caillebotte for his series of major paintings on the theme of the modern city. Caillebotte was therefore depicting subjects within a stone's throw of his family home, which were all new streets, buildings and services constructed within his own lifetime.

Brought up in the aftermath of the 1848 revolution and the upheaval of the transformation of Paris during the Second Empire, Caillebotte trained first as a lawyer. Only after military service during the Franco-Prussian War of 1870 did he turn to painting, training at the Ecole des Beaux-Arts and in the studio of Léon Bonnat (1834–1922), a successful Salon painter who, in 1874, probably introduced him to Degas. This fateful meeting gave Caillebotte access to the whole group of independent artists, with whom he began exhibiting in 1876.

At the third Impressionist exhibition of 1877, Caillebotte showed three major paintings depicting life on the modern streets of the quarter near Saint-Lazare Station. These were *The Pont de l'Europe* (1876), *The House Painters* (1877) and *Paris, Rainy Day. Rainy Day* shows the intersection of the rue de Moscou and the rue de Turin, on the rue de Leningrad. This runs from the Saint-Lazare Station at its southwest end to the Place Clichy, painted by Renoir in 1879–1880, at its north-east end. All these early compositions were large in scale, but *Rainy Day* was by far the largest, and most ambitiously monumental, the final canvas measuring over 2 meters (7 feet) long by 3 meters (10 feet) wide. Unlike Degas' earlier city view, *Place de la Concorde* (1873), in which apparently haphazard cropping of figures gives an air of the snapshot, a glimpsed moment in time, Caillebotte's picture has a quality of frozen grandeur that looks forward to Seurat's huge works *Bathing at Asnières* (1883–1884) and *Grand Jatte* (1884–1886).

All three city scapes were based on a linear geometry, and on perspective studies of the sites in question. The linear framework of *Rainy Day* is based on a cross. The central vertical line runs through the lamppost and its reflection, the horizontal cuts through the eye level of the figures and the bases of the buildings,

dividing the composition into four equal sections. The framework is less precise in the painted study than in the final oil, for in the study the lamppost is marginally off center, to the right. Thus Caillebotte has adjusted the composition to fit his structural design. The proportions of the study are squarer than the final, specially made canvas, which is more elongated. This provides the extra width needed for the expansion of the right half of the composition necessary to place the lamppost centrally. A number of drawings survive to confirm the calculation Caillebotte brought to this picture, including the complex linear framework which incorporates two sets of proportions – the 1:2 ratio in the cross structure, and also the 5:8 ratio of the classical Golden Section.

Caillebotte's study for *Rainy Day* is closer in style to his more overtly Impressionist work, which dates from after this series of city scapes. The procedures he adopted for the city scapes, with careful preparatory drawings, perspective studies and oil sketches, was characteristic of the methods recommended by the Ecole, where he had so recently trained.

In the later 1870s, he turned away from the rigorous precision which governed the production of these early works. His later freedom of touch and broader, more colorful handling, are already apparent in the *Rainy Day* study. Colors, which became more muted and broken in the final picture, were still fresh and pure in the study. Blues and yellows dominate his palette, the yellow in this case representing not the warmth of sunlight but the sickly colored light from the thundery sky. The blues are the misty blues of rain-obscured distances.

Colors are used relatively pure, or mixed with white to give the pale tints of the background. They are scumbled on thinly in places, such as on the figures, and then worked over in thicker, undiluted paint. Outlines were roughly indicated, the colors varying according to the local colors of the scene. Thus a pale sandy color appears among the wet cobblestones, and darker browns and blue-grays were used to indicate the figures. That

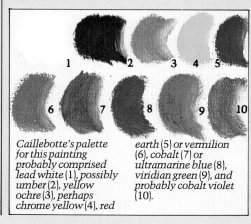

Caillebotte's palette for this painting probably comprised lead white (1), *possibly umber* (2), *yellow ochre* (3), *perhaps chrome yellow* (4), *red* *earth* (5) *or vermilion* (6), *cobalt* (7) *or ultramarine blue* (8), *viridian green* (9), *and probably cobalt violet* (10).

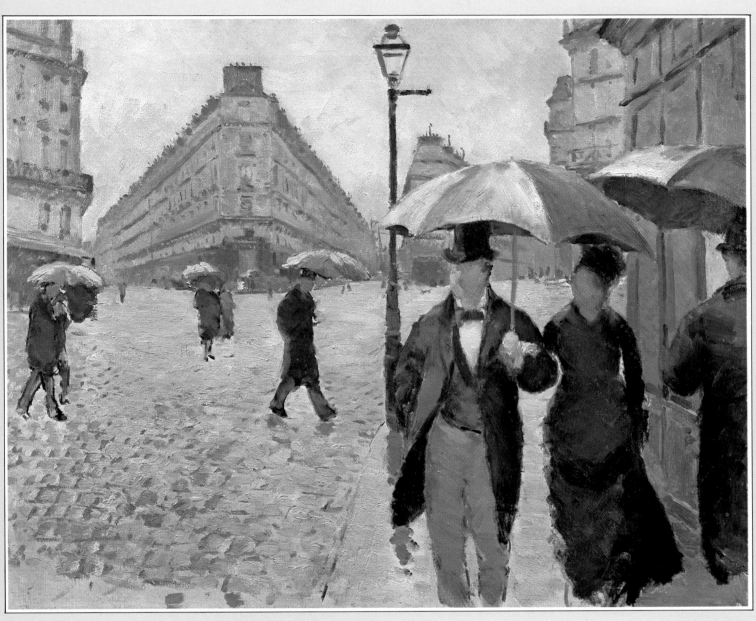

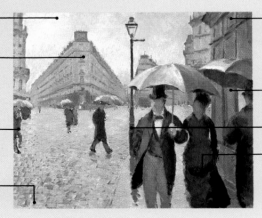

White dominated opaque color laid in broadly for sky

Dull yellow ochres and blues suggest sultry overcast light on buildings

Strong fluid outlines loosely blocked in to portray figure

Off-white canvas preparation left bare

Wet-in-wet slurred reds and blues

Red earth, or possibly vermilion, in subdued mixture

Viridian green based hue for modern lamppost

Masses of color blocked in broadly to give general effect, applied mainly wet into wet

In this painted sketch, Caillebotte planned the general composition and palette for his final version of the theme. The study may have been done out of doors, but was more likely a studio work composed after drawings and careful studies. Here the palette is fresher and the colors, though mixed, are brighter than in the finished work. The study is appropriately sketchy in its execution, with gaps left unpainted where the pale ground shows through.

This is the final work for which the sketch was made. Much larger than the preparatory oil, it measures 209 x 300cm (83¼ x 118½ in). The specially made canvas is more elongated in its proportions than the standard format portrait 15 canvas used for the sketch, allowing the artist to give more breadth to the scene. Elements of the sketch — a strip all around the edge — were cropped from the final version to bring the scene forward and to tighten the carefully calculated compositional design. Several extra figures were added, most notably the two women in the distance to the right of the lamppost. The finish here is much tighter and crisper.

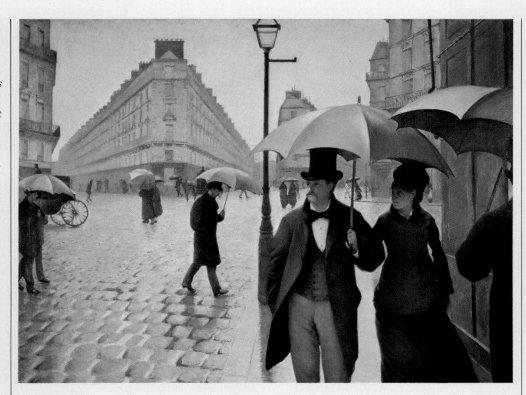

key compositional feature, the modern lamp-post, was painted in vivid viridian green, mixed with white to make it brighter and opaque. The overall balance of tints — pale in the left half of the picture, darker and richer in the right — is more striking in the study than in the final composition, which gains in strength, but loses the colorful immediacy of the study.

Caillebotte's work has traditionally been overlooked in preference to that of better known figures like Manet, Degas and Monet. However, his style, until the late 1870s, was perhaps closer to that of Degas and Manet than that of Monet, but has a strength and originality which are unmistakeable. Because of his wealth, and his consequent role as financial supporter of many of his Impressionist friends during the 1870s, Caillebotte's stature as a painter has, until recently, tended to be underestimated. This was probably exacerbated by the fact that, in the early 1880s, after a very active decade of struggle on behalf of the movement in Paris, he retired almost completely from Parisian artistic circles. This move was not dissimilar to that of other painters like Monet and Cézanne at this time. Caillebotte, Degas and Pissarro were the most active in organizing the Impressionist shows during the 1870s. Disillusionment with their lack of success and with disagreements among the group's members may have caused Caillebotte's retreat. However, as a result, his later work was little known outside a small circle of friends and family, although he continued to paint until his death.

These two little figures beneath the umbrella are painted with lively simplicity. Dark contours place their forms, which are then broadly filled in with stiffer, more opaque paint. Work on the rendering of the cobblestones was evidently done after the figures, because dabs of the pale color for the cobbles overlaps that on the figures. It also smudges over the line at the base of the distant building. The palette is dominated by varied yellow and blue hues in muted mixtures, but is enlivened by occasional touches of subdued reds. Most colors contain plenty of lead white, to give the effect of scattered atmospheric light.

Fluid lines of dilute browns or blues were thinly brushed in for contours, which were then blocked in by thicker, more opaque paint. A further reworking added weight and form to these figures, so that the resulting subtle modulations of hue and tone give a sense of their bulk. The brushwork helps here too, for, despite its briskness, it follows forms and 'sculpts' the figures. This can also be seen on the umbrellas, where the direction of the brush echoes the swelling forms. Detail is kept to a minimum, as can be seen in the lack of facial features. The final layer of the lightest hues is thickly impasted.

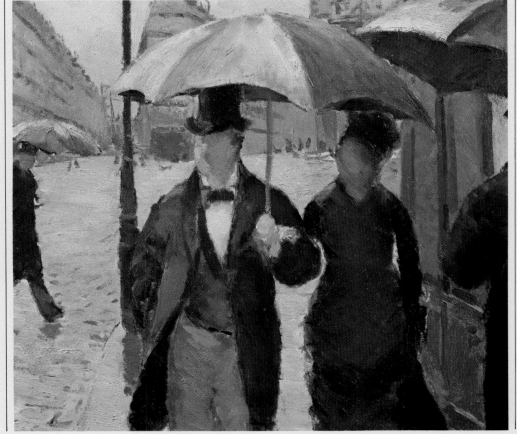

Actual size detail
Paint was loaded on in thick strokes to evoke the forms of the cobbled street, with a separate slab of color for almost each individual cobblestone. Linear strokes of dragged color define the general grid pattern of the blocks. The pale off-white ground shows through among these colors, which were not preceded by a thin ébauche layer. Caillebotte concentrated on the texture of the road, leaving definition of precise detail to the final work. For this reason, he did not bother to cover the entire foreground, but left the extremities of the painting bare. He may already have decided on the compositional cropping which cut these edges in the final work.

EDOUARD MANET

Roadmenders in the rue de Berne/Paveurs, rue de Berne
(1878)
Oil on pale gray primed canvas
63cm × 79cm/25in × 31½in

During the middle 1870s, for six years, Manet had a studio on what is now the rue de Leningrad, in a new residential quarter for the middle classes close to, and immediately north of Saint-Lazare Station in Paris' eighth *arrondissement*. From his studio window, Manet could look up the rue Mosnier, now the rue de Berne, onto the view which he depicted in a number of canvases including the present one, just before he left the studio in 1878. The bright palette and new light tonalities evident in this picture show the influence of Impressionist techniques and ideas upon Manet. Although friendly with his younger colleagues and meeting them regularly at cafés and *soirées* in the 1860s, it was only after 1870 that Manet succumbed to their influence. He began making outdoor sketches around 1870 and 1871, and, in 1874, he worked during the summer with Renoir and Monet at Argenteuil, a riverside village on the Seine, close to the north-west side of Paris, where many of the new middle classes were having villas built.

Monet had settled in Argenteuil in 1872, and the area became a popular one for communal landscape painting by the Impressionists during the 1870s. It was sufficiently close to Paris to permit the artists easy access to Paris for exhibitions, materials, social gatherings and meetings with dealers. At the same time, it afforded them a variety of landscape subjects — village, garden and river scenes — all of a gentle, domestic nature. Although Manet was never wholeheartedly committed to Impressionist ideals, he did work directly before nature during the mid 1870s, and continued to do so on occasions. He lightened and brightened his palette as a result of this experience, and, although he did not adopt the limited palette of the Impressionists, continuing to use black and some earth colors, the stark tonal contrasts typical of his work of the 1860s gradually gave way to closer, paler tonal harmonies.

Roadmenders in the rue de Berne is a stunning example of Manet's ability to capture open air light effects. It was painted on a canvas slightly smaller than the standard vertical landscape 25, which measures 81cm (32in) by 62.1cm (24½in), but, since standard measurements varied marginally from one color merchant to another, it may have been a standard format. A neutral pale gray ground on extra fine canvas has left the grain of the weave apparent, which is exploited in places by dragged color. The ground color enhances the overall effect of pale luminosity in the painting, uniting the many creamy tints of the paint layer. The paint layer colors are light and pastel-like, with much lead white added to them to increase their light-reflection, and their evocation of sunlit effects.

Looking north-west, up the rue de Berne, the afternoon sun falls from left to right across the street depicted. Its warm yellow color bathes the road and buildings to the right, producing light-filled shadows which are bluey-violet by contrast. No dark shadows or dramatic contrasts of tone break up the unity imposed by the sunlight. The atmospheric blueness at the far end of the receding street is admirably represented here, where Manet has rubbed a thin translucent veil of pale opaque blue over the stone colors, to give a floating insubstantial quality to the reflected light in the shadows. His harsh studio lighting of the 1860s has given way to the natural warm-cool outdoor effects studied by the Impressionists.

The all-pervasive sunlight works with the compositional layout to produce an ambiguity between surface and space in this painting. The unifying light and lack of contrast between depth of hue in foreground and background tend to contradict the illusion of space created by the dramatic recession of the street diving into the distance. The same pale blues of the background are apparent on the nearby buildings and figures, and the gash of brilliant blue sky at the top left further pushes the background forward, toward the picture surface. The rectangular red-brown block of the hoarding in the upper left is the largest block of deep color in the picture, so, because its color is striking and its shape echoes the straight edges of the picture, it sits insistently on the picture surface. This pulls the background forward too. The hoarding's shape also echoes the rectangle of the distant building which blocks the end of the street, and thereby links this shape to the picture surface.

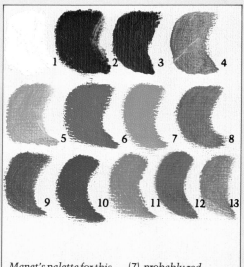

Manet's palette for this painting probably comprised lead (1) and zinc whites, black (2), possibly umber (3), raw sienna (4), yellow ochre (5), red earth or red lead (6), vermilion (7), probably red alizarin lake (8), cobalt blue (9), ultramarine blue (10), chrome green (11), viridian (12) or cobalt green (13). Cerulean blue may also have been used.

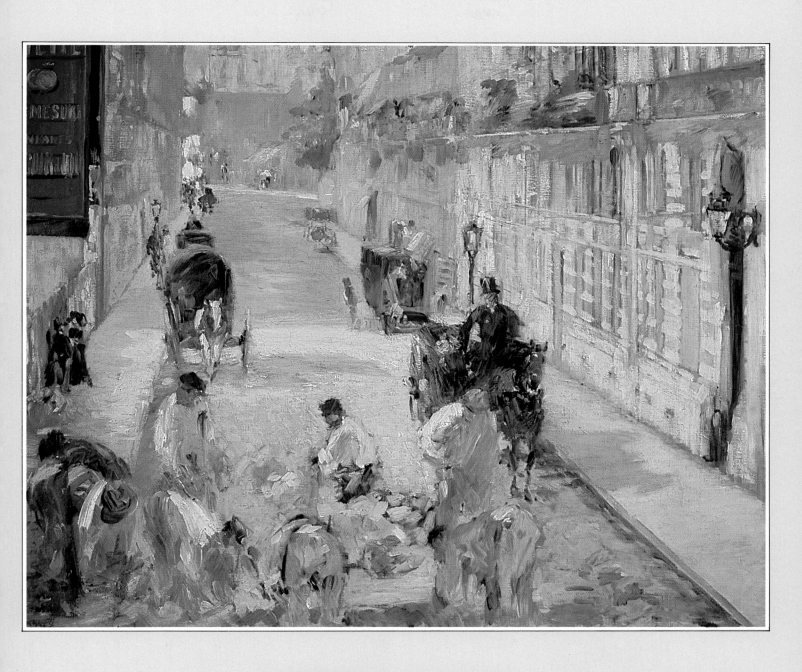

Pale opaque blues with white thinly applied to suggest an atmospheric haze in the distance

Yellow ochre used relatively pure

Light-filled shadows containing reflected blue from the sky depicted by opaque blue with white

Dryish dragged color, chalky in consistency

Almost pure white used for brightest highlights

Vermilion added for flowers, contrasting with vivid chrome greens

Slurred red alizarin lake worked wet into wet

Wet-in-wet application of paint with several partially mixed colors

Pale gray ground, visible on unpainted bottom edge

This painting shows how Manet abandoned the use of dark tonal contrasts and stark juxtapositions of black and white, that had characterized his work during the 1860s. This happened in part under Monet's influence. Here, white has been added to most of the colors, making them pale and pastel-like in tint, and more appropriate for depicting flooding sunlight outdoors.

The artist's viewpoint, looking down from his studio window onto the scene, tips the street up toward the picture surface, eliminating the skyline, which might have reinforced the recessive features of the picture. Recession is, however, strengthened by the changing scale of brushwork, which is distinct in the foreground and blurred in the background, and by the diminishing scale of figures and the perspectival lines on the buildings on the right. Thus Manet sets up a tension in the painting, a fragile equilibrium between those elements which encourage a naturalistic, spatial reading of the scene, and others which stress the two-dimensional design qualities of the painting.

Manet's brushwork is lively and descriptive, following the forms of figures and buildings, and emphasizing varied surface textures. The men in the foreground are paving this new street with cobblestones, indicating its recent construction. The gap on the left side of the street, behind the wooden palisade, appears still in the process of construction. Like many of his contemporaries, Manet ignored the dark crowded medieval quarters that still survived, and which had been popular with the Romantics, concentrating on depicting the most modern, newly erected parts of the city. These sunny, clean, cobbled streets, with their novel pavements, represented modernity, and, at the same time, offered light-filled settings which appealed to the Impressionist eye.

Delicate, pastel-like creams evoke the sunlit distance, with cool, contrasting blues to give the hazy, light-filled shadows. The addition of large quantities of white enhances the light-reflective properties of the paint layer itself. The pale blues were brushed on thinly but opaquely, and are similar to the blues used in Renoir's Rocky Crags (1882). Yellow and chrome greens with added white were used for the foliage. Juicier blue and white paint was flicked on thickly and slurred to create the tiny distant figures.

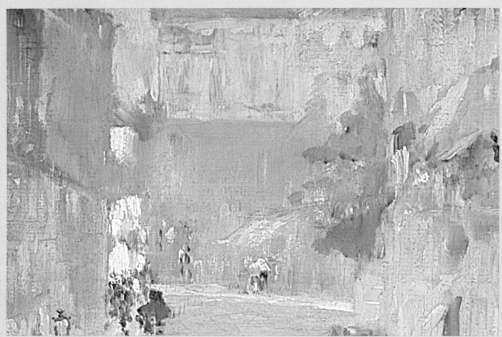

This detail shows very loose and free brushwork using several colors to each stroke. They are partly slurred together but their separate hues are still often quite distinct. Dragged, the paint allows the ground or earlier dry touches to show through. The palest, greeny-blue may be cerulean blue, the more violet blue is probably ultramarine.

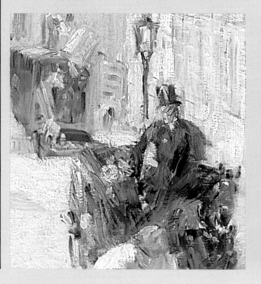

Vigorous handling combines both wet-in-wet and wet-over-dry work. A fine, grainy canvas texture is evident in places, and the pale gray ground is occasionally revealed too. Touches of mixed orange make a vivid contrast with the lively complementary blues. Manet's loose, unfocused handling adds to the feel of bustling immediacy.

Actual size detail
A thin transparent black layer underlies the pile of stones on the lower

left. This was rubbed or scraped down by the artist, revealing a speckle of pale gray ground at the canvas nodes. Scraping down was a common practice used to eliminate irregularities left by the first ébauche layer. The blurred vagueness around the shoulders and head of the bending

worker is also evidence of scraping down. Opaque colors were applied both wet in wet and wet over dry over the ébauche layer. This loosely and broadly handled color creates a sense of immediacy which reflects the concern for modernity shown in the choice of subject. The colors are

mostly broken, pale earthy tints and ochres. Some, such as the blues and yellows, only have large quantities of white added to them. The warm pale yellow may be a mixed hue, or possibly the Naples yellow that Renoir began to use in preference to chrome around this time. The

paint is generally quite thin, although mainly opaque, but some areas show loading of the brush leaving raised marks on the surface. The touch of the brush helps to create texture. Hog's hair brushmarks are often left visible as a result, and can be identified. In this work, flat, square and rounded

ends are used, in sizes varying from 5mm ($\frac{1}{4}$in) to 1.5cm ($\frac{5}{8}$in). In the unpainted parts at the bottom edge, the pale gray ground is most obviously revealed. Wear to this edge has rubbed the ground off the raised nodes of the canvas, leaving the darker hue of the linen showing through.

EDGAR DEGAS

Portrait of Duranty/Portrait de Duranty
Distemper and pastel on sized but unprimed canvas
100cm × 100cm/39½in × 39½in

Cool, aloof, intellectual, Degas was the epitome of the Parisian dandy. Abandoning historically inspired academic subjects early in the 1860s, he began a lifelong commitment to rendering the modern life subjects which he saw around him. Influenced by an eclectic appreciation of the art of the Old Masters, and by the great nineteenth century painters, especially Ingres and Delacroix, Degas fused in his art the grand traditions of draftsmanship and coloring. He combined tradition and innovation. He wanted to bring a new emotional subtlety to painting, to rid art of the schematized caricatures of the emotions to which academic artists resorted. His aims were summarized by his friend Edmond Duranty in 1876: 'by means of a back, we want a temperament, an age, a social condition to be revealed.'

Degas met Duranty around 1865, and established a close friendship with this kindred spirit. Duranty had been a staunch supporter of Realism for more than a decade, and had edited a shortlived review *Le Réalisme* in the mid 1850s. An art critic and novelist in the vein of Gustave Flaubert (1821–1880) and Emile Zola (1840–1902), his fame was eclipsed by the success of these writers, leaving him an ironic cynicism akin to that of Degas himself. Duranty was the only writer in his social circle whom Degas portrayed, and he appeared in works other than this portrait.

The *Portrait of Duranty* comes toward the start of the period between 1875 and 1885 which saw Degas' most prolific experiments in artistic techniques. Around this time, artists were increasingly exploiting the matness of modern paints, and here Degas used a combination of opaque non-oil-based mediums. Distemper – a water-based glue-bound medium – provided the basic material of the portrait, which was executed on unprimed canvas. A shine apparent only in areas where the raw canvas is revealed, suggests that the fabric was first sized, with a glue size. The combination of distemper overworked with pastel used here has adhered inadequately to the flexible fabric support, and paint losses are clearly visible in places. The palish beige linen color of the canvas was also intentionally left bare in many parts, and its warmth unifies the overall tonality which, because of subdued canvas tone, results in muted harmony.

The mediums – distemper and pastel – are both mat and opaque, scattering reflected light from the picture surface. The pastel, with its distinct powdery hatched marks, is clearly visible worked over the freely brushed distemper colors. The pastel was used selectively, especially on the figure of Duranty, where it focuses attention on the sitter by strengthening drawing and heightening color. Strokes of a startling violet-blue, used to express reflected light in the shadow, for example on the raised middle finger supporting the sitter's head, have an almost floating, luminous quality. A darker, greener blue pastel was worked into the blue of the jacket, and some black strokes add lines of definition to the form of the figure. Pastel hatching on the face constructs form in terms of modeled color and tone, but, because their direction does not always follow the form, these marks have a life of their own. They contradict the formal structure of the face – even at a relatively distant viewing range – and this results in a striking tension between illusion and surface pattern.

Compositionally, the picture is powerful, and typical of Degas' daring experiments with pictorial construction and space. Influenced by Japanese prints and photography, he sought to express 'the particular note of the modern individual, in his clothing, in the midst of his social habits', as Duranty stated in 1876. Adopting an unusual square format which stresses surface flatness, Degas placed the sitter's head centrally, the midpoint of the canvas coinciding with Duranty's raised fingers pressing against his skull. This was perhaps a humorous reference to the man's intellectual intensity, as well as a typical pose. The figure, thus placed, seems oppressed by the mass of roughly indicated books on the shelves immediately behind him. He appears trapped in a shallow space, completely surrounded by the evidence of his trade, which, in the abrupt slope of his crowded desk, effectively separates him from the spectator – whose gaze he avoids.

Degas' alignment of the bookshelves is also no accident. The second shelf down on the left links with the third down on the right, and together they form a disturbing horizontal which cuts across the picture space, denying recession, and pushing close up to the picture surface. Colors, like the bright blue and the brown beneath it in the foreground left, serve a similar function, linking with comparable colors in the background to flatten the pictorial space. The overall effect of such devices is to emphasize the disquieting tension between abstract design and illusionistic representation, which gives a taut sense of presence and immediacy to the sitter.

Unlike the Impressionists, with whom Degas was associated by friendship and a commitment to alternative, unofficial exhibitions, Degas did not work from nature: 'art is not a sport' he maintained. He always worked in the studio, often from memory and from reworking ideas within his own pictures, preferring the effects of artificial light to outdoor lighting. For him, art was 'falsehood', a picture was 'something which calls for as much cunning, trickery and vice as the perpetration of a crime.' Yet to the casual observer, the final effect was often one of guileless and almost casual immediacy. This result, achieved sensitively in this portrait, is characteristic of many of Degas' works.

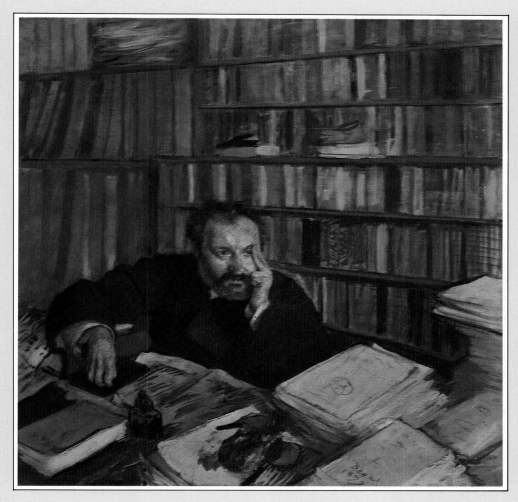

Like many of his more daring contemporaries, Degas began to experiment with square format canvases during the 1870s. It is likely that his avid experiments with work on paper supports, which were easily cut, altered and added to as need demanded, fed his ideas, permitting him to develop them with great confidence onto the more costly canvas supports. Although Degas only infrequently used oil on unprimed canvas, because it was technically unsound, water-based paints were safe to use with raw canvas. In fact, the dull gloss visible on the unpainted parts of this picture suggests that Degas did give his support limited protection by applying a layer of size glue. At that time canvases could then be bought ready sized, but without a layer of ground color, and Degas may well have used such a product here. Just as Degas was experimenting with fairly binder-free oil colors, applied with turpentine to give dusty, mat effects, so too he used naturally mat media. Here gouache and pastel – the mattest of all media – were combined to give a pale, light-reflective surface.

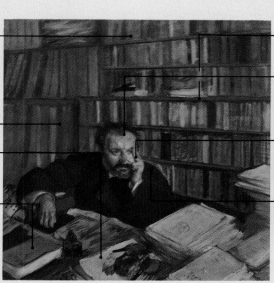

Red earth paint has flaked to reveal unprimed but sized linen canvas

Thinly dragged gouache color

Flaking of gouache which has adhered inadequately to the canvas support

Evenly applied layer of gouache, ultramarine or cobalt blue. Gouache is always opaque because all colors contain added body color, or white

Striking compositional horizontal stresses pictorial flatness

Broadly hatched strokes of pastel define form of head, but create independent, emphatic pattern

Brilliant blue, probably ultramarine, strokes of pastel for reflected light in shadow

Strengthening of contours with black pastel

In places the thinly applied gouache has been strengthened by the addition of black pastel. Degas' signature is ingeniously placed to follow the plane of the pink bookcover so that it appears as part of the printing. Flaking is particularly visible in the off-white gouache.

Free and simplified handling belie the crisp confidence of Degas' draftsmanship. Mainly executed in gouache, the twisting movement of the wrist and hand are superbly captured. Pinks are used for the light parts, with contrasting greens for the shadows. Black gouache was overlaid to strengthen the drawing of the fingers by defining the divisions between them more clearly.

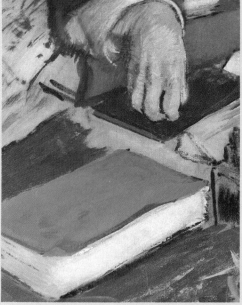

Degas' pastels included black (1), various shades of pink (2-5), red earth (6), ultramarine blue (7, 9), dark greenish-blue cobalt blue (8) and possibly pale viridian green (10).

Actual size detail
The unifying function of the raw sized canvas is apparent here, where it appears as a color and texture among the gouache and pastel. The texture of the canvas is vital, breaking the flow of the colors to give a vibrant effect, where the darker linen shows through the pale hues on top. The horizontal threads of the canvas are evident on the figure's brow, giving the appearance of deep, pensive furrows. The head is emphasized by combining gouache underpainting with pastel overworking, where line is used as color.

These two drawn studies show how the artist began his portrait. Only minor changes were made when he transferred the life study of the figure to the canvas. The torso was shifted to stress his raised right shoulder and the modeling of this arm was made more monumental. The new angle of the shoulders was echoed in the more acute angle of the desk, following the sweep of the shelves and seeming to trap the powerful bulk of Duranty among his cluttered papers. The final, striking design of the background shelves, with their strong bisecting horizontal lines, was invented by Degas.

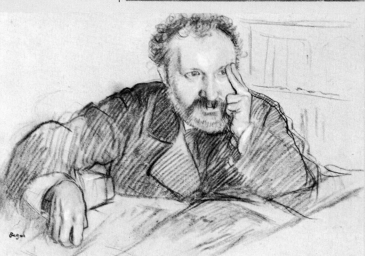

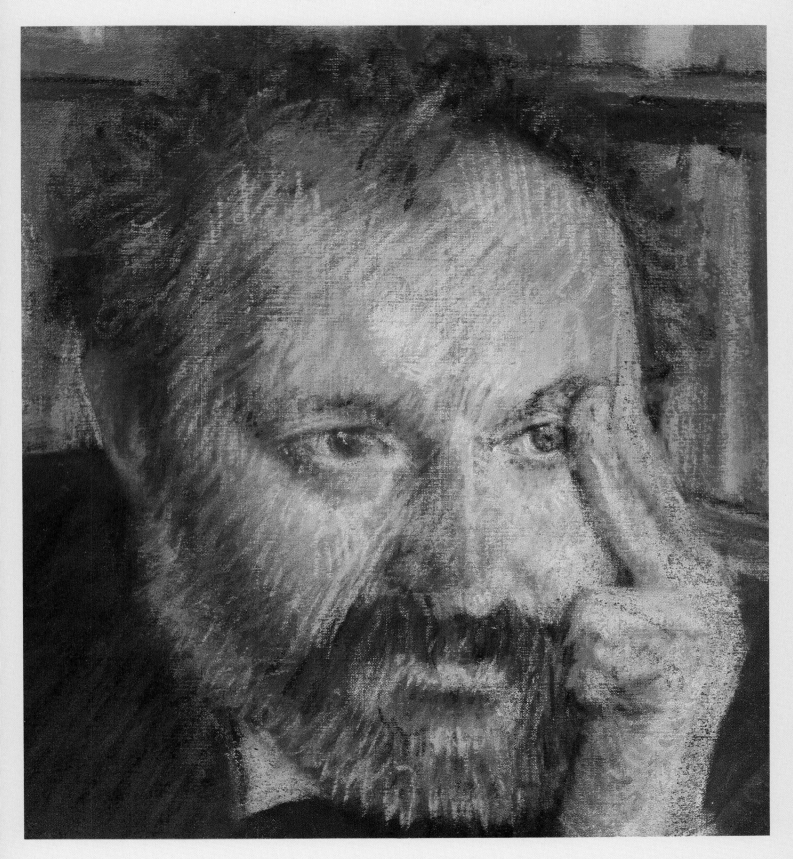

1880 1890

During the 1880s, the Impressionists consolidated their technical innovations of the previous decade, while a new generation of artists emerged who began to question Impressionist ideas and adapt their techniques to new ends. From 1879, the cohesion of the original Impressionist group was eroded by the introduction of newcomers. The appearance of Paul Gauguin (1848–1903), and soon after of Georges Seurat (1859–1891) and Paul Signac (1863–1935) at the Impressionist group exhibitions fanned the flames of disagreement which were growing among the older members. Some, like Pissarro, were in favor of moving with the times. Others, like Monet and Renoir, resented the newcomers. Thus, while individual friendships and allegiances were maintained during the 1880s, the overall cohesion of the Impressionist group began to disintegrate early in the decade. Symptomatic of this change was the final Impressionist group show in 1886, which was dominated by the newer artists, the Neo-Impressionists.

The legacy of the 1870s

By the late 1870s, most artists in the Impressionist group were beginning to find more tightly organized, structured ways of depicting their visual 'sensations' of nature. Paul Cézanne (1839–1906), early in the second half of that decade, began to adopt what has since been termed his 'directional' brushstroke. This meant that his brushmarks were all generally

Right *Berthe Morisot's* In the Dining Room *shows the artist's maid in her house, rue de Villejuste, Paris. It was painted in 1884. In the 1880s, like most of her Impressionist colleagues, Morisot continued to make studies of effects of natural light and color on outdoor and interior scenes. Here, daylight floods from the large windows behind the figure, but as in Pissarro's portrait of his wife sewing (1879), harsh contrasts between light and shade are eliminated. Shadows, like that from the maid falling toward the spectator, are filled with reflected light, and the contrasts are between warm and cool hues. Brushwork is lively, dragging the pale opaque colors to create the blurring effect of light dissolving form and contour.*

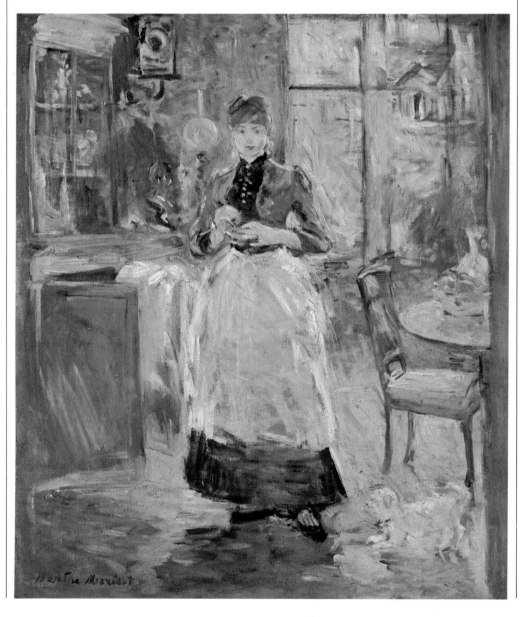

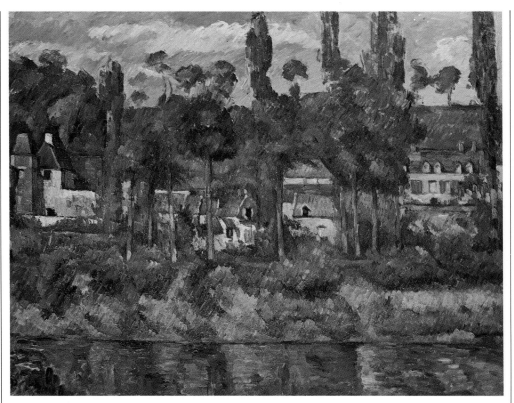

Left *Cézanne's* The Castle of Médan *was probably painted in the summer of 1880, when Cézanne was staying at Médan with his friend the novelist Emile Zola. He owned the small island in the Seine from which the view was painted. Cézanne has aligned the riverbank and the village parallel to the picture plane. A series of bands thus run horizontally, echoing the top and bottom edges of the painting. Combined with the verticals of the trees, they form a strong compositional grid. Hatched strokes of paint are used almost uniformly over the picture, and the color is of almost the same saturation throughout. These devices stress the flatness of the picture surface.*

placed in parallel lines, similar to a hatched drawing technique, usually running from top right to bottom left in his paintings. This particular direction is logical for a right-handed painter. Originally, in more traditional and academic painting, the underlying compositional structure was based on line, on the use of drawing by contour and by edges of forms, on a conventionalized fall of light and shade, to give a linear or tonal skeleton on which color was then laid.

The Impressionists' concentration on color which involved starting their pictorial layout with colored touches which represented the colored patches they perceived in nature, meant that structure evolved as the painting progressed, through a combination of two key elements. The first was the planned, overall compositional design of the subject on the canvas; the second was the build-up of delicate color values and warm-cool contrasts, which slowly cohered into a harmonious unified effect equivalent to the effect afforded by the natural scene. Drawing as a separate, self-contained activity in painting, was abandoned. As Cézanne himself recalled in his later years 'Drawing and color are not separate at all; in so far as you paint, you draw. The more color harmonizes, the more exact the drawing becomes.'

In the first half of the 1870s, the Impressionists had relied on descriptive brushwork — brushwork which echoed and followed forms in their painting — to aid the modeling pro-

duced by color values. But during the latter half of the 1870s, brushwork became more independent of form and took on a life of its own. This gradual freeing of touch from its more basic role of describing form had important consequences. It meant that the artist's visual sensations of patches of colored light were more accurately conveyed and also that a greater awareness of flat, plastic qualities in painting were stressed. The size of brushstroke was kept relatively uniform over the entire canvas, and so it no longer aided an illusion of recession, but emphasized the physical surface of the picture. Thus, the artist forced the spectator to remember that the picture confronted was a *painting*, which had its own reality, and was not simply an extension of the spectator's world. The Impressionists were not concerned to produce an art which fooled the eye into believing it saw the 'real' world, but rather to stress to the viewer the individual nature of the artist's perceptions.

By the end of the 1870s, Renoir and Pissarro had both developed their individual equivalents to Cézanne's constructed 'directional' brushwork. It is clearly apparent in Renoir's foreground figure in *Place Clichy* (1879–1880), which sets up a striking contrast with the blurred, rubbed effects which evoke the background bustle of the crowded Parisian street. The tightness of the brushwork on the cut-off female figure acts as a device to focus the viewer's attention on her. Pissarro, who had

Right *Renoir completed this work,* Monet Painting in his Garden at Argenteuil *around 1874. This shows the artist with his outdoor painting tools in the early 1870s. A three-legged, collapsible easel is used for easy portability and a small paintbox can be seen on the ground below. Nearby is a folded, white painting parasol. This would have been used during bright sunny spells to shade the work and eliminate brilliant reflections off the wet paint surface. An overcast sky here gives bright light but no cast shadows to enhance form. Horizontals and verticals of the fence and buildings run parallel to the picture plane, a geometry softened by the varied brushwork suggesting foliage and flowers. Colors were premixed and worked wet in wet. But this is – for Renoir – quite a heavily loaded surface and paint was also added wet over dry.*

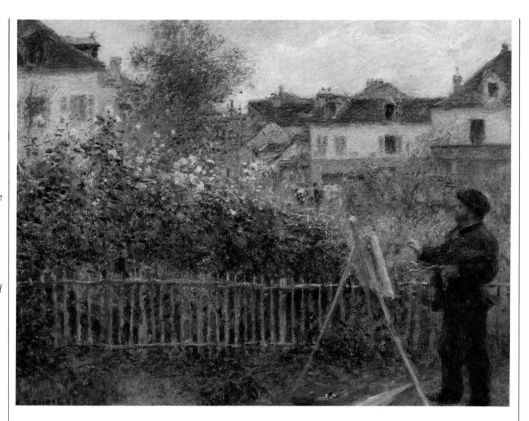

worked regularly beside Cézanne during this decade, used a more controlled, directional touch in works like *The Backwoods of l'Hermitage, Pontoise* (1879), a magnificent, large canvas which can be seen as a summation of his work of the 1870s, and in *Peasants Tending Cows* of 1882. Pissarro's technique was to develop, along with his association with the younger generation of Neo-Impressionist painters, into his pointillist style of the late 1880s. By 1886, this new group of artists, who developed a more scientific approach to Impressionism, were dubbed the Neo-Impressionists. In Renoir's work, the new tightness heralded a return to more traditional painting methods, in which he revived the practice of making preparatory drawings and studies, and did many large-scale studio figure compositions, while remaining committed to Impressionist brilliance of color and luminosity.

Seurat and the Neo-Impressionists
The new Impressionist style of ordered brushwork was adopted by the young Georges Seurat (1859–1891), short-lived leader of the Neo-Impressionists, when he first began painting oil studies from nature in the early 1880s. His personal variation was a criss-cross application of hatched strokes which gave his studies a surface uniformity comparable to that found in Impressionist paintings of that date. This technique may in part have originated with

Delacroix (1798–1863), who occasionally used it, and in the oil sketching methods which Seurat learned at the Ecole des Beaux-Arts. Like Degas, Seurat trained — if only briefly in the late 1870s — in the *atelier* of one of Ingres' pupils. Like Degas too, Seurat retained from this experience a commitment to drawing, to careful preparatory studies, both drawn and painted, and to a monumental classically harmonious symmetry in his finished studio compositions. In a way, Seurat was a modern classicist, fusing aspects of that tradition, in particular a belief in strong modeling of form, with the Impressionists' dedication to the rendering of natural outdoor light. However, Seurat's novelty lay in his desire to find a systematic, scientific mode of rendering natural atmospheric light which, unlike the approach of the Impressionists, would leave nothing in his paintings to chance. During the first half of his brief career until the mid 1880s, he concentrated upon systematizing the depiction of color and light in his paintings, adopting a variant of the Impressionists' limited palette of bright colors.

Nineteenth century writers on technique had recommended widely accepted, if slightly varied formulae of different combinations of colors for depicting each category of painting — figure, landscape, portrait, genre scenes, and so on. By contrast, the limited palette of the Impressionists — which improved the porta-

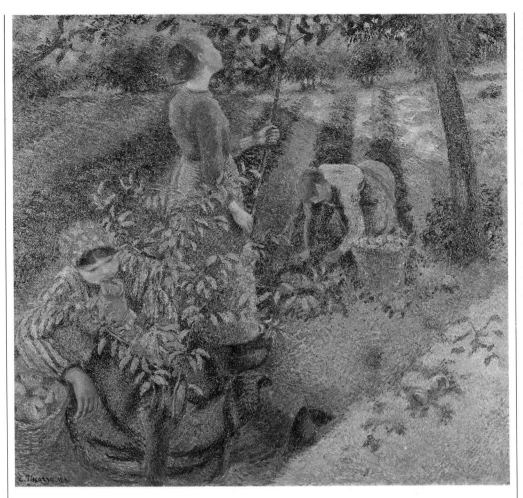

Left *In* Apple Picking *(1886), Pissarro was experimenting with the decorative properties of a square canvas format. A number of preparatory drawings for this major, large-scale work survive. They show the care with which the artist planned the picture. Three figures recede in space. They echo the strong diagonal of the violet shadow, which runs from center bottom to off-center, right. In the upper right, a second triangle of sunlight repeats in reverse that at lower right. The power of these shapes and the shadow, in relation to the square canvas shape, gives the painting a patterned flatness. The brushwork consists of small hatched touches which are, however, not yet Pointillist in size. The brushstrokes create a web of texture which strengthens surface qualities, while also evoking forms. Color is richer and more muted than in the artist's later Pointillist variant of this theme, which dates from 1888.*

bility of their equipment — required of these artists greater versatility and an intimate knowledge of their few colors, to enable them to adapt their palette to suit a wide variety of different subjects and weather conditions.

The Impressionists' palette colors were not strictly speaking 'prismatic'. None conformed precisely to the full, pure chromatic saturation found in the spectrum of colored lights produced by a prism for the simple reason that they were combinations of chemical pigments. What the Impressionists did was to choose pigment colors which approximated most closely to the common notion of the chromatic circle, concentrating on primary colors (red, yellow, blue) and one or two secondary colors (orange, green, violet) which, when mixed, produced a wide range of bright hues. Relative degrees of darkness or colorful neutral tints were made by mixing complementary or near complementary colors. Complementary colors are those colors opposite each other on the color circle — red and green, blue and orange or yellow and violet. This enabled the artists to avoid the sullying effects of adding

brown or black to give darker tones. For pale tints, increased amounts of lead white were usually added to the initial mixture.

Documentary evidence and scientific pigment analysis together with visual examination of the paintings can give a reasonably accurate idea of the colors generally used by the Impressionists. The most common colors were lead white, chrome yellows, cadmium yellows, yellow ochre, emerald green, viridian green, cobalt blue, ultramarine blue, red and crimson alizarin lakes, and vermilion. Black virtually disappeared from the palettes of all but Renoir and Cézanne after the mid 1870s, and even they used it only as a color in its own right, and not as a means to darken other colors for tonal shadows. Chrome yellows were in fact abandoned by most of these artists in the late 1870s, when it was realized they tended to blacken in contact with pigments which included sulphides. Renoir commented on this problem, and the change it necessitated in his work, emphasizing one important aspect of coloring. This was that brightness of color depended more upon the relationship of colors

within a picture, than on the brilliance of the individual colors. For this reason, he adopted the dull Naples yellow in place of the bright chrome yellows.

In the late 1870s, Monet substituted cadmium yellows for the problematic chromes. He, Pissarro, Alfred Sisley (1839–1899) and Mary Cassatt (1845–1926) all used cobalt violet relatively unmixed from the early 1880s on. This pigment had, however, been used by them much earlier, but only in mixtures. Cézanne and Renoir both used some of the duller – but pale – earth colors, like yellow ochre, raw sienna, green and red earths, and also Naples yellow. Renoir called these 'intermediaries', by which he meant colors which could be obtained by mixing the brighter primary colors and white. However, these artists tried to avoid

The Neo-Impressionist palette

The Neo-Impressionists were even more rigorous in their attitude toward color mixtures than were the Impressionists. The latter often slurred together or even premixed colors opposite each other on the chromatic circle, because these gave colorful neutral-to-gray hues. The Neo-Impressionists rejected such mixtures as too sullied. Instead they advocated only the mixing of hues next to each other on the chromatic circle, which gave brighter, purer mixtures. Like the Impressionists, they increased the reflective luminosity of their paint surfaces by adding white to most of their colour mixtures. Although as late as 1883 to 1884, when Seurat completed his first major canvas *Bathing, Asnières*, earth colors were included in his palette, after that date he banished them

Right *Mary Cassatt's* Lydia Crocheting in the Garden at Marly *(1880) shows the artist's sister Lydia, who was an invalid. It was exhibited at the sixth Impressionist exhibition of 1881, and Degas remarked that it looked well in studio light. The subdued tint of the ground harmonizes with the predominance of middle tonal values of this picture. It was painted in shadowless overcast lighting. The figure is cropped and pushed close to the viewer, against a band of rich, reddish plants. This band seems like a solid slab of color. This produces a flattening effect which is reinforced by the flat color of the path and the grid of windows behind. All of these devices draw attention to the figure.*

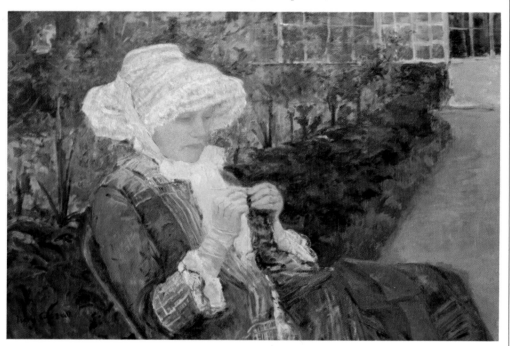

dangerous overmixing, so the duller tube colors were adopted only as an expedient.

The more colors are mixed together, the darker the resulting hue, because pigments react 'subtractively'. This means that the amount of light they reflect back to the eye diminishes proportionately with each additional color in a mixture. Colored light reacts in the opposite manner, or 'additively', so that adding colors of light together produces an increasingly pale mixture, resulting finally in the pure white light which is a reconstitution of the entire prismatic rainbow. Thus, avoiding overmixing of pigment colors was also a means of retaining the maximum light-reflective power of each individual pigment color, as, for example, Naples yellow direct from the tube would be paler than would a palette mixture.

from his color range. His first follower, Paul Signac, recorded the typical Neo-Impressionist palette, which was an extended version of the Impressionist palette, excluding the earth colors. For their yellows they used the cadmiums, from deep through to pale, and the alizarin lakes and vermilion were their reds. Cobalt violet, ultramarine and cobalt blues, and cerulean blue covered the purple to blue range. They used more greens than the Impressionists – viridian green, and two 'composed' greens, probably different hues of chrome green, which was a commercially produced mixture of chrome yellow and Prussian blue.

Since the seventeenth century, the artist's palette had traditionally been laid out in a tonal arrangement, starting with white nearest the thumbhole and moving out around the

Right *Louis Hayet, painter friend of Pissarro and his son Lucien, painted this color circle based on Ogden Rood's color wheel. Such charts aided Neo-Impressionist painters in their choice of hues for their meticulously colored canvases. By contrast to Chevreul's earlier color circle, here there is greater stress on the range of greens. Only colors found adjacent on the circle were premixed by these artists so the colors retained their purity of hue.*

Above *This sample of an ordinary weight canvas dates from about 1900. It has a white 'absorbent' ground of the type preferred by Neo-Impressionist painters. This sample was primed probably with a single coat of glue and chalk based primer, and was widely sold by French color merchants.*

palette edge to end in the black. During the 1870s, the new limited Impressionist palette may well have modified this layout because, by the early 1880s, a new method for arranging the palette seems to have emerged. Unlike previous painters, the Impressionists did not premix and lay out all their tints prior to painting. Their rapid methods of recording fugitive effects of light necessitated constant readjustments in their colors, which were mixed only as and when needed. Their method of merely squeezing out blobs of their tube colors, and mixing or applying them slurred as needed, gave far greater scope for spontaneity during the painting process than had the premeditated mixtures of earlier artists. During the 1870s, it is likely the Impressionists evolved the new prismatic layout for their colors. This meant arranging them according to their position on the chromatic color circle, which was based on the order of the rainbow colors of the prism, rather than tonally, from white to black.

This procedure was tightened up and systematized by the Neo-Impressionists. Since, apart from in their preparatory oil studies from nature, rapid handling to capture fugitive lighting effects was not part of their method, palette layout again became premeditated. Not only were their pure tube colors laid out according to the color circle — yellows, reds, violets, blues, greens and back to yellow — but their tints of these colors with white were also prepared in advance and laid out in a separate row on the artist's palette.

However, the Neo-Impressionists continued to use certain methods developed by the Impressionists. For instance, they, like the Impressionists, were convinced of the advantages of mat paint surfaces and of mixtures with white which gave greater light-reflectiveness and therefore a more luminous, accurate evocation of natural atmospheric light. Similarly, like the Impressionists from the 1870s, the Neo-Impressionists shunned the use of varnish over their finished pictures. Varnish distorted the

carefully calculated, delicate color relations, darkened the pale opaque surface effects and destroyed the matness of their paintings. The Neo-Impressionists also adopted the Impressionists' use of relatively oil-free paints because the mat paint surfaces these produced provided a superb visual analogy with the matness of natural surfaces under sunlight. The Neo-Impressionists sought new ways of recreating the effects of vibrant outdoor light. One such method was the adoption of canvases prepared with absorbent grounds.

For oil painting, artists had traditionally preferred relatively non-absorbent, oil-based grounds, because they enhanced the oil colors by leaving the paint layer with the glossy finish and rich colors which were considered desirable. However, absorbent grounds were reintroduced by color merchants in the early nineteenth century. These were similar to the gesso grounds made from chalk and glue which had been used with tempera before the Renaissance. The merchants' motives were purely economic, as absorbent grounds dry more quickly than the oil-based variety. However, absorbent grounds draw oil from the colors, producing a dryer, chalkier paint layer than is possible on oil-based grounds, and this was ideal for the Neo-Impressionists. This mat paint finish, in combination with the white absorbent ground gave a brilliant light-reflective quality which was perfectly suited to creating the visual effects sought by the Neo-Impressionists.

Left *This detail from The Attributes of the Arts (1766) by the French artist Chardin (1699-1779) shows a palette, knife, paintbox and brushes. The palette is oval in shape and shows a tonal layout of colors. They are set out in a row, starting with white nearest the thumbhole, working round to the darkest hues. Hog's hair brushes here are attached to their handles with leather thongs. This makes them round in form. With the introduction of tin ferrules, a flat shape could be made. This was popular with the Impressionists. A metal dipper to hold painting medium or diluent is clipped to the edge of the palette. Dark hardwood was usually used for palettes, and this made it difficult for artists painting on light grounds to judge their color values when mixing on the palette.*

Although in his large finished canvases from the first half of the 1880s, Seurat used an opaque paint layer which obliterated most of the white ground, this still adds to the general brilliance and durability of his paint layer. However, in his studies — often from nature — his open criss-cross brushwork often left the ground showing through. It is clear, especially from earlier examples, that he was then also using tinted grounds, particularly gray, in a manner similar to that employed by the Impressionists. On occasions, unlike the Impressionists, he also used small wood panels, usually cigar box lids, which were often left unprimed so that the warm reddish-orange wood played an active role, unifying and complementing the openly applied colors in the paint layer. As in academic practice, these little paintings were either *études*, which served as memory aids, annotating Seurat's first impressions of light and color on the scene, or they were rapidly executed compositional sketches in which he experimented with various alternative compositions for large-scale works. All these elements, together with his careful tonal drawings of individual pictorial components, were finally used as the raw material for his controlled studio pictures.

Seurat's drawing technique, which was adopted by many of his followers, was quite individually distinctive, despite a similarity to the drawing techniques of Millet's late works which clearly inspired them. In the early years of his career, although pursuing his interest in color through reading, and studying masters like Delacroix, Seurat concentrated almost exclusively on developing his drawing technique. This was very much in line with academic practice, yet the resulting images achieved their lucid, timeless classicism with little reference to accepted academic methods. Seurat's preferred drawing medium was black Conté crayon, an artificial chalk so fine as to be almost waxy in feel. He worked on rough hand-made Michallet paper — a famous French brand — which had distinctive paper-mold marks and was commonly called 'Ingres' paper. By varying pressure with the soft chalk on this irregular creamy-white surface, he could achieve great variations of tone. Gentle marks caught only on the protruding ridges or tufts of the paper, leaving the hollows white, while heavy marks crushed the tufts, forcing the crayon into the hollows and resulting in a totally blackened surface. Thus, by varying his touch, Seurat was able to create every possible nuance of tonal gradation, from the white of the paper through to solid velvety blacks. This mature drawing method totally renounced the use of line to create the edges of form, relying completely on subtle tonal modeling instead, enabling Seurat to evolve his strong handling of form through tonal contrast, which he translated in his painting into color modulations and contrasts.

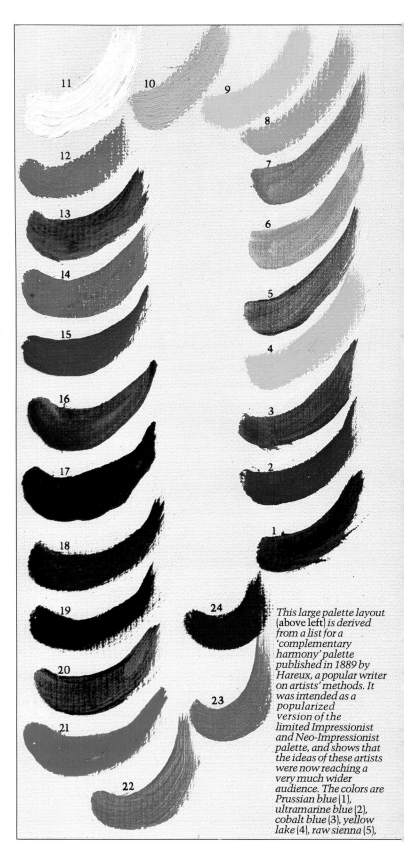

This large palette layout (above left) is derived from a list for a 'complementary harmony' palette published in 1889 by Hareux, a popular writer on artists' methods. It was intended as a popularized version of the limited Impressionist and Neo-Impressionist palette, and shows that the ideas of these artists were now reaching a very much wider audience. The colors are Prussian blue (1), ultramarine blue (2), cobalt blue (3), yellow lake (4), raw sienna (5),

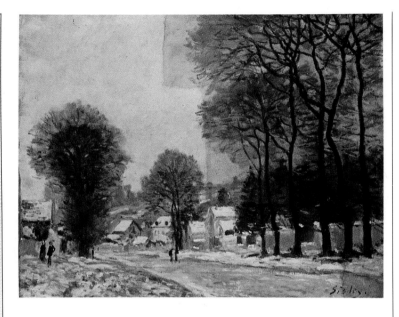

Left *This photograph of Sisley's* Snow at Louveciennes *(c1874) was taken during cleaning by the Courtauld Institute Department of Technology in London. It shows the dramatic effects of dirt and discolored varnish. Yellowed varnish makes the blues appear green, and casts unintended warmth over all color values. To avoid this danger, most Impressionists and Neo-Impressionists preferred unvarnished paintings. They also preferred to leave works unvarnished because they sought mat effects, and varnish not only made the surface glossy, it also darkened the pale tints selected to evoke natural light.*

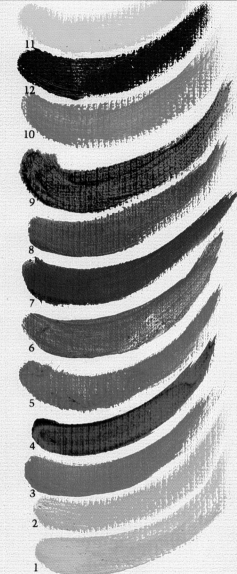

Left The Gleaner *(c1883) by Georges Seurat was drawn in black Conté crayon on Ingres paper. Seurat built up the tonal gradations in his drawing by varying the pressure and the density of the marks. The white of the paper glows through, giving the sensation of light emanating from the drawing itself. Although the criss-cross web of strokes may seem bold and disordered, the technique may in fact have been inspired by the approach for oil sketching taught by his academic tutor Lehmann. Seurat used similar handling in his small oil sketches of this period. Of even greater importance in the formation of Seurat's distinctive drawing style were undoubtedly pastel works by Millet. Seurat's mature drawing, like this one, is completely tonal in style, avoiding hatched lines or contours that contain form. Instead, the forms loom out of the prevailing darks.*

Indian yellow (6), yellow ochre (7), deep cadmium yellow (8), pale cadmium yellow (9), Naples yellow (10), flake white (11), vermilion (12), alizarin crimson (13), rose madder (14), Indian red (red earth) (15), burnt sienna (16), Vandyke brown (17), raw umber (18), ivory black (19), viridian green (20), emerald green (21), cobalt green (22), chrome green (23), and malachite green (24). The smaller palette (above right) shows Signac's prismatic palette layout. The colors were arranged *according to the color circle and not in the traditional tonal order. The colors are mid cadmium yellow (1), deep cadmium yellow (2), vermilion (3), alizarin crimson (4), rose madder (5), cobalt violet (6), ultramarine blue (7), cobalt blue (8), cerulean blue, viridian green (9), pale chrome green (10), deep chrome green (11), and pale cadmium yellow (12). Certain of the colors, such as yellow lake, are not available today, so modern equivalents have been shown instead.*

Below *Seurat developed his dot touch during the summer of 1885, when this work,* Le Bec du Hoc at Grandchamp, *was executed. The detail from the center cliff edge (right) shows that, despite a reduced size of touch, the shape of mark still varies, subtly differentiating textures and following forms. The dot method enabled Seurat to note minute gradations of tone and changes of hue, giving him great control over his depiction of form and colored light.*

Pointillism and color theory

Seurat's mature pointillist technique, in which almost uniform 'mechanical' dots of pure color were built up over the entire paint surface, was already inherent in his work before 1885, although it was handled quite differently. Thus a dotted effect is discernible in his Conté drawings and in a painting technique adopted from the Impressionists. In this, his use of dragged, chalky paint catching on the raised canvas grain or on earlier dried brushstrokes in works like *Bathing* (1883–1884) presents the eye with an erratically speckled effect as broken layers of color reveal previous colors. However, his methodical application of colored dots, developed in works like *Le Bec du Hoc* (1885), was a systematization of previously

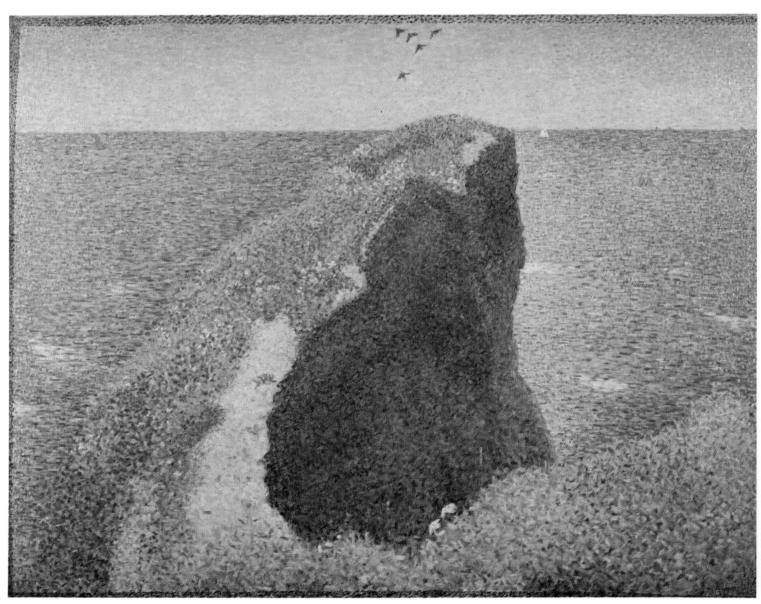

'accidental' effects. Recent scholarship suggests that Seurat's use of the dot technique was inspired by contemporary developments in color printing. Seurat showed great interest in this popular art form, both because of its techniques and its stylized designs. Seurat's radical taste for popular, 'democratic' art forms — which had precedents in the sources used by, for example, Courbet and Manet — and his fascination with modern science and technology, reflected his radical political leanings.

Seurat found the theoretical basis for his use of individual dots of prismatic color to depict the fusion of color and light in nature in the important treatise *Modern Chromatics* written by the American color theorist Ogden Rood and published in 1879. However, these ideas had been prefigured in the writings on color by theorists and critics such as Michel-Eugène Chevreul, Charles Blanc and John Ruskin which Seurat also consulted. Rood maintained that optical mixtures of rays of colored light, reflected from the paint surface and fusing on the spectator's retina, would be far superior in luminosity to the effects afforded by conventional, dull palette mixtures.

In Seurat's painting, the rays of colored light emanating from each separate spot of colored pigment were not intended to result in optical mixtures of greater intensity than their original individual components. They were also not intended to fuse completely on the retina, for the dots were generally too distinct for that. Rather, when seen at the appropriate viewing distance, which was considered to be of three times the length of the pictures' diagonal, the incomplete fusion of colored dots resulted in a flickering optical sensation. This was because, as the influential French Symbolist critic Félix Fénéon perceptively noted in 1886, 'the retina, expecting distinct groups of light rays to act upon it, perceives in very rapid alternation both the disassociated colored elements and their resultant color.' For Seurat, this gave a pictorial equivalent for the shimmering subtleties of transparency and reflected light found often in the halftones and shadows in nature. Seurat's use of small touches of color enabled him to achieve a twofold objective. On the one hand, it lent a limpid atmospheric luminosity to the painting. On the other, it gave a powerful sense of modeled forms. This was because Seurat could create minute variations of tone, from rich saturated color through to the palest tones, by increasing the proportion of white added to his color.

Between 1886 and 1888, Seurat began to extend his desire to systematize painting, searching for methodical means to convey predictable emotional effects in painting through precise combinations of line, color and tone. This new preoccupation was inspired both by the writings of his contemporary, the psychologist and aesthetician Charles Henry,

and by the ideas of the literary Symbolists, who were then coming to prominence. In the late 1880s the Symbolist movement in painting grew out of the literary Symbolist movement. Reacting against accepted ideas of naturalism and against modern society and technology, Symbolism emphasized the inner, emotional world of the creator as against the external natural world which had for so long been the chief source of artistic inspiration.

Aspects of Symbolist ideals pervaded most artistic developments during the late 1880s and 1890s, and the movement represented the first widespread repudiation of Impressionist ideas. Despite this reaction, the Impressionists' painting methods continued to provide a rich source of inspiration for many artists. Developments in the 1890s and after, which appear to be reactions against Impressionism, in fact owe much to the lively potential unleashed by Impressionist stylistic and technical innovations.

Left *This is an example of a chromotypogravure, published in the magazine* L'Illustration *in December 1885. In this early method of color reproduction, colors were reproduced as a series of dots. This may have inspired Seurat's development of his Pointillist method. He is known to have been fascinated by both modern technology and images derived from popular culture. This detail shows the similarity between Seurat's method, and that used here in color printing.*

PAUL CEZANNE

Mountains seen from l'Estaque/Montagnes vues de l'Estaque (c1878–1880)
Oil on cream-prepared paper, mounted later on canvas
53.3cm × 72.4cm/21in × 28½in

Born in Aix-en-Provence, not far from the French Mediterranean coast near where this picture was painted, Cézanne's upbringing under the clear golden light of the south was permanently to influence his vision as a painter. After regular, extended periods in the French capital during the 1860s and 1870s, a dislike of the city, and disillusionment with his lack of success, encouraged Cézanne to return to a more isolated existence in the south. Although visited regularly by friends, like Monet and Renoir in the early 1880s and, later, by the younger generation of artists, Cézanne spent less time in Paris, occasionally staying and working with colleagues in the northern countryside. The generally more stable, good weather, clearer light and purer atmosphere of the south of France provided Cézanne with the best conditions under which to pursue his particular preoccupations in painting from nature.

Cézanne painted slowly and carefully, often working on a single canvas off and on over several years. For this reason, the relatively more stable southern climate worked in his favor, enabling him to return to a motif, or subject, on many successive days and find comparable atmospheric effects. He realized that the effects of sunlight could not be reproduced in painting, but that the artist had to represent light through color. His fastidious concern with finding the precise tone or color value for each brushstroke in a painting, resulted from the need to construct an overall harmony of color — equivalent to that in nature — in which no single note was out of tune with the others. One incorrectly judged value in a painting would thus have necessitated reworking the entire canvas, to make it harmonize with that one jarring note.

Mountains seen from l'Estaque is an example of Cézanne's sustained study from nature. As with many eighteenth and early nineteenth century landscape oil sketches, this work was executed on paper. This support may have been chosen by Cézanne for economy and portability, because its large size and the degree of finish suggest that he did not see it simply as a sketch. Another important painting of around 15 years later, *Still Life with Plaster Cupid*, was done on an almost identical support. Cézanne bought the support for *Mountains seen from l'Estaque* ready primed with a cream commercial ground. Prepared paper was sold both in standard canvas size and in the differing standard paper sizes. This support is close in size to the horizontal landscape format 20, which measures 73 × 54cm (29 × 21in), and also to the *demi-grand aigle* prepared paper format measuring 75 × 52cm (29½ × 20½in). Prepared paper was normally sold with a creamy pale tinted priming, available in two different finish textures. The first gave the appearance of canvas fabric, for canvas was pressed into the wet ground and

then peeled off to leave its imprint. The second finish had the bubbled appearance of modern emulsion paint applied with a roller; this was the type chosen here by Cézanne. Pinhole marks in the corners of such paper supports are a reminder that they had to be attached to a firm card or wooden backing during painting.

In *Mountains seen from l'Estaque*, as in *Still Life with Plaster Cupid*, Cézanne intentionally allowed the cream ground to show through among the colors in the paint layer, leaving it completely uncovered in places. There it reads as a color in its own right among the applied colors of the paint layer, saving the artist time, or standing for highlights he intended to add in later. Like Renoir, Cézanne exploited the contrasting effects of warm and cool colors in his painting. Where the warm cream ground shows through, it creates vibrant contrasts with the cool colors in the paint layer. Thus, by juxtaposing opaque blues, for example on the skyline, left, against the cream of the ground, they are mutually enhanced. The cool blue appears even bluer and cooler, the cream of the ground is warmed, appearing pinkish against the blues. Because warm colors advance and cool colors recede optically, they can be used to model form and structure spatial recession. Cézanne's limited palette means that subtly modulated mixtures and repeated usages of the same color in different contexts, gives an extraordinary harmony to the work.

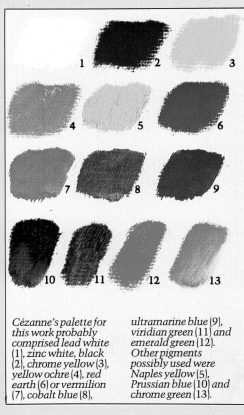

Cézanne's palette for this work probably comprised lead white (1), zinc white, black (2), chrome yellow (3), yellow ochre (4), red earth (6) or vermilion (7), cobalt blue (8), ultramarine blue (9), viridian green (11) and emerald green (12). Other pigments possibly used were Naples yellow (5), Prussian blue (10) and chrome green (13).

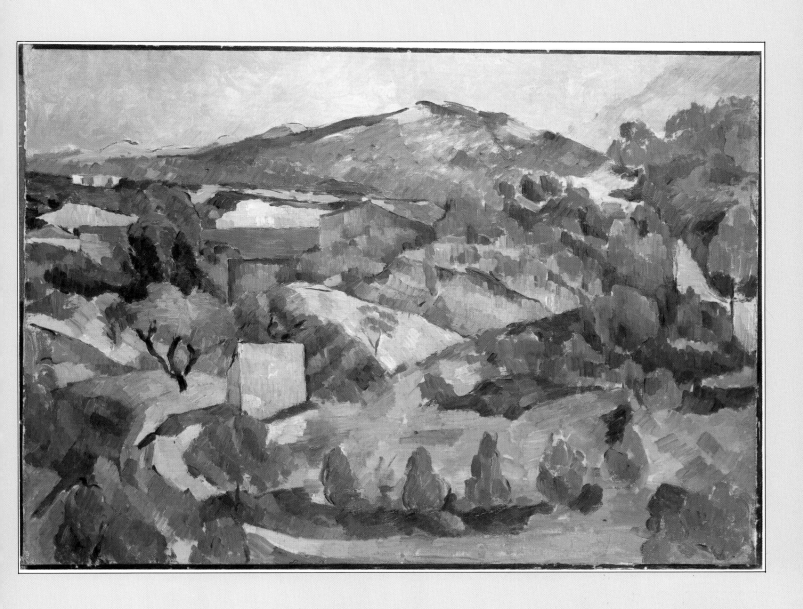

Thinly applied thus translucent sky paint, cream ground visible

Uncovered cream ground among skyline colors

Absence of tree shadow leaves strong form of swelling mound unbroken

Cast shadow tinged with reflected blue from sky

Fluid lines define form and suggest shadow

Hatched reworking of sky colors probably unfinished

Broadly scrubbed in colors for mountain

Accent of bright red, probably vermilion

Vertical parallel hatched brushwork follows plane

Full, curved strokes of the loaded brush for tree foliage

Cézanne's separate brushstrokes of paint serve both to record his visual sensations of color, and to structure his composition. The touches here vary according to the angle of planes and the direction of forms. The trees in the foreground are depicted with curved strokes which suggest their characteristic form. Local colors are bright in the clear light, modified only by the warm sunlight and cool blue shadows. The fall of light, from right to left across the view, casts shadows which add structure to the composition.

Brushstrokes depicting background areas are equal in size to those used in the foreground. This device is contrary to the more conventional use of varied brushstroke size to suggest depth and recession. More traditional landscape painters tended to paint the foreground broadly and diminish the scale of touch for 'distant' objects. Similarly, Cézanne avoided the use of aerial perspective – the lightening of hues toward the sky line to evoke distance. He painted his landscapes with the same degree of color saturation throughout. This tends to flatten the design close to the picture plane, producing tension between the surface pattern and the illusionistic qualities in the work.

Vertical, block-like strokes of color help define the form of the building, while the blue light-filled shadow attached to the side wall adds solidity. The shadow cast by the building anchors it in space, defining the ground plane on which it stands. The paint is thick and opaque. Its white hues evoke the quality of sunny southern light, bouncing off pale, dusty surfaces. The flowing rhythms of the parallel brushmarks almost sculpt the changing directions of planes of the landscape terrain.

The foreground stone building in Cézanne's picture shows the outdoor effects of warm sunlight. Unlike most of the other Impressionists, he often chose side-lit scenes, and here the rays fall at an angle of about 45° across the landscape, from right to left. The warm yellow sun casts a blueish shadow, picking up reflected light from the clear blue Mediterranean sky. This even shadow adds structure to the composition by 'anchoring' the form which casts it, and defining the ground plane on which the building sits. Alternating planes of warm and cool colors give form and space to the scene, although, by stressing the picture plane, the emphatic brushwork and strong colors tend to work against simple illusion.

The 'directional' brushwork evolved by Cézanne in the late 1870s can be seen in this picture. In places, for example the more roughly executed mountain in the background, the lack of finish has left the earlier, less organized brushwork exposed, but generally the size and direction of touch is fairly uniform. Sometimes the direction of touch sweeps round, following and emphasizing the separate interlocking folds of the landscape, as in the foreground parts. A high viewpoint, looking down on the scene, was chosen by Cézanne, and this tips the landscape up, flattening it closer to the picture plane and cutting down the sky area.

Cézanne preferred to work outdoors in very clear, crisp lighting conditions, particularly after storms when the air is very pure. In such light, even distant vistas appeared quite close and the phenomenon of aerial perspective — local colors becoming paler and bluer toward the horizon — was at a minimum. This meant that the colors of the landscape were at their most saturated and pure, and distant colors had almost equal strength to those close to. This uniform saturation of color is apparent in this picture, and it contradicts the illusion of space because background colors are as rich as those in the foreground. Cézanne's uniform size of touch, which makes the viewer very aware of surface qualities and textures, has a very similar effect. The contradictions between surface flatness and illusionistic space in Cézanne's painting, like that of Monet and Pissarro, create a characteristic visual tension. This work was first owned by Gauguin, who greatly admired Cézanne's methods.

Actual size detail The cream ground over the paper support is clearly visible here, for it is left uncovered along the line of the mountains. There, the cream color makes the cool blues of sky and hills more intense. The ragged paper edge is visible on the left. For preservation, the work was laid down on canvas, probably when Gauguin owned it in the early 1880s.

Cézanne's Still Life with a Plaster Cupid from the mid 1890s is painted on a support comparable to that used for Mountains at l'Estaque. It too was executed on commercially prepared paper, primed with a cream ground which shows through among the colors. In places, the cream ground was left bare to stand as a hue and tone in its own right, while on the center right, the thinly applied warm and cool colors of the floor area are influenced by the cream of the ground glowing through.

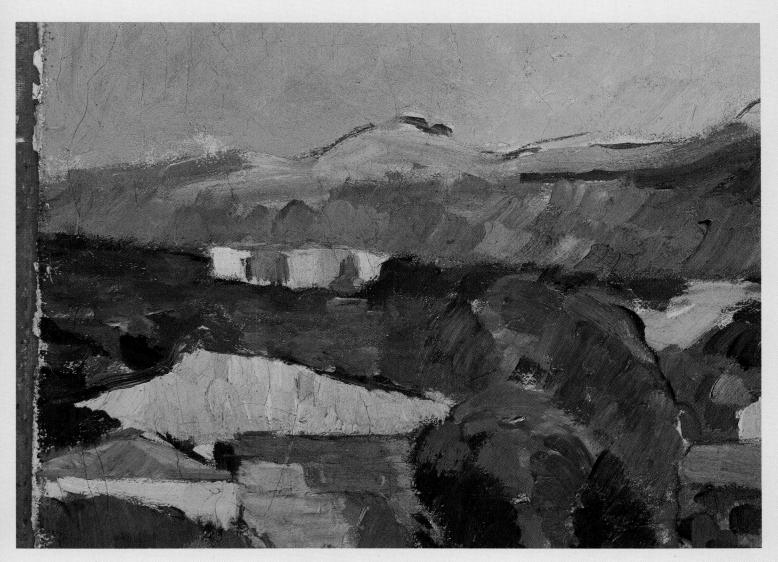

Contrasts in brushwork
and paint thickness are
visible here. This
difference gives distance
to the peak. However,
this is contradicted by
the zigzagged pale blue
which overlaps the paint
depicting the hillside in
the middle distance.

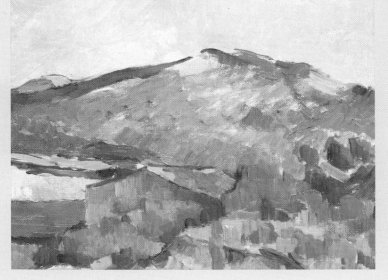

PIERRE AUGUSTE RENOIR

Rocky Crags at l'Estaque/Rochers à l'Estaque (1882)
Oil on white primed canvas
66cm × 80.5cm/26in × 31¾in

Like Monet, Renoir began the new decade of the 1880s by seeking out new sites for his subjects. In the spring of 1881 he went to North Africa, following in the footsteps of Delacroix (1798–1863), who had made a similar journey almost 50 years earlier. In the winter of 1881 to 1882, Renoir made the traditional pilgrimage to Italy. This journey had earlier been considered essential to artists following the classical tradition in art, but, in the nineteenth century, it had become inextricably associated with the academic monopoly through the Prix de Rome system. Renoir hoped thereby to allay criticism directed at his work, which had in the 1870s classified him as a revolutionary. He was in the process of rejecting what, by this time, he considered the insubstantiality of the Impressionist method, and was seeking to combine the Impressionist vision and palette with a more organized, structured technique.

At this time, he logically turned to Cézanne's example, for that artist had, in the late 1870s, been developing a tighter method for organizing the record of his visual sensations on the canvas. Cézanne's so-called directional brushstroke, visible in works like *Château of Médan* (c1880) proved an inspiration to Renoir, whose paintings Cézanne criticized as being formless.

On his return from studying the Raphael frescoes in Rome and the Pompeian frescoes in Naples, Renoir stopped off at L'Estaque to visit Cézanne in early 1882. There he fell ill with pneumonia, and was nursed by Cézanne. *Rocky Crags at l'Estaque* dates from this visit, and it was probably executed while Renoir was working in the company of Cézanne. While Cézanne clearly admired and learned from Renoir's sophisticated use of warm-cool color harmonies, Renoir evidently studied Cézanne's methods for giving greater structure to the arrangement of his compositions.

During the first half of the 1880s, Renoir experimented with thick, smooth white grounds, which obliterated the canvas texture and provided a brilliant base for reflecting maximum light back through the translucent, jewel-like colors of his paint layer. Unlike the smooth, mat absorbent gesso grounds of Italian and Flemish panel painting, Renoir's grounds were oil-based, glossy and relatively non-absorbent. They were applied with a palette knife, presumably by Renoir himself, as a roughness at the edges reveals the marks of the blade. The grounds were usually added over a grainy single coat of white commercial priming, which provided an excellent key for the additional layer. Other examples suggest that the thick, knifed ground was occasionally applied directly on the raw — but presumably sized — canvas. Renoir's son Jean recalls in his memoirs of his father, the ingredients of his later grounds, which were probably not dissimilar to those of this period. Lead white was mixed with one-third linseed oil and two-thirds turpentine spirit. A ground of this type, added over a commercial preparation, is apparent under *Rocky Crags*. Its smooth white surface increases the rich color saturation, especially of the more transparent hues in the paint layer, giving them an effect comparable to light shining through stained glass. Noting Renoir's preference for light and transparent colors, one writer later commented 'the white of the ground today plays the role which the kaolin of his plates once did', referring to the time when Renoir painted on porcelain.

Although in places, stiff, chalky dragged effects of paint are used in *Rocky Crags*, with the addition of opaque lead white, the overriding impression is one of juicy, brilliant color. Some premixing of colors is evident, but most are juxtaposed or slurred together on the paint surface itself. Renoir's mixtures never produce the dull neutrals, which usually result from mixing more than two colors, or from combining two colors directly opposite each other on the color circle. Such neutrals were more colorful than those obtained by adding black or dark earth colors, but they were nevertheless still muddier than those produced by Renoir's method. This involved mixing hues near each other on the color circle — like blue and red, or green and yellow. This method was later to form the basis of Neo-Impressionist color mixtures. Renoir's colors in this picture are so pure and separate as to be relatively easy to pick out. Transparent viridian predominates among the greens, cobalt among the blues. The yellows were cadmiums, and the duller Naples yellow was probably also used. A red alizarin lake, in places slightly browned with age, is used alone and mixed to provide oranges. Lead white appears in many of the pigment mixtures.

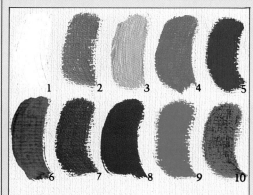

Renoir's palette for this painting probably comprised lead white (1), yellow ochre (2), Naples yellow (3), vermilion (4) or red earth (5), red alizarin lake (6), cobalt blue (7), possibly ultramarine blue (8), viridian green (10), and possibly emerald (9) or chrome greens.

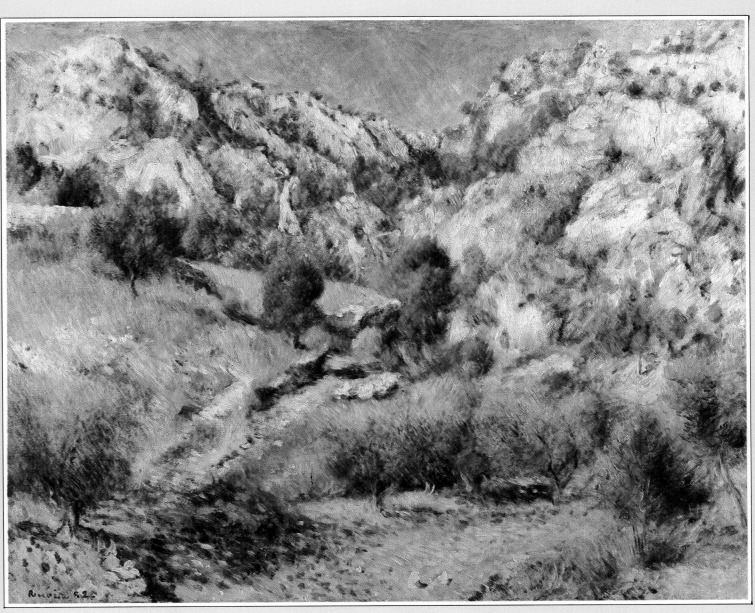

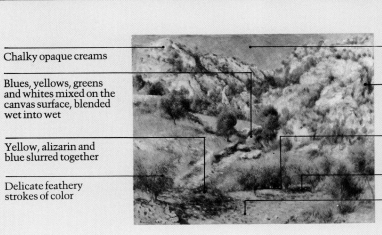

Chalky opaque creams

Blues, yellows, greens
and whites mixed on the
canvas surface, blended
wet into wet

Yellow, alizarin and
blue slurred together

Delicate feathery
strokes of color

Directional, parallel
strokes for blue of sky

Blues represent cool
reflected light in
shadows

Discolored alizarin, or
burnt alizarin, used for
lines of tree trunk

Rubbed on atmospheric
blues for cast shadows

Individual dabbed
brushstrokes of color

*Though some of Renoir's
colors were mixed on
the palette, he often
combined them on the
paint surface itself,
delicately blending one
hue with another to
result in a partial
combination of the two.
This gives vitality and
durability to his colors.
The paint layer is fairly
thin, with translucent or
transparent jewel-like
colors applied over
thicker opaque colors. A
squarish portrait 25
format suits the high
tipped-up viewpoint.*

This picture uses a technique with which Renoir had begun experimenting in the mid 1870s. In particular, in the foreground among the trees, the dry paint layer colors have been overlaid with a fine veil of pale opaque blue, which has been rubbed on to enhance shadow areas. This blue veil creates a film of color which appears to float in front of the actual paint layer brushstrokes, giving an effect of the ethereal blue light of the atmosphere. This effect is comparable to that achieved by Manet in the background of his *Roadmenders in the rue de Berne*, 1878. In *Rocky Crags*, the blues are also exploited amongst the shadows of the rocks, which are given form by the contrast of warm sunny colors against the cool blues of the shadows.

Although here Renoir has not yet adopted the directional stroke of Cézanne as universally as he was to in mid 1880s canvases, his touches are nevertheless tending to fall into regular parallel patterns. However, rather than taking on a life of their own, divorced from a descriptive role, Renoir's parallel touches sweep from one angle to another following the movement of land in foreground and rocks, and describing the pattern of foliage in the trees. Thus his brushwork remains personal and basically naturalistic.

The working alliance forged by Cézanne and Renoir during this stay was maintained throughout the 1880s. In 1883, 1888 and 1889 Renoir either visited or worked with Cézanne in the south, and in 1885 Cézanne traveled north and worked with Renoir at La Roche-Guyon, north-west of Paris.

Like all the darkish areas in Renoir's painting, this is depicted with richly saturated hues. Dark translucent blues were worked fluidly with an oil and turpentine medium added by the artist, and modified by the addition of wet blended colors. Alizarin lake, a rich transparent blueish red, is worked into the blue, and dabs of yellow ochre are added, some over dry and some over wet color below. Touches of viridian green can also be seen in this detail.

Here the color is more thickly and opaquely impasted, with chalky creams and yellows to suggest the sunlight of the south on the dusty rocks. Thinner films of color – yellow over blue, green over yellow and pale mauve over blue – were applied lightly and unevenly to modify the colors below without obliterating them.

This larger detail shows the variety of Renoir's touch and its descriptive qualities. Thinly, finely dragged color suggests the foliage, while elongated, fluid strokes of burnt alizarin lake stand for the tree trunks and branches. Dark, saturated blues and greens are slurred together for the shadows.

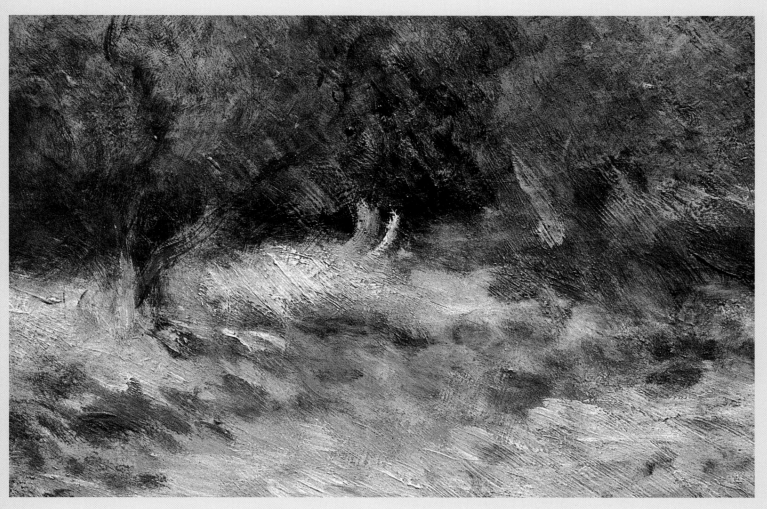

Actual size detail
Light-reflecting, luminous creamy-whites and yellows evoke the chalky soil where the olive trees grow. The silvery blue-green of their foliage is aptly conveyed by the artist's lightly brushed translucent layers of blue and viridian green. The gnarled tree trunk is suggested by thinly applied red. This may be alizarin red discolored with age, or the intentionally darkened hue of burnt alizarin. The floating, atmospheric blue of the shadow below the tree is an excellent example of Renoir's skill in evoking virtually intangible films of color, by applying a veil of rubbed or brushed color so thinly that it seems to float in front of the colors below. Blue with much white added serves this purpose here.

BERTHE MORISOT

*Woman and Child in the Garden at Bougival/Femme et
enfant dans le jardin à Bougival* (1882)
Oil on unprimed canvas
59.6cm × 73cm/24in × 28¾in

Berthe Morisot and her sister Edma both began training for careers in art in the mid 1850s. They made copies after Old Masters in the Louvre, including the Venetian painter Veronese (1528–1588), in the latter years of the decade. From early on in her career Berthe Morisot admired landscape painting, especially that of Corot (1796–1875), and wished to begin working out of doors. In 1861 she was introduced to Corot, with whom she worked on landscape subjects around his home at Ville d'Avray, west of Paris, and she became his pupil. As early as 1864 she exhibited two works at the annual Salon exhibition. Since women were still excluded from life classes, they were effectively prohibited from competing in the history painting category, the height of academic achievement. Thus, the undermining of academic authority through the growing popularity of modern life subjects and landscape painting gave women greater opportunity to achieve renown within the terms defined at that time.

In 1868 Fantin-Latour (1836–1904) introduced Morisot to Manet, who painted her in his *Balcony*, exhibited in the Salon the following year. Manet advised her on her work, to the extent of retouching her painting of the *Artist's Sister Edma and their Mother* (1870), which was shown at the Salon of 1870. A devoted friend and loyal colleague, Morisot exhibited at every group show of the Impressionists, apart from the fourth in 1879 when she was pregnant – she had married Manet's brother Eugène in 1874. True to the Impressionist hard line, she sent no works to the Salon after the first group show in 1874. She also joined in the auction organized with Monet, Renoir and Sisley in 1875 to raise money, although she herself was not in financial need. Her work fetched higher prices than that of the others. In addition to painting in oils, Morisot worked regularly in watercolor and pastels.

Berthe Morisot had a house in Bougival to the west of Paris where, from 1880, she regularly spent her summers painting from nature. This picture, which probably shows her four year old daughter Julie with her maid Paisie, was painted in the garden at Bougival. Morisot's distinctive style and vigorous, nervous brushwork are clearly in evidence here. Her choice of an unprimed support at first seems unusual, for the Impressionists rarely used raw canvas under oil paint because the colors sink and dull, and the oxides in the oil are destructive, corroding the canvas fabric. However, closer examination of the bare canvas, revealed especially at the bottom right-hand corner, suggested that the canvas was indeed primed, but on the reverse side. Removal of the painting from the wall revealed another picture, painted on the original primed face of this standard format portrait 20 canvas, which had proved unsatisfactory and had been abandoned by the artist. Rather than waste the canvas, Morisot simply untacked it from its supporting stretcher, turned it over, and tacked it back on. Few artists primed their own canvases at this time, preferring to buy ready primed canvas directly from the color merchant. Morisot did not prime this new surface, but exploited both its color and its marked texture in her handling of the subject.

The almost orange-brown of the canvas fabric, which may be a linen-cotton mixture, is left most visible among the acid greens of the sunlit grass. Here it adds a warm unifying tint which sharpens those cool green hues. The paint has been built up to its greatest density in the central oval of the composition. This is reminiscent of Corot's technique, for he built up the relief of his pictures toward the central point of interest in his compositions. Yet it is also quite logical here, both because of the centrally placed figures, and because – in accordance with the Impressionist commitment to depict personal visual experience – human binocular vision concentrates upon the central oval field of focus. Many less finished Impressionist paintings betray this unequal distribution of paint, indicating that the four corners of the rectangular canvas were usually the last parts to be fully resolved and tightened. In this work, where the paint is thinnest, it is very dull because its oil binder has sunk rapidly into the absorbent raw canvas. Where it is thickest, the layering of color has gradually sealed the canvas, and the final reworkings have left those parts glossier.

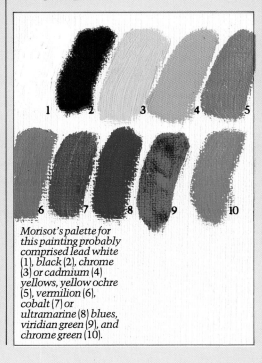

Morisot's palette for this painting probably comprised lead white (1), black (2), chrome (3) or cadmium (4) yellows, yellow ochre (5), vermilion (6), cobalt (7) or ultramarine (8) blues, viridian green (9), and chrome green (10).

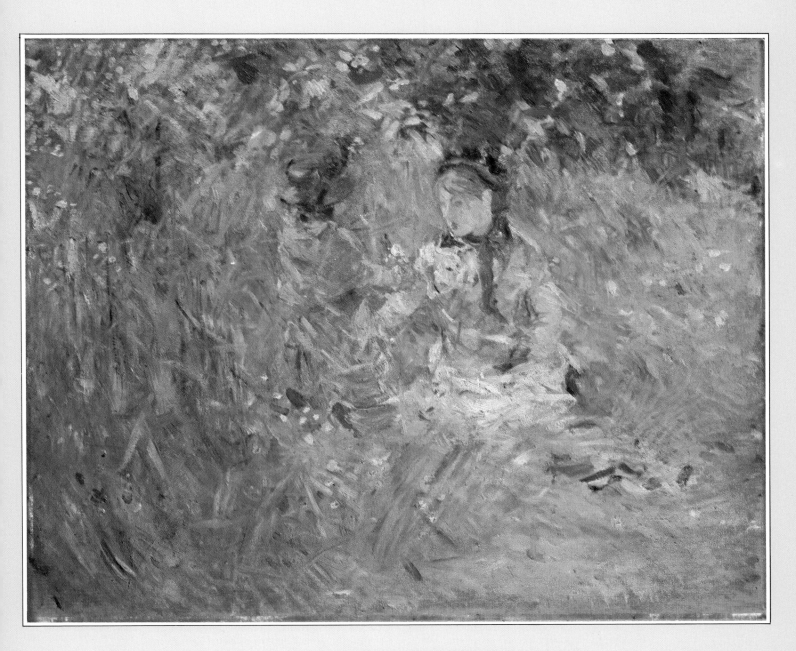

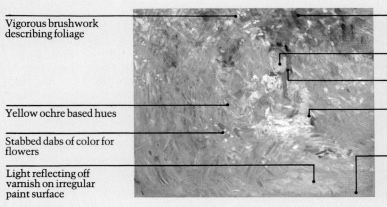

Vigorous brushwork
describing foliage

Yellow ochre based hues

Stabbed dabs of color for
flowers

Light reflecting off
varnish on irregular
paint surface

Viridian green based
mixtures

Wet-in-wet handling of
flesh tints

Vermilion worked wet
into wet

Touches of blue,
probably cobalt, with
white slurred wet into
wet

Raw canvas showing
through near edge
among loosely applied
colors

*This is one of the few
examples of the use of
unprimed raw canvas
under oil colors in
Impressionist painting.
It is a standard format
portrait 20 canvas. The
ready primed side of the
support was turned after
an unsuccessful start so
the artist could reuse the
canvas back. The warm
orangey brown of the
fabric was exploited by
Morisot to unify the
paint layer colors and
add warmth to the cool
greens.*

Morisot's loose, dashing touch is used almost everywhere except for the woman's face. This is more tightly and carefully built up with smoother application of paint, but it is not excessively blended or modeled. In the more shadowed parts, like the neck, cool tints are added to suggest the reflected hues from sky and grass. Elsewhere, the lively dragged, broken and slurred brushwork gives a vital sense of light flickering off and blurring forms, evoking the summer atmosphere. Black may have been used for the color of the woman's hat, and vermilion red was slurred in wet with white for the bonnet ribbon. White was applied almost pure for the highlights on the dress. In the shadowed areas, the white was modified to a colorful neutral hue with pinks, greens and blues.

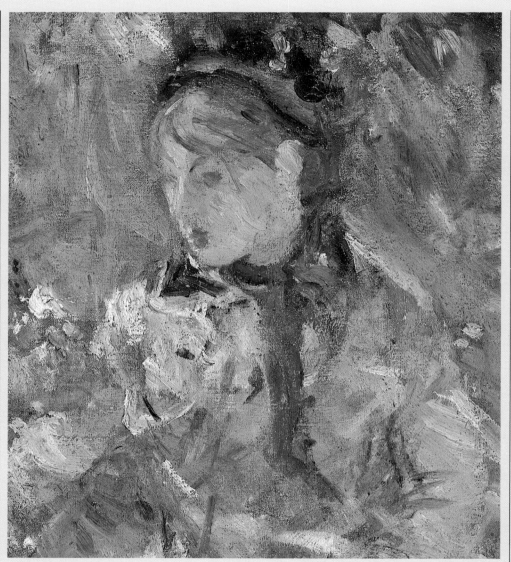

Actual size detail
In the more thickly painted and reworked central area of the painting the build-up of color has sealed the raw canvas to leave the color glossy. However, in this thinly painted corner even the varnish has become dull and sunk into the absorbent support. The unusually orange hue of the canvas may indicate that it is a cotton rather than a linen-based fabric, a support which gained in popularity during the nineteenth century. As raw canvas is so absorbent, it draws out the oil from the paint, which makes the brush drag as color is laid on. This makes it a difficult surface to work on initially. The use of oil paint on raw canvas was proscribed by technical experts as the oxidizing elements in the oil gradually eat into the unprotected fabric.

Combined with the upward sweep of brushstrokes depicting tall grass on the left, the lack of excessive reworking particularly in the bottom right corner creates a ground plane, perhaps a path, which gives extraordinary eloquence to the composition despite minimal detail. The composition excludes sky and distance, closing the figures round with an envelope of green, which nevertheless appears to recede back to the right. The darkest green mixtures are above the figures, reversing the traditional method which called for darks in the foreground. The overall tonality of the picture is pale and bright, with much white used in all the color mixtures. The limited palette is dominated by greens, mainly mixed greens incorporating viridian and yellow. A slurred, partly wet-into-wet combination of yellow and vermilion with white was used for the little girl's dress, while a purer vermilion depicts

Paisie's bonnet ribbon. Smudges of blue, probably cobalt, appear on her dress, mixed in with some of the greens. Creamy hues dabbed amongst the greens convey reflected light from seeded sun-dried grasses, the whole unified by Morisot's strikingly free brushwork.

During the 1880s, Berthe Morisot's Paris house became a key meeting place for the Impressionists and their friends. From 1886, regular gatherings took place where Monet, Renoir and Degas joined the Symbolist poet Stéphane Mallarmé, Berthe Morisot and Eugène Manet to exchange news and views on artistic developments in Paris. Thus Morisot was a central figure in maintaining contact amongst members of the Impressionist group as their paths diverged geographically. She remained loyal to Impressionist ideals and techniques throughout her career.

Brushwork for the child's bonnet follows the forms of the hat, helping to give it shape and structure. This contrasts with the freer handling of color for the grass and foliage in the background. Yellow ochre is the basic hue of the hat, which may be darkened by the addition of black, worked wet into the yellow.

Sweeping, dragged brushstrokes of yellow ochre and mixed greens blend from the dress to the grass, suggesting the ill-defined forms as the child's body disappears among the tall grasses. Touches of almost white paint evoke white flowers.

MARY CASSATT

Woman in Black/Femme en noir (*c* 1882)
Oil on pale primed canvas
100.6cm × 74cm/39¾in × 29in

Mary Cassatt came from a wealthy family near Pittsburgh, Pennsylvania, and early on showed her determination to pursue a career in art by enrolling at the Pennsylvania Academy of Fine Arts, Philadelphia, apparently against her father's wishes. It was still unusual, not to say unconventional, for women of middle-class origins to desire or seek a profession at that time, for ladies were not expected to do paid work. If they did, their social status suffered. In Europe, where Cassatt went after four years' study in Pennsylvania, it was easier for a woman to become an artist, as Cassatt herself stressed: 'After all give me France. Women do not have to fight for recognition here if they do serious work.'

Her first travels in Europe from 1866, were to study the Old Masters, for relatively few examples of their works were then available to American students on their own continent. During the Franco-Prussian War and Paris Commune of 1870–1871, Cassatt went back to America, returning to Europe when hostilities ceased. She then went first to Italy, spending eight months studying the work of the proto-Baroque painter Correggio (*c* 1489–1534) in Parma. In 1873 she, like Manet earlier, went to Spain to learn from the art of Velazquez in Seville and Madrid. Her earliest entries to the Salon exhibitions, from 1872, show the influence of Manet's 1860s Spanish themes and style. After a visit to Belgium and Holland to study the art of painters like Rubens, she finally settled in Paris.

Her meeting with Degas, and through him the Impressionists, in 1877 meant that, like Gustave Caillebotte, Cassatt was a relative latecomer to the Impressionist group. At Degas' invitation she began exhibiting with them in 1879. Degas had seen her entry to the 1874 Salon, and commented 'There is someone who feels as I do', a remark which gains resonance in view of their lifelong friendship, which evolved from the time of their meeting. Cassatt later recalled 'I already knew who were my true masters. I admired Manet, Courbet and Degas. I hated conventional art. I began to live.' In common with Degas, Cassatt felt that art should be based on a solid study of the Old Masters, on disciplined work from the model, and on complete mastery of line, color and compositional organization.

Unlike Degas, her circumscribed social position as a middle-class woman meant that her range of subject matter was limited. For while men like Degas had unrestricted access not only to teaching studios where the life model was used, they could also hire male or female models to pose nude in their own studios. For women, who were not even permitted to be alone in a room with a man if he were not a relative, work even from clothed male models was unacceptable. Thus Cassatt's chief sub-

jects – domestic interiors, women reading and doing needlework, mothers and children and middle-class leisure activities indoors and out – were determined by what was appropriate for a woman of her class at that time. These restraints resulted in a great awareness in Cassatt of the oppression of women, and she aligned herself openly with the American struggle for women's suffrage.

Her earliest techniques owe much to Spanish art and to Manet. Her palette was then still dominated by somber hues which created a stark fall of light and shade reminiscent of Manet and which reflected the studio environment. Bright colors – reds, blues, greens – sang out in works like *Torero and Young Girl* (1873) against the subdued foil of dark hues and a plain background. Her figures were treated close up to the picture surface, large in scale, dominating the picture space with lively strength. As her style developed, she gradually abandoned the tonal palette for an Impressionist palette of pale tints, bright colors, and colorful rather than brown shadows. As Degas noted around 1890, Cassatt became preoccupied with the 'reflections and shadows on skin and costumes' in her sitters, which she handled with the opaque color mixtures characteristic of Impressionism.

Like Manet, Degas, Renoir and Cézanne, Cassatt never abandoned the use of black, as can be seen from her *Woman in Black*. But, like them, she used it as a color in its own right, not as a substance to tone down and sully pure color, for use in shadows. Her composition here is typically taut and carefully calculated in relation to the canvas edges and shape. The

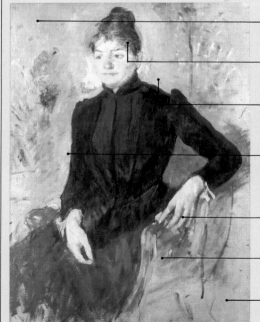

Opaque pink gray layer modifying ground color

Scraped down *ébauche* layer still apparent

Fairly thick, loaded colors rapidly dragged directly over ground

Original position of sitter's right arm changed and moved right

Wet flesh colors dragged with clean dry hog's hair brush

Dryish color thinly roughed in

Oatmeal color of ground left exposed

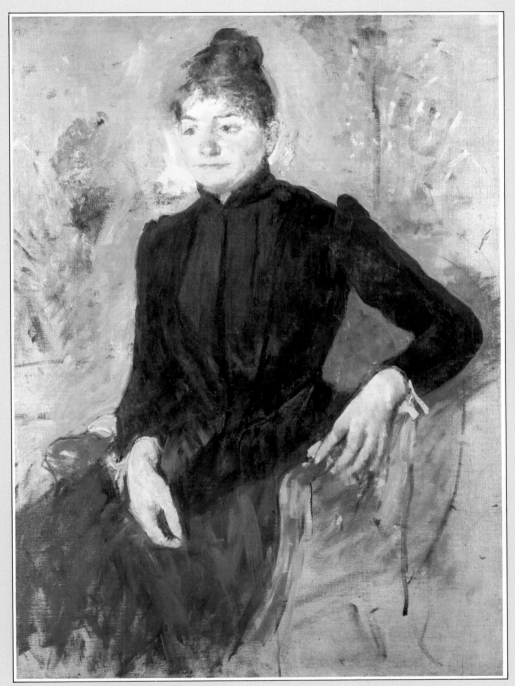

The unfinished nature of Cassatt's portrait clearly shows her method of working. Contours of the form were laid in and later strengthened with dilute color – probably a mixture of burnt alizarin crimson and black. This same color was used to lay in the masses of the figure's somber costume, but the subtlety of the mixed hue means that undue harshness is avoided. All parts of the figure handled in this first ébauche were then left to dry, and certain areas, notably the head, were then scraped down. Some of the scraped areas of the head are still apparent among the incomplete final touches. Parts of the background were sketched in broadly in thicker paint, which has been dragged across the fine but grainy canvas texture. In the upper and lower right of the picture, the oatmeal color of the thin ground remains uncovered. To the left of the head, the background was roughed in with an opaque pinky gray color. Thicker opaque color was also built up on the face, hands and chair. In the flesh areas, Cassatt's characteristic dragging of the wet colors, a personal variant of the old technique of blending, was used to soften and blur the initial vigorous handling of the form. The painting was executed on a standard format vertical landscape 40 canvas.

figure is pushed close to the canvas surface, filling the space. Her coiled hair is close to the top edge, and her elbow, positioned close to the right edge of the canvas, creates a precise tension. The elongated format of the standard vertical landscape canvas 40 (100x73cm/39½ x29in) aptly suits the tense upright pose of the sitter. This vertical emphasis is strengthened by the position of her right arm, creating a vertical to left of the center of the picture, which ends in the stark contrast of the flesh tints of her hanging hand against the mixed alizarin and black colors of the dress.

The unfinished state of the picture, whose sitter remains unknown, provides ample evidence of Cassatt's working methods. Both dryish and fluid lines, laid rapidly, indicate the contours of the figure and chair, while the rudiments of the interior are loosely summarized, not by broad washes of color, but by chalky, dragged undiluted color scrubbed hastily onto the surface. Logically with a portrait, the bulk of the paint build-up is concentrated on the head and figure, with the face brought to a fair degree of completion.

Cassatt's brushwork is broad and decisive, and the varied width of her brushes, from the fine contour strokes to the wide strokes on the dress, are clearly discernible. Her character-istic handling of flesh, as in the sitter's left hand, where the wet paint has been pulled and blurred across the original contour line, dates from around 1880. It was probably achieved by stroking the wet color with a clean, dry hog's hair brush, so that it smoothed the separate touches of color, blending them together, and adding a softening sense of captured movement to the crisp underdrawing. Cassatt's changes to the left elbow, which are still visible, indicate her concern over the position of the arm, and the foreshortening of the forearm, in relation to the canvas edge. Her awareness of the visual power of the void, the shape created between objects, is clear in her careful structuring of this part of the composition. This relationship between object and void, exploited also by Degas and Cézanne in particular, is apparent in her finished compositions, like *Girl in an Armchair*, (1878).

Mary Cassatt's historical position as an important member of the Impressionist group has suffered because, both as a woman artist and as an American in Paris, her work did not fall into any simple art historical category. However, the strength and originality of her art, which included printmaking and pastels, provide indisputable evidence of her stature as an artist.

Actual size detail *Brushwork and paint thickness vary greatly, including slurred wet-into-wet and wet-over-dry handling. The much used mixture of burnt alizarin and black serves for the contours of the fingers. The technique whereby with a dry bristle brush was dragged over wet flesh tints softens the crisp execution of the hand, blurring the pale hues into the darker contour. This gives a feeling of lively movement. The mixed black and burnt alizarin of the dress are visible, and a freely added sweep of cobalt blue mixed with white was added to represent the cuff. In the area below the hand, dryish color was roughly scrubbed on in a thin but opaque layer.*

Near the woman's left eye and ear the ground is worn and specks of raw canvas color show through. This might have been caused by excessive scraping of the ébauche layer. Touches of bright vermilion and white can be seen on the face, and red lake on the ear. Yellow ochre dominates the mixture used behind the head. In places it was clearly brushed over the head colors, indicating it was added fairly late. The flesh colors were dragged and slurred wet with a dry hog's hair brush. Thick, stiffish colors were loosely applied for the background on the right where the ground can also be seen.

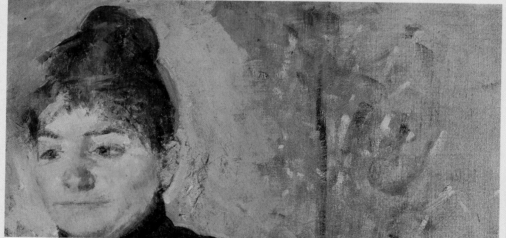

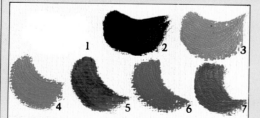

Cassatt's palette for unfinished work probably included lead white (1), black (2), yellow ochre (3), vermilion (4), burnt alizarin lake (5), cobalt violet (6), and cobalt blue (7).

The chair arm was a late addition, probably added when the woman's right arm was moved in closer to the center to make the pose more three-quarter than full-face. It appears the dress was at first intended to fill the space where the chair arm now is. Outlined in alizarin and black, the chair arm was filled in with a yellow ochre mix, which loosely covers the original design.

EDGAR DEGAS

Portrait of Mademoiselle Hélène Rouart/Portrait de
Mademoiselle Hélène Rouart (1886)
Oil on putty-color primed canvas
161cm × 120cm/63½in × 47in

During the 1880s Degas' failing eyesight was giving him serious difficulties with his work in general, and with oil painting in particular. This large portrait of Hélène Rouart was one of the last major works in oil attempted by the artist, and his final statement on the theme of the sitter in a characteristic environment, which had preoccupied Degas since the Bellelli family portrait of 1859–1860. Degas had had problems with his eyesight since the early 1870s, and in part as a result of this, he gradually turned to media like pastel, which offered a more direct method of coloring. With oil painting, the artist mixed colors on the palette more than on the support itself, and this extra stage was eliminated by working with pastel, in which the colors are applied and mixed directly on the support.

Degas' friendship with Hélène Rouart's father, Henri Rouart, began in 1870. Rouart was a successful and wealthy industrial engineer, who took up landscape painting and also amassed an impressive art collection, which included Egyptian artefacts, Old Masters and modern painting from works by Corot and Millet to the Impressionists themselves. He owned many works by Degas, whose portrait of his daughter was part of a grander project to portray the entire family, a project curtailed by the death of Mme. Rouart. Henri Rouart was encouraged by Degas to show his work, and apart from regularly lending Impressionist paintings from his collection for exhibition, he also exhibited his own work at almost all the eight Impressionist group shows between 1874 and 1886.

The works from Rouart's collection which surround Hélène's figure in this portrait have been identified. The glass case to the left contains three wooden Egyptian statues, the nearest a funerary figurine. On the wall behind her are, at the top, part of a Chinese silk hanging, and to the right a view of Naples painted by Corot in 1828, possibly included as an allusion to Degas' own familial attachment to that port. Below the Corot is a black crayon drawing of a peasant woman by Millet. Rouart also owned several important pastels by Millet, which may have influenced Degas' development of the medium, late in his life.

Hélène Rouart is thus presented not in an environment which complements or clarifies her own individual character, but one which tells the viewer about her social role as her father's daughter. Indicative of the cloistered, chaperoned life led by most middle- and upper-class unmarried women in this period, this portrayal of Hélène Rouart shows her trapped among her father's belongings, like another of his possessions. The taut precision of Degas' composition, and the shallow, claustrophobic pictorial space aptly convey this.

Degas has placed Hélène Rouart immediately behind the symbol of her absent father, his huge study chair, which dwarfs her physical presence. To her right, she is hemmed in by the free-standing glass case which houses her father's Egyptian statues, the nearest of which — ironically the funerary figurine — echoes her own pose, its head level with hers. This visual pun was perhaps a humorous reference on Degas' part to the stiff formality often imposed on women of her class, by the restraints and expectations of society. However, Degas was not renowned for his sympathy towards women. To her left, she is crowded by the pictures hung on the wall, and their distance from her is made ambiguous to stress the airless feel of the home environment that closes around her. Above, the dark reds of the wall hanging push down and, linking with the same reds of the chair back, squeeze her between them. The blue border at her head level creates a striking horizontal which equates visually with the upper framing edge of the picture, which brings it and the red hanging up toward the picture surface, further diminishing the pictorial space. The blue border meets the frame of the Corot at right-angles, just behind her head, a device which anchors her, tightly immobilized within the composition. Hélène Rouart is completely enclosed in the rigid network of interlocking geometrical shapes and planes that surround her seated figure.

In addition to the chair, the foreground is blocked and dominated by a table piled up with her father's papers, which are a further reference to the implied weighty presence of her father in the painting. The three-dimensional glass structure of the display case could have been used by Degas to open and define a sense of space around his sitter. Instead, its receding

Stiffly brushed color including red earth

Front edge of glass case forming part of careful compositional grid

Adjustments to angle of shoulder make them echo the compositional horizontals, pulling her square to the picture plane

Thin transparent underlay (*ébauche*) showing

Unfinished, blurred adjustments to hand

Loosely scumbled dilute color over pale ground

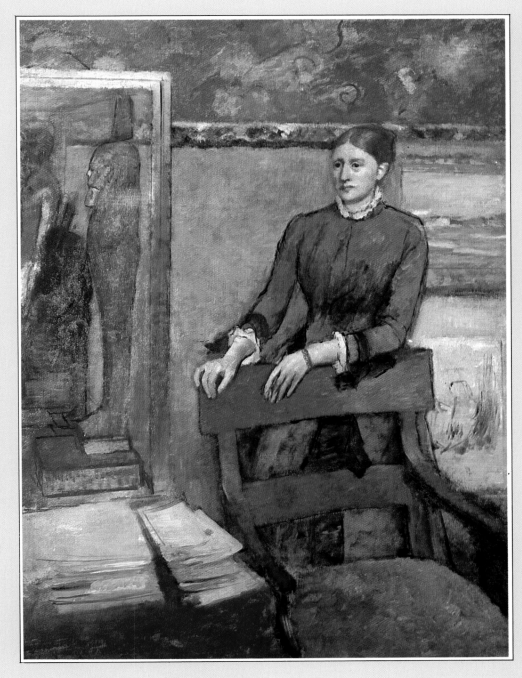

By the time this work was painted, Degas' eyesight was becoming poor and his field of vision restricted. This disability may account for the loosely finished state of the picture. However, the artist had lost none of his powers of acute psychological perception and the work lacks nothing in its surety of touch or compositional precision. As ever, Degas was concerned to portray his sitter's persona in its subtlest nuances. Here Degas shows the contradictions faced by middle-class women in late nineteenth century French society. The geometrical grid in which Hélène Rouart is trapped in this composition aptly echoes the formal claustrophobia of her lifestyle. The color range, with it muted, broken hues, reinforces the mood of the picture. This canvas is not a standard format.

metal frame is barely distinguishable, and the front square edge dominates in its flattening reiteration of the picture edge. Whether or not the portrait was intentionally left incomplete, is not known. In its present state it certainly lacks neither power nor impact, despite idiosyncracies like the hidden or missing little finger of Hélène Rouart's right hand.

Painted on a large standard format, portrait 100 canvas, this work has a monumental quality. Overall, its tone is subdued, the colors mostly broken in mixtures, and earth colors are used. Like in Gauguin's works later, many of which were influenced by Degas, dull harmonies unite the painting, and no strong lights or darks disrupt the middle tone which predominates throughout. A light Indian red earth was used to outline the paler forms and general structure of the composition, over a

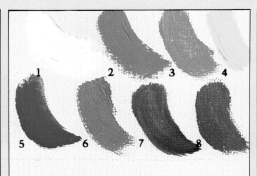

Degas' palette for this painting probably included lead white (1), zinc white, yellow ochre (3), red earth (5) and Prussian blue (7).

Lemon yellow (4), vermilion (6), cobalt blue (8) and chrome green (2) may also have been used.

A transparent umber underlay or ébauche leaves the pale putty colored ground glowing through. Black is used thinly to outline the chair. Opaque, probably Prussian blue and white are 'floated' in thin scumbled veils over the darks below, and appear brilliant by contrast. Indian or earth red, and Prussian blue were both used for outlines on the dress. A flap of blue from the dress was added over the dry paint of the chair bar, to lock the figure more tautly against the chair.

putty-colored commercial preparation which blends perfectly with tonal and color scheme. For other areas, a darker color, possibly Prussian blue, was used to indicate contours. On the figure, raw umber outlines alternate or are overlaid with dark blue ones. On the hands the two colors are mingled wet in wet. The first *ébauche* layer on the figure was applied in thinly scumbled dilute Indian red, which was left to show through the uneven semi-opaque blue layer on top. The blue is thinnest over her corseted breasts, so the red underlay aids the sense of swelling form. Where the brick red is exposed among the blues it appears, by contrast, to have the brilliance of vermilion. This is typical of the exaggerated brightening of a color which can be achieved either by warm-cool complementary contrast, or by juxtaposing lighter colors, the orange-red, against darker ones, the blue. The insistent use of these two dominant colors in the picture, the warm brick red and the steely blue, which appear repeatedly in modified tints, provide the rich harmony which unifies the composition.

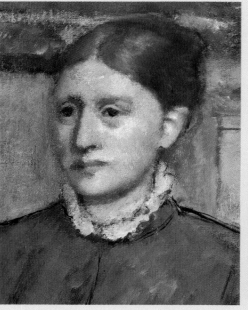

The contours are washed on in umber, and reworked around the ear with dabs of red. Prussian blue contours were reinforced over red for the dress and neck frill. Delicate warm-cool modulations of varied pinks and greens were used for the flesh colors, which are more impasted than elsewhere. The fine canvas texture is still visible, and can be seen among the dragged and more thinly applied colors. The face coheres

well at a distance, although up close it seems very freely handled. The dull pinkish beige of the background wall was laid in vertical strokes which go up to the edge of the face on the left, and over the original counter line, thus changing the shape of the face. The first shoulder line is also still visible.

Actual size detail
*Contours of red and blue
are intermingled. Red
was sometimes laid over
Prussian blue, and vice
versa. These hues are
used both wet over dry
and, in places, wet
slurred into wet. The red
is probably red earth, its
hue made more intense
and brilliant in contrast
to the dark Prussian
blue, but it could be
vermilion. Umber and
Prussian blue outline
the fingers, and were
slurred together with the
wet pink and green flesh
tints during the process
of adjustment. The
handling is direct and
immediate.*

PAUL SIGNAC

The Dining Room/La Salle à manger (1886–1887)
Oil on white primed canvas
89cm × 115cm/35in × 45¼in

Signac was based in Paris throughout the height of the Neo-Impressionist movement, leaving only in 1892 to settle on the Mediterranean coast at St. Tropez. Virtually self-taught, he based his early techniques on Impressionist painting, until he saw Seurat's *Bathing, Asnières* at the Independents' exhibition in 1884. Signac had been one of the founders of the *Groupe des Artistes Indépendants*, which in 1884 established exhibitions free of awards or juries as an alternative venue to the official Salon exhibitions. In addition to showing their work at the eighth Impressionist exhibition in 1886, the Neo-Impressionists showed regularly with the Independents, and with the Belgian independent artists at their *Les XX* shows also founded in 1884. Although the Belgians had already established links with French art, inviting the Impressionists – like Monet and Renoir in 1886 – to show with them, their closest ties were with the Neo-Impressionists. A number of Belgian artists, like Théo van Rysselberghe (1862–1926) and Henri van de Velde (1863–1957), members of *Les XX*, adopted the Neo-Impressionist style.

The Neo-Impressionists, reacting against the 'romantic' naturalism of Impressionism, and seeking a more scientific method with which to convey their pictorial ideas, found sympathy in the latter half of the 1880s among the Symbolist writers and poets who had begun to displace naturalism in literature in the early 1880s. As their theories extended in the second half of the 1880s, the Neo-Impressionists discovered a kinship between their aims and those of the Symbolist writers like Félix Fénéon, their most astute supporter, Gustave Kahn and Jean Moréas. The Neo-Impressionists no longer sought merely to capture fleeting effects of light and color in nature, as they saw the Impressionists doing, instead they wished to render a more universal and timeless record of contemporary life. Signac was the theoretician of the new movement, explaining its ideas and defending it in his book *From Eugène Delacroix to Neo-Impressionism*, which was published in 1899, in fact long after the movement's peak. Although inevitably written from Signac's personal bias, it reflected the ideals of the Neo-Impressionists, and it has been characterized by the influential modern art historian, Linda Nochlin, as 'an important document of that aesthetic universalism, that attempt to unite and synthesize all human thought and feeling in a symbolic, law-based harmony which animated so many literary and artistic enterprises of the last twenty years of the nineteenth century.'

In 1886, the year in which *The Dining Room* was begun, Signac adopted the 'dot' brushstroke which Seurat had developed in his monumental canvas *Sunday Afternoon on the Ile de la Grande Jatte* painted between 1884 and 1886. In addition to its function in dividing the different color components within a picture, the dot technique enabled the Neo-Impressionists to render minute variations in tonal value. In general, the Impressionists had sought to rid their paintings of tonal modeling, which was still associated with academic painting, and instead to study effects in which contrasts of tone (light and dark) were reduced to a minimum. The flatness this brought to their paintings enabled them to maximize the tensions inherent in painting, between the two-dimensional picture surface, and the illusion of depth. The Neo-Impressionists restored tonal modeling to their pictures, but instead of reverting to the gradations between white and brown characteristic of academic classicism, they explored the means of presenting tonal gradation through the use of juxtapositions of pure color.

In Signac's *Dining Room*, the scene is backlit from a window, giving a dramatic light creating silhouettes and strong contrasts of light and shade. This type of lighting was used occasionally by Degas, but not by the Impressionists, who avoided such extremes of contrast. When sunsets were painted by them, for example certain of Monet's haystack series from 1890–1891, any shadows were brilliant with colored light, reflected from surrounding objects and the sky. In Signac's picture, the back lighting creates a strong sense of form and structure in the composition, a frozen solemnity which may be an ironic criticism of the formal, ritualistic quality of the middle-class life depicted. Form is created by gradations of color from pale tints to full saturation. Thus, the highlighted areas are shown as barely tinted or yellowish whites. These then pass through a series of minute gradations in which increasing amounts of local color are added until, in the darkest parts, almost pure saturation of the tube colors is reached. To darken the shadow hues

Signac's limited 'prismatic' palette used here probably comprised lead (1) or zinc white, cadmium yellow pale (2), cadmium yellow mid and deep (3), vermilion (4), red alizarin lakes (5), cobalt violet (6), cobalt blue (7), ultramarine blue (8), cerulean blue (9), viridian green (10) and light and dark chrome greens (11, 12).

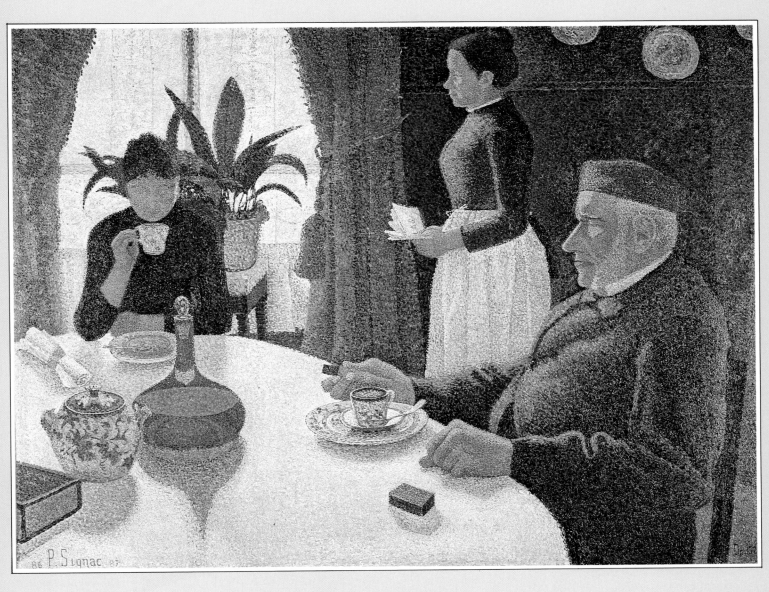

Source of *contrejour* or back lighting effect

Simplified, stylized facial features

Local colors modified by color of warm yellowish-orange light, with added touches of cool blues for color of shadows

Reflected color picked up from carafe, modifying color of tablecloth, with blue for color of shadow

Tone of background lightened to detach figure, conforming to laws of simultaneous contrast of tones

Highlights speckled with dots of orange-yellow to depict warm light

Deep blues and blue-greens built up in separate touches to indicate shadowed parts

Signac's use of strong contrejour *or* back light *exaggerates the stylized starkness of his figures. Their strict profile and full face poses echo those used two years earlier by Seurat in his monumental work,* La Grande Jatte, *and show the influence of stylized ancient Egyptian art on both painters. Like Seurat, Signac did a series of major paintings of modern life themes. Signac's three paintings, all of interiors, were executed in the later 1880s. Dining Room was painted on a standard portrait 50 format canvas.*

The monumental stillness of Signac's figures comes from a combination of their static poses with a strong sense of modeled form. While the Impressionists preferred to suppress stark contrasts of light and dark to avoid tonal modeling, the Neo-Impressionists often used dramatic back or side lighting to enhance the sense of form. They replaced the academic modeling of tone in monochrome creams and browns with colorful modeling. This technique exploited the natural lightness or darkness of particular hues, with added white. Thus, pale yellow stands for highlights, with the local colors of the object, say the man's jacket, carefully gradated from that palest hue through to deepest blue.

without adding sullying black or earth colors, green and blue are mixed on the palette and juxtaposed next to purer blues. Effects of reflected color among the local colors are represented by additional dots of the appropriate hues. The careful gradation of tones applied in small dots gives a stiff, sculptural artificiality to the composition, whose color scheme is dominated by the complementary colors orange-yellow to blue-violet.

As with Impressionist painting, opaque paint is a crucial feature of the Neo-Impressionist technique. Mat, opaque hues, with white added, have far greater light-reflective luminosity than transparent colors, through which light penetrates before being reflected back to the eye, producing darker, more saturated color. Thus mat, opaque, unvarnished surfaces bounce the maximum amount of tinted light back to the eye to create the effects of partial optical fusion these artists desired. Signac was instrumental in encouraging Seurat to abandon earth colours, such as those used in *Bathing, Asnières* (1883–1884), and to adopt the purer version of the Impressionist palette. He was also influential in van Gogh's lightening of his palette. Signac and Vincent van Gogh worked together at Asnières in 1887, and Signac encouraged the Dutch artist to replace his somber, essentially tonal palette with bright 'prismatic' colors, thus introducing him to a more modern use of complementary contrasts than that which van Gogh had learned through studying Delacroix.

To avoid sullying his colors, Signac mixed only those hues adjacent to each other on his prismatic palette. The colors were then placed in separate small dots on the picture surface to keep them from blending while wet. He avoided accidental blurring of one color into another by allowing each layer of color or dots to dry before adding more. The dots are too large for any complete fusion of colors on the viewer's retina, but the partial fusion of the dots of color causes some optical vibration. This gives an effect of luminous atmospheric light to the picture.

Actual size detail
The Neo-Impressionist touch was theoretically a uniform dot, but the slight changes of shape almost imperceptible at the correct viewing distance become clear close up. Here, small dots become dashes, which follow the direction of the forms, the edge of the plate, helping to structure form. Among the blues of the shadow, an airy feeling of light is created by the added touches of contrasting orange, which stand for the flecks of warm light penetrating the luminous shadow. In a few instances, the dots turn into fine lines, outlining shapes, like the blue on the spoon and the white highlights on the cup. The deepest shadow, on the cuff, is modified by flecks of paler blue and, close to the highlight, by touches of orange which show the blurred edge between light and shade.

CAMILLE PISSARRO

Apple Picking at Eragny-sur-Epte/La Cueillette de pommes, Eragny-sur-Epte (1888)
Oil on white primed canvas
60cm × 73cm/23½in × 28¾in

In 1884, Pissarro moved further from Paris to Eragny-sur-Epte, north-west of the city and a few miles east of Giverny, where Monet had settled the previous year. Unlike Renoir, who at this time turned back to inspiration from classical art, Pissarro always remained open to the new ideas of younger artists, and soon adopted the novel Neo-Impressionist style which was emerging in the mid 1880s. He met Seurat and Paul Signac (1863–1935) in autumn 1885, and, acknowledging the importance of the scientific theories evolved by Seurat, began to use the pointillist technique. Pissarro's friendship and allegiance were invaluable to these younger artists, for he argued strongly for their inclusion in the Impressionist group shows, which many of the older members resisted. Apart from their style, they were disliked by some of the group for their commitment to anarchist political principles, which had grown in popularity in France, and which Pissarro himself espoused from the mid 1880s. Any association with radical politics was felt by some of the artists to threaten the cautious acceptance which the Impressionist style had so recently gained among Parisian collectors. Thus at the last group show in 1886, Monet and Renoir were absent because works by Seurat and Signac were included. However, this disagreement did not sour the relations between Pissarro, Monet and Renoir, who at this time were meeting regularly at monthly Impressionist dinners at the Café Riche in Paris.

Pissarro explained the Neo-Impressionist theories to his dealer Durand-Ruel in a letter written towards the end of 1886. He stressed the importance of Seurat's role as inventor of the theory, and described the new function of color, which replaced mechanical mixtures of pigments with optical mixtures, where colors partially fused in the spectator's eye. The component parts of each optical color mixture were to be painted in separate touches so that they retained their color purity. When colors were mixed on the palette, they could only be combined with close neighbors on the color circle, so as to avoid excessive dulling of the hues. Pissarro noted that the great color theorists who had influenced Seurat's thinking were Chevreul, the Scot Maxwell, and the American Ogden Rood. Optical color mixtures, they argued, were more luminous than mixed pigments.

Execution or brushwork was considered unimportant by the Neo-Impressionists, as Pissarro explained: 'originality consists solely in the character of the drawing and the vision of each artist.' The descriptive, individualistic style of touch, associated with Impressionism, was dubbed 'romantic' by the Neo-Impressionists, who sought a more impersonal, mechanical touch to eliminate such gestural individualism from their work. Thus personal originality, which had for so long been linked with a personally distinctive style in brushwork, was rejected in favor of a more restrained and anonymous handling. This aim was in keeping with the cooperative ideals of anarchist politics, and yet, ironically, in practice it caused Seurat much distress. He felt that his 'anonymous' touch – his distinctive handling in effect – was under threat of genuine anonymity, as the numbers of his followers or imitators grew.

The Pointillist dot was considered the ideal vehicle for placing individual myriad touches of bright pigment on the canvas, to obtain the component elements of color without excessive mechanical mixing. Although the dots were too large to be invisible and create full optical fusion of the components on the retina, partial fusion was intended to take place, resulting in a shimmering illusion of atmospheric color. Despite the theory, few of the actual 'dots' are completely round. Frequently, as can be seen in Pissarro's *Apple Picking*, the uniform-sized touches of color are the shape of small brushes, tiny rectangular blocks which build up to form a dense mosaic on the picture surface. They also do not completely avoid a descriptive function. For example, in this picture, and even in Seurat's first major painting in the technique, *Sunday Afternoon on the Ile de la Grande Jatte* (1884–1886), the brushmarks vary in direction, following form and indicating changes of plane, even showing slight variations which echo changes in the texture of surfaces. Thus, the tree trunk in *Apple Picking* is executed with long vertical strokes of color, by contrast to the tiny criss-cross hatching which describes the grass. On Pissarro's figures, too, direction of touch, often curved to follow the form, gives substance to his figures and helps to separate them from their background.

The Neo-Impressionist method was very slow and laborious, for each layer of touches had to dry thoroughly before more dots were added. This was to avoid wet-in-wet slurring, which detracted from the purity of the individual touches of color. The white ground commonly used on Neo-Impressionist canvases provided the most brilliant and light-scattering base possible, enhancing the luminosity of the colors laid on top, and showing through in places with its own stark brightness. Palette colors were more limited than those of the Impressionists, in that no earth colors were used, but more of the brightest tube colors, particularly greens, were added instead. The pervasive effects of outdoor light, especially sunlight, were recorded by the Pointillist technique. Among the shadows on grass, for example, could be found the true greens of the grass, the darker blue and violet colors – the complementary color of the warm sunlight with additional blue reflected from the sky – and also the orange-yellow tinges of sunlight scattered into the shadows. Each of these

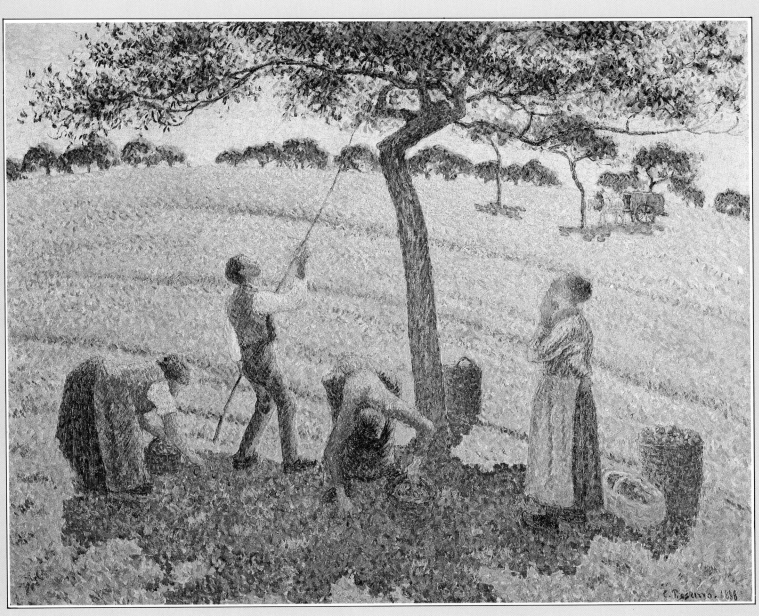

Dark decorative tree shapes emphasize curve of skyline

Decorative shape of tree echoes skyline, a device also used by Cézanne, and Monet in *Antibes* (1888)

Fall of sunlight 'melts' edge of form

Individual touches of complementary red and green vibrate

Short vertical strokes for tree trunk

Delicate painted contours outline form of figures

Pool of colored shadow creates a strong shape delineating the ground plane and anchoring the figures in the composition

Pissarro's relative naturalism of the 1870s has given way to a greater degree of formal stylization in the composition, handling and treatment of forms. However, compared to the work of Seurat, whose Pointillist method Pissarro had adopted by this date, Apple Picking remains essentially naturalistic. Although his color mixtures are now purer, they still reflect the colors observed in nature. The canvas is a standard format portrait 20.

features of light and color were recorded in separate dots of the different hues, to result in an overall effect of brilliantly colored atmospheric light.

During the latter half of the 1880s Pissarro adhered to these theories, but, in the end, finding them too slow and inhibiting in terms both of personal expression and of financial necessity, he abandoned Pointillism. The period had caused him even more economic hardship than he experienced previously, for neither his dealer Durand-Ruel, nor the public at large, appreciated his new style. Having begun to establish himself in the early 1880s, many of his most loyal collectors were unable to follow his Pointillist departure, leaving him in quite dire circumstances.

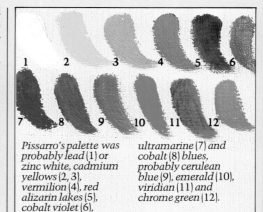

Pissarro's palette was probably lead (1) or zinc white, cadmium yellows (2, 3), vermilion (4), red alizarin lakes (5), cobalt violet (6), *ultramarine (7) and cobalt (8) blues, probably cerulean blue (9), emerald (10), viridian (11) and chrome green (12).*

Pale tints of the colors used in the foreground appear in the background, unifying the painting while aiding the sense of distance through recession. Touch is varied to describe the shape of forms.

Color is built up to suggest form. Strokes are hatched or criss-cross, following and evoking form, while the choice of tint and hue serve the same function. The highlighted parts of the figure are depicted in pale glowing yellows, suggesting the fall of sunlight. The shadowed parts, filled with blues reflected from the sky, are painted a correspondingly dark hue, dominated by cool blues. Warm orange-red touches permeate the shadow to suggest reflected rays of sunlight. Delicately painted lines outline the forms.

The Neo-Impressionists preferred canvases primed a brilliant white. They often used chalk and glue rather than oil-based grounds. These were more absorbent and resulted in a matter, more luminous paint surface. The white of Pissarro's ground shows through among the abrupt dabs of color, adding brilliance to the effects of light. Even where it is covered with colors, the white of the ground improves their brightness. Here, Pissarro only mixed colors adjacent on the color circle, retaining maximum purity and avoiding dull neutrals.

Actual size detail
Lively reds and blues are the dominant hues on this figure, whose unusual pose has been depicted with grace and simplicity. The theme of work runs throughout Pissarro's art, from the small, toiling figures and distant suburban factories apparent in his work of the 1860s and 1870s, to the more monumental figure compositions, chiefly of female agricultural workers, which date from the early 1880s on. These works echoed Pissarro's belief in cooperative rural labor, an ideal associated with anarchist political thought. The figure is outlined and the form evoked in broad, rounded masses, with a simplicity reminiscent of Millet. Within these masses small directional strokes of individually applied colors construct form through contrasts of warm and cool colors, as well as of pale and saturated tints. Thus the highlighted parts are rendered in pale hues of yellows, oranges and greens, the shaded areas in darker tints of reds, blues, greens and violets. Contours are added to strengthen and contain the forms.

Pissarro's brushstrokes here are much smaller and closer to the Neo-Impressionist's dot than in the earlier version of this composition painted in 1886. However, they do not conform precisely to a round dot mark. Color is divided into areas of mainly pale, warm hues contrasting with areas in which darker, cool hues predominate. Warm colors — reds, oranges and yellows — are introduced in small, flecked touches in among the cool blues and greens of the shadow areas to suggest reflecting sunlight.

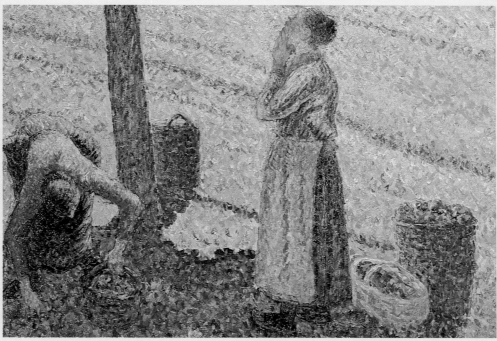

CLAUDE MONET

Antibes (1888)
Oil on pale putty-color primed canvas
65cm × 92cm/25½in × 36¼in

From the late 1870s Monet, having established his methods for depicting fleeting effects in nature, began to explore new, more demanding subjects. In 1878 he settled in Vétheuil, where his first wife Camille died in 1879. During the harsh winter of 1879–1880, he painted the dramatic effects of the break-up of ice on the nearby Seine river. These scenes set the tone for his work on the more elemental side of nature, which he pursued throughout the decade. In 1881 Monet moved to Poissy, again on the Seine, north-west of Paris, but closer to the city than Vétheuil. First this area, then that around Giverny, a short distance west of Vétheuil, where he finally established a home in 1883 which he bought in 1890, provided Monet with a more placid style of subjects to counterpoint the dramatic scenery he sought when traveling during those earlier years. His first major retrospective show, of 56 paintings, was held at Durand-Ruel's gallery in spring 1883.

Monet found his new, challenging subjects scattered the length and breadth of France. In the early 1880s, he maintained his habit of working along the Normandy coast, concentrating on the high, striking white cliffs between Etretat and Pourville. Then, in December 1883, he and Renoir traveled south to the Côte d'Azur and Genoa, a brief trip serving Monet as a scouting tour on which he studied the coast for possible subjects. Monet returned there alone in January 1884, and painted at Bordhigera and Menton around the French-Italian border.

Contrary to his practice in the late 1860s and early 1870s, Monet wished to work alone and kept this visit a secret from Renoir. He remarked in a letter to his dealer, Paul Durand-Ruel, in January 1884, that it would inhibit him working in a twosome, maintaining 'I have always worked better in solitude and after my own impressions'. Renoir had had experience painting in the south in the previous two years, and Monet may have wished to find his feet in the new environment, with its disconcertingly brilliant light and colors, without his friend watching over his shoulder.

Monet evidently found it difficult to pitch his colors and tones high enough to capture even the late winter brilliance he witnessed around him in southern France. He was unable to work in poor weather, stressing it was a landscape which demanded the sun. When the sun did shine, it produced a 'glaring, festive light' and brilliant blues and pinks which he feared would anger those of his critics who had not seen it for themselves, even though he felt his own translations of the tints to be well below their actual brightness. He described the colors he saw as those of the pigeon's throat and of flaming punch — shimmering, evanescent films of colored light. After four years of trips devoted mainly to the wilds of Normandy and especially the rugged Atlantic coast of Brittany around Belle-Ile, in 1888 Monet returned to the south. He was attracted by its total contrasts of landscape, light and color.

It was on this second visit that Monet painted *Antibes*. His subjects in the south were dictated chiefly by information on local beauty spots obtainable from tourist guides, as he was a stranger to that area. This information directed him to sites that were visually interesting, and which would also attract potential collectors, who often preferred to have views of well-known scenes with which they were familiar, rather like high-class postcards. Once more his visit was spread over late winter and early spring and was spent on subjects at Antibes and Juan-les-Pins.

In this painting, Monet's evolution of a brushwork style, where different marks 'stand for' different natural phenomena, is clearly in evidence. There is a sure confidence of touch in his almost calligraphic brushmarks. Flamboyant curving strokes indicate the distant line of hills, against which — with calculated casualness — he emblazons the stark, almost silhouetted arabesque of the tree trunk. The curve of the tree has been adjusted during execution, to exaggerate its rhythmic shape. The emblematic blueness of the water is broken only by the dragged vibrancy of wet-over-dry colors, placed horizontally to indicate the rippling water surface. The lower branches of the tree remain above the level of the horizon, limiting the illusion of distance, which could have resulted from allowing them to overlap the horizon line. The vegetation is rendered by short curled or abrupt dabbed strokes, often blending several colors on a single brushstroke.

The pale tinted priming on this standard vertical marine 30 canvas has been almost entirely obliterated by the opaque paint layer colors. Under both sky and sea, Monet applied a general underlay, perhaps to make the ground more light-reflective and luminous, because it is a brilliant chalky, pinkish-white, lighter in color than the original ground. The fine grain of the canvas is left barely noticeable. Over this underlay, which is in itself visible

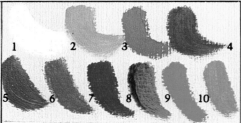

Monet's palette for this work probably comprised lead white (1), *cadmium yellows* (2), *vermilion* (3), *red alizarin lake* (4), *cobalt* blue (5), *cobalt violet* (6) *and viridian green* (8). *Ultramarine blue* (7), *emerald* (8) *and chrome* (9, 10) *greens may have been used.*

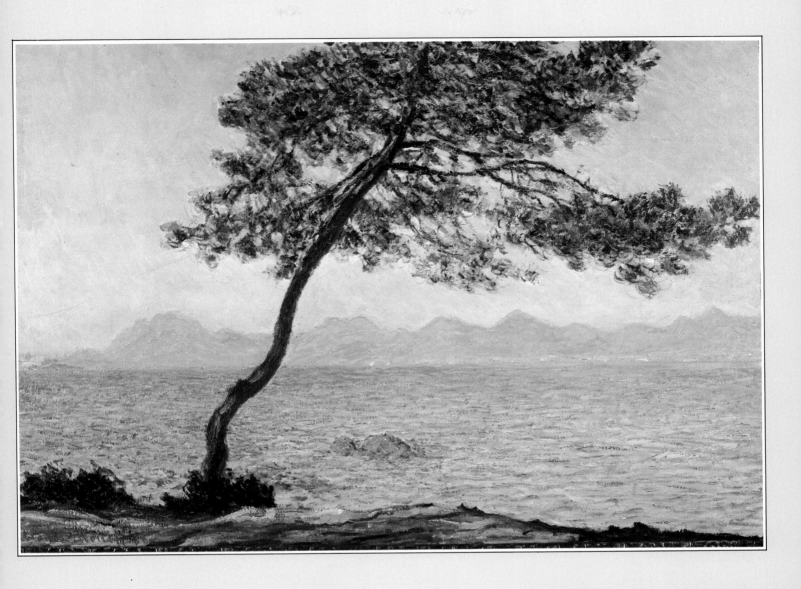

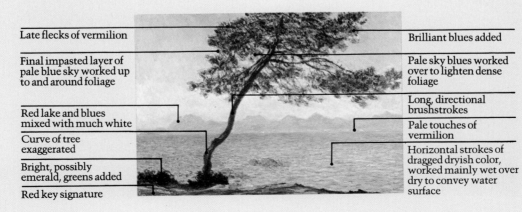

Late flecks of vermilion

Final impasted layer of pale blue sky worked up to and around foliage

Red lake and blues mixed with much white

Curve of tree exaggerated

Bright, possibly emerald, greens added

Red key signature

Brilliant blues added

Pale sky blues worked over to lighten dense foliage

Long, directional brushstrokes

Pale touches of vermilion

Horizontal strokes of dragged dryish color, worked mainly wet over dry to convey water surface

Like Pissarro in Apple Picking *which dates from fall 1888, Monet's spring painting of* Antibes *used the device of a dark curving tree set against pale background colors. This composition was of a type popular with Japanese artists. The brilliant pastel blues and pinks of the setting make a superb foil for the darker more severe contrasts in the tree and foreground, where harsh juxtapositions of red and green predominate. The extremes are modified by the appearance of blues among the tree foliage, and the paler reds picked up along the distant waterline. For this painting, Monet used a standard format canvas vertical marine 40.*

Gaps in the pale underpainting of the sky, among the foliage, reveal the duller, darker hue of the commercial preparation which is pale putty in color. On the lower left, slurred wet-in-wet blues and white are added thickly, to give more light and break up the dark masses of foliage. Among the impasted, overlaid and slurred blues on the right, the brilliant blueish white tint of the underlay can be seen. Tiny flecks of vermilion enliven the greens.

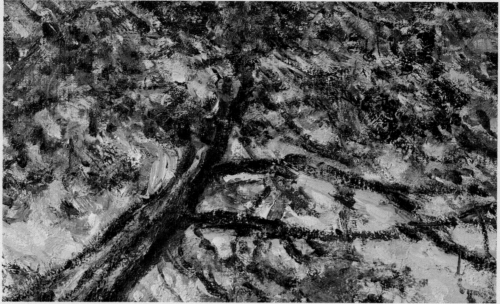

The flamboyant curve on the tree was exaggerated by Monet. The colors of the sea cut into the concavity of the form on the right, while the tree colors are built up over dry sea paint on the left, convex curve. The vigorous arabesque of the line is echoed on a smaller scale by Monet's brushwork here and along the mountainous skyline. Fluid, sinuous brushmarks are balanced by dryish dragged paint and impasted dabs of color in the foreground leaves. Richly loaded paint in broad strokes of reds and greens give immediacy to the foreground land.

only in places among the tree foliage and the sea brushstrokes, Monet built up the paint layer in stiff impasted strokes, which are especially vibrant where broken and dragged, allowing the earlier colors to show through.

The sky colors were roughly scumbled in, and worked around the tree, while the sky patches amongst the foliage were mainly worked in over the colors of the branches. The cobalt blue and alizarin crimson hues of the hills were heavily loaded with white, to make them very pale and luminous. Mixed viridian green and white were applied over the darker greens in the immediate foreground, and the same bright green was carried over as small dabs on the water surface, linking these two tonally contrasting areas. A bluer cobalt and white mix was also worked late over the water surface, and picked up by individual blobs of the same hue in the tree foliage. The reds of the foreground, a vermilion-based mixture, were used in the final retouching, again in the tree, and this same color was used for the artist's signature. This is often a clue to the final color touches applied by the artist.

Monet's Antibes paintings were exhibited at Theo van Gogh's gallery in early summer of 1888. Having seen the works, Monet's friend the poet Stéphane Mallarmé (1842–1898) wrote to him 'This is your finest hour'.

This detail shows the unpainted canvas edge, where raw linen is visible due to wear and flaking. The dull, pale putty, slightly discolored ground is visible here. The pale blues of the final sky layer go up to and around the upper edge of the mountains, leaving the thin, opaque underpainting exposed. Tiny wet-over-dry strokes of pale vermilion punctuate the softer pastel pink and blue hues.

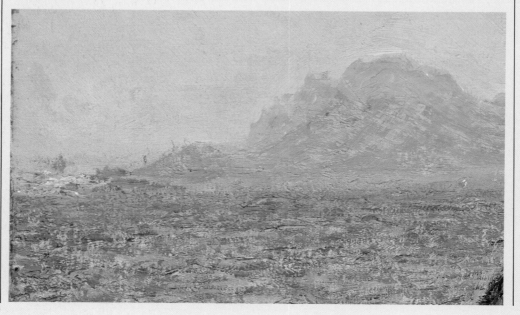

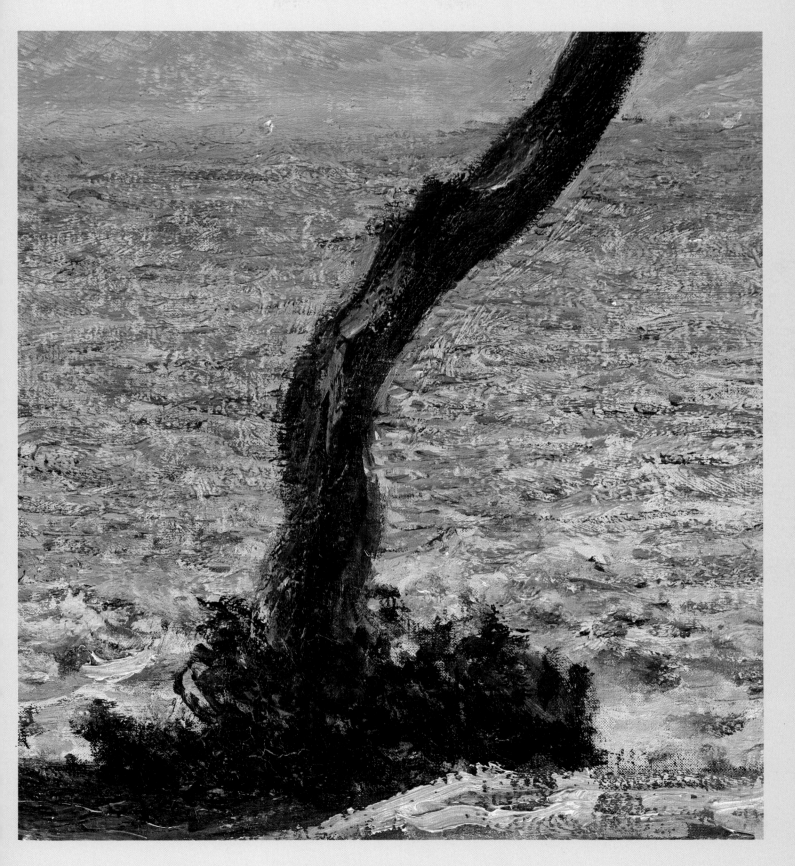

GEORGES SEURAT

The Can-Can/Le Chahut (1889–1890)
Oil on white primed canvas
169cm × 139cm/66½in × 54¾in

Dissatisfied with the apparently casual, arbitrary methods of the Impressionists, Seurat aimed at a more permanent, monumental record of modern life, an art elevated to the stature of Egyptian or classical art. During the first half of the 1880s, he devoted himself to developing his 'color-and-light' or 'chromo-luminarist' method of scientifically recording the unified effects of light and color in nature. His academic training, albeit relatively brief, gave him a foundation in the classical tradition and in careful draftsmanship which was to remain with him throughout his career. He soon abandoned the more linear emphasis of academic drawing, preferring instead the softer, more tonal approach which had been growing in popularity — particularly among independent artists — and these studies he used to analyze delicate gradations in the fall of light and shade. Seurat's knowledge of the theories of simultaneous, or complementary contrast of tones and colors was gained by thorough reading of Chevreul's theories, and later publications like those of the American Ogden Rood, which appeared in a French edition in 1881. He exploited the phenomenon of simultaneous contrast in his drawings, before he had begun to use color.

In drawings like *Seated Boy with a Straw Hat*, a study, drawn in 1883–1884, for one of the seated figures in *Bathing, Asnières*, the use of simultaneous contrast of tones can be seen. Where a dark block of tone meets a lighter one, the tones are mutually enhanced by contrast. This means that the edge of the dark block will appear optically darker by contrast, and the light edge lighter. In this drawing, Seurat has incorporated this optical effect physically. Thus, he has drawn the background paler behind the boy's back, and the boy's back darker, where the two meet, to exaggerate the contrast and to separate the boy's figure from the background, thereby giving it solidity. Similar handling is visible along the profile of the boy's face. The technique is reversed where the light falls from the right directly on the boy, highlighting his arms and legs. Thus, the light parts on his limbs have been made lighter, and the background darkened, to maximize the contrast and again make the figure stand out from the background.

These effects of tonal contrast are visible in nature, but are not commonly 'painted into' a picture, because they necessitate drastic adjustments to the tone of the background, resulting in an artificial and visually disturbing lightening and darkening of the background. However, for Seurat, these effects were perfect for strengthening structure and modeling in his drawings, and, incorporated in his paintings, they increase the sense of form while introducing an eerie unreality to their atmosphere. Although in his paintings the gradation from black to white of the studies was replaced by gradations from saturated pure color through to white to avoid sullying the hues, the principle remains the same. It can be clearly seen in *Can-Can*, where the planes of the background appear to swell in and out of the picture, as they darken or lighten, depending upon their proximity to the forms in front. For example, the background darkens noticeably in intensity where it adjoins the pale hues of the front dancer's skirt.

In Seurat's painting, contrasts of color replace contrasts of black and white, so that the contrast between light and dark is also one between color complementaries. Thus warm colors, especially dots of orange signifying the gaslighting, pervade the pale creamy-white areas, while darker, cool blues, violets and greens dominate the shaded parts away from the light. The orange-blue complementary pair is the basis for the color harmonies, while dots of orange indicating reflected gaslight are speckled over the entire canvas. The stiff stylization of the composition is far greater than during his earlier phase. This resulted from his study of the recent work of the scientist Charles Henry, with whom Seurat became acquainted in 1886. Henry worked on scientific means to formularize the relationship between line, color and tone and their impact on the emotions. For example, warm orange-reds, such as those which dominate this painting, were considered to denote gaiety. Similarly, lines moving upward, like the legs, arms and facial features of the dancers reinforced the emotion associated with warm color. Seurat's late paintings, based loosely on Henry's theories, were all designed on the basis of the particular emotions evoked by line, tone and color. Thus in these works pale, warm colors signified gaiety and action, while dark cool colors stood for sadness with middle tones and a balance between warm and cool colors in a painting indicating harmony and tranquility.

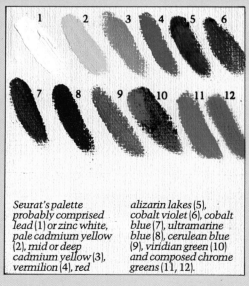

Seurat's palette probably comprised lead (1) or zinc white, pale cadmium yellow (2), mid or deep cadmium yellow (3), vermilion (4), red alizarin lakes (5), cobalt violet (6), cobalt blue (7), ultramarine blue (8), cerulean blue (9), viridian green (10) and composed chrome greens (11, 12).

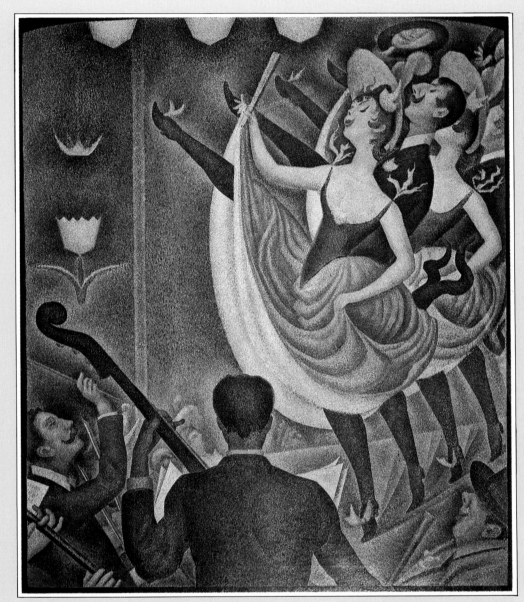

Within a matter of years of their execution contemporaries began to note the dulling of the brilliant pitch of Seurat's colors. This makes it difficult to assess the impact of the color or its effects in Seurat's work, for it is impossible to know how different they now are. However, Seurat's use of separate touches of pure color in tiny dots in fact resulted in an overall subdued, almost gray tint in his painting, as can be seen here. This is because the color fusion that actually takes place is in fact subtractive – or darkening and graying in effect – in accordance with the laws of pigmental color, as opposed to the additive laws of colored light. In the latter, the mixture of colored lights becomes increasingly lighter, finally resulting in white light. The painting was designed to work on a very large scale – larger than the biggest standard format easel size. The canvas measures 169cm x 139cm (66½ in x 54¾ in), and this reproduction is only a few centimeters (inches) high. A comparison with the actual size detail shows how greatly the color is concentrated by this size reduction of the whole picture.

Lines had a comparable function — upward moving lines expressed joy or gaiety, horizontal and vertical lines indicated tranquil balance, and downward moving lines meant sorrow. It was felt that systematization of these theories could lead to a formula for painting, in which the emotional impact of the picture could be scientifically predetermined. This idea of a universal absolute in the ordered representation of expression in art, is very much in keeping with certain ideas then current in Symbolist theory. However, it also marks a modern alternative to the classical absolutes of truth and beauty, which had become so associated with the constraints of academic dogma in the nineteenth century.

Recent scholarship has suggested that, in his art, Seurat aimed to find a new means of expression by combining the classical with the modern. The famous art historian and theoretician, Charles Blanc, whose book *Grammar of the Arts of Drawing* Seurat consulted in the 1870s, saw the Renaissance as the perfect model for the modern society which sought social and artistic progress through science. Seurat may thus have adapted Blanc's theory which offered the artist a radical way of reconciling in his painting his apparently contradictory admiration for classical harmony and modern technological methods.

Although Seurat remained the undisputed leader of the Neo-Impressionists, his rigorously scientific method was gradually abandoned by his followers after his early death in 1891. They each sought more personal variations of the Pointillist style. Seurat's decorative stylization and his use of classical proportions were much admired by twentieth century artists.

Warm-hued gas lighting provides main light source, depicted as dots of orange throughout

Caricatural upturned features denote gaiety

Background tone and color modified to complement contrasting tones and colors on figures

Solid outlines not entirely suppressed

Colored frame painted on canvas around work complements colors of picture, protects them from influence of colors beyond frame, and reinforces pictorial reality

Against the pale orange-yellow skirt edge, the background is made dark blue by contrast to strengthen the form and separate it from the background. This device also maintains color harmony throughout the painting. Comparable modifications are made all over the canvas.

As in Jules Chéret's poster for the Folies Bergère, Les Girards, of 1877, features are stylized and forms are elongated by Seurat. In Can-Can, however, the stylization stressed the artificiality of the entertainment world, expressing its brittle gaiety.

This detail of Seurat's black Conté crayon drawing on coarse Ingres paper from 1883-1884 shows his mature tonal drawing technique. Precise outline and distinct hatching are entirely suppressed in Seated Boy with a Straw Hat. Instead, subtle gradations of tone are achieved by varying the pressure of the soft, dense crayon on the paper. Lightly applied strokes catch only on the paper tufts, leaving the hollows white. Firm marks cover the paper to create deep velvety blacks. These tonal variations sculpt form.

Actual size detail
This detail comes closest to suggesting how Seurat's surfaces appear in actuality, for his effects are impossible to recreate in book reproductions. The first dots of color, the blues and creamy whites, are in fact elongated dashes which follow the forms, in this case the line of the skirt. Rounder dots in paler blue, orange and pale orange, are all worked over dry color to avoid sullying the purity of the separate hues. So, the dots are not completely uniform in shape or direction, and they set up rhythmic patterns across the picture surface. The orange dots are meant to evoke the pervasive luminosity from the gas lamps. The colors are all opaque to reflect light from the paint surface, but among the blue dots white ground can still be seen.

Seurat's small oil sketch for Can-Can is one of several preparatory works for the final picture. His typical working method echoed academic practice, in that he used drawn studies, oil studies, and oil sketches of the composition like this one. It measures only 21.5cm x 16.5cm (8½in x 6½in), and is painted on wood panel, probably a cigar box lid. Seurat often used this type of support for his oil sketches. It is primed with white and has not only a painted frame on three sides, but a painted wooden framing strip was also added.

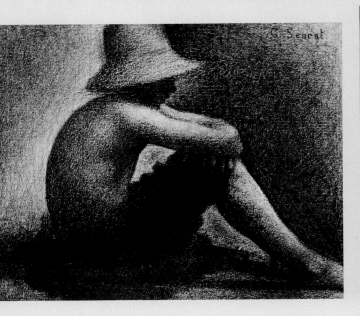

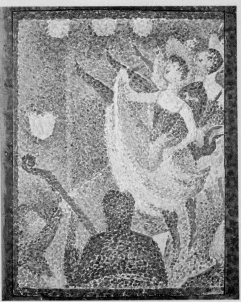

INTRODUCTION

1890 1905

In the 1890s, the public acceptance of the older Impressionists was still only selective. Monet, especially through his 'series' paintings of *Haystacks, Poplars* and *Rouen Cathedral*, had achieved widespread success, both critical and financial. Renoir had similar good fortune. However, Sisley, and Pissarro, who had abandoned the Pointillist style, continued to gain only limited recognition. Cézanne, still working in relative isolation from all but close colleagues, remained virtually unknown to the public before his first one-man show at Vollard's Gallery in Paris, in 1895. The ambiguous attitude of the art establishment toward Impressionism can be seen clearly in the reaction to Caillebotte's legacy to the state in 1894 of his superb collection of 65 Impressionist paintings. Only eight of Monet's 16 canvases were accepted, as were a mere seven of Pissarro's 18, six of Renoir's eight, six of Sisley's nine, two each of Manet's four and Cézanne's five pictures. Degas was the only artist to have all his works, a total of seven, in the legacy accepted for entry into the national French collections. From the mid 1880s, other new art styles had begun to emerge and to question the tenets of the Impressionist movement.

Gauguin and van Gogh
Both the Dutch artist Vincent van Gogh (1853–1890) and the French artist Paul Gauguin (1848–1903) combined elements of the realist tradition with subjective expression. Gauguin,

Below *John Singer Sargent's work* Monet Painting on the Edge of Wood *was executed around 1890. Sargent was an American, born in Florence, and trained as a painter in Paris. He was friendly with Monet in the later 1880s and visited Giverny several times to see him. This canvas shows Monet's continuing practice of outdoor work which he maintained throughout his life.*

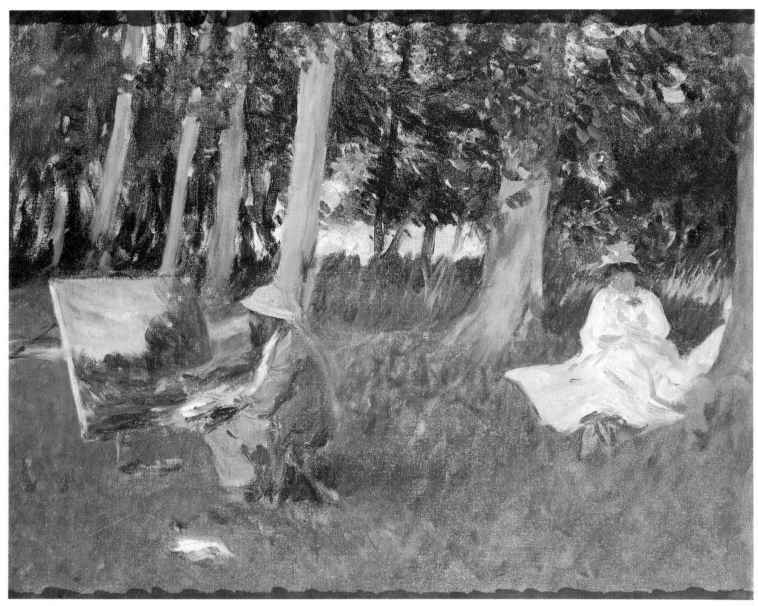

however, came more immediately than van Gogh under the pervading influence of the Impressionist group, whose works he collected in the late 1870s. Van Gogh, by contrast, had been drawing and painting seriously in Holland for almost six years – more than half of his life as a painter – by the time he came to Paris in 1886 and had his first real contact with the works of even the older French masters like Delacroix (1798–1863) and the Barbizon landscapists, let alone with the newest Parisian art. Inevitably, therefore, van Gogh's style was already well formulated before his contact with French art, and it owes more to his Dutch Realist contemporaries and to Dutch Old Masters like Frans Hals (c1580–1666) and Rembrandt (1606–1669). Van Gogh's painting style is essentially graphic, as if he drew with color. His mature, post-1887 pictures exhibit a personal, simplified adaption of Chevreul's influential theories on complementary color contrasts, which he exploited for their emotive power, exaggerating the colors he found in nature.

During the first half of the 1880s, Gauguin came particularly under the influence of Degas, Pissarro and Cézanne, and began by working from nature. However, he was soon to abandon Impressionist ideals. In works like *Four Peasant Women* (1886), his debt to Pissarro is clearly apparent. He adopted the short, directional brushstroke characteristic of Pissarro's work of the early 1880s, and his subject is comparable to Pissarro's of that time, except that Gauguin chose to dress his peasant figures in fancy regional Breton costumes rather than ordinary working clothes. This was a feature more commonly found in the paintings of rustic genre scenes fashionable at the Salon exhibitions which rarely showed agricultural laborers actually working. Compositionally, too, there are similarities with Pissarro's art. Gauguin pushed his large-scale figures close up the picture surface, and flattened the pictorial space by eliminating the sky and instead depicting his figures against a modulated green background. Even the slightly stylized anonymity of the women's faces are comparable to the simplified features often found on Pissarro's figures.

However, more strongly non-naturalistic, decorative elements – features of his mature style – are already apparent in this work. The flattened pictorial space itself works decoratively, giving no precise geographical location. Similarly, the frieze-like distribution of the figures across the picture surface, linked by the undulating rhythms of their arms and white collars, stresses abstract pictorial qualities. The rhythm in the figures to the right is echoed and reinforced by the curved tree which, although 'behind' them, appears ambiguously near to the picture surface. Even closer in feeling to this work are Degas' interior scenes of women bathers, of which 10 examples were shown at

Left *This small oil study,* Head of a Woman, *by Vincent van Gogh shows how formed van Gogh's style was, before he left Holland for Paris. Rich impasted paint was laid on vigorously, in the manner of Frans Hals, one of the seventeenth century Dutch precursors that van Gogh admired. In this work, painted in December 1885, the color is brighter and the paint is more opaque and contains more white than that used for his first large work in oil,* Potato Eaters *of April 1885. Paint is handled wet in wet. The colors are mainly premixed and slurred further into each other on the paint surface. All parts are impasted, but the highlights, like those below the throat, are even more thickly loaded. The modeling of form is still mainly tonal.*

the last Impressionist group exhibition in May 1886. The cramped, claustrophobic space in which Degas commonly located his figures – trapped, as it were, within the tight confines of the four sides of his pictures – is similar to that sought by Gauguin in this exterior, but studio-painted composition. Gauguin was inspired by the simplified form, color and flat compositions of popular prints, and by his experiences of 1886–1887 when he experimented with the simplified techniques of ceramic decoration. He went on to produce far greater symbolic stylization in works like *Vision After the Sermon* which was painted in 1888.

By 1888 at the latest, both Gauguin and van Gogh were experimenting – possibly alone as well as jointly – with oil colors on raw, unprimed canvas, which readily absorbs the oil binder. In Impressionist painting, such technical travesties were rarely found, unprimed canvas normally being used only with non-corrosive and non-oil-based colors like gouache. However, both Gauguin and van Gogh evidently relished the appearance of raw canvas, particularly of rough sacking or hessian, which they exploited from time to time, as in van Gogh's *Chair with Pipe* (1889). Gauguin was more committed to this type of coarse support texture than van Gogh, but even he rarely used its potential in combination with the paint layer colors to full advantage. On the contrary, he avoided the gestural brushwork, characteristic of Impressionism, developing instead evenly painted, flat areas of color where variations in thickness or impasto played little part. The smooth, mat surface and opaque

quality of his colors were further enhanced by his addition of extra wax to his paints.

Van Gogh remained more committed than Gauguin to the use of commercially ready primed canvas, which he tended to buy in rolls and stretch up onto stretchers himself. This was marginally cheaper than buying ready stretched canvases. For the ground he preferred gray, putty, white and sometimes, like Millet, a bold pink. He often allowed the color of the ground to show through among the paint layer colors, and take an active role in the final effect alongside his graphic brushmarks. His thickly applied colors and buttery impasted brushstrokes evoked varied textures, while following and strengthening the sense of form in his subjects. He sought and exaggerated the natural shapes and rhythmic lines in the objects he depicted, but remained consistent in his commitment to study and work from nature. In some paintings a compositional ambiguity suggests van Gogh's interest in the Impressionists' novel approach to pictorial structure and space. Like many other artists at the time, he too, collected Japanese prints. However van Gogh's continued concern to achieve a satisfactory depiction of depth in his landscapes with the aid of a perspective frame, are a reminder of his debt and allegiance to the art of the Old Masters.

Van Gogh's paint surfaces, like those of the Impressionists, show the mark of the artist's hand, creating textures which reinforce awareness of the paint surface. Both the bold strokes of van Gogh's brush and his exaggerated color, proved important sources of inspiration in the evolution of the Fauve style in the early twentieth century.

The Fauves — Matisse and Derain

The two main Fauve artists, Henri Matisse (1869–1954) and André Derain (1880–1954), worked together at Collioure in the south of France in the summer of 1905, in a productive partnership not dissimilar to that of Monet and Renoir in 1869. There they evolved their own distinctive contributions to the vibrant style, which subsequently earned them the title 'Wild Beasts' from critics later that year.

Aspects of their new approach were also already present in the work of the Neo-Impressionists, particularly the mature works of Signac, and in the anti-naturalistic paintings of Gauguin. In 1888, Gauguin told his followers in Brittany to intensify the colors found in nature in order to stress their essential characteristics and to abandon 'imitative' color. These views were remarkably close to Matisse's ideas. Yet Gauguin's advice departed from his practice, in which he developed a personal symbolic art almost exclusively derived from his imagination and eclectic borrowings from the earlier art of many cultures.

Matisse, by contrast, sought neither symbolic color nor imitative color, but color in its own right, subject only to the harmonious relationships established within the painting.

Right *Paul Gauguin painted* Vision after the Sermon, Jacob wrestling with the Angel *at Pont Aven in 1888. As its name suggests, Gauguin's work was concerned with inner rather than external truth. He combined stylized images of Breton figures in a shallow pictorial space with a 'vision' in the top right corner. Thus the 'real' and 'imagined' worlds depicted, are separated by the strong, diagonal of the tree, which was inspired by Japanese prints. Like the Impressionists, Gauguin studied Japanese prints and even adopted their use of bold, flat areas of solid color. The figures are distributed unconventionally, cut off and framing the canvas edge at the left and in the foreground. No identifiable source of light is used, a device which, looks forward to developments in Fauvism.*

Left *Matisse's* Landscape at Collioure *dates from the summer of 1905. This landscape was painted on the French coast near the Spanish border. It was painted alla prima, wet into wet, the colors kept as pure and bright as possible by placing them side by side rather than slurring them. However, the broad strokes, solid areas of color and long sinuous lines show Matisse moving away from the influence of Signac, whose Neo-Impressionist methods had dominated his work the previous year. Light is suggested, not directly depicted by the juxtaposition of vivid colors.*

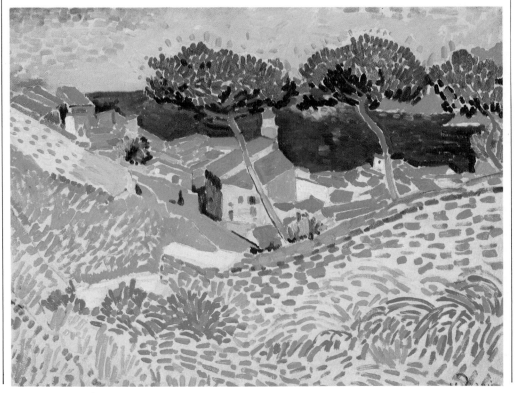

André Derain's Collioure *was, like Matisse's landscape (above), painted in 1905. Derain's landscape combines dashes of color, derived from the Neo-Impressionist method, with more broadly brushed areas of flat bright hues. He wrote from the south that 'the light here is very strong, the shadows very luminous. The shadow is a whole world of clarity and luminosity which contrasts with the light of the sun – this is what is known as reflections.' His words might have come from an Impressionist, although his color is breaking away from strictly naturalistic depiction. The white ground gave added luminosity to the colors.*

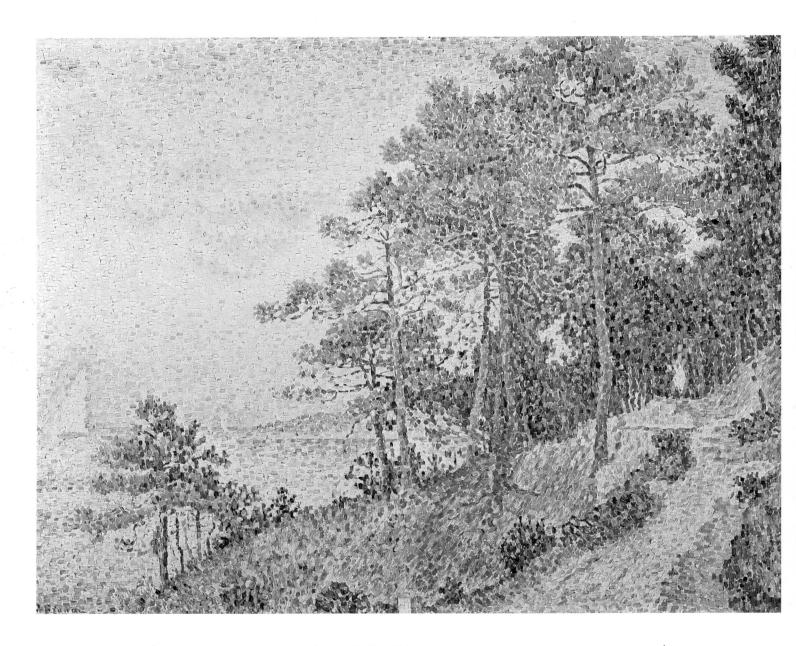

Above Saint-Tropez, the Customs House Pathway *by Paul Signac was painted in 1905. Signac's style in the 1900s was freer than his work in the late 1880s and shows a less rigorous touch. The detail (right) shows the mosaic-like application of blocks of color, which vary in hue and tone to build up the formal structure of the subject. This method was abandoned by the Fauve painters.*

He stated in 1908 'It is impossible for me to make servile copies from nature, which I am obliged to interpret and subordinate to the spirit of the painting.' Matisse's inspiration came more from what he discovered in his own painting than directly from nature. Unlike Gauguin's synthesizing approach, Matisse's art was both analytical and conceptual, as he emphasized 'For me, everything is in the conception. It is thus necessary to have, right from the start, a clear vision of the whole.' Despite this conviction, however, Matisse's paintings — especially the color correspondences — were often heavily worked and transformed during the painting process itself. Thus, as with the Impressionists, the final appearance of direct-

ness and spontaneity in his work was frequently in contradiction to the laborious care of his execution. Matisse found the methodical application of color theory in the work of the Neo-Impressionists too restricting. His approach to the use of contrasting and complementary colors was more intuitive and instinctive.

The Fauve painters generally adopted the brilliant white canvas preparations preferred by both Impressionists and Neo-Impressionists in the 1880s. Like the Impressionists, the Fauves appreciated the textured, grainy single priming. This luminous and light-scattering base was often left partially uncovered by their loose, open paint handling. For Matisse in particular it often served to separate areas of contrasting color, assisting in the vibrant activation of such juxtaposed blocks. While the Impressionist use of color contrasts had concentrated mainly on the complementary yellow and violet-blue pair, because these most aptly imitated the effects of sunlight and shadow in nature, Matisse shifted to the red-green complemen-

taries. This pair creates the greatest optical vibration when juxtaposed because the two colors are the closest in tone of any on the color circle. As the eye tires of reading, say, the red as dominant, the green at once appears to come forward and dominate. This vacillation of the eye between the two colors vying for dominance sets up an optical vibration, which enhances the color properties of each simultaneously. By focusing upon the red-green pair — which Matisse often biased towards pink-turquoise — he avoided the emphasis on the naturalistic representation associated with the Impressionists' use of color. It was also a pair which, again because of tonal equivalence, affirmed the flatness of the picture surface by negating the illusion of depth.

All the Fauve painting techniques and devices stressed the activity of painting itself above all else. Although remaining figurative in subject matter, brushwork, color and drawing were all finally freed in their painting from the restrictions of naturalistic representation.

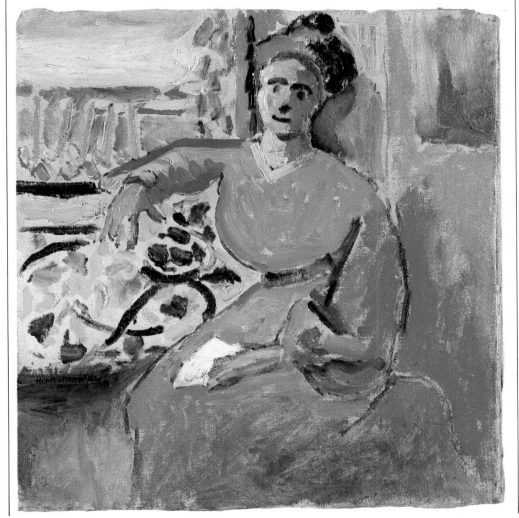

Left Woman in Front of a Window *(1905) by Matisse is a tiny, non-standard size canvas, almost square in shape. The white ground shows among the broken touches of color for the window and bay beyond. The handling here contrasts with that for the interior. Broad areas of flat bright color are applied quite thinly but opaquely. They fill in fluid blue lines which surround the form. A fall of light appears to be depicted on the face alone, but it does not in fact conform to any naturalistic effects. It simply divides the face into two separate areas of color. Colors in the composition are already being adjusted by Matisse to evoke light by contrasts and hue, rather than by imitation of actual colors perceived. Color balance – like the greens in the top right and bottom left across the reds, oranges and yellows – is more important than direct representation. Thus internal pictorial needs determine color structure.*

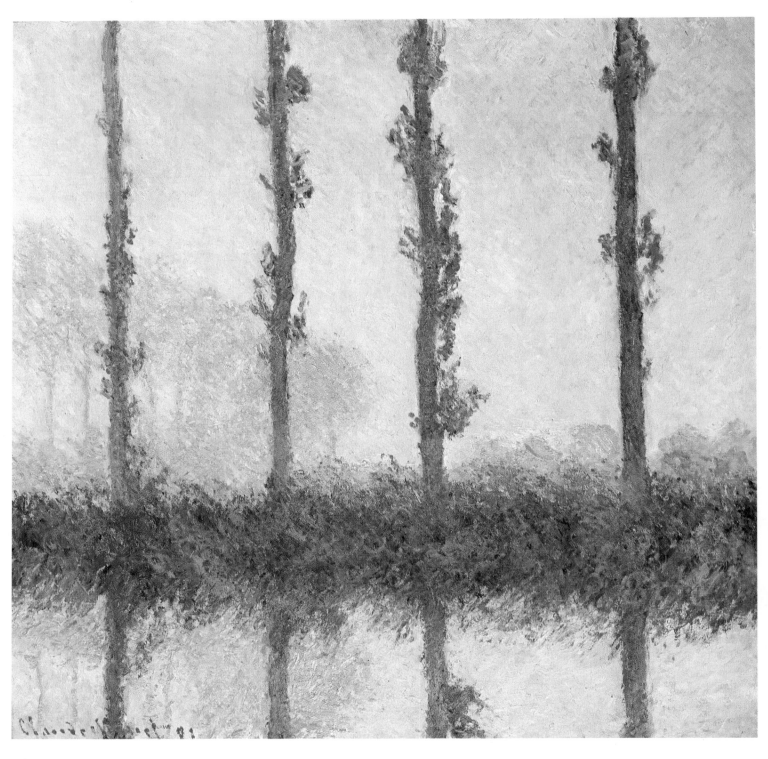

Above Monet's Four Poplars, *(1891) was painted in oil on pale-primed canvas. Monet's sensational use of the square canvas format is obvious here.*

Although the bank recedes slightly to the left, the strength of the geometric grid structure emphasizes the picture plane. The play between the dark, cool

foreground grid and the pale warm hues of the curving background line of trees animates the painting further. The relationship of these elements to the overall

square is tautly handled. This painting is from one of Monet's 'series', an approach to subjects in varying lights, which he perfected in the 1890s.

156

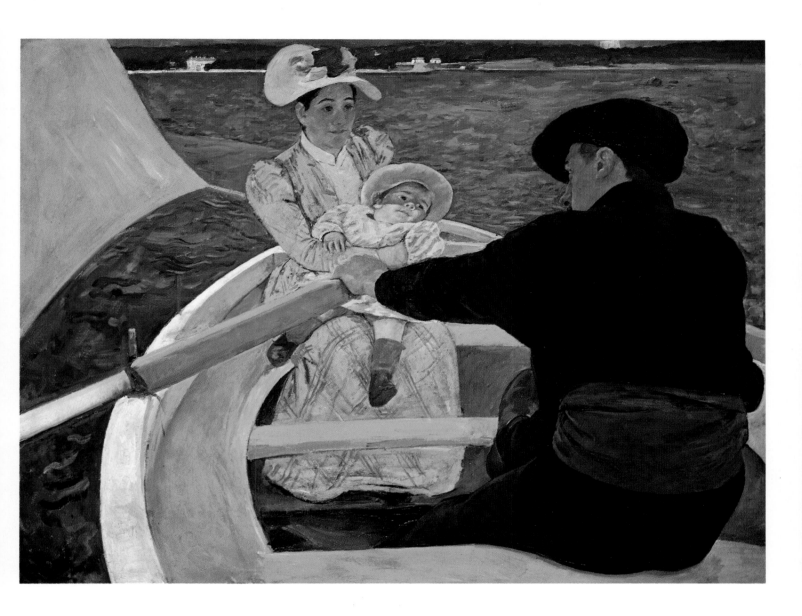

The legacy of Impressionism

Impressionism had freed painting from the conventions of tonal *chiaroscuro*, giving new emphasis to color, pure bright luminous spectral color. It had offered new approaches to space and to composition, which liberated art from the window-on-the-world illusionism dominant since the Renaissance. It had freed brushwork from its purely illusionistic or descriptive role, pointing the way both to greater emphasis on abstract, formal qualities in painting, and to a greater expressive potential in touch.

The Impressionists had fused line and color, drawing and painting, resolving the centuries-long dichotomy between these two elements of art. They had found new, more appropriate techniques with which to exploit the full potential of modern materials. Yet, still faithful to the nineteenth century natural philosophy, they all remained more or less committed to a depiction of the natural world.

It was in his transformation of their ideas that Seurat, in his late paintings, suggested a new, more stylized and non-naturalistic artform, which Gauguin, in his entirely different way, pursued in his Symbolist Tahitian paintings. With the Fauves, and Matisse in particular, the final legacy of Impressionist naturalism was overthrown, as color was freed from its imitative function, paving the way for the twentieth century abstraction already implicit in the avant-garde art of the 1860s and 1870s. Thus, until 1907 and the advent of Cubism, the radical approach and techniques of Impressionism remained a powerful force with which successive generations had to come to terms.

Above *Mary Cassatt painted* The Boating Party *in 1893/1894. A high viewpoint tips up the plane of the blue Mediterranean water, and reduces the sky to a thin bright blue line. All the blues are rich and saturated, linking across the surface to stress the spatial ambiguities created by the strong curved shapes, such as the sail and boat. Within these broad flat shapes, the figures of woman and child are handled with contrasting delicacy of tone and touch.*

VINCENT VAN GOGH

Peach Trees in Blossom/La Crau d'Arles: pêchers en fleurs
Oil on canvas (1889)
65.5cm × 81.5cm/25¾in × 32in

Following a turbulent early career which included work in the picture dealing trade, teaching, and religious missionary work, van Gogh finally turned to painting in his late twenties, around 1880. The first five years of his career as a painter were spent in his home country, Holland, where he studied briefly in the Hague in 1883, and in Antwerp in the winter of 1885 to 1886. In keeping with academic practice, van Gogh concentrated at first solely upon drawing, but he experimented with a variety of unusual media, including waxy black lithographic chalk, and carpenters' broad graphite pencils. These enabled him to produce harsh contrasts of light and dark, with powerful line and modeling, features which characterized his early Dutch style, and which were retained in his later work where color contrasts were substituted for contrasts of tone. He was greatly influenced by the Dutch Old Masters, and by his contemporary Dutch realist painter friends.

He went to France in March 1886, knowing little of the complex trends in modern painting that would greet him on his arrival. He had studied and read about earlier French painters, like Delacroix, Millet and the Barbizon School of landscapists while in Holland, and on his visits to England and France in the early to mid 1870s. In Paris, where he remained until February 1888, he lived with his brother Theo in Montmartre. They had a close but often difficult lifelong friendship, and Theo's work as an art dealer with the firm of Boussod & Valadon provided the financial support Vincent needed to survive as a painter. Their correspondence is an invaluable source of information on the artist's life and work.

Although at first van Gogh's work showed no real influence from his move to Paris, he soon met many of the new generation of artists. He worked for a time in the *atelier* of Frédéric Cormon (1845–1924), where he met Toulouse Lautrec and Emile Bernard (1868–1941). Bernard was, with Gauguin, one of the founders of the school of artists based at Pont Aven in Brittany. In the fall of 1886 van Gogh met Gauguin himself, and, through Theo, became acquainted with Degas, Pissarro, and the Neo-Impressionists Signac and Seurat. Van Gogh worked regularly outdoors at Asnières, painting landscapes alongside both Bernard and Signac in 1887, and, through Signac in particular, he learned to lighten his palette and use bright complementary color contrasts. Although he briefly adopted a broken touch akin to that of the Neo-Impressionists, he in fact remained only superficially influenced by the Neo-Impressionists and Impressionists.

Toward the end of his time in Holland, he had already been evolving a more colorful, free handling, influenced by what he read of Delacroix's techniques and by his own study of the bold painting of Dutch artists like Frans Hals (c1580–1666). The impact of the complexities of modern French art on van Gogh paled to insignificance beside his admiration for artists who exploited color like Delacroix and the Provençal painter Adolphe Monticelli (1824–1886). Like many of his contemporaries, van Gogh was greatly attracted to Japanese prints, which he began to collect in earnest from late 1886, even organizing an exhibition of them in the Parisian Café Tambourin in March 1887. But, unlike his contemporaries, van Gogh was not interested in the novel pictorial qualities of Japanese prints, instead delighting in their bold color and their representation of nature.

Disturbed by the unfamiliar bustle and excitement of Paris, and seeking the color and light he perceived in Japanese prints, van Gogh set off for the south of France in February 1888. He settled in Arles, in Provence, where *Peach Trees* was painted the following year. After a brief flirtation with Gauguin's Symbolist style, during that artist's visit to van Gogh between October and December 1888, van Gogh returned to his first love, to finding in his art a modern idiom which situated man in nature. Unlike Gauguin, van Gogh disliked working from his imagination, preferring to have subjects in nature to refer to for his inspiration. *Peach Trees* was one of six studies of spring done in 1889, and he complained to Theo of the problems in painting the shortlived effects of blossom. In fact, in this picture, the paint of the blossom lies over earlier dry paint in many places, suggesting that this is one of those which van Gogh reworked from memory in July 1889, after his move to Saint-Rémy.

Peach Trees was executed on an inexpensive study or ordinary weight canvas, primed a yellowish off-white, which the artist may himself have stretched up onto a standard portrait 25 (65.5 × 81.5 cm/ 25¾ × 32 in) stretcher. The thin layer of priming has left a grainy canvas texture, which is apparent in the more thinly worked parts between the bold impasted brushstrokes. Underpainting is present only in the area of the sky, where thin mat colors were broadly laid in. For this, muted colors were used, white barely tinted with pale blue for the upper part of the sky, and with a pinkish-gray for the lower half. This was worked over with short horizontal strokes of brighter color, cool sharp blues and pale greens, probably cobalt or malachite. As with the Impressionist technique, van Gogh's colors included white in most of his mixtures, and the paint layer is covering and opaque. Only an alizarin lake – possibly a burnt alizarin – was used in its original transparent state, in order to denote the trunks of the peach trees.

Van Gogh's brushwork is vigorously descriptive, echoing the textures and forms in his subject. Although the impasted build-up of

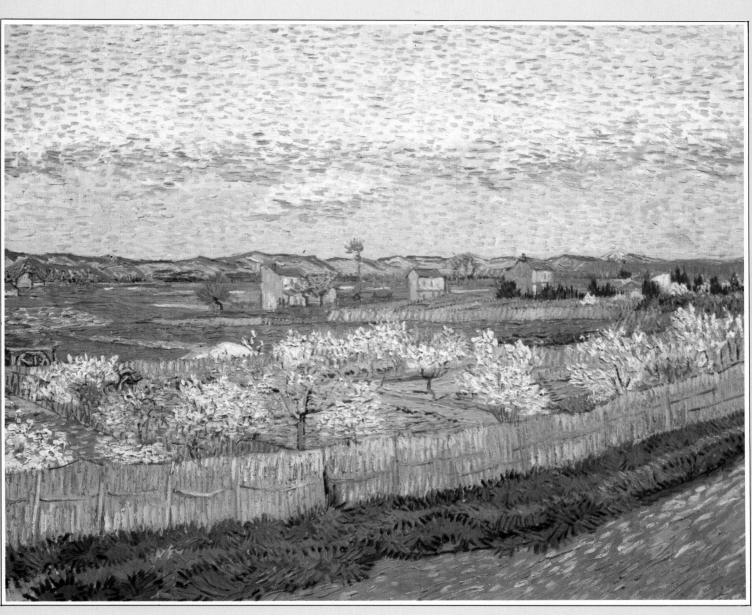

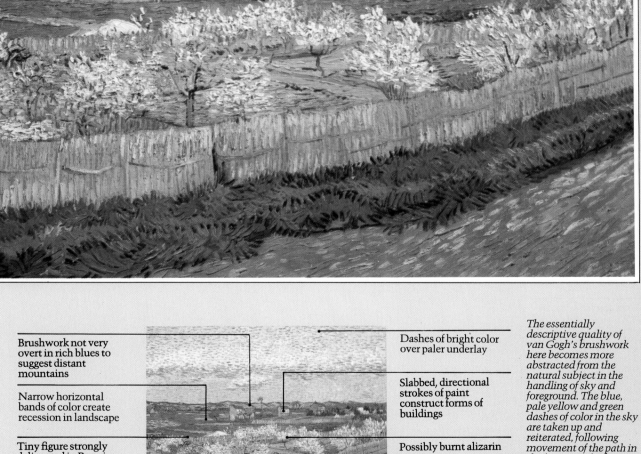

Brushwork not very overt in rich blues to suggest distant mountains

Narrow horizontal bands of color create recession in landscape

Tiny figure strongly delineated in Prussian blue

Vigorous splayed brushstrokes imitate grass

Dashes of bright color over paler underlay

Slabbed, directional strokes of paint construct forms of buildings

Possibly burnt alizarin

Vertical strokes describe fence

Blue dashes added over dry earth tints

The essentially descriptive quality of van Gogh's brushwork here becomes more abstracted from the natural subject in the handling of sky and foreground. The blue, pale yellow and green dashes of color in the sky are taken up and reiterated, following movement of the path in the foreground. The colors are heightened, but still naturalistic, and the creation of recession and space is carefully organized.

paint tends to emphasize the patterned surface of the picture, his careful concern with establishing a strong sense of space and perspective through the receding fields and changing scale of objects, confirms his commitment to traditional Dutch landscape painting.

While this picture is brilliant and luminous, its more subdued hues, for example in the foreground, look forward to his work at Saint-Rémy between May 1889 and May 1890. During that period, his nostalgia for the somber hues of the Dutch countryside led him to use less brilliant colors than those which characterized his stay in Arles. In May 1890, van Gogh returned to the north, but not to Holland. He settled in Auvers-sur-Oise, an old haunt of the Impressionists, north-east of Paris, where he died at the end of July 1890.

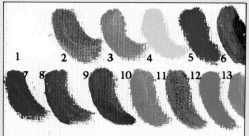

Van Gogh's palette probably comprised zinc white (1), raw sienna (2), yellow ochre (3), chrome yellows (4), red alizarin lakes (6), ultramarine (7) or cobalt (8) blues, Prussian blue (9), cobalt green (10) and viridian green (11). Red earth (5), and emerald (12) and chrome (13) greens may have been used.

Actual size detail
The texture of the canvas, thinly primed with off-white, can still be seen between the more impasted strokes with which the surface is loaded. Even though it is often obliterated, the pale ground remains a stable luminous tint that helps maintain the overall brilliance of the colors used. The opaque colors, often loaded with white, have a similar effect, because they bounce light back to the eye. The addition of extra color for the blossom suggests this picture was reworked later. Van Gogh executed six paintings of spring blossom that year, and is known to have completed some of them later in the year, after the brief season of blossom was over. Brilliant touches of what are probably red earth, cobalt blue and cobalt green enliven the more muted earth colors and the pale blossom.

Van Gogh constructed the sense of recession using finer handling for the distances. Varied forms and textures are characterized by changes in brushwork. Thin horizontal strokes suggest the receding fields in alternating blues, greens and creamy hues. Paint is worked mainly wet over dry in unblended dabs.

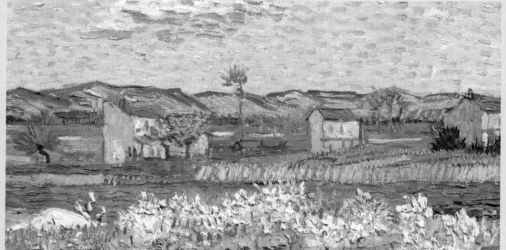

Thin, opaque layers of pale tinted color – pale green in places, pale blue in others – were applied and allowed to dry before the artist added short horizontal strokes of brighter, more saturated color. These wet-over-dry patches animate the sky in a relatively unnaturalistic way in comparison to the more naturalistic handling which dominates the rest of the painting. The paint is chalky, thick and full of white pigment even in the quite saturated hues.

The paint layer colors are almost entirely opaque and densely loaded, the mark of the bristle brush remaining apparent in the raised paint. Wet-in-wet slurring is visible among the colors denoting the grasses, while wet-over-dry dragged paint used for the fence creates a stippled, vibrant effect. Colors are mainly mixed and broken, but the green and blue are relatively 'pure'.

PAUL GAUGUIN

Te Reroia (1897)
Oil on unprimed hessian
95cm × 130cm/37½in × 51¼in

Gauguin lived in Tahiti for two periods from 1891 to 1893, and 1895 to 1901, so *Te Reroia* was executed around the middle of his second stay. Although born in Paris, much of Gauguin's early life, from 1849–1855, had been spent in Peru, and, later, traveling extensively first as a merchant seaman and then with the navy between 1865 and 1871. His early travels gave him both a taste for the exotic, and a restlessness which he never overcame. During the 1870s he worked on the Paris stock exchange, losing his job during the financial slump of 1883.

He had taken up painting as an amateur in 1873, but by 1879 was already exhibiting with the Impressionist group, albeit against the wishes of some of the members. Through his guardian Gustave Arosa, Gauguin met the Impressionists, and from 1879 he occasionally painted with Pissarro, whose style and approach had a marked influence on his early development. Gauguin also worked with Cézanne in 1881, but his enthusiasm for discovering what he thought to be Cézanne's 'secret' method made Cézanne both angry and resentful. Despite Gauguin's consistent argument that the younger generation of Symbolist painters were all dependent on his totally innovatory style, he himself was highly eclectic, using sources as widely disparate as Far Eastern Buddhist and Asiatic art, the Greek Parthenon frieze and Manet's *Olympia* (1863). He had photographs from these and other sources with him in Tahiti, and wrote of them that 'when marbles or wood engravings draw a head for you, it is so tempting to steal it.' Gauguin clearly had the feeling that such borrowings were in some way wrong, making his art less original or casting doubt on his own creative abilities. However, such practice was common, and all his borrowings were transformed in his work, resulting in a completely personal style.

Gauguin's rejection of decadent Western society, and turning to what he considered the more genuine, naive simplicity of life in the South Seas, was symptomatic of a broader cultural disillusionment in Europe at that time. The Symbolist movement in art and literature can in general be seen as a reaction against the ills of the industrial society, which artists saw growing up around them, and an urge for a more introspective, contemplative ideal. Neither Gauguin himself, who was a sophisticated European intellectual, nor his art, can be considered primitive as such. Yet, by choosing to live among so-called primitive peoples, and by embuing his art with emblems and meaning derived from various non-European and non-Christian sources, Gauguin sought to express his belief in the importance of natural innocence and simplicity. With pessimistic horror he watched Western civilization spread, relentlessly imposing its own ideas and destroying

original civilizations wherever it went. The primitive life that Gauguin hoped to find in Tahiti, and had read about in idealized guidebooks before he left, had long disappeared from the French colony by the time he arrived there. Gauguin's understanding of Polynesian culture and rituals came from historical textbooks taken out with him, because Christian missionaries had already destroyed the indigenous culture. The reflective melancholy of Gauguin's art represents both his own mood, and a pessimistic view of the times in which he lived.

Early in Gauguin's career, the critic Félix Fénéon, reviewing the last Impressionist exhibition in 1886, had remarked upon the 'dull harmony' of his paintings, which resulted from the muted close tones of his colors. The unnatural, almost dream-like quality produced by his colors, is apparent in *Te Reroia*, painted 11 years later in Tahiti. They give to the painting the quality suggested by the title, which means 'Daydreaming'. On 12 March 1897, Gauguin wrote to his friend Daniel de Monfried about this painting, saying 'Everything about this picture is dreamlike: is it the dream of the child, the mother, the horseman on the track, or, better still, is it the painter's dream?' Unlike the Impressionists, Gauguin did not seek to represent the surface appearance of things in his painting. Instead, like the French Symbolist poet Stéphane Mallarmé, Gauguin sought the essence of reality in his art, the individual's experience of the object, rather than its external characteristics. Gauguin's painting was anti-naturalistic because he tried to depict his conception of the world, not simply his perception of it.

Gauguin's technique was often dictated in part by external factors. He was frequently short of money, and had to use whatever materials came cheaply to hand. His paint surfaces – often deliberately meager – were sometimes thin because he had inadequate supplies of paint. He had already begun to experiment with rough, coarse canvases, which could express a rugged primitive or ethnic quality, with van Gogh in 1888. However, in Tahiti, his use of hessian fabric was sometimes the result of financial hardship. The unprimed sacking support in *Te Reroia* adds to the so-called barbaric qualities Gauguin admired, its hairy surface is distinctly visible among the delicate colors of the paint layer.

Gauguin reacted against what he considered to be the self-conscious virtuosity of Impressionist handling, preferring to apply his colors with little gestural inflection, in broad areas of subtly modulated hues. He often added wax to his paints, to increase their matness and the smoothness of his surfaces. It would have been easier to handle wax-filled colors in the warm Tahitian climate, where they would remain malleable, whereas they would become too stiff to paint with in the colder environment of

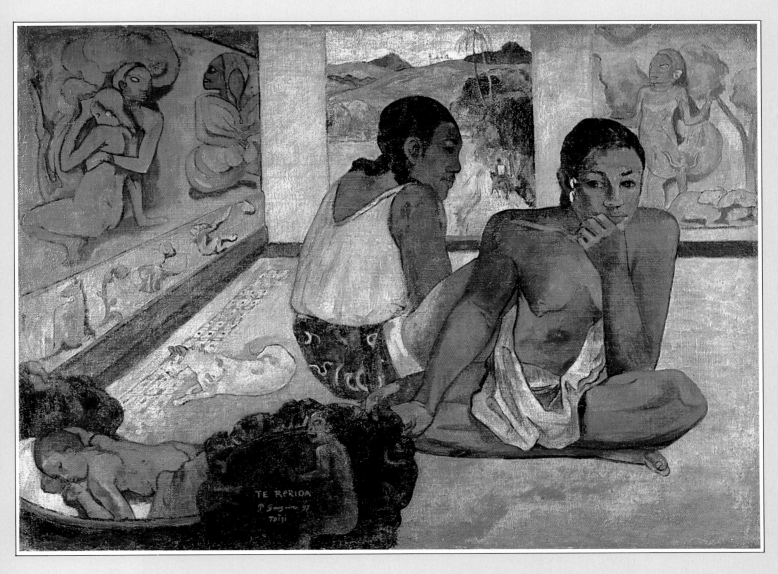

Premixed broken colors worked both wet in wet and wet over dry

Hessian texture strongly apparent at contours

Title, signature and date pick up vermilion and reinforce it across picture surface

Accent of muted vermilion or red earth

Thinly and flatly laid opaque colors

Tints in which yellow ochre predominates unifying background and floor colors

Paint applied with knife then reworked in thinly brushed paint

Prussian blue flowing lines strengthen contours

This work, executed by Gauguin in Tahiti in March 1897 six years before his death, has a brooding melancholy which is evident both in the muted, broken colors and the strange, unreal light. The external world through the door appears as a picture on the wall, distinguished by its brighter hues. The figures are treated as simplified, statuesque forms, the one to the fore especially Buddha-like in both pose and enigmatic gaze. The dark sinister symbolism of the murals and the carvings on the cot evoke the dream world suggested in the title.

Gauguin's palette probably comprised lead white (1), black (2), sienna (3), yellow ochre (4), cadmium yellows (5), red earth (6), vermilion (7), Prussian blue (8), viridian (10) and chrome (11) greens. Cobalt blue (9) may also have been used.

northern Europe. The paint is thinnest at the contours, where dark Prussian blue or dark earth red was used to outline the initial compositional structure. These lines were in places reworked and reinforced later, after the forms had been built up. Thus it is at the contours too that the rough canvas shows through most strongly, although it gives a tapestry-like effect to the entire picture.

Parts of the background, such as the right half of the floor, were applied first with a palette knife, giving a surface flatness, then overworked in thin translucent color with a brush. The somber tones of the interior contrast with the view through the door, executed in more brilliant hues which enhance the dream-like atmosphere of the room.

Gauguin's final years were spent on the Marquesas Islands in the Pacific. Although his work was greatly admired by fellow artists during his lifetime, it was only after his death that he finally achieved the widespread fame he had coveted so strongly.

Actual size detail
The monumental simplicity of Gauguin's handling of this head belies the sophistication required to achieve it. Forms are reduced to smooth planes of subtly modulated hues, which give the appearance of sculpture. The greenish-bronze cast to the flesh tints reinforces this association. Echoing the other head, this one is also placed against a pale background, the yellow ochre tints being picked up and repeated as accents suggesting light on nose and brow. The flesh areas tend to be the most loaded parts, but still the rough weave of the hessian support remains visible. It was unprimed, and the resulting absorbency of the fabric has dulled the oil colors. The addition of wax to the colors may have increased this effect, which has definitely been enhanced by the dark color of the raw fabric. Fibrous hairs which protrude from this hemp cloth have been 'glued' flat by the paint. No identifiable light source illumines the figure; instead, an eery luminosity seems to come from within.

The unlit head of the woman in profile is starkly silhouetted against the pale acid hues of the landscape beyond. These sharp greens pick up the green cast of the flesh hues, accentuating them rather than making them warmer by contrast. The artist plays on the air of unreality in the work by avoiding any clear link between the interior and exterior scenes. The thin walls of the hut have no bulk, giving no hint of perspective to the door jambs. No compositional devices link the floor to the distant pathway, and so there is no coherent middle distance connecting foreground to background. This emphasizes the introspective nature of the subject. The more richly loaded paint on the head helps detach it from the background, which is broader and thinner in its color application.

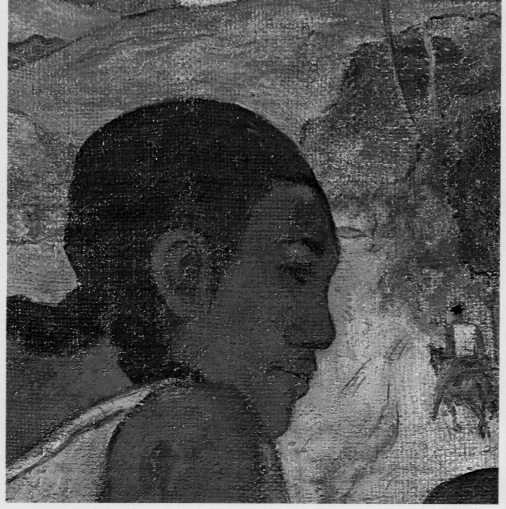

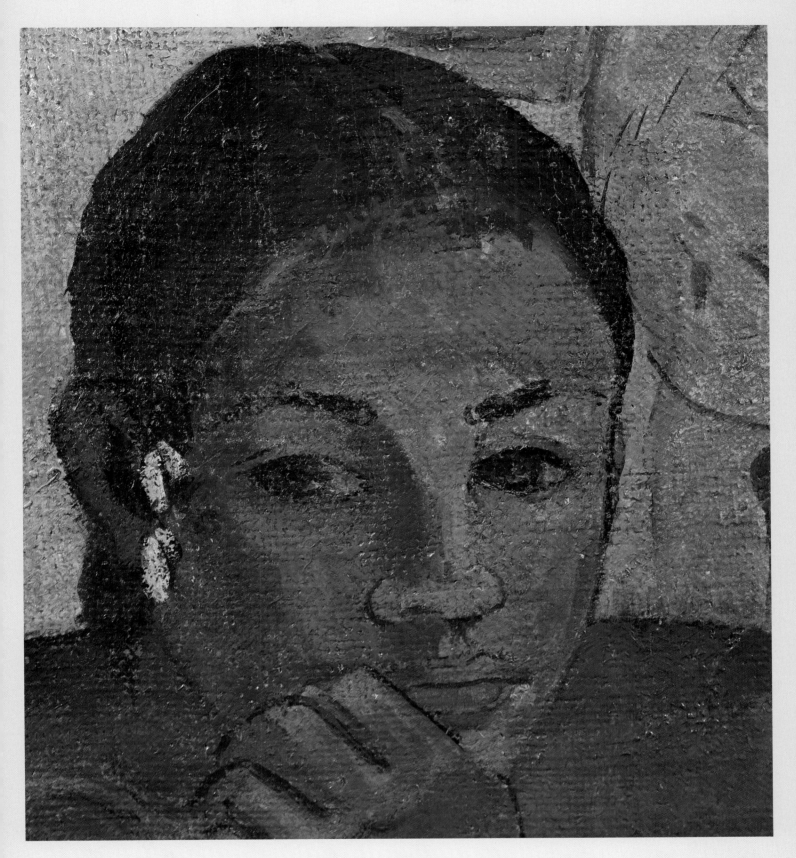

HENRI DE TOULOUSE-LAUTREC

The Tête-à-tête Supper/En Cabinet particulier (1899)
Oil on pale primed canvas
55cm × 45cm/21½in × 17¾in

In 1884, Toulouse-Lautrec moved into a studio in Montmartre, which formed his base for the following 13 years. Lautrec found his main subjects in Montmartre with its popular, fashionable nightlife. He had trained in the studio of Léon Bonnat (1834–1922), from 1882, then in the studio of Frédéric Cormon (1845–1924), where in 1886 he met van Gogh, and also the artist Louis Anquetin (1861–1932). Although Lautrec had met the singer and café proprietor Aristide Bruant in 1885, the artist's meeting with Anquetin introduced him to the latter's brilliant circle which frequented Bruant's café-cabaret Le Mirliton in Montmartre. From this time, Lautrec regularly worked in Montmartre's cafés, sketching its characters and entertainers from life. He also painted courtesans and prostitutes. Indeed, the central figure in *Tête-à-tête Supper* was the famous *demi-mondaine* Lucy Jourdan, eating in a private cubicle at the then famous restaurant, the Rat Mort, in the rue Pigalle.

Lautrec's earliest painting style was derived from the Impressionists, more especially the hatched brushwork used by Pissarro in the late 1870s and early 1880s. Lautrec exploited the decorative, surface effect created by this type of patterned brushwork. This mid 1880s to 1890 handling was later replaced by a freer, more open technique, where fluid, graphic contours outlined blocks of more uniform color, applied with rapid, bold sweeps of the brush. He often varied his touch — dots, short lines and zigzag strokes — to create a decorative equivalent for different surface textures, in a manner similar to, but less naturalistic than, that found in van Gogh's pen drawings.

Lautrec was greatly influenced by the techniques, style and subject matter of Degas, who was a close neighbor between 1887 and 1891. Lautrec's art, however, has a more immediately accessible feel to it than Degas' more intellectual style. Like Degas, Lautrec experimented with painting with turpentine which was called *peinture à l'essence*. In Degas' method, oil was drawn out of his colors by placing them on blotting paper. Then the chalky paint was diluted with turpentine and applied like a wash to his support. Because the turpentine spirit evaporated quickly, the colors dried rapidly, so that the paint surface could be reworked and built up without enormous delays. Unlike paint applied thinly in glazes, with this technique the color dries mat, and has a chalky surface only thinly and sparely colored. Similarly, as in Degas' *Portrait of Hélène Rouart* (1886), Lautrec preferred dull muted ground colors, and a palette of broken rather than pure bright hues. These colors suited the indoor nightlighting that he, like Degas, so frequently depicted. Lautrec also experimented with the dulling, absorbent effects of unprimed canvas, and with using unconventional supports like brown cardboard.

Tête-à-tête Supper was a late painting, executed on a primed, squarish, standard format canvas. Although the paint layer is thin, it is all-covering and this makes it hard to identify the ground color accurately. It is undoubtedly pale, because its luminosity lights up the dark translucent colors laid on top. It may be a pale putty or oatmeal color. The canvas is fine in weave, relatively smooth in texture, and suited to Lautrec's fluid application of color. The light in the picture is theatrical, and does not conform to a specific source of lighting, but is arranged arbitrarily to shine from below onto the central figure's face, exaggerating and caricaturing her features. Like the graphic art of the painter and caricaturist Honoré Daumier (1808–1879), Lautrec's drawing summarizes the essential features of his subjects, adding only as much detail as is needed to capture the important elements of personality and environment. This facility with caricature is an important feature of his style, which was also necessary in his lithographic work. In the posters, which he began to produce in 1890, visual simplicity and direct impact were demanded both by the technique and by the commercial function of the image. His experiments in color lithography made it one of the most important and exciting media in late nineteenth century art.

The composition in *Tête-à-tête Supper* is strong and direct, giving an effect of immediacy through the abrupt cropping of the seated gentleman which creates an impression of a fleeting encounter. Yet — as in Degas' works — the appearance of immediacy is deceptive, for the picture is carefully structured and balanced. The background is sketchy and simple, with only the gas lamps on the left to punctuate its yellow-green blandness. Beneath, a solid block of dull loosely brushed Indian red, suggests the red plush seating, which forms a strong horizontal where it meets the greenish hues above. At the center point of this horizontal rises the

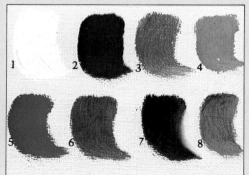

The palette for this work probably consisted of lead white (1), black (2), yellow ochre (4), red earth (5), Prussian blue (7) and viridian green (8). Sienna (3) and red alizarin lake (6) may also have been used.

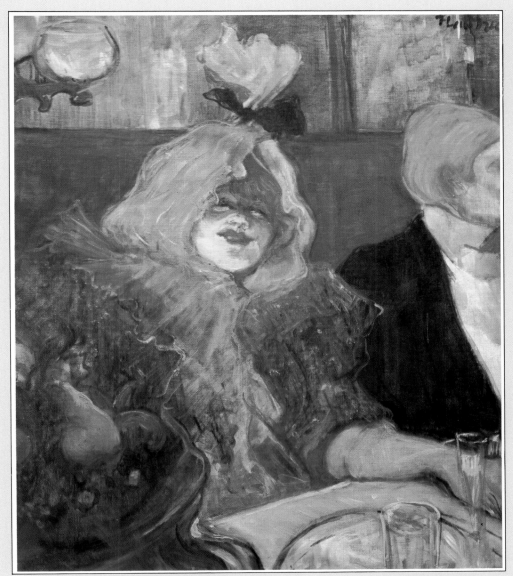

Lautrec's characteristic thinly worked paint layer is apparent here. His technique, like his fascination with experimentation, seems to derive mainly from Degas. He also used colors diluted with turpentine to make them wash-like and mat. This was a very rapid handling method, which allowed for reworking after only a short drying time. Lautrec's reworkings are in color which is only slightly thicker and more opaque. This gave a final effect of immediacy and capturing a fleeting encounter. However, unlike the other Impressionists, both Lautrec and Degas preferred to study the effects of artificial light rather than full daylight. Lautrec used a standard format portrait 10 canvas for this painting, and its squarish proportions are well suited to the compositional design.

flamboyant beribboned hairstyle of Lucy Jourdan. Her yellowish blonde hair is streaked with green reflections. The vigorous brushwork, its lively energy echoing the sitter's personality, changes to a drab reluctant touch when describing the partial figure of her escort.

The tabletop, which the viewer appears to look down on, as if standing engaged in conversation with the sitter, supplies evidence of the event's location. Glasses and dishes form the after-dinner debris, while a luscious dish of fruit almost lurches out of the frame toward the viewer. The analogy between the ripe lushness of his sitter and the full fruits beside her, is a stereotypical image in European painting.

Lautrec's spare, thin paint surface, in which there is virtually no impasto, nevertheless creates a surprising richness of surface textures. The surface is relatively uniformly covered, with fluid translucent washes overlaid with delicate opaque scumbles. For example, the ruffles of her dress almost appear to float. The pictorial space is shallow, confined by the visual barrier of the table and fruit dish in the foreground, and cut off at the back by the wall of greenish hues, emphasizing the claustrophic artificiality of the life-style depicted. Lautrec was at this time already suffering from the effects of alcoholism from which he died two years later.

Strongly graphic, dark contours define shape

Thinly applied opaque reds appear translucent

Thickly applied opaques for highlight

Palish opaque whites and greens thinly scumbled over washed black layer create optical grays

Transparent black wash over paler underlay

Cropped composition on side and bottom edges pushes figures forward to enhance impression of immediacy

The decorative form of the gas lamps adds pictorial interest to the flatly placed and painted back wall. They are thinly washed with translucent paint, outlined with vigorous, dark brushstrokes. A splash of opaque yellowish-white stands for the flame within. The gas lamps do not provide the light source which falls on the main subject. The woman is strikingly lit from below, producing an almost unflattering raking fall of harsh lights and shadows on her face. It would seem that a light is hidden behind the fruit bowl, projecting up onto her face like a spotlight. However, such a light would in fact have more effect on the garments she wears. Thus Lautrec creates an arbitrary lighting for purely dramatic, compositional reasons.

The inclusion of two heads underplays the portrait function of the picture. The woman's blonde hair is streaked with vivid but pale viridian green with white, adding to her flamboyance and to the drama of the light. Lautrec's method makes the shapes between the forms, in this case the red seating, as active forms themselves.

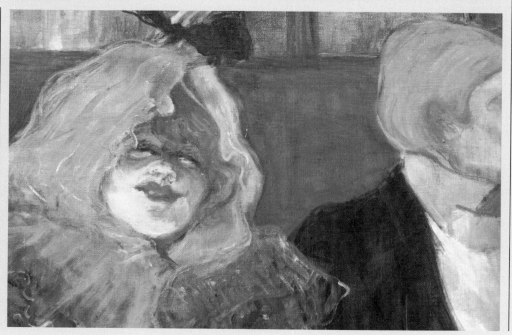

Actual size detail
*The lively, fluid
handling of the still life
on the table in the
foreground is typical of
Lautrec's skilled but
sketchy technique. The
paint is very thinly
applied, washed on color
diluted with
considerable quantities
of turpentine spirit. The
rapid drying promoted
by the evaporation of the
spirit allows for speedy
reworking, like the
addition of further thin
layers here, and of
accents like the green
strokes which give
substance to the glass.
The fine canvas has a
thin commercial
priming, in a pale tint.
This may be an oatmeal
or off-white hue. It is
hard to identify this
with certainty because
its tint is modified by
the thinly washed colors
of the paint layer. Thus
the paint layer, although
often translucent or
even transparent in
places, is sufficiently
colored to disguise the
ground color.*

PAUL CEZANNE

Large Bathers/Les grandes Baigneuses (*c*1898–1905)
Oil on creamy white primed canvas
136cm × 196cm/53½in × 77⅛in

Cézanne has frequently been placed under the broad and uninformative Post-Impressionist banner, although, like Monet, he remained true to the essentially naturalist tenets of Impressionism throughout his career. That label seemed appropriate when his aims were considered more monumentally structural and suggestive of permanence, in contrast to the notion of Impressionist painting as transient and unstructured. However, when Cézanne's painting is seen in terms of techniques and painting methods, it is far closer to that of the Impressionists than to the anti-naturalist art — like that of Gauguin — normally labeled Post-Impressionist. Recent researchers into Impressionist painting have begun to question these accepted ideas, for so long taken at simple face value, about the 'spontaneous immediacy' of Impressionist practice, to demonstrate just how careful and calculated was their approach to painting. Within this context, Cézanne's work after the 1870s does not appear in opposition to the aims of the Impressionists. His commitment to recording his visual sensations remained with him throughout his life, as did his use of an Impressionist palette and basic Impressionist working methods. His late, large figure compositions done from the imagination, like the *Large Bathers*, were no more or less unrealistic than the bather compositions he executed in the 1870s, nor is his color in them any less naturalistic than that of Renoir's Impressionist interiors, like *The Parisian* (1874). Both used their observation and understanding of the effects of outdoor light, to give comparable luminosity to pictures which were in fact executed in the studio.

During the final 10 years of his life, Cézanne worked, among other things, on three major compositions of women bathers set in landscape surroundings. Studies of their chronology suggest that this version was the second begun by Cézanne, but that all three overlapped in time of execution, for they were worked on over many years. The theme of nudes in a landscape has a long and distinguished history in European painting, and many artists in the latter half of the nineteenth century took up the challenge it offered as a subject. Such paintings had, of necessity, to be worked from the imagination, because posing nude figures out of doors was unacceptable at that time. Matisse, early this century, was the first artist to paint nudes posed outdoors. Cézanne in particular, was an artist of exceptional reticence where it came to using live models, rarely doing so in his Aix-en-Provence studios for fear of the suspicious prudery of his provincial neighbors. In fact, only once during the period when he executed his large bather compositions is he known to have worked directly from a model. This was in Paris, in 1898–1899. Thus his sources for his figures tended to be from past art, either his own student studies, or his studies after the Old Masters.

The rich blues, which dominate the color harmonies of this version of the *Bathers*, evoke the atmospheric blue which saturates the Mediterranean countryside, without depicting a specific landscape. The figures are modeled through contrasts of warm and cool colors, blues for the receding contours of the figures, as their limbs turn out of sight, and warm pinks, oranges and yellows for the flesh as it comes out toward the viewer. No particular fall of light is used to sculpt the form, although a sense of light is created through the appearance of shadows cast by the limbs of the two main seated figures to the foreground right and left. Instead, as with color, form is suggested by the way in which the tone is modified over the forms, pale in the fleshy parts that swell out toward the viewer, and darker as the forms turn away. As in Renoir's *Parisian* the highlights, or rather, in the Cézanne, the parts closest to the spectator, are the most thinly painted, leaving the off-white ground glowing through. The 'shadows' or parts furthest away, are the most thickly painted. When the picture is lit with a light raking across it from the side, the density of built up paint in those areas is visible. The intense blues of the contours are like tramlines, ridges of layered color following the outlines of the figures, creating a physical structure or relief which contradicts recession, but creating an illusion which has the effect of enhancing it.

The academic method advocated painting the lights thickly and the shadows, or edges of forms, thinly, to produce a relief which imitated the actual relief of the subject. Thus Cézanne's method, like that of Renoir, is in opposition to traditional means. It is closer to pre-Renaissance methods of representing form, when — before actual light and shade had been copied by artists — the parts of the form nearest the viewer were painted pale, and the receding parts were painted as becoming progressively darker. This is one of the reasons why independent artists, who broke away from *chiaroscuro* techniques, were denigrated as 'primitives'. This was referring to the so-called primitive painters in pre-Renaissance Italy. The work of these latter artists was then generally considered flat and lacking satisfactory illusionism. They also, like the Impressionists, avoided the use of black for shadows, because it sullied the purity of their colors. Instead, the Italian primitives gradated their tempera colors from white through to full color saturation to suggest form. Cézanne's method also has parallels with this use of color, although medium and handling are, of course, quite different.

Cézanne's composition for *Large Bathers* has been called architectural in feeling, because it evokes an architectural solidity both in the monumental simplicity of the individual figures,

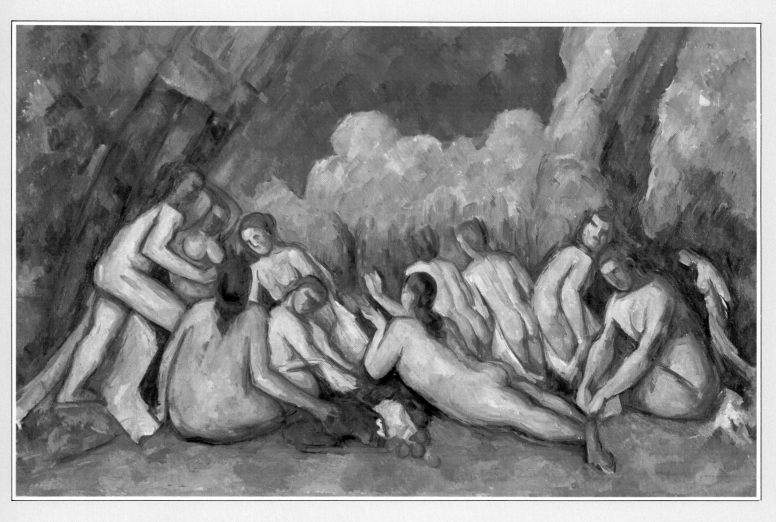

Cézanne's group of partially draped female nudes is treated with monumental grandeur reminiscent of the classical tradition, although his handling of the subject breaks with tradition. In effect, he is restating that tradition in contemporary terms. His knowledge of light, color and the atmospheric blues of the Provençal landscape have influenced his studio compositions of imaginative subjects. The figures are disposed in a frieze-like band parallel to the picture plane. Warm colors dominate in the foreground, but are modified by the blues which permeate the entire painting. The forms closest to the spectator are painted most thinly.

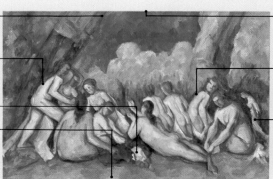

Subtly modulated blues applied in parallel strokes

Contours, or receding edges of forms, worked in thickly built-up blues forming raised ridges

Dog and still life

White ground exposed in places left unpainted; bottom edge extended by 7.5cm (3in) during painting

Incomplete top strip hidden by frame – sky area reduced by artist during execution

Monumental forms of figures relate to powerful handling of tree trunks

Altered but apparently unfinished figure shows modification in progress

and in their overall relationship to each other and to the huge pillar-like forms of the trees. Cézanne modified his composition, progressively adding 7.5cm (3in) to the bottom of the picture, on canvas that had been turned over the base of the stretcher. Similarly, he reduced the height of the picture, along the top of which is a strip of about 7.5cm (3in) where the paint is thinner and less worked. This is usually hidden by the frame. This adjustment enabled Cézanne to extend the open foreground separating the audience from the figures, and to reduce the expanse of sky above them. The canvas proportions chosen for this and the other two large bather pictures, seem to confirm the chronology put forward for the three *Large Bather* pictures. The earliest canvas is elongated in format, the second, the present *Large Bathers*, is less elongated, and the final variant is the squarest in its proportions.

From the mid 1880s, following his father's death, Cézanne's financial freedom enabled him to pursue his artistic interests without the pressure to sell to a generally unsympathetic public. His first major retrospective exhibition was only to take place at Vollard's gallery in Paris in 1895.

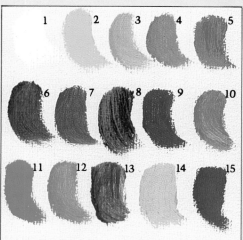

Cézanne's palette for this work probably comprised lead white (1), chrome (2) or cadmium yellows (3), yellow ochre (4), vermilion (5), red alizarin lakes (6), cobalt blue (7), viridian green (8), ultramarine blue (9), *emerald green (11), green earth (terre verte) (13). Naples yellow (14), red earth (15), cerulean blue (10) and chrome green (12) may also have been used.*

Actual size detail *Cézanne's painstaking, slow method of painting can be seen here. The proportions of the figure have been changed as the painting progressed, and this leg has clearly been shortened. The calf is now thinner, and the foot about 3.75cm (1½ in) further up. The original position is apparent from the ridges of dry paint over which the final colors were opaquely applied. Light catches and bounces off the varnished surface at these points. At the bottom edge of the drapery in the lower left the white ground shows bare among the strokes of varied blue and green. It serves as the palest tonal value. Thickness of paint application varies considerably. The top and bottom left areas are thinly worked in opaque paint, as is the drapery. The reworked parts are inevitably more loaded, but the contours and the wedge shape between the heel and drape are built up most. The successive layering of rich blues for the contours are evidence of Cézanne's concern to create the effect of roundness in the forms.*

Above this upper line remains about 7.5cm (3in) of partially painted canvas which the artist decided to exclude from the composition. It is hidden beneath the frame when exhibited. The white ground glows through the more thinly applied areas of color, as here.

The incomplete form of a dog, caressed by an unfinished hand, dominates the middle foreground, beside a still life of fruit which harks back to Manet's Luncheon on the Grass (1863) and to Cézanne's own numerous studies of fruit. Above the dog, further alterations had been made.

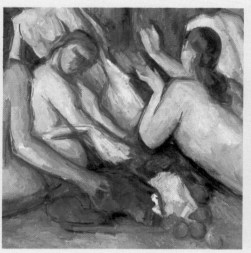

In the thinly painted parts, the ground still shows, adding luminosity to the rich hues of the paint layer. Variations in the paint application are apparent. The dark areas show repeated reworkings which contrast with the thinly worked pale hues. Oppositions between opacity and translucency are also exploited.

ANDRE DERAIN

Portrait of Matisse/Portrait de Matisse (1905)
Oil on pale coffee-color primed canvas, primed on
front face only
$46cm \times 35cm/18\frac{1}{8}in \times 13\frac{3}{4}in$

Born in 1880 at Chatou, one of the old Impressionist haunts near Bougival, west of Paris, André Derain began painting at the age of 15. In 1898, he attended life classes at the independent Académie Camillo in Paris, where the Symbolist painter Eugène Carrière (1849–1906) taught regularly, and met two of the future Fauve painters, Henri Matisse and Jean Puy (1876–1960). In June 1900, on a suburban train, Derain met Maurice de Vlaminck (1876–1958), a neighbor from Chatou with whom he established an immediate friendship, and the two young artists set up a communal studio. Vlaminck was also to become a Fauve painter. In 1901, at the important exhibition of paintings by van Gogh — who was a great influence on the Fauves — Derain introduced Vlaminck to Matisse. From late 1901 to late 1904, Derain's career was brought to a halt by his military service, but he returned to Chatou and to painting in September 1904.

1905 was the crucial year in the development of the Fauve style, and it was at the historic September exhibition of independent artists, called the Autumn Salon, that the title 'Fauve' was coined. During that summer, Matisse and Derain worked together in the south of France at Collioure, the Mediterranean port that had been 'discovered' by Signac in 1887. The Fauve style is usually defined in terms of liberated bright color, but — unlike the earlier Neo-Impressionist, or the later Cubist styles — its exponents had no specific platform of theories, nor did they form a distinct movement. Fauvism, which was a comparatively short-lived style concentrated in the years 1905 to 1907, was more the product of friendships and artistic contacts. Its artists had very different styles of painting, but they held a common concern for using bright, non-descriptive color.

The partnership between Derain and Matisse is celebrated in this pair of portraits from their campaign of 1905, portraits which also highlight the differences between the styles and aims of the two artists. In his study of Matisse Derain's brushwork shows his debt to van Gogh, whom he greatly admired. Derain wrote of van Gogh in 1902, a year after seeing the Dutch artist's exhibition: 'Van Gogh offers not so much total cohesion as a unity of spirit.' Derain's touch is reminiscent of van Gogh's parallel hatched brushstrokes, particularly in the handling of Matisse's beard.

In his color, however, Derain's allegiance is to Gauguin, whose work had again been forcefully brought to his notice that summer when he and Matisse visited Daniel de Monfried to see his collection of Gauguin's paintings. The burnt golds, sharp greens and brick reds of Gauguin's later Tahitian paintings are the basis for Derain's palette in his portrait of Matisse. With the exception of the cobalt blue and white of the shirt, all his colors are mixed

hues, achieved by combining two or more colors. These result in a muted harmony which is comparable to that found in Gauguin's pictures. Within the broad areas of color, Derain's hues are varied and modified, but overall, the picture appears as a series of blocks of flattish color. Although Gauguin's brushwork had more delicacy and finesse than Derain's vigorous touch, there are remarkable technical similarities between Derain's result here, and Gauguin's work.

It even seems that Derain was encouraging the analogy with Gauguin by his choice of a canvas with a grainy texture, albeit one much less coarse than Gauguin's typical hessian. The Fauve artist chose a coffee-colored preparation, which must have been applied by Derain himself, for it is less solidly opaque than the usual commercial grounds, and it only covers the face side of the canvas indicating that it was primed after stretching. This ground, which protects the canvas while simultaneously giving it the color of unprimed canvas, is also a reminder of Gauguin's use of raw canvas surfaces. Its color unifies the colors in the paint layer, making them more subdued in tone to complement their muted Gauguinesque hues. The mixed, broken colors, the predominantly middle tones, and darkish ground of Derain's picture, are in marked contrast to the brilliant luminosity of Matisse's portrait of Derain. Derain's head also has a descriptive solidity which is lacking in Matisse's painting.

Derain's fairly smooth, flat application of solid color — orange-yellows and yellowish greens — in the background of the composition, pushes Matisse's head, which inclines toward the spectator, further forward. Its texture separates it from the figure of Matisse, all of which is handled with more open, block-like strokes of color. This gives the bust a sense of form, which is further enhanced by the use of light. The depiction of an identifiable fall of light, in colors which still approximate to natural light and shade, make the Derain less truly Fauve than the Matisse. In the Derain, the light falls from the right, giving a powerful highlit effect to the right two-thirds of the face and the neck. The contrasting, predominantly viridian green and white shadowed side of the face, is a complement to the pinkish-oranges of the lit side. Thus, in addition to producing a startling interplay of colors, there remains a powerful sense of form sculpted by a specific light and shade.

The first outlines and contours of the form were laid in dark, probably Prussian, blue, diluted with turpentine and applied fluidly with a sable hair brush. The execution is then *alla prima*, with wet-in-wet reworking where necessary, and Derain has left the individual marks of the brush clearly visible. Hog's hair brushes were used, with color applied thickly and, in general, opaquely. The dark viridian

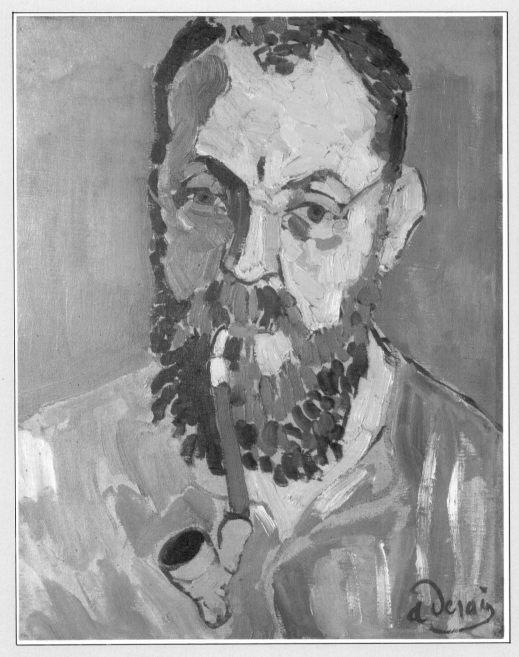

Derain and Matisse
worked together at
Collioure in the summer
of 1905, when this and
Matisse's portrait of
Derain were both
painted. Matisse
appears intensely
introspective in this
dynamic study. His gaze
is directed outwards but
not focused upon the
spectator. The angle of
his head, pitched
forward slightly and
positioned high up on
the canvas, emphasizes
this mood. A lively fall
of strong light and shade
accentuates the strong
forms of the head. The
lights are handled in
warm orange pinks, the
darks in cool greens. The
painting is alla prima,
boldly and rapidly
executed in large,
loaded brushstrokes
with the coffee-colored
ground showing actively
among the broken colors
which dominate the
painting. The elongated
form of Matisse's head
and beard relate well to
the standard format
vertical landscape 8
canvas chosen by
Derain.

The background is handled with distinctive brushwork, which helps to make the head stand out. It is more smoothly and evenly laid, with wet-in-wet blending of orange yellows and yellow greens brushed directly over the muted ground color. The middle tone of the ground subdues the luminosity of the colors while unifying them. The grainy canvas texture remains apparent through the more thinly applied areas and also where stiffer colors are dragged over the surface. A painting medium, such as oil and turpentine mixed, may have been added to the background colors to make them more fluid.

green and cobalt blue mixture used for the shadow side of the beard is the only area where the color is translucent. Other palette colors here include vermilion, red lake, and yellows, probably the sounder cadmiums, all in mixtures. A 2.5cm (1in) stroke of cobalt violet mixed with white is placed, as a livid contrast to the surrounding greens, to the left of the sitter's nostril. The brush sizes used are easy to identify from the individual touches of applied color. They are mainly round-ended, all flat, varying in width from 6mm ($\frac{1}{4}$in) in the beard, to 1.25cm ($\frac{1}{2}$in) or even 1.9cm ($\frac{3}{4}$in) width in the shirt and background.

By 1907, Derain had begun to abandon the brilliant colors of Fauvism, and, later, under the influence of Cubism, he returned to a somber tonal palette, dominated by earth colors. Derain met the poet Guillaume Apollinaire (1880–1918) in 1904. The poet later described the Fauve period of Derain's style as 'youthful truculence', stressing the sobriety of his post-Fauve work, and his passionate study of the Old Masters.

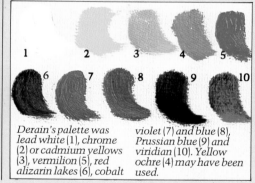

Derain's palette was lead white (1), chrome (2) or cadmium yellows (3), vermilion (5), red alizarin lakes (6), cobalt violet (7) and blue (8), Prussian blue (9) and viridian (10). Yellow ochre (4) may have been used.

The features of the face are reduced to simplified blocks of tone and color. Broad single strokes are used for the eyelids, brow and nose. The spectacles are merely suggested by an orange stroke or two, and left to the spectator to 'complete'. Pink-orange and green-blue provide the key colors as well as tonal contrasts.

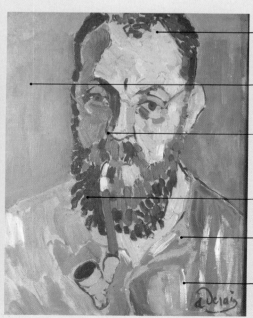

Mixed pale pinks and oranges thickly laid in opaque paint for the highlights

Wet-in-wet blended and smoothed mixtures of orange, yellow and green for background

Striking single brush-stroke of cobalt violet mixed with white animates surrounding hues

Viridian green and cobalt blue mixed for shadow

Coffee-colored ground left bare among pale blue strokes and fluid Prussian blue contours

White dragged wet into cobalt blue and white mixture

Actual size detail
*The paint layer colors
are almost entirely used
opaque, mainly with the
addition of white to give
a subtle luminosity.
Thinly dilute contours
were applied to
establish the figure, and
this was then painted
directly, with no
underpainting, in
thickly loaded
brushstrokes. Although
the brushwork has a
lively, almost separate
existence in places, such
the beard, in general it is
still descriptive,
following and sculpting
the forms of the face. A
mixture mainly of
viridian green and white
describes the shadows,
applied over wet to
modify a bluer tint
below on the left side.
Pinks and oranges,
mixed with white,
record the light side of
the face, with a brilliant
touch of vermilion
beneath the eye. The
colors are all worked
wet into wet.*

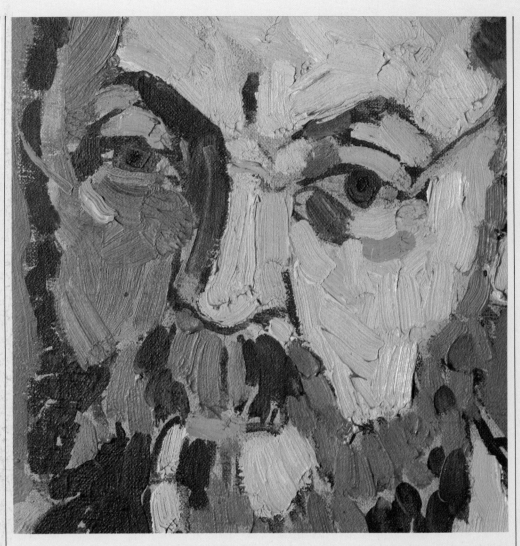

*A single sweep of red
provides the pipe stem.
The bowl is worked in
bright, probably
chrome, yellow. The
pale blues of the shirt are
applied in strokes which
follow and outline the
shape of the pipe. The
coffee color of the
ground shows through
the blocked in colors.*

HENRI MATISSE

Portrait of Derain/Portrait de Derain (1905)
Oil on white primed canvas, primed on front face only
39.3cm × 28.8cm/15½in × 11½in

Henri Matisse was born in Picardy, in northern France. He came to painting late, in 1890, having first trained as a lawyer. Between 1895 and 1897, he studied in the *atelier* of Gustave Moreau (1826–1898), the Symbolist painter whose love of color had an important influence on Matisse. When Moreau died, Matisse left the *atelier*, which was taken over by a less sympathetic master. He journeyed in the south of France in 1898, and in 1899 worked in an independent studio under the Symbolist painter Eugène Carrière (1849–1906), where he met Derain. In 1904 he began his regular periods of working in the south of France, painting that year with Signac, who lived at St.Tropez. Matisse's early career as painter was characterized by daring innovatory steps, followed by longer periods of careful reassessment and consolidation. His apprenticeship, as he saw it, continued for many years beyond what was typical at the period, only really ending with his first major imaginative composition *Luxury, Calm and Voluptuousness*. This was painted in 1904–1905 in a style derived from Signac's late Pointillism, and exhibited at the Independents' Salon in Spring 1905, where it was bought by Signac.

Unlike the essentially naturalistic color oppositions of yellow-blue/violet which characterized Impressionist color, Matisse began to exploit the more abstract, and at the same time more vibrant, oppositions of red-green. Because red and green colors are the closest in tone of all the complementary color pairs, they set up a dazzling sensation which gives its own light and brilliance, without any direct imitation of natural effects of light. Thus the properties of color itself, and the interactions of color with their power to create light, instead of reproducing the effect of light, were the basis of Matisse's mature art. Color no longer stood for, or symbolized, anything external to painting itself; it was color as color.

By the time Matisse painted his portrait of Derain, he had rejected the mosaic-like pointillist touch of Signac. The restraint of this imposed systematic method had served its purpose for Matisse, in opening the way to a more directly pictorial handling of pure color. When broken touches of color appear among larger, flat areas of color in Matisse's Fauvist work, they do so in order to enhance intuitive color correspondences, not to fit in with a preconceived color system.

The thin white ground, applied only on the face side of his fairly fine, ordinary-weight canvas, was already degraded as a result of surface abrasion before Matisse began work on it. This was possibly because it had rubbed against other canvases while being transported. Thus the white finish of the canvas is broken by tiny dark dashes and dots, where the somber linen color of the canvas has appeared through the worn ground. This marginally reduces the luminosity of the surface, where it shows through among the colors of the paint layer. However, the white of the ground still increases the overall luminosity of the picture, and the flatness it gives enhances the pictorial flatness.

Matisse's brushwork in the handling of the shirt, with its radiating parallel marks, is reminiscent of the brushwork of van Gogh. However, it remains much less ostentatious and lacks the emotional charge inherent in the latter's handling. Elsewhere in the picture, Matisse's brushwork has an unselfconscious awkwardness. Its directness is such that it avoids the comparatively tasteful descriptiveness in Derain's *Portrait of Matisse*. Thus Matisse's brushwork stands for itself, instead of playing an illusionistic role. In the background, a hasty scrubbing application is used, while on the head, abrupt strokes of thick impasto vie with longer, flowing lines — as in the sweeping application of premixed red lake and white on Derain's hat. Matisse's unconventional brushwork gives an air of excitement and urgency to the picture.

No identifiable light source falls on the figure, which is treated in broadly complementary pairs of colors contrasting with the background. Orange-red on the face contrasts with the cobalt blue and white of the background on the right, while the viridian green and white mixture of the left side contrasts with the red lake and white mixture, which probably also contains a touch of vermilion, for the hat. This red also contrasts with the pure viridian of the hair, and the viridian tint beside the ear and on the neck.

The pale yellow yoke of the shirt creates the lower third of the green-blue-yellow outer color ring. However, except for the cobalt violet monogram, there is no contrasting violet counterpart for the yellow, which acts as a subtle foil for the scintillating hues of the upper half of the painting, drawing attention

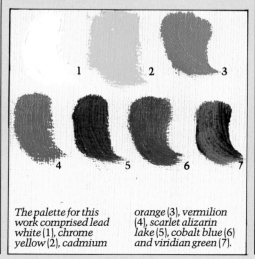

The palette for this work comprised lead white (1), chrome yellow (2), cadmium orange (3), vermilion (4), scarlet alizarin lake (5), cobalt blue (6) and viridian green (7).

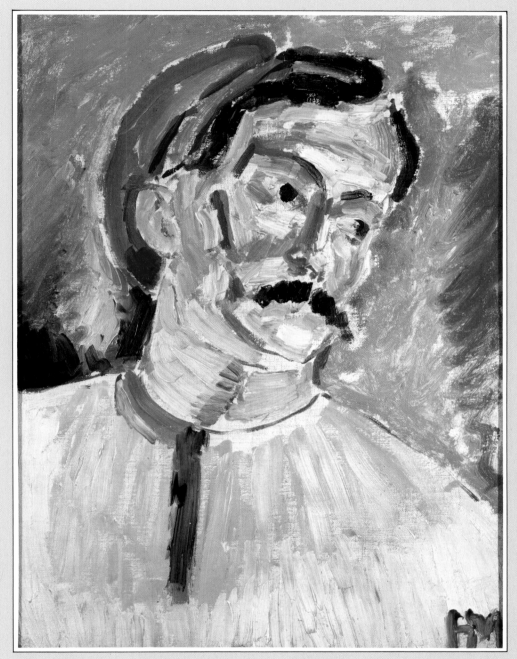

Matisse's head of Derain is more adventurous than Derain's portrait of Matisse in color, light and handling. Instead of a subdued ground color, Matisse chose a brilliant white, which was thinly laid and slightly abraded from wear or rubbing, perhaps even before he began work. This was doubtless accidental. The white enhances the glowing luminosity of the colors, and is often left to show among them. The palette is severely limited, exploiting colors which are almost unmixed except with white, and are in complementary pairs. There is no specific fall of light, but light seems to glow from within because of the mutually enhancing effect of the complementary colors. The blueish viridian green, used for the background on the left and for the hair, the left side of the face and the shirt band, contrasts with the blueish red of the scarlet lake on the hat. The orange-reds on the face are made livelier by the cobalt blue and white mix used for fluid contours and for the background, right. Matisse's brushwork shows an exuberant irreverence for traditionally accepted modes of paint handling. The sitter's backward tilt creates a distance effect, cutting him off from the spectator.

Strong, radiating strokes of chrome yellow and white, and white with a touch of blue, denote the shirt yoke and suggest the form below. The speckled, abraded white ground is seen among the brushstrokes.

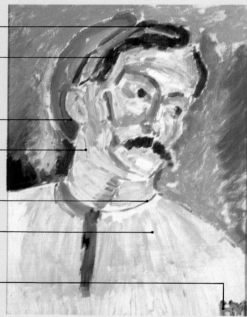

Slight cracking in thickly loaded green

Unmixed viridian green dragged over white ground leaves speckled effect showing canvas texture

Blue and red slurred wet in wet gives dull violet

Pale mixture of viridian green and white applied to modify wet oranges underneath

Dilute cobalt blue and white for contours

Rubbed surface reveals dark specks of raw canvas where ground abraded

Slurred cobalt violet monograph

to the main subject, the head. The solid stroke of green that follows the curve of the neck and dips vertically down the shirt, gives an ambiguous sense of form to the figure, and anchors the head to the shoulders. The contours of the figure were applied fluidly with a sable hair brush, in a light cobalt blue close to the color of the right background. The blue on the chin and neck links across the contrasting orange-red to the blue background, just as the saturated viridian green of mustache and hair link across to the green of the left background. The light in Matisse's painting comes from within, from his carefully calculated oppositions of brilliant, pure color.

The picture was painted *alla prima*, the reworkings painted directly over and mingling with the wet paint below. The pink hues first used for the left side of the neck were then adjusted to their complementary opposite, green — a change resulting not from the demands of naturalism — the colors Matisse saw in the sitter — but from internal pictorial necessity. This type of alteration, where adjustments were made to the colors during the painting process, to shift or correct their corresponding harmonies or contrasts, is typical of Matisse's work.

The evolution of a painting by Matisse is thus a dialectical process, in which the individual component colors are constantly adjusted, in relation to each other and to the whole, until a satisfactory internal pictorial coherence is reached. By the time his Fauve style had evolved, during the summer and the ensuing months of 1905, Matisse had stated the basic artistic problems which were to preoccupy him throughout his long career.

Actual size detail
Wet-in-wet slurring is seen here, as is the rich impasto on the face. Dirt and yellowing of varnish is apparent close to the ridges in the paint, in the eye-whites, neck and forehead highlights.

The colors are both premixed and blended wet in wet on the canvas surface, over the initial, limited indications of the figure which were painted in fluid cobalt blue and white.

Over the white ground a dilute cobalt blue and white mix was applied for the contours, and viridian green and premixed white was loosely scrubbed to fill the background. Reds and pinks block in the hat and ear. Viridian green and white were then slurred wet in wet for the richer, thicker parts.

CHRONOLOGY

KEY
- ● Important dates in the lives of featured artists
- ● Featured paintings
- ● Important paintings
- ● Important dates or events in the lives of other artists
- ○ Other artistic events and exhibitions
- ● Technical developments
- ● Historical events

1840	1841	1842	1843	1844	1845	1846	1847	1848	1849

Gustave Courbet ● 1844 1st Salon exhibit ● 1849
1819 born in Ornans; 1839 leaves Ornans for Paris

Edgar Degas ● 1845 enters Lycée Louis-le-Grand
1834 born in Paris

Edouard Manet
1832 born in Paris

Camille Pissarro ● 1842 attends boarding school in suburbs of Paris
1830 born in Virgin Islands, Danish West Indies ● 1847 returns to join f

Pierre Auguste Renoir ● 1844 family moves to Paris
1840 born in Limoges

Claude Monet
1840 born in Paris; brought up in Le Havre on Normandy coast

Jean-Francois Millet ● 1844-46 early florid style ● 1848 *Winnow*
1814 born in Gruchy, Normandy ● 184

Paul Cézanne
1839 born in Aix-en-Provence

Alfred Sisley
1839 born in Paris

Gustave Cai
1848 born in

Berthe Morisot
1841 born in Bourges, France

Mary Cassatt
1844 born in Allegheny, Pennsylvania, USA

Paul Gaugui
1848 born in

● 1841 **Frédéric Bazille** French Realist artist, influenced by Manet, friend o
● 1844 Eugène Boudin meets several of the Barbi
● 184
● 1847 Couture *Roma*
○ 1840 **Emile Zola** French novelist born ○ 1845 Balzac *Les Paysans* ● 184
○ 1842 Chevreul's course in the contrast of color advertised at Salo
1843 **Henry James** American novelist, lives and works

● 1844 wood pulp paper invented by F.G. Keller
● 1840 Viridian green becomes available commercially
● Early 1840s cadmium yellows commercially available
● 1841 collapsible tin tubes first patented by American painter John Goffe

● 1848 revolu
● 1848 Marx a
● 1844 Treaty of Tangiers ends French war in Mo
● 1843 world's first night club *Le Bal des Anglais* opens in

50 | 1851 | 1852 | 1853 | 1854 | 1855 | 1856 | 1857 | 1858 | 1859 | 1860 | 1861 | 1862 | 1863 | 1864 | 1865 | 1866 | 1867 | 1868 | 1869

alon – 3rd class gold medal for *After Dinner at Ornans* ●1860 works in Honfleur ●1866 *Deer Haven at Plaisir Fontaine, Doubs*
849-50 *Burial at Ornans* ●1855 *Studio* painted and exhibited with other pictures ●1862 opens a teaching studio

●1853 begins copying in Louvre; studies law briefly ●1859-60 paints *Portrait of Bellelli Family*
●1855-56 trains briefly at Ecole des Beaux-Arts ●1862 meets Manet ●1865 exhibits race scene at Salon

850 pupil of Couture at Ecole des Beaux-Arts ●1856 makes copies of Old Masters at the Louvre ●1862 *Concert in the Tuileries*
 ●1859 *The Absinthe Drinker* rejected at the Salon 1865 *Olympia* shown at Salon

●1852-54 lives in Venezuela ●1856-60 works regularly around Paris ●1861 meets Cézanne at Académie Suisse ●1867 *L'Hermitage at Pontoise*
usiness, Virgin Islands 1855 arrives back in Paris ●1859 exhibits landscape at the Salon; meets Monet at Académie Suisse

 ●1856-57 apprentice porcelain painter ●1862 enters Ecole des Beaux-Arts ●1867 *Portrait of Bazille*
 ●1864 works with Monet, Bazille and Sisley

 ●1856-57 draws caricatures ●1860 works at Académie Suisse ●1865 works with Courbet at Trouville
 ●1858 meets landscapist Boudin ●1862 enters Gleyre's studio *La Grenouillère* 1869 ●

ne of first major peasant subjects, shown at Salon ●1857 *Gleaners* exhibited at Salon 1868 pastel version *Autumn, The Haystacks*●
eaves Paris for Barbizon ●1859 *Angelus*, not shown until 1865 completed; oil version begun

●1855 attends college in Aix ●1861 stops studying law, goes to Paris; meets Pissarro at Académie Suisse
 ●1858-59 studies law but wants to become a painter

 ●1857 sent to London to prepare for commercial career ●1866 shows first works at Salon
 ●1862 enters studio of Charles Gleyre in Paris

 military service and law studies 1868 ●
 Bachelor of Law 1869 ●

●1855 lives in Paris ●1861 works with Corot ●1864 2 landscapes at Salon
●1856-57 studies with pupil of Ingres and Delacroix meets Manet; friendship with Degas 1868●

●1851 family moves to Europe, settling in Paris ●1861-65 attends Pennsylvania Academy of the Fine Arts
●1855 visits Paris World Fair ●1866-70 in Europe

Paul Signac
1863 born in Paris

George Seurat
1859 born in Paris

Vincent van Gogh ●1857 brother Theo born
1853 born in North Brabant, Holland joins Hague branch of art dealers Goupil & Cie 1869●

●1856 school in Orléans ●1865 becomes merchant seaman seaman with French navy 1868

ives in Lima, Peru

Henri de Toulouse-Lautrec
1864 born in Albi

Henri Matisse | 1869 born

Impressionists born **Emile Bernard** artist friend of Gauguin and van Gogh, founder member of Pont-Aven group in Brittany born 1868●
artists ●1852 Corot exhibits first open-air painting of a French site ●1862 Sarah Bernhardt's debut in Paris at Comédie Française
Corot exhibits first open-air painting ●1855 Whistler arrives in Paris 1861 Wagner *Tannhauser*, a scandal in Paris
the *Decadence* chief Salon attraction ●1857 Baudelaire *Fleurs du Mal* ●1862 **Claude Debussy** French composer born
Théodore Rousseau's first work accepted by Salon since 1836 wins 1st class medal ●1862 International Exhibition, London; Hugo *Les Misérables*
●1850 **Guy de Maupassant** French writer born ●1857 Daubigny awarded Legion of Honor and also criticized for painting 'impression' of nature
Europe born ●1854 **Arthur Rimbaud** French Symbolist poet born 1861 Charles Garnier designs Paris Opera
 ●1856-57 Flaubert *Madame Bovary* ●1863 Baudelaire *Peintre de la vie moderne* published
 ●1856-57 Duranty publishes periodical *Le Réalisme* 1863 Ingres *Turkish Bath*
●1851 Great Exhibition, London abortive plan by Monet and friends for alternative to Salon show 1867●
 ●1855 Paris World Fair including works by Ingres, Delacroix, Rousseau; Courbet exhibits independently in his *Pavillion du réalism*
 ●1856 magenta introduced ●Early 1860s snapshot photography developed
●1850 cobalt green available ●1850s magnesium flare and battery give artificial light for photography
1895) ●1856 aniline (coal tar) dyes developed alizarin crimson (synthetic madder) introduced 1868●
 Mid 1850s stereoscopic viewers popular ●1862 green oxide of chromium available as artists' pigment
●1850 collapsible tin tubes still cost 10 centimes extra in France ●1859 cobalt violet introduced 1863 *Salon des Refusés* exhibition
London ●1854 zinc white oil paint manufactured ●1860 cerulean blue
●1852 2nd Empire begins ●1860 Abraham Lincoln elected US President ●1867 Maximilian executed in Mexico
●1853 Baron Haussmann begins reconstruction of Paris ●1862 Nobel uses nitro-glycerin as explosive
Paris and elsewhere in Europe ●1856 **Sigmund Freud** Austrian, founder of psycho-analysis born
Engels *Communist Manifesto* ●1859 Charles Darwin (1809-1882) *Origin of Species* ●1867 Zola *Thérèse Racquin*
●1853 Crimean War ●1856 Americans make first Western treaty with Japan ●1863 French capture Mexico City
●1852 Louis Napoleon proclaims himself Emperor Napoleon III ●1861-65 American civil war ●1865 Lincoln assassinated

| 1870 | 1871 | 1872 | 1873 | 1874 | 1875 | 1876 | 1877 | 1878 | 1879 | 1880 | 1881 | 1882 | 1883 | 1884 | 1885 | 1886 | 1887 | 1888 | 1889 |

Gustave Courbet ● 1872 in exile in Switzerland dies 1877
● 1871 President of Commune Art Commission

Edgar Degas ● 1872 visits New Orleans ● 1876 24 works in 2nd Impressionist group show ● 1885 meets Gauguin at Dieppe
● 1870 discovers sight in right eye poor ● 1879 *Portrait of Duranty* ● 1886 Durand-Ruel exhibits wo

Edouard Manet ● 1873 sells 29 paintings to Durand-Ruel ● 1878 *Road Menders on the rue de Berne* ● 1884 memorial exhibition and studio sale, Paris
● 1870 joins National Guard ● 1874 works at Argenteuil with Monet and Renoir dies 1883

Camille Pissarro ● 1872-73 works with Cézanne at Pontoise and Auvers ● 1879 *Mme Pissarro Sewing* ● 1886 adopts Pointillist technique
● 1870 flees to London with family because of war ● 1883 one-man show at Durand-Ruel gallery ● 1888 Ave

Pierre Auguste Renoir ● 1874 *La Parisienne* one of 7 works at 1st Impressionist group show ● 1882 *Rocky Crags at l'Estaque* painted while working with Cézann
● 1881 travels to Algiers and Italy ● 1887 *Large Bathers*

Claude Monet ● 1872 settles in Argenteuil ● 1877 begins *St Lazare Station* paintings ● 1883 settles in Giverny
● 1870-71 visits London and Holland ● 1875 works sold at Impressionist group auction ● 1881 moves to Poissy ● 1884 works in south of France ● 1888 *Antibes*

Jean-Francois Millet dies 1875 ● 1881 Sensier's influential biography published

Paul Cézanne ● 1873 *House of the Hanged Man* ● 1878-79 *Mountains seen from l'Estaque* ● 1886 Zola's novel *The Masterp*
● 1874 3 works at Impressionist group show ● 1882 works at La Roche Guyon with Renoir

Alfred Sisley ● 1872 Durand-Ruel begins buying paintings ● c1877 *Boats on the Seine* ● 1881 one-man show at *La Vie Moderne* ● 1889
● 1875 settles at Marly-le-Roi ● 1880-82 lives in Veneux-Nadon near Moret-sur-Loing

Gustave Caillebotte ● 1872-73 trains at Ecole des Beaux-Arts ● 1879 25 works at 4th Impressionist group show ● 1886 *Garden at Petit-Gennevill*
● 1870 called up for active service 1874 meets Degas ● 1877 study for *Paris, Rainy Day* ● 1883 retreats from Parisian art world to his home near

Berthe Morisot ● 1872 visits Spain ● 1876 joins 2nd Impressionist group show ● 1882 *Woman and Child in the* ● 1887 participates in Inte
● 1874 9 works in 1st Impressionist group show *Garden at Bougival* ● 1885 visits Holland

Mary Cassatt ● 1872-73 travels and studies in Europe; finally settles in Paris ● 1882 *Woman in Black* ● 1886 exhibits at the 8th (and las
● 1870 returns to Philadelphia ● 1877 Degas invites her to join the Impressionists group Impressionist group show

Paul Signac ● Early 1880s working under influence of Impressionists ● 1889
● 1884 co-founder of Independents; meets Seurat

George Seurat ● 1874 first drawings ● 1877-79 attends Ecole des Beaux Arts 1883-84 *Bathing, Asnières*, first major oil composition
● 1875 Municipal Art School – 1876; reads Blanc's *Grammar of the Arts of Drawing* ● 1886 *La Grande Jatte*

Vincent van Gogh ● 1873 transfers to London Branch of firm ● 1880 begins career as painter ● 1885 paints *Potato Eaters* dies
1875 transfers to main Paris office ● ● 1876 dismissed, returns to England as teacher and lay preacher *Peach Trees in Blossom* 1889 ● 1890

Paul Gauguin ● 1871-72 works for Paris stockbroker; part-time painter ● 1879 sculpture in 4th Impressionist group show ● 1885 meets and quarrels with Degas ● 1888 Brittany, t
● 1876 begins buying Impressionist works ● 1881 8 works in 6th Impressionist group show

Henri de Toulouse-Lautrec ● 1884 lives and works in Montmartre
● 1886 attends Cormon's studio

André Derain
1880 born at Chatou, near Paris

Henri Matisse ● 1887-89 studies law

1871 **Paul Valéry** French poet born 1876 **Maurice de Vlaminck** French co-founder of Fauvism born ● 1886 Moréas *Symbolist manifes*
1870 Fantin-Latour *Batignolles Studio* 1876 Philadelphia World Fair 1881 **Pablo Picasso** Spanish artist, co-founder of Cubism born
1872 Whistler *The Artist's Mother* 1876 2nd Impressionist group show 1882 **Georges Braque** French painter co-founder of Cubism born
1871-93 Zola *Les Rougon-Macquart* series of novels 1878 Paris World Fair 1881 Durand-Ruel resumes purchase of Impressionist works
1873 Durand-Ruel begins buying Impressionist paintings 1880 Maupassant *Contes* 1883 Amsterdam World Fair 1888 Gustave
● 1870 **Bazille** dies 1875 Impressionist auction includes works by Monet, Renoir, Morisot, Sisley 1886 Rimbaud *Les Illumination*
1874 1st Impressionist group show, Paris 1879 Ibsen *A Doll's House* 1883 **Wagner** dies 1886 Durand-Ruel shows
1876 Debussy *L'Après-midi d'une Faune* 1881 *Chat Noir*, first cabaret, founded in Paris by Rodolphe Salis 1889 P
1877 3rd Impressionist group show 1881 6th Impressionist group show 1886 8th and last Impressionist
1879 4th Impressionist group show 1884 Independents' exhibitions founded
1880 5th Impressionist group show 1885 Impressionist dinners instituted
1882 7th Impressionist group show

● Early 1870s first experiments with color photography
● 1873 first color photographs successful ● 1886 George Eastman develops
● 1879 Ogden Rood *Modern Chromatics* ● 1889
● Early 1880s glass instead of varnish becomes popular for paintings
● Late 1880s Eadweard Muybrid

● 1873 Germans leave France ● 1880 France has about 26,000 km (16,200 miles) of railways ● 1888 George
● 1871 Germany united by Bismarck ● 1880 French Socialist Party founded ● 1887 M.W. Goodwin
● 1879 **Albert Einstein** German physicist born ● 1889 fir
● 1871 revolt in Paris, 3rd Republic proclaimed; siege of Paris by Prussians; Paris commune – rules Paris 2 months to May
● 1874-80 economic crisis affects picture dealing, hence artists ● 1883 France gains control of Tunis
● 1870-1 Franco-Prussian War; Napoleon capitulates at Sedan ● 1880 France annexes Tahiti
● 1881 population of Paris 2,200,000 ● 1886 Bonaparte and Orléans fam

Years across top: 0 1891 1892 1893 1894 1895 1896 1897 1898 1899 1900 1901 1902 1903 1904 1905 1906 1907 1908 1909

●1892 exhibition at Durand-Ruel gallery
w York; *Portrait of Hélène Rouart* ● 1895-1905 makes pastel studies of Russian dancers **Edgar Degas** dies 1917

890 abandons Pointillist method ●1896 January-March and September-November in Rouen
ce of paintings still only 500 francs; *Apple Picking* ●1898 offered studio by Matisse dies 1903
1896 *The Renoir Family* ●1900 increasingly paralyzed by rheumatism **Pierre Auguste Renoir**
●1903 moves to Cagnes in south dies 1919

890 first 'series' paintings – *Haystacks* followed by *Poplars* ●1898 61 paintings shown at Petit gallery ●1903 new series of *Waterlilies* **Claude Monet**
●1892 begins *Rouen Cathedral* series difficulties with eyesight; visits Venice 1908● dies 1926

ses split in their friendship; October – inherits fortune after father's death● 1898-1904 paints *Large Bathers*
890 exhibits with *Les XX* in Brussels ● 1895 on Pissarro's advice Vollard shows 150 paintings dies 1906

●1893 show at Theo van Gogh's gallery, Paris;
ves to Moret paints *Church at Moret* series dies 1899

he Roses **Gustave Caillebotte**
genteuil dies 1894

tional Exhibition **Berthe Morisot**
at Petit gallery dies 1895

●1893 show at Durand-Ruel gallery ●1898 first visit to America since 1871 ●1904 awarded Legion of Honor **Mary Cassatt**
890 visits exhibition of Japanese prints at the Ecole des Beaux-Arts in Paris ●1901 visit to Italy by the French government dies 1926

n Gogh at Arles ●1893 buys house in St Tropez; town becomes famous for artists as a result **Paul Signac**
890 visits Italy; elected member of Belgian *Les XX* dies 1935

dies
1891

●1891-93 lives in Tahiti ●1894 back in Paris ●1897 paints *Te Reroia* ●1901-03 lives in
les with van Gogh ●1895-1901 lives in Tahiti Marquesas Islands until his death

●1891 first music hall posters for Moulin Rouge dies
●1892 first color lithographs *Tête-à-tête Supper* 1899● 1901

890 intends to become engineer ●1899 meets Matisse while studying under Carrière● 1905 *Portrait of Matisse* **André Derain**
●1900 meets Vlaminck ●1904-05 works with Vlaminck dies 1954

890 on takes up painting; studies at Academy Julian ●1901 on exhibits with ●1905 *Portrait of Derain* **Henri Matisse**
●1895-97 studies at Ecole des Beaux-Arts Independents coins term 'Cubism' 1908● dies 1954

1893 **Maupassant** dies ●1896 **Verlaine** dies ●1900 Paris World Fair Kandinsky first abstract paintings 1909 ●
1893 Art Nouveau spread in Europe ●1902-05 Picasso Blue Period
●1898 **Moreau** dies ●1905-06 Picasso Rose Period
1893 Chicago World Fair ●1903 Henry James *The Ambassadors*
32-1923) designs Eiffel Tower ●1896 **Boudin** dies ●1900 Freud *Interpretation of Dreams* ●1905 'Fauves' named at Autumn Salon
1898 **Mallarmé** dies ●1905 Marinetti *Futurist Manifesto*
pressionist paintings in New York ●1900 **Nietsche** dies Stravinsky *Firebird* ballet performed in Paris 1909 ●
rld Fair – Eiffel Tower opened first daily comic strip in San Francisco Chronicle 1907●
up show ●1896 **Goncourt** dies ●1904 **Fantin-Latour** dies
●1891 **Rimbaud** dies ●1895 first public film show, Paris ●1903 **Whistler** dies **Tolstoy** dies 1910
●1903 **Chekhov** dies

●1894 Louis Lumière invents cinematograph

ated photo paper
evreul dies ●1896 new evidence on innocence of Alfred Dreyfus suppressed
1892 anarchist violence in Paris Louis Lumière develops process for colour photography using 3-colour screen 1907●
blishes photographs of moving figures
stman perfects Kodak camera cadmium red available 1910●
ents celluloid film ●1893 trial in Paris over Panama Canal corruption ●1906 Dreyfus rehabilitated
y Day celebrations, Paris ●1898 Zola writes *J'Accuse* in defence of Dreyfus
●1904 Church and State separated in France
●1895 Freud *Study on Hysteria* ●1899-1902 Boer War ●1903 King Edward VII visits France to establish Entente
●1898 Paris metro opened Cordiale
nished from France ●1894 Dreyfus trial begins, anti-Semitism rife in France ●1901 Queen Victoria dies Louis Blériot flies across Channel 1909●

185

Academic This painting discipline was based on and conformed to the official standards set by the Academy. The Academy in France, first founded on Italian lines in the 1640s, was, until 1863, in control of the Ecole des Beaux-Arts. This included jurisdiction over the Rome Prize and other awards and the official Salon exhibitions. The Academy was a conservative body, promoting a traditional, conservative style and method, based upon classical principles.

Alla prima *Alla prima* is an Italian phrase meaning painted solely wet in wet and usually, but not necessarily, at a single sitting. It is used most commonly with reference to oil painting.

Ambient light Broadly speaking, ambient light means the diffused and reflected light which fills the environment outdoors.

Atelier (studio) The *atelier* had two meanings in nineteenth century France. On the one hand, it meant the location where masters provided a setting and models for students who chose to study with them. This was a teaching studio. On the other hand, it simply meant the studio where individual artists executed their own work. Most nineteenth century studios were especially designed for the purpose, with the high ceilings and the high northern light which was preferred by most academic painters. Garrets were often used by poor painters for, although small, they had good light and were cheap.

Back light *see contrejour.*

Binder *see medium.*

Blanc, Charles Charles Blanc was an influential nineteenth century art historian and theorist. In 1867, he published *Grammaire des arts du dessin (Grammar of the Art of Drawing).* An administrator in the Ecole des Beaux-Arts, Blanc was committed to the Renaissance tradition in art, yet his work was important for many young artists, including Seurat. Politically, Blanc was a utopian Socialist, which may have appealed to the radical Neo-Impressionists.

Blending Blending is a term most commonly used with reference to academic painting practice to mean the blending together of separate touches of color for halftones, until the gradations of tone and the marks of the brush are imperceptible. The method most widely recommended was the deft slurring of each tone into the next by means of a touch of each of the tones on the brush. The blending brush was introduced in the nineteenth century especially to facilitate this process, but most authorities considered it a slick, softening and unsatisfactory alternative to the approved method. The soft fan-shaped blending brush was dragged dry across the wet paint of the halftones, blending them and obliterating the mark of the brush.

Blocking-in Blocking-in usually refers to the broad application of masses of light, shade, and color, in the early stages of a painting. It helped to obliterate rapidly the glaring brightness of the ground, permitting the artist to see the general effect in the painting more quickly. It is a term which normally has wider application than the very specific term *ébauche. See ébauche.*

Bouvier, P.L. Bouvier was a painter of Swiss extraction who in 1827 published an influential volume called the *Manuel des jeunes artistes et amateurs en peinture (Handbook for Young Artists and Painting Amateurs),* which provides vital information on artistic practice and materials in early nineteenth century France.

Casts Casts are plaster copies taken from objects. Traditionally, art students have made drawing from casts. At the Ecole des Beaux-Arts, casts were usually made from suitable earlier sculpted masterpieces and antique sculpture. This was in order to educate the students' eyes in ideal beauty in the human form as well as to train them in drawing. Since plaster casts are more or less white, they simply present the student with a solid object devoid of color over which lights and darks play. Casts were thus used before the student graduated to work from the live model, to inculcate in them a knowledge of tone in drawing, which it was considered essential to learn before using color.

Chiaroscuro The broad meaning of *chiaroscuro* in painting and drawing is the rendering of forms by a balanced contrast of light and shadow which serves to give relief to forms and an illusion of space and depth to the composition. It was a technique introduced in the Renaissance, when it was perfected by Leonardo da Vinci (1452-1519). By the early nineteenth century, French academic painters were preoccupied with rendering the subtle gradations of tone which separated the highest lights and the deepest shadows. Ideally, the lights were opaque, and the shadows depicted with transparent paint. By this time, *chiaroscuro* was not simply a technical device, but also embodied a universal ideal of truth and beauty in art.

Chroma *see color.*

Color (chroma) Color, chroma and hue are three terms used here synonymously to indicate the color of things as perceived by the eye – their appearance of redness or greenness for instance. Color is also used to refer to artists' colors, or paints ground with a binder for use in painting.

Color grinding In oil color grinding, dry pigment particles are ground with an oil medium or binder under friction, to achieve a thorough 'wetting' of each pigment particle, and a complete and even dispersal of all the particles in the binder.

Color temperature Color temperature refers to the identification of color by relative warmth or coolness. In broad terms, those colors on the blue half of the color circle are cool, while those on the red side are considered warm. Within this, a red, for example alizarin crimson, can be said to be cool relative to a hotter red like vermilion, because alizarin tends toward blue-violet in hue, while vermilion tends toward orange, another warm color.

Complementary colors Complementary colors are those found opposite each other on the color circle – red and green, yellow and violet, blue and orange. When these color pairs are placed side by side – especially when they are close in tonal value – they are mutually enhanced and appear to oscillate as the eye seeks to differentiate the two hues. Complementary or simultaneous contrast of tones takes place between blacks or grays, and whites. When juxtaposed these hues appear respectively darker or lighter where they join. The scientific basis for these phenomena, which had previously only been observed empirically, was laid by Eugène Chevreul in the 1830s in France.

Composition In painting the composition is the design or arrangement of, for example, lines, masses of light and shade, and colors, to form a coherent unity on the picture surface.

Contour While the outline of a form is simply an invented line which follows the outer silhouette of the form, contour lines include lines inside the edges of the form, which suggest a three-dimensional quality.

Contrejour (back light) *Contrejour* literally means 'against the daylight' and, as its name suggests, is a light source situated behind the artist's subject. It tends to throw the subject into silhouette, creating extremes of contrast between light and dark, usually with very limited halftones. This lighting was used to dramatic effect by Degas, for example in *Woman Against a Window* (c 1872).

Croquis (thumbnail sketch) The small *croquis* is a free drawing often jotted down from the imagination in which the artist toys with ideas for poses for figures or groups of figures. These may be incorporated in the *esquisse. See esquisse.*

Darks The darks are those parts hidden from the fall of light in a painting. Traditionally, they were rendered thinly and with transparent earth colors. When treated with a loaded brush and opaque paint, transparent glazes of dark hues were added to give the darks depth and create an illusion of recession in painting. This is because it is hard to create an illusion of recession with opaque color, but dark transparent paint lends itself well to a sense of depth in a painting.

De Piles, Roger De Piles was an important seventeenth century art theorist. He published several volumes on art theory and practice, including *Les Premières élémens de la peinture pratique (First principles of Painting Techniques)* (Paris, 1684), which gives invaluable information on painting practice in France at that period.

Diluent A diluent is the liquid used to dilute or thin a paint. For example, the diluent most commonly used with oil paints is turpentine; the diluent for watercolors is water.

Dragging Dragging denotes the movement of a stiff bristle brush loaded with color, across a dry, rough surface. The roughness can come from the textured surface of a grainy primed canvas or irregularities resulting from previous applications of loaded paint which have dried. In dragging, the wet paint catches only on the raised parts of the dry surface texture, allowing the colors below to show through and create a vibrant, stippled effect of broken color.

Drying oils Drying oils are oils which have the property of forming a solid, elastic surface when exposed to air in thin layers. The drying oils most commonly used in oil painting were linseed oil, walnut oil and poppy oil. Examples of non-drying oils unsuitable for painting, are olive oil and almond oil.

Ebauche (lay-in) The *ébauche* is the underpainting or thinly painted lay-in of the lines, broad masses of light and shade, and the halftones of the subject, which provided the base for the finished painting. The *ébauche* had to be completely dry, and then scraped down, before the final finishing or reworking of the painting began. The academic *ébauche* was normally executed in somber earth colors ranging in tone from deep browns to pale

creams. The former were usually transparent, the latter always opaque. Progressive independent artists, like the Impressionists, avoided the dark *ébauche*, beginning their work in bright hues related to the local colors of their subject.

Esquisse (sketch) This is the compositional drawing or painting which embodied the artist's first inspired idea or design for the final painting. Part of the academic painting procedure, the painted *esquisse* was normally preceded by drawn sketches and, if and when the final work was to be executed, the artist followed up the painted *esquisse* by carefully drawn and painted *études* or studies from life of individual elements in the composition. The compositional scheme was then transferred by drawing onto the final canvas, and the slow, meticulous process of executing the finished picture began. Careful finish was not expected for the *esquisse*, in which spontaneity and originality were the prime qualities sought. In 1816 a competition for the painted *esquisse* was introduced at the Ecole des Beaux-Arts as part of the Rome Prize system.

Etude (study) In academic figure painting the *esquisse* was the most freely and spontaneously executed stage, and the *études* were drawn or painted studies of individual compositional elements, relatively slowly and carefully worked under static studio lighting conditions. By contrast, in landscape painting, the *étude* formed the loosely worked stage, in which the artist's response to the natural effect was captured. The landscape *étude* was executed out of doors, and speed was essential to render the fast changing, ephemeral lighting effects which

had to be translated into paint. In academic landscape painting, these small *études* from nature formed the raw material, the visual vocabulary, which aided the artist's memory when the final work was undertaken in the studio.

Fat Fat oil color means paint which contains the maximum possible amount of oil, even in excess of that with which it was ground. The basic rule in oil painting is fat over lean. This means that paint with a high fat or oil content should only be applied late in the painting process. *See lean.*

Film color Film color is a term used to indicate intangible color, like the atmospheric blue of the sky or the color reflected on the surface of water. Film color is thus distinct from surface color, which is the color visible on the surfaces of tangible objects. *See surface color.*

Full-face light Full-face light falls directly onto the subject from behind the artist. Although some nineteenth century writers attributed the popularization of this type of lighting to the Impressionists, it was used by both Ingres and Manet before them. Full-face light, like *gris clair*, suppresses tonal contrasts outdoors, because shadows from objects are cast behind them, out of the artist's view. Full-face light is the most luminous and brilliant lighting effect, because maximum light is reflected off all available surfaces back into the viewer's eye. Because no shadows are visible under this type of light, it tends to flatten forms. This contrasts with side lighting which emphasizes the modeling of forms. *Contrejour* or backlighting is the opposite of full-face lighting. *See contrejour, side lighting.*

Glaze A glaze is a thin, oil-rich application of transparent color in a liquid film over dry colors to adjust, enrich and unify them. In general, glazing was associated with academic practice, and was mainly avoided by the Impressionist painters. Glazing was normally the final stage in the painting procedure – as the glaze was rich in oil, no leaner paint could be added on top without risking the durability of the picture. This conforms to the oil painting rule – fat over lean.

Gouache Gouache is opaque watercolor paint. It contains the same ingredients as watercolors, which are transparent, but with the addition of chalk. This makes the colors less saturated. As they are opaque, they reflect more light compared to the richer luminosity of watercolors used over white paper. The binder for watercolor is usually gum arabic in solution, while other ingredients may include sugar-water to aid flexibility, a wetting agent to give uniform flow of color on surfaces, and glycerin as a moistener, plus a preservative. In the late nineteenth century, honey was sometimes still in use as a moistener in watercolors and gouache colors.

Gris clair *Gris clair* is a French term used frequently in the nineteenth century to denote a particular quality of light. *Gris clair* meant the type of even, neutral light produced by a bright but overcast sky, where there is no direct sunlight and thus no shadows. Under this light, tones are close in value with extremes of light and shade suppressed, and local colors are their most pure and unmodified. This was one of the types of lighting preferred by the Impressionists.

Ground (priming) These terms refer to the layer or layers with which the support is coated to prepare it to receive the paint. In oil painting on canvas, a glue size layer was usually followed by one, two or occasionally three layers of opaque oil-based paint. Absorbent grounds, made with chalk and glue, which had been popular in tempera painting, were revived in the early nineteenth century. In particular the Neo-Impressionists liked them. Most artists used commercially primed canvases in the nineteenth century. Priming refers both to the ground and to its application.

Halftones Halftones refer to the gradations of tone in painting and drawing which separate the strongest lights from the deepest shadows. They are intended to soften the transition from lights to darks, creating an authentic illusion of relief on forms and suggesting solid objects in a 'real' space.

Hatching Hatching is a term normally used in drawing to indicate the use of parallel strokes or lines, generally placed close together to suggest halftones or shadow. The term is also occasionally used to refer to parallel, separate strokes of the brush in painting.

Highlights *see lights.*

Hue *see color.*

Impasto Paint applied in thick, raised daubs is called impasto. It can also refer to a generally loaded build-up of the paint layer, leaving brushmarks apparent, as distinct from a smooth, carefully blended, flat paint surface.

Impression In their landscape studies from nature, nineteenth century artists sought to record their first 'impression' of the scene, of the fleeting effects of light and color out of doors. The

impression is thus both the impact of the scene upon the artist and the painting which records that experience. The Impressionists were concerned to retain in their paintings that quality of the first, immediate impression, even in works which were not 'spontaneously' painted at a single sitting. Their concern was thus as much with rendering the appearance of spontaneity, with finding a visual language which embodied that idea, as with spontaneous painting *per se.* This method is difficult to practice because of the inherent laboriousness of the oil painting process.

Independent This fairly general term is now used to refer to artists, whether more or less innovatory in style and methods, who rejected academic standards or the academic teaching program which processed painters in the nineteenth century. Manet, for example, was an independent, but so was his non-academic teacher, Thomas Couture.

Lay-in *see ébauche.*

Lean Lean oil color is paint in which the oil or fat content has been reduced, usually by indirect means such as diluting the paint with turpentine. In accordance with the oil painting rule fat over lean, the application of paint on the canvas should begin lean, and become progressively fatter or oilier with each successive layer. Artists like Degas and Toulouse-Lautrec made their oil color lean, quick drying and mat in finish by first placing the paint on blotting paper to soak out excess oil. This was then diluted with turpentine before being applied directly to the support in the form of a fluid colored wash. This was called *peinture à l'essence.* Other artists, including Monet and

probably Pissarro, soaked oil out of their paint in the manner of Degas, but used it undiluted, in a stiffish paste to enhance chalky, dragged effects in their painting. *See fat.*

Lights (highlights) Lights are those parts directly illuminated by the fall of light depicted in a painting or drawing. They are normally depicted in painting by impasted opaque cream or off-white paint.

Loaded A picture is said to be loaded when it is painted thickly, often with a heavy impasto. A loaded brush is one charged to its full capacity with paint.

Local color Local color is the true color of an object when seen under neutral daylight. This is distinct from the apparent color of an object when modified by non-neutral light, for example reddish sunset lighting or colored light reflected from another object.

Medium (binder) The medium or binder is the substance which cements the pigment particles together in a form suitable for painting. Oil is the binder in oil painting, for example, and gum arabic that in watercolor and gouache. The binder also serves to make the paint adhere to the ground on drying. Painting medium can also refer to the substance or mixture of substances with which the artist alters the original consistency of the paint during the actual painting process. For example, Renoir used a mixture of linseed oil and turpentine as a painting medium. Medium has a third, more general usage, as the type of paint in which a picture is executed. Oil was the medium used by most Impressionists.

Modeling In painting or drawing, modeling means the representation of three-dimensional form.

The depiction of a fall of light and shade which 'models' the form is commonly used to achieve this effect. The Impressionists often used color contrasts or color temperature to suggest three-dimensional form, as opposed to the tonal contrasts of light and dark associated with academic modeling.

Neo-Classicism Neo-Classicism is the name given to an artistic movement which began in Rome in the mid eighteenth century and spread rapidly throughout Europe. It aimed to revive the art of antiquity. Unlike earlier revivals of classical art, actual examples of antique art were by then available as models for artists to emulate. This was because archeological work from the mid eighteenth century, for example at Pompeii and Herculaneum, had uncovered evidence of what antique art had really looked like. Antique sculpture and reliefs survived better than painting, and so Neo-Classical painting relied more heavily on examples of sculpture. Transferred into painting, this often resulted in a shallow pictorial space and a frieze-like distribution of figures across the picture surface. Figures and gestures often had a static, rather frozen quality, and flesh modeling was often reminiscent of carved stone. In Neo-Classical painting, color was restrained, and the composition usually balanced and symmetrical. Line and draftsmanship were important, and a high degree of finish with imperceptible brushwork was desired. The French artist Jacques-Louis David (1748-1825) is recognized as the purest exponent of the style.

Opaque An opaque surface or color is one more or less impervious to rays of light, which are reflected back to the eye. Certain pigments are by nature opaque in an oil binder. These include some of the earth colors and lead white, which is acclaimed for its excellent hiding power. *See transparency.*

Optical grays Optical grays are achieved in oil painting by adding a thinly scumbled veil of opaque pale color over a darker, dry hue. The latter remains visible but is modified to a cool grayness by the pale veil of color on top. Warm effects can be created optically by laying a thin translucent veil of a darkish hue over a pale dry color below.

Paint layer The paint layer is the actual layer or layers of color applied by the artist in the execution of the painting. However, this does not include the ground or preparation layer, or the final layer of varnish, if applied.

Palette Palette refers both to the flat surface on which an artist lays out and mixes colors, and to the particular range or selection of colors used by an artist for a particular painting. More generally, palette can be used to refer to a color range characteristic of an individual artist or school of artists. This would include, for example, the so called 'prismatic' palette associated with the Neo-Impressionists and the 'limited' palette referred to in discussions of Impressionist painting.

Pastel A pastel is a colored stick made of pigment mixed with just enough gum binder to hold the particles together. Pastels can vary in tint from the deepest pure pigment color, through a tonal range of increasing paleness achieved by adding more white chalk. Since they contain virtually no binder, pastels are very dusty and barely adhere to the support to which they are applied. Paper is the most popular support for pastel. As a result works executed in pastel are highly fragile, and need 'fixing' with a sprayed film of fixative. This can be made by dissolving a small amount of resin in a volatile solvent such as alcohol. Because pastels contain no binder, they are the most opaque and light-reflective of all colored media.

Pictorial space The pictorial space is the illusion of space created 'behind' the picture plane, to suggest 'real' space and depth. This may even include an illusionistic continuation of the real space of the spectator into the separate, constructed space of the painting.

Picture plane The picture plane is the plane occupied by the actual surface of the picture.

Pigment Pigment refers simply to the powder color from which paints are made. Pigments are insoluble in the liquid binder with which they are combined, and they give their colored effect by being spread over a surface. Dyes, or soluble colors, impart their coloring power by staining or being imbibed by the binder. Lake colors are pigments made by precipitating a dye on an inert, colorless base. The two chief categories of pigment are organic and inorganic. Organic pigments belong to the organic division of chemical compounds, such as those based on carbon, hydrogen, nitrogen or sulfur. Organic pigments derive mainly from vegetable sources, or may be made synthetically. They tend to be less stable and more fugitive than inorganic pigments. These derive from minerals and ores and are either found naturally or made synthetically.

Priming *see ground.*

Reflected light, reflected color Reflected light is light which bounces off a surface and is therefore indirect. When that surface is colored, white light is tinted with that color, altering the color of any object on which the light then falls. Nineteenth century studio walls were often painted a muted hue to prevent reflected light disturbing the halftones and shadows across the model. Similarly, blue sky, green trees or red buildings, visible from the studio window, could tinge the light falling on the model. Academic artists in particular tried to avoid this type of reflected color, which fluctuated and altered the colors on the model. By contrast, complicated effects of reflected light and color were often actively sought out by Impressionist painters, as they were effects found naturally in outdoor conditions. Suppression of such effects in studio painting often resulted in an artificial, static or deadening effect in the work produced.

Rubbing *see scumbling.*

Salon This was the official art exhibition in Paris, established in 1667 by the Academy as the respectable venue where their work could be shown. It was named after the *Salon Carré* in the Louvre where exhibitions were originally held. From 1831 the Salon was usually held annually. The only year for which there was no jury regulating admission of work was 1848, the year of revolution. In 1863 a *Salon des Refusés*, an exhibition set up by those artists refused by the Salon jury, was held. This resulted in public and critical hostility and thus did not further the cause of the many independent artists like Manet who exhibited in it. The reactionary nature of the academic Salon finally prompted the emergence of alternative exhibitions, like those of the Impressionist group from 1874, and the *Salon des Artistes Indépendants* in 1884.

Saturation Saturation in color refers to its degree of intensity or vividness of hue. Full saturation suggests the absence of white or of neutralizing or dulling elements. In oil painting, full saturation is often taken to mean the richness of the color as it comes out of the tube. Unsaturated color tends toward a neutral pale grayness.

Sauce *Sauce* was a word commonly used in nineteenth century France to indicate fluid, dilute color usually in the *ébauche* stage of painting. *Sauce* was normally a dark, reddish-brown, transparent mixture to which turpentine and often also a boiled drying oil like linseed oil, which would dry relatively quickly, had been added. *Sauce* was often used derogatorily in the second half of the century to refer to paintings dominated by rich dark browns, which looked as if painted with 'gravy'. The dark *sauce* was often technically dangerous, as bitumen was frequently used in it, and it was avoided by independent painters who preferred pale, opaque paint layers.

Scumbling Scumbling is the rough application of thin opaque color over an earlier layer of paint or over the ground so as to modify the color below. Although the scumbled layer is opaque, it is applied so thinly that it is translucent, thus the color below can be seen as if through a veil. The scumbled layer is usually applied with a bristle brush and an irregular, coarse stroke so that unevenness of color and the mark of the brush are left apparent. Rubbing is a comparable term used occasionally to describe the broad blocking-in of background color, especially during the *ébauche* stage of painting. *See glaze.*

Side lighting This is light which falls from right to left or left to right across an object. It enhances the sense of form by giving balanced areas of light and shade with gradated halftones between. This type of lighting was preferred by academic painters because it stressed the modeling of forms.

Sketch *see esquisse.*

Structure of a painting on canvas The traditional structure of an oil painting is a series of layers. Working from the surface down these would usually consist of a varnish layer; colored glazes; a paint layer with pigment particles in an oil binder; the ground or preparation; a layer of glue size; and finally the canvas fabric. The different layers within the paint layer can usually be clearly differentiated because of the layered painting procedure. However, using wet-in-wet or *alla prima* techniques, the Impressionists often produced a much more unconventional paint layer, where separate coats of color are indistinguishable. They also preferred not to varnish their pictures. Monet, Cézanne, Renoir and Pissarro are the most noted for their anti-academic, unconventional methods of paint handling.

Studio *see atelier.*

Study *see étude.*

Support The support is the surface upon which the painting is executed. The most common supports for easel painting in nineteenth century France were canvas, wood panel, cardboard and paper. Canvas fabric – usually linen – was normally stretched onto wooden frames or 'stretchers', to make it sufficiently rigid to paint upon. Paper could be tacked to board or cardboard during painting, and later glued or 'laid down' on canvas or panel to preserve it.

Surface color This is the color visible on the surfaces of objects, as opposed to film color. *See film color.*

Thumbnail sketch *see croquis.*

Tone, tonal value Tone or tonal value refers to the lightness or darkness of a color on a scale from white to black. The tonal value of a color is thus its position on a tonal scale gradated in steps from the lightest light through to the darkest dark. A color high in tonal value is thus very pale, high on the tonal scale meaning close to white. A pale tint means a color dominated by the presence of white. *See saturation, color.*

Transparency

Transparency, as opposed to opacity, is the capacity of a color to transmit light. A transparent color is clear and unclouded like glass, water or stained glass. Such colors, like the red lakes, ultramarine or viridian green in an oil binder, can be used effectively for glazes. They produce an optical fusion of the color of the glazed layer with the color below. Transparent colors were rarely used by the Impressionists, who normally added white to them to render them opaque, light-reflective, and thus a good visual metaphor for effects of light in the atmosphere.

Varnish Varnish is a resin in solution in a volatile solvent, which,

when applied in a thin coat on a surface, dries to a hard, glossy and normally transparent film. Varnish is usually the final coat added to protect an oil painting from dust and atmospheric pollution. During the 1880s in France, many artists preferred to frame their paintings under glass rather than varnish them. The glass protected the painting, while avoiding the immediate darkening and long-term yellowing which result from the addition of varnish to the paint surface. It also prevented the transformation of their intentionally mat paint layer into a glossy surface.

Vibert, Jéhan-Georges

Although undistinguished as a painter, Vibert undertook considerable research into artists' materials and methods, both historical and contemporary, which formed a series of talks given at the Ecole des Beaux-Arts probably in the late 1880s. In the early 1890s he published a volume on his research *La Science de la peinture (The Science of Painting)*, which provides invaluable material on painting methods in the Impressionist period. Vibert produced some of his own materials, including a special ground based on chalk and cheese-glue for use under tempera painting on panel, which was marketed by the prominent French color

merchants Lefranc et Cie.

Wet-in-wet painting Wet-in-wet painting means the application of one color over or into another before it is dry. Wet-in-wet painting, or the slurring of wet colors into each other leaving them partially mixed on the surface of the painting, is not necessarily synonymous with *alla prima* painting. Wet-in-wet handling can be used alongside wet-over-dry techniques in a painting which may be built up over an extended period.

Wet-over-dry painting Oil painting wet over dry indicates that color is applied over paint which has already been allowed to dry. Where

these dry areas are executed in a vigorous or impasted technique, dragging often results when wet paint is added, especially if the paint is fairly stiff in consistency.

Work from nature Work from nature means work executed directly from the chosen subject, in front of any live or real subject in the real world. This is as opposed to subjects worked from the artist's imagination in the absence of a direct model, or work done from other art. With reference to the Impressionists, work from nature is often taken to mean work done out of doors or *en plein air* (in the open air), as opposed to landscapes painted in the studio.

BIBLIOGRAPHY

Arnheim, Rudolph *Art and the Visual Perception,* University of California Press (1974)
Bazin, Germain *Corot,* Hachette (1973)
Boime, Albert *The Academy and French Painting in the Nineteenth Century,* Phaidon (1973); *Thomas Couture and the Eclectic Vision,* Yale University Press (1980)
Broude, Norma *Seurat in Perspective,* Prentice-Hall (1978)
Callen, Anthea *Renoir,* Oresko Books (1978); *Courbet,* Jupiter Books (1980)
Doerner, Max *The Materials of the Artist,* Hart-Davis, MacGibbon (1976)
Elderfield, John *Fauvism and its Affinities,* The Museum of Modern Art, NY (1976)
Gettens, R. J. and Stout, G. L. *Painting Materials, A Short Encyclopedia,* Dover (1966)
Gibson, James J. *The Senses Considered as Perceptual Systems,* Allen and Unwin (1966)
Gombrich, Ernst *Art and Illusion,* Phaidon (1962)
Gowing, Lawrence *Matisse,* Thames and Hudson (1979)
Havel, Marc *La Technique du Tableau,* Dessin et Tolra (1974)
Herbert, Robert *Barbizon Revisited,* Museum of Fine Arts, Boston (1962)
Hemmings, F. J. W. *Culture and Society in France, 1848-1898,* Batsford (1971)
Homer, William I. *Seurat and the Science of Painting,* The M.I.T. Press (1964)
Isaacson, Joel *Claude Monet, Observation and Reflection,* Phaidon (1978)
Lloyd, Christopher *Pissarro,* Skira, MacMillan (1981)

Mayer, Ralph *The Artist's Handbook,* Faber and Faber (1977)
Minnaert, M. *The Nature of Light and Color in the Open Air,* Dover (1954)
Nochlin, Linda *Impressionism and Post-Impressionism,* Prentice-Hall (1966)
Pollock, Griselda *Mary Cassatt,* Jupiter Books (1980); *Millet,* Oresko Books (1977); and Orton, Fred *Vincent van Gogh,* Phaidon (1978)
Rubin, William (ed) *Cézanne: The Late Years,* Thames and Hudson (1978)
Shikes, R. and Harper, P. *Pissarro, His Life and Work* Quartet (1980)
Wechsler, Judith *Cézanne in Perspective,* Prentice-Hall (1975)
Welsh-Ovcharov, Bogomila *Van Gogh in Perspective,* Prentice-Hall (1974)
Whitely, Jon *Ingres,* Oresko Books (1977)

Museum Publications
Alfred Sisley, Nottingham University Art Gallery (1971)
Centenaire de l'Impressionnisme, Editions des musées nationaux, Paris (1974)
Jean-François Millet, Hayward Gallery, London and Grand Palais, Paris (1975-76)
Gustave Caillebotte: A Retrospective Exhibition, Museum of Fine Arts, Houston and The Brooklyn Museum (1976-77)
Post-Impressionism, Weidenfeld and Nicolson and The Royal Academy of Arts, London (1979)
Camille Pissarro, Hayward Gallery, London and Museum of Fine Arts, Boston (1980-81)

ACKNOWLEDGEMENTS

Key
t top
b bottom
l left
r right

Page 8-9 Musée du Louvre, Paris/photo Hubert Josse; **10** Dordrechts Museum, Dordrecht; **11** Museum of Fine Arts, Boston; **12-13** A. Callen; **14,15** Musée du Louvre, Paris/photo Hubert Josse; **17** The Trustees, The Wallace Collection, London; **18, 19** Musée du Louvre, Paris/photo Hubert Josse; **20** Collection Lefranc-Bourgeois, Le Mans; **21** The Phillipps Collection, Washington; **22,23,24** Courtauld Institute of Art, London; **25** Home House Society Trustees/Courtauld Institute Galleries, London; **26** Musée du Louvre, Paris/photo Hubert Josse, **27** Victoria and Albert Museum/Crown copyright reserved; **28,29,30** Musée du Jeu de Paume, Paris/photo Hubert Josse; **31** Trustees of the British Museum, London; **32t** Metropolitan Museum of Art, New York/Bequest of Mrs H. O. Havemeyer, 1929; **32b** Nationalmuseum, Stockholm; **33** Metropolitan Museum of Art, New York; **34** Southampton Art Gallery; **35-37** Musée du Louvre, Paris/photo Hubert Josse; **39-41** Musée du Jeu de Paume, Paris/photo Hubert Josse; **43-45** National Gallery, London/photo Mike Fear; **47-49** Wallraf-Richartz Museum, Cologne; **50** M. Marc Havel, Paris; **51-53** Musée du Jeu de Paume, Paris/photo Hubert Josse; **55-57** National Gallery, London/photo Mike Fear; **60-61** National Gallery, London; **61r** M. Marc Havel, Paris; **62** National Gallery, London/photo Mike Fear; **63** Home House Society Trustees, Courtauld Institute Galleries, London; **64t** photo Ray Gardner; **64b** Metropolitan Museum of Art/gift of Mr & Mrs Henry Ittleson, Jr., 1964; **65** Musée du Jeu de Paume, Paris/photo Hubert Josse; **66** Fitzwilliam Museum, Cambridge; **67** Neue Pinakothek, Munich/photo Bavaria Verlag; **69t-71** Metropolitan Museum of Art, Bequest of Lillian S. Timken, 1959; **69b** photo A. Callen; **73-75** Musée du Jeu de Paume, Paris/photo Hubert Josse; **77-79** National Museum of Wales, Cardiff/photo Mike Fear; **81-83** Home House Society Trustees/Courtauld Institute Galleries, London; **85-87** Musée du Jeu de Paume, Paris/photo Hubert Josse; **89, 90t, b1, 91t** Ashmolean Museum, Oxford; **90br** Home House Society Trustees/Courtauld Institute Galleries, London; **91b** Musée du Jeu de Paume, Paris/photo Hubert Josse; **93-95** Chicago Art Institute; **97-99** Fitzwilliam Museum, Cambridge/Reproduced by kind permission of the Trustees of the Lord Butler of Saffron Waldon, K.G., P.C., C.H., F.R.S.L., **101, 102t, 103** The Burrell Collection, Glasgow Museum and Art Galleries, **102b** Metropolitan Museum of Art, Rogers Fund, 1918; **104** National Gallery of Art, Washington; **105** The Burrell Collection, Glasgow Museum and Art Galleries; **106** Wadsworth Atheneum, Hartford, Connecticut; **107** Ohara Museum of Art, Kuranshiki, Japan; **108** Metropolitan Museum of Art/gift of Mrs Gardner Cassatt; **109t** photo Ray Gardner; **109b** Minneapolis Institute of Arts/William H. Dunwoody Fund; **111t** Home House Society Trustees/Courtauld Institute Galleries, London; **111b** Trustees of the British Museum/photo Eileen Tweedy; **112** Tate Gallery, London/photo Mike Fear; **113** Mary Evans Picture Library; **115,116t, 1, 117** National Museum of Wales, Cardiff/photo Mike Fear; **116r** Courtauld Institute Galleries; **119-121** Museum of Fine Arts, Boston; **123-125** National Museum of Wales, Cardiff/photo Mike Fear; **126-129** Birmingham Museum and Art Gallery/photo Mike Fear; **130-133** National Gallery, London/photo Mike Fear; **135-137** Collection State Museum Kröller Müller, Otterlo, The Netherlands; **139-141** Museum of Fine Arts, Dallas; **143-145** Home House Society Trustees/Courtauld Institute Galleries, London; **147,148, 149br** Collection State Museum Kröller Müller, Otterlo, The Netherlands; **149t, bl** Yale University Art Gallery; **150** Tate Gallery, London/photo Mike Fear; **151** National Museum Vincent van Gogh, Amsterdam; **152** National Gallery of Scotland, Edinburgh; **153t** Statens Museum for Kunst, Copenhagen/photo Hans Peterson; **153b** Museum Folkwang, Essen; **154** Musée de Grenoble/photo Ifot, Grenoble; **155** Private Collection, Switzerland; **156** Metropolitan Museum of Art, New York/H. O. Havemeyer Collection; **157** National Gallery, London; **159-169** Home House Society Trustees/Courtauld Institute Galleries, London; **171-173** National Gallery, London/photo Mike Fear; **175-181** Tate Gallery, London/photo Mike Fear.